A SPY IN CANAAN

A SPY IN CANAAN

HOW THE FBI USED A FAMOUS PHOTOGRAPHER TO INFILTRATE THE CIVIL RIGHTS MOVEMENT

Marc Perrusquia

MELVILLE HOUSE
Brooklyn
London

A SPY IN CANAAN

Melville House Publishing
46 John Street
Brooklyn, NY 11201
and
8 Blackstock Mews
Islington
London N4 2BT

mhpbooks.com
facebook.com/mhpbooks
@melvillehouse

ISBN: 978-1-61219-341-0
ISBN: 978-1-61219-440-0 (eBook)

Designed by Richard Oriolo

Printed in the United States of America

10 9 8 7 6 5 4 3 2 1

A catalog record for this book is available from the Library of Congress

CONTENTS

A SPY IN CANAAN

INTRODUCTION

D R. MARTIN LUTHER KING, JR., stretched onto the bed, curling ever so slightly to his side. He looked crisp yet casual in his suit trousers and shirtsleeves. If he worried the FBI had bugged his room here at the Lorraine Motel in Memphis, as it had in so many hotels across America, he didn't show it. Leisurely, he threw his arm behind his head and stared into the camera. It was rare for King, viewed by some in the media as tense and aloof, to be at such ease with a newsman.

But this was different.

The man holding the camera was Ernest Withers, a slightly chubby, extremely personable freelancer known to some civil rights insiders as Ernie, the down-home Beale Street studio photographer with press credentials, a wispy mustache, and a wide smile few could resist.

Yet to the FBI special agent who slipped Ernie cash, the photographer was something far different—a confidential "racial" informant smuggling

precious nuggets of intel from behind the color barrier separating black and white America. By this time, 1966, Withers had been working for the Bureau for as many as eight years. He became so valuable that in 1967 his handlers began protecting his identity in internal reports with a code number, ME 338-R.

What, if anything, Withers told the FBI on this warm June day in 1966 isn't known. Yet records show the newsman began relaying dozens of tips on King and his staff two years later as Memphis's volatile sanitation strike erupted. Troubled that the Southern Christian Leadership Conference (SCLC) was overrun with Communists and dangerous militants, King's old adversary J. Edgar Hoover oversaw what would become the latest in a series of FBI campaigns to disrupt and discredit the thirty-nine-year-old Nobel laureate.

In Memphis, Withers played a critical role. Starting two weeks before King's April 4, 1968, assassination and continuing for another year and a half as SCLC aides repeatedly returned to Memphis, he shot photos and relayed intelligence that painted a troubling portrait: one of King's top aides appeared to harbor sympathies for a virulent strain of Black Power, he said; others on King's executive staff exhibited an intense militancy. King, too, was meeting with Black Power militants. Collectively, the details fueled deepening skepticism within an already hostile FBI as to whether the civil rights leader intended to keep his movement nonviolent.

"I'm not going to place the blame here on Ernie Withers," King's long-time friend Rev. James Lawson would say years later after Withers died at age eighty-five, after his secret finally came out. The heralded photographer had been the FBI's go-to man inside the movement in Memphis for more than a decade.

Lawson found it hard to accept. A chief architect of the sit-in and Free-dom Rider movements, he'd worked with Withers for years. What he didn't know was that he, too, became the focus of dozens of tips Withers passed to the FBI: one involving the militant pastor's plans to coach young men in ways to dodge the draft, another on a trip he'd planned to communist Czechoslovakia—even a sermon he preached that seemed to question the virgin birth of Christ.

Yet even now, his hair snow-white and his voice weary, the aging activist-

pastor struggled. Ernie must have been induced. Manipulated. After all, he was vulnerable. With eight children to feed he was always in need of extra cash. No, he couldn't blame Ernie. Besides, things were different back then. They trusted the FBI. They had no idea just how far Hoover would go to destroy King—how hard the FBI had worked to derail the movement.

"In the age in which we lived we were not as aware," Lawson argued.

THIS BOOK TELLS the story of the double life of Ernest Withers and how this closely guarded government secret finally came to light. Against all odds, my financially struggling newspaper overcame powerful laws that allow the FBI to shield the identity of informants—even to lie about them—long after their work is over, even after they die. The story of this on-again, off-again investigation starts in 1997, when a retired FBI agent first told me about Withers. Following years of detective work and a costly lawsuit that forced the FBI to release a mother lode of classified records between 2013 and 2015, we finally broke the news that the beloved civil rights photographer had secretly spied on the movement for as many as eighteen years—the very movement he helped propel with his iconic black-and-white photographs.

It was a radical rewrite of history.

Withers is a legend in Memphis. A street and a building are named for him. He's honored by a brass "Blues Note," the local equivalent of the Hollywood Star, embedded in the sidewalk along world-famous Beale Street. Though many today might not recall the "Original Civil Rights Photographer," his work is buried deep in our collective conscious.

The picture of Dr. King riding one of the first integrated buses in Montgomery? Withers shot it. The haunting photo of Emmett Till's wispy great-uncle Moses Wright pointing an accusing finger at the teen's killers? That's his, too.

When I first started sizing up this story, digging through boxes of old records and yellowed newspaper clippings, it was clear Withers's life was extraordinary, even without the FBI component. He navigated an astonishing, almost surreal, range of highs and lows: a friend to famous bluesmen like B.B. King and Howlin' Wolf; a policeman who served as one of Memphis's early black officers, only to be kicked off the force for

bootlegging; a chronicler of Negro Leagues baseball who knew the legends Satchel Paige, Willie Mays, and Roy Campanella; a dinner guest at Jimmy Carter's White House. As a witness to the aftermath of Dr. King's 1968 assassination, he used his incredible access to view King's body in a funeral parlor morgue room, and even held a piece of the fallen civil rights leader's skull in his hands.

Withers's incredible saga is told in this book from a reporter's perspective—a narrative of discovery. It recounts, piece by piece, the many unfolding sides of this complicated and historically significant man's life. For all he did, it was his role as a hard-charging freelance photographer for America's black press—newspapers serving a largely African American readership—where Withers shone. He shot timeless photos of the Little Rock Nine anxiously walking to their first day of classes at military-occupied Central High; of striking garbagemen carrying placards reading "I AM A MAN" as they fought for dignity and a living wage in Memphis; of the mournful funeral of Medgar Evers, the Mississippi NAACP field secretary ambushed under his carport as he came home from work to his wife and children.

Withers's work earned him the trust of the movement's leaders, people like King, Evers, and Lawson, and many others whose activism brought them to Memphis—Ralph Abernathy, James Forman, Fannie Lou Hamer, Andrew Young, James Bevel, Virgie Hortenstine, and Dick Gregory among them. But none knew his secret.

HIS FBI WORK was prolific. Between 1958 and 1976, Withers produced a staccato of photographic prints, negatives, and oral intelligence. His collaboration contributed more than 1,400 unique photos and written reports to the files of the FBI's massive domestic intelligence vault, a history detailed for the first time in this book.

In return, he was paid $20,088—an amount roughly equal to $150,000 in 2018. It wasn't huge. But it was considerable. The tight-fisted FBI paid most of its informants nothing. Though Withers was among as many as 7,400 so-called ghetto informants operating nationwide for the surveillance state of the late 1960s, he was in a select group. Among scores of Memphis informers, he was one of just five getting paid in 1968 to report on the racial strife there.

His first known contact with the FBI as an informer came in 1958 in Little Rock, where he helped identify renowned activist James Forman, then an obscure Chicago schoolteacher who'd begun turning up at civil rights skirmishes and was put under investigation as a suspected Communist. A single, surviving report tells the story. Withers came into the Little Rock field office one day with legendary *Jet* magazine reporter Simeon Booker, who endured his own controversy as an alleged informer. These were simpler days. By the mid- to late-1960s, many black journalists were openly defying the FBI's overtures for information. But in the innocence of the movement's early days, journalists like Booker looked to the FBI for protection. The details of Withers's early cooperation remain sketchy. But one thing is clear: he got in deep.

His relationship with the FBI blossomed in 1961. He began working with special agent William H. Lawrence, the resolute William F. Buckley–styled conservative who ran the Bureau's domestic intelligence unit in Memphis for over two decades and eviscerated the Communist Party there. The two men shared much in common. Both grew up Baptist. Both had law enforcement backgrounds. Both loved music. A jazz enthusiast, the savvy Lawrence knew how to manipulate mutual interests—how to connect with potential informers. He knew, too, of Withers's scandalous career as a cop. It hindered the photographer at first. But Lawrence knew he was onto something good. Citing Withers's "many contacts in the racial field," the agent found ways to steer around skeptical supervisors and advance Withers from a lesser, "confidential source" into the ranks of directed informants.

He was valuable on several fronts. First, he helped the FBI assemble dossiers, for which identification photos were critical centerpieces. The FBI wanted clear, up-to-date images as it cataloged the movement, building a virtual library of secret files on civil rights workers, peace activists, and other "subversives." Group photos Withers shot often were cut up at FBI offices into face shots and placed in individual files. Copies were shipped to other FBI field offices or shared with local police. Often, the agency bought photos Withers had shot at events he'd covered on his own as a newsman. But increasingly, starting in the summer of 1961, Lawrence dispatched Withers to shoot in the field.

Demand for pictures grew as Northern "agitators" began pouring into

the area to assist impoverished sharecroppers kicked off their land for trying to vote and as a radical sect known as the Nation of Islam began recruiting on Beale Street. Often, the photographer received explicit advance instructions. In April 1966, for example, Withers was directed to photograph a march against the Vietnam War while "posing as a newsman." Following Lawrence's directives to "get good facial views of the participants," Withers delivered eighty 8-by-10 identification photos to the FBI's Memphis office.

THE RELATIONSHIP CENTERED on photos. Yet, from the start, the FBI paid him for oral intel, too. In July 1961, for example, Lawrence paid the photographer $15 (about $120 today) to tap his contacts for information on a busload of Freedom Riders headed to Memphis. In time, Withers began operating like a listening post—acting as the FBI's eyes and ears in the black community. He and Lawrence met in periodic intervals. In lean times, this might happen every few weeks or so. During the chaos of the 1968 sanitation strike it became virtually a daily routine. Driving these investigations were Hoover's obsessions with black America, Cold War fears of insurrection, and, later, the riots and unrest that shook urban America in the mid- to late-1960s. These were volatile times—the greatest internal crisis since the Civil War.

Overtly, the FBI aimed to protect the country's internal security—to prevent violence and preserve civil order. Withers proved effective. While informing on the Invaders, a homegrown Black Power group, he aided in the arrests of two militants accused of murder and another of assault. He reported others advocating the use of incendiary Molotov cocktails. But he also helped the all-white FBI understand that not every youth sporting a faddish dashiki and an Afro hairstyle was a revolutionary.

Yet just as congressional investigations uncovered wide abuse nationally in the FBI's domestic surveillance, the Withers files document repeated disregard for the rights of law-abiding citizens simply exercising rights to free speech, dissent, and political affiliation. Forget what you think you know about an informant. The intelligence informants of the 1960s surveillance state weren't criminal informants pursuing narrow threads of information to build a specific case for prosecution. They captured broad swaths of per-

sonal and political data that jeopardized careers and livelihoods. An enthusiastic gossip, Withers thrived in the role. He routinely relayed backbiting rumors and potentially damaging private details: A civil rights worker in Fayette County had contracted a venereal disease, he said. King aide James Bevel had "weird sexual hangups." Memphis NAACP leader Maxine Smith had left her husband, Vasco, and was living in a Midtown apartment.

Even soul singer Isaac Hayes was implicated. Months before he released *Hot Buttered Soul* to diverse acclaim, Hayes mirrored the rhetoric of the day, giving a fiery Black Power speech—details Withers relayed to the FBI despite the singer's admonitions to the all-black audience against repeating his comments.

When King's SCLC launched a chapter in Memphis in 1969, Withers, the consummate insider, gained a seat on its board of directors, funneling inside accounts of meetings, financial information, and names of individuals he viewed with suspicion to special agent Lawrence. As a newsman, he could ask for personal information without a hint of suspicion: names, addresses, occupations, phone numbers. Phone numbers made for especially pernicious inquiries. Lawrence used them to conduct warrantless searches of a subject's toll charges. Over time, as the mainstream movement collapsed, the FBI revised Withers's code number, shifting him from racial informant ME 338-R to extremist informant ME 338-E, who reported on fringe groups like the Black Panthers, which had formed a small Memphis organization, and a resurgent Communist Party.

"Withers is no innocent," said retired Marquette University professor Athan Theoharis, an authority on civil rights–era FBI surveillance who reviewed many of the Withers records. "He knew what he was doing."

DID WITHERS BETRAY the movement? It's a question with many answers—all of them subjective. To his faithful circle of family and supporters, who have zealously defended his legacy, the answer is an emphatic no. "In the battle between Hoover's F.B.I. and King's movement—between those who tried to suppress our rights and those who fought against them—nothing in these files shakes my belief about which side Ernest Withers was on," writer Daniel Wolff, the photographer's friend and collaborator on two books, wrote in an early defense.

But the central question about Withers's FBI collaboration isn't whether he betrayed the movement; it's something far more vexing, involving personal relationships and friendships like the one Withers shared with Coby Smith, a young activist in 1967 who cofounded the Invaders with Charles Cabbage, an intellectual-turned-petty-street-criminal who viewed the older photographer as a "dear friend." Between 1966 and 1969, Withers passed dozens of photos of the two men to Lawrence. He relayed intel that the agent included in scores of written reports. That intel led to both young men's placement on the Security Index, the FBI's list of "dangerous" subversives to be rounded up in time of national crisis.

"He betrayed my friendship," said Smith, who distanced himself from the Invaders when its rhetoric grew increasingly violent, earning a doctoral degree in education. Still, the stigma stuck and it took him years to find work in Memphis. "He was our family photographer. And, you know, he took the yearbook pictures. He took the prom pictures. He took the parade pictures."

Withers took Kathy Roop Hunninen's wedding photos—and secretly funneled scores of pictures and bits of intel about her to the FBI. A former war protestor and civil rights activist, she suffered years of trauma and depression after she lost her federal job in 1986 when reports surfaced of the FBI's long-running investigation of her as a suspected Communist in Memphis in the late 1960s and early '70s. "This man has ruined my life. He has ruined my life," Hunninen said. "Betrayal? Betrayal isn't even the word. I have been scarred for life."

NONE OF THIS can change the good he did. Though he remains obscure to many, arguably Withers is one of the great photographers of the twentieth century. He shot as many as a million photos over sixty years documenting black life in the South. If he'd only shot three he would still secure a spot in the pantheon of immortal shutterbugs: King on that integrated bus. Till's great-uncle pointing that accusing finger. And his haunting photo of Memphis's striking garbagemen dressed in their Sunday best, carrying those "I AM A MAN" signs as they protested for the most basic of rights—to make a living wage; to work with dignity; to be treated as human beings. Each was pivotal and consequential.

"I view him as a guy who ran significant risk to photograph and record our history," said Andrew Young, King's close aide who was later elected mayor of Atlanta and appointed by President Carter as ambassador to the United Nations. "He always showed up. And that was important to us. Because that helped us get our story out."

Whatever motivated Withers to collaborate with the FBI—money, patriotism, or his long ambition to be a cop—his story is instructive. It opens a window into a dark, injurious period. We know the macro, the sweeping, big picture of our government's spying on Americans. But we know so little of the micro, the intricacies of how authorities induced or compelled individuals to inform on their fellow citizens. Even now, fifty years later, restrictive laws make those types of details elusive. It is not my intention to erode the memory of Withers, nor to reduce him. He will forever remain a Memphis hero. Instead, my hope is that the story of Ernest Columbus Withers will help fill in many of those gaps that still exist in the twin histories of civil rights and government surveillance.

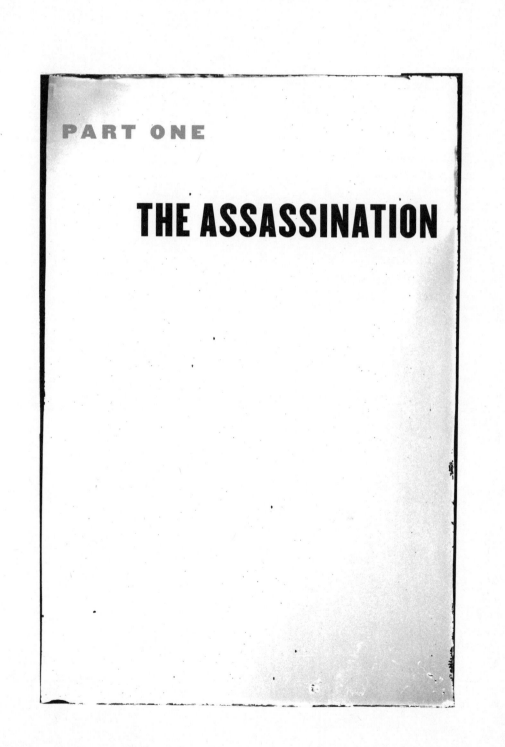

PART ONE

THE ASSASSINATION

IN THE SHADOWS

APRIL 4, 1968

WILLIE RICHMOND LOGGED THE TIME: 4:10 p.m. He'd been spying on Dr. Martin Luther King, Jr., for over four hours now. From his post at the back of a brick firehouse overlooking the Lorraine Motel, the Memphis policeman aimed his binoculars across the street toward King's second-story room. He marveled at what he saw—as if he could reach out and touch everything. "The view from the fire station window was very good," he later reported. In his field glasses, Richmond could see a kaleidoscope of detail: the concrete steps, the motel balcony, the railing glazed in a gaudy turquoise, the dark numbers on the door—306—and the many visitors coming and going, appearances he carefully recorded on a notepad throughout the bright afternoon.

And he could see Ernest Withers.

The affable photographer pulled into the Lorraine's parking lot shortly after four, the policeman noted, a little less than two hours before it hap-

pened, before the world stood still—before a sniper shot King as he stood on the balcony outside his motel room at a minute after six o'clock, a half hour before the sun set.[1]

As always, Withers blended right in.

King knew him and liked him. They'd first met nearly twelve years earlier, in 1956, when the personable freelance newsman had journeyed down from his hometown of Memphis to Montgomery, Alabama, where King would make history and Withers would shoot a photo for the ages. The U.S. Supreme Court had just outlawed segregated seating on that city's public buses. The year-long Montgomery bus boycott was over. Withers rose at four that morning. With pluck and an uncanny knack for being at the right place at the right time, he aimed his camera as the then twenty-seven-year-old civil rights leader climbed the metal steps of a Montgomery City Lines coach with his closest friend, Ralph Abernathy, and took a seat near the front.

Click!

He shot a beautifully composed photo: King—slender, pensive—gazes out the window. He wears a stylish fedora propped high on his forehead. Abernathy sits to his left, looking hard at the camera. Behind them are a busload of white faces—an assortment of housewives out on their morning errands; a couple of young boys looking alternately curious and bored; a prim woman in a dress suit studying the passing scenery through the shiny glass. At the very back, a white man stands in the aisle. His feet are crossed in a carefree stance; his arms spread wide, gripping both overhead rails. Like the others in this Norman Rockwell–like image, he appears content, seemingly oblivious to this revolutionary moment in American history.

Through the years Withers would use his unique access to capture many other memorable pictures: King as he preached; as he froze with suspicion when police confronted him outside Medgar Evers's funeral; as he marched through Mississippi's sweltering heat.

King posed for a series of portraits Withers shot right here at the Lorraine two years earlier in 1966, up in room 307. Not many journalists could penetrate the civil rights leader's personal world. The white media found him to be stiff and guarded. Yet Withers, always affable, always a hearty laugh to set his subject at ease, teased out another side of King, capturing

him in rare repose. In one shot, King reclines on his bed in his shirtsleeves, resting without a care against the headboard. He stares nonchalantly out his open motel door in another, toward the direction from which the sniper's bullet would come two years later, when he'd returned to rally the city's striking sanitation workers.[2]

"He had all the access he wanted," Andrew Young, King's right-hand aide, would recall years later. "Yes, I remember Ernest Withers as a lot of fun. And any time you went to Memphis, he was with us and we laughed together. We joked together, and he was sort of one of the family."[3]

So it was on the day of the assassination that no one, not officer Richmond watching from the firehouse, not the various members of King's entourage out enjoying the cool spring air, found it at all irregular as Withers mingled in the courtyard.

And no one seemed to notice as Withers slipped off repeatedly over the course of Memphis's volatile, seven-week-old garbage workers strike to meet with a tall white man in a dark suit, an FBI agent, who was handing him cash.

THE LORRAINE PULSED with energy that afternoon. The tempo had moved at a furious pace ever since King took up residence there a day earlier. Aides and visitors coursed through the complex. At any given time, one might catch a glimpse of a famous face, Jesse Jackson or Andrew Young, or even Abernathy or King himself, passing through the courtyard or along the balcony or down to the greasy-spoon diner for a bite to eat.

It was "a beehive of activity," Withers told the man in the suit.[4]

The Lorraine often had that feel. As a hub of black life in segregated Memphis, it hosted many of the big names who passed through the city, entertainers like Cab Calloway, Aretha Franklin, and Nat King Cole, and many of the great ballplayers, including Jackie Robinson and Satchel Paige. It opened at the height of Jim Crow as a small, two-story inn, a beacon of light surrounded by flophouses and prostitutes five blocks from the Mississippi River in downtown's dreary warehouse district. The Lorraine Motel's recent addition, a modern, two-story motor lodge, built of ordinary cinder block, added more rooms, more light, most noticeably a space age–styled

tower out front ablaze in flashing neon, proudly proclaiming the "Lorraine Motel."[5]

When King came to town he stayed there, too. But never had any of his trips to Memphis been so anticipated—so watched.

Officer Richmond stayed busy. He jotted down auto tag numbers. He scribbled names of faces he recognized. A group of young troublemakers, Black Power advocates, had set up operations in room 315, several doors down from King along the balcony's concrete deck, he recorded.

But, for the moment, the plainclothes policeman focused on Withers.

He watched as the photographer climbed back into his sedan with Rev. James Bevel, the fiery, "crazy genius" of King's executive staff. Two other men got in, too. Richmond couldn't identify them. It didn't matter, really. Bevel was enough. As one of King's top aides, he was a prime target.[6]

Logging the time, 4:20 p.m., Richmond watched as the car sputtered out of the Lorraine's busy lot and disappeared down Mulberry Street.

WITHERS WAS SPENDING long hours with King's staff.

He'd stayed late into the night the last two days, in strategy meetings, listening to the explosive arguments and pleas for order, as the men met with local activists and community leaders. They rehashed the recent excitement—the riot, the National Guard troops, the brutal cops, the unrelenting pressure from white leaders who deeply resented King, an outsider, injecting himself in Memphis's affairs. King and his aides had come to town two weeks earlier to assist the city's 1,300 striking sanitation workers. The garbagemen had walked out in a wildcat strike after two coworkers were crushed to death in a malfunctioning packer. They stepped away from poverty-wage jobs, into the streets to protest.

For King, this Memphis campaign—his latest crusade against injustice—started almost as a dream, a glorious step back to the movement's vibrant early days.

As many as fifteen thousand people gathered the night of March 18, 1968, to hear him speak. Withers was there with his cameras. The crowd roared with enthusiasm. Shouts of *"Tell it!"* and *"Go on! Go on!"* rang

through the hall. There was a thunderous ovation. King was so moved, so inspired, he agreed to return to Memphis to lead a march.[7]

Then disaster struck.

On March 28, 1968, as King walked arm-in-arm with Abernathy and Memphis religious leader H. Ralph Jackson, leading as many as ten thousand demonstrators through downtown Memphis, violence broke out at the back of the march. Hot-headed youths smashed store windows. They looted. Police responded with Mace and clubs. In the melee, an officer shot and killed a fleeing protestor, Larry Payne, just sixteen. His mother was inconsolable.[8]

The media blamed *King*. He couldn't sleep. He was drinking heavily.

The trouble in Memphis widened deep divisions among his staff. They seemed to be spinning apart. But after regrouping in Atlanta, they returned on April 3, King determined to lead a peaceful march. His very reputation depended on it. Still, the city's leaders obtained an injunction blocking another march. Worse yet, young militants hounded King, playing a dangerous game of extortion, seeking money in exchange for peace.[9]

For all the tension, it was peaceful that afternoon, that last day. King got up late. He ate a catfish lunch with Abernathy. His brother, A.D., a pastor in Louisville, Kentucky, had arrived. Together, the two brothers phoned their mother in Atlanta. They joked and laughed. When Andrew Young arrived from court with the good news—the injunction had been lifted—King was so giddy he tossed a pillow at his aide. Like two college fraternity brothers, they had a pillow fight.[10]

UP ON THE eighth floor of the federal building, an austere office tower overlooking the Mississippi River's great sweep past downtown Memphis, special agent William H. Lawrence sucked on a dark tobacco pipe and reflected on the many developments. Spread before him were his notes, a scrawl of long, run-on sentences containing the many bits of intelligence Withers had relayed, his accounts of the raucous meetings, the shouting matches, the young militants, and a small but titillating detail his informant picked up the night of that rousing speech: King in the company of as many as a dozen staff members—and "one unidentified *female*."[11]

Lawrence was under enormous pressure. J. Edgar Hoover's years-long campaign to discredit the civil rights leader had been reenergized, by two startling developments: King's hugely unpopular opposition to the Vietnam War and his Poor People's Campaign, a plan to unleash thousands of impoverished citizens in Washington later that spring to camp, to protest—to disrupt government operations if necessary—until officials did something substantial to end poverty. Hoover wanted dirt. Something good. Something to finally knock the wind out of King.*

Lawrence had seen Hoover's fervor for King before.

The agent had opened a file on the civil rights leader back in 1965, trying to prove he'd had an "extramarital relationship" with singer Harry Belafonte's first wife, Marguerite, an attractive movement volunteer. The salacious tidbit never amounted to anything, just thirdhand gossip, a tale Lawrence picked up from two of his "racial sources," Memphis activists who'd heard it through the movement grapevine. Unreliable or not, it didn't matter. When his report hit Washington, Lawrence was ordered to press his sources for more. Agents in New York and Atlanta were put on it, too. Those were the weeks after King won the Nobel Peace Prize. Hoover was enraged: King—a *degenerate*. How could they give *him* the *Nobel Prize*?[12]

So Lawrence went back. The story was the same: Several years earlier, King was said to have been "infatuated" with Mrs. Belafonte. He made "an utter fool of himself," following her "from city to city," Lawrence reported. But it was just gossip. His sources knew nothing.[13]

Now, at forty-eight, the square-jawed Lawrence knew his career was winding down. He'd seen incredible highs and lows over his twenty-four years with the FBI, virtually all of it served in Memphis in internal security, chasing Communists, radicals, and other Americans viewed by Hoover as real or potential domestic enemies. In 1954, Lawrence arrested Junius Scales, the wealthy Communist Party-USA organizer who'd been in hiding for years—a huge coup. Lawrence was legend in Memphis. He and his col-

* Starting that February, headquarters circulated a series of memos revisiting old gossip about King's "sexual aberrations" and his new, heightened militancy. A key memo concluded that the march on Washington might not only lead to violence, but *violence might be its goal*. A memo on March 4 urged the need to "prevent the rise of a messiah" like King, "who could unify, and electrify, the militant black nationalist movement." Following the violence in King's March 28 demonstration, the Memphis office was advised to "get everything possible on King" and to "stay on him until he leaves Memphis."

leagues shattered the Communist Party there, driving the few surviving members underground or out of Tennessee altogether.

In later years, as the social upheaval of the 1960s took root, his focus shifted. He fixed his attention on militancy in the civil rights movement and the New Left: a long list of "extremists," agitators, peace activists, draft dodgers, Black Power advocates, student reformists, hippies, and revolutionaries—people Hoover thought were pushing the country to the brink.[14]

King was one of them.

The civil rights leader seldom came to Memphis. Consequently, the FBI's local security file on him never grew very thick. Even now, following his return to the city a day earlier, on April 3, he was elusive.

Undercover police had followed him from the airport. But a carload of angry supporters cut them off, stalling the pursuit. Running all day from meeting to meeting, King gave a mesmerizing speech that night. He spoke as a rainstorm thundered outside, seeming to prophesy his own death. "I just want to do God's will. And he's allowed me to go up to the mountain. And I've looked over, and I've s-e-e-n the promised land," King said, swaying to his own hypnotic cadence. Nearby, Withers shot pictures from his spot in the media pack. "I may not get there with you. But I want you to know tonight that we as a people will get to the promised land!"[15]

But then he disappeared again. For hours—nothing. All night. No one seemed to know where he was.[16]

Still, things were moving fast. Between King's return and the chaotic pace of the sanitation strike, the daily marches, the frequent clashes with police, Lawrence had more than he could keep watch over. But as the April 4 sun fell toward the Mississippi's flat, west bank across from the federal building, he had his best racial informant on the case.

AS WITHERS STEERED his car from the Lorraine toward the Memphis skyline, a dozen details weighed on him—Lawrence, another march, the young militants, his neglected business back on Beale Street. But at top of mind now was his passenger, King's "director of direct action," the eccentric Jim Bevel.

Some in King's organization thought Bevel was mad. He claimed to hear

voices. Intense, charismatic—a prolific womanizer—he certainly was peculiar. An ordained minister, he wrapped his rigid, in-your-face views in Holy Scripture—and shocking profanity. Some derided him as "The Prophet." He dressed the part, too, in his own eclectic way. Today, riding in Withers's car, he wore a crisp button-down shirt and dress pants. But just as often he sported a yarmulke, a Jewish skullcap, signifying the Baptist preacher's connection to God, and a pair of blue country overalls, a testament to what journalist David Halberstam called Bevel's "own permanent protest of segregation," a way to honor African Americans kept in poverty by racism.[17]

With his news cameras, Withers had been following Bevel around Memphis the past two weeks, picking up on the young pastor's quirks. He passed a flow of salacious tidbits to Lawrence, a pattern that would continue over the next two years as the activist moved in and out of Memphis.

Bevel has sex "hang-ups," Withers said.

He's separated from his wife, the beautiful Nashville sit-in leader, Diane Nash.

He speaks in "extreme vulgarities and obscenities."[18]

But it was Bevel's intense militancy that most interested the FBI.

Withers had caught a glimpse of it, Bevel's fire, his unfiltered rhetoric, when he followed the activist to LeMoyne College two weeks earlier. Overlooked by the media, the unscheduled lecture at historically black LeMoyne would have been difficult for the FBI's all-white Memphis field office to surveil if not for the enterprising informant.

Bevel "gave a most virulent black power talk, claiming that the white power structure through economic pressure will eventually attempt to exterminate the Negroes in the United States in some form of genocide," Lawrence wrote after debriefing Withers. The photographer delivered pictures—and graphic accounts—chronicling the meeting. He said the activist, accompanied by several Black Power militants, had used vile obscenities, "shocking some of the women who were present." Bevel encouraged the impressionable students to reject the help of white "do-gooders" who had no "real soul feeling" for African Americans, to read the writings of black separatist Elijah Muhammad and revolutionary Frantz Fanon, and "come into the black power movement."[19]

Filed under "Racial Matters," a long-running Hoover program that kept

a suspicious eye on black America, Lawrence's thirteen-page report fueled deepening skepticism within an already hostile FBI as to whether King intended to keep his movement nonviolent. Who knows, Bevel may have been only venting that day. Just showing his crazy side. But to the FBI this was valuable, fresh intel. A suspected Communist, King's quirky aide was a man under intense watch—a man Hoover's strategists back in Washington believed was flirting with treason.[20]

EIGHT BLOCKS NORTHEAST of the Lorraine, Withers dropped off Bevel at Clayborn Temple, the venerable, Romanesque Revival stone church that served as headquarters for the sanitation strike. It buzzed with people. Withers had spent many an hour here since the strike started back in February, listening to the impassioned speeches, the strategy sessions, the caustic arguments, and the angelic singing, absorbing the electric energy. He'd move through the crowds with the ease of a politician. Everybody knew him. A former cop who'd walked a beat on Beale Street and who now ran a popular photography studio there, he had arrested or assisted several of the strike supporters over the years. He'd shot baby pictures, graduation photos, and family portraits for many others. Even more knew him as a newsman—a high-profile freelancer for *Jet* magazine, the pocket-sized "Bible" of black America, and the weekly newspaper, the *Tri-State Defender*, the Memphis satellite operation of the *Chicago Defender*.

At events like these, the rallies, the big marches, he typically wore professional attire—a suit and tie, sometimes a pair of dark, plastic-rimmed eyeglasses that made him look a bit like Bo Diddley. He commanded attention. Two box-like contraptions dangled from his neck, each an old-fashioned twin lens reflex camera that required him to peer down through a viewer mounted on top. He was as much a fixture here as the massive, arched windows of glittering stained glass, the sweeping, panoramic balcony, and the imposing, four-story bell tower. Like a hidden microphone, or a fly on the wall, he was invaluable to agent Lawrence.

Withers briefed Lawrence on the backgrounds of strike leaders, people like Rev. James Lawson and O. Z. Evers, both middle-aged community leaders viewed by the FBI as militant agitators; he told the agent about a power

struggle that threatened to splinter the strike's brittle alliance of supporters; he provided current, real-time news. The government could move swiftly on his tips, but his greatest asset was his intimate knowledge of Memphis.[21]

So many unfamiliar faces were showing up at protests and rallies. Lawrence needed someone to connect the dots: Who was who? Who *knew* who? Who was related by blood? Who worked together, and on which causes? What were their occupations? Where had they gone to school?

Withers, described by Lawrence as a source "most conversant with all key activities in the Negro community," could deliver all of that.

These FBI investigations purportedly aimed to prevent violence, to preserve civil order. If that's all it had been, perhaps when it finally came out years later there would have been far less consternation, far less fury about what the FBI had been doing. At the time, to the government, there seemed ample justification. Less than a year earlier, race riots had devastated Newark and Detroit. But the response—the overreach and the many abuses—would forever taint these operations.

In Memphis, Lawrence helped the Memphis Police Department open a domestic intelligence unit, a sort of FBI Lite, one of many "Red Squads" that cropped up across the country. Swapping information with the FBI on virtually a daily basis, MPD's Red Squad numbered a dozen or more officers. It recruited informants, surreptitiously opened mail, and reportedly even tapped phones as it assembled files on hundreds of law-abiding citizens doing nothing more than exercising basic rights of free speech and dissent.

"It shows how dirty, how rotten, how filthy they were," said Bobby Doctor, who came under investigation in 1968 and nearly lost his job as a field-worker for the U.S. Civil Rights Commission in Memphis when Lawrence gave the agency a report on his political, and personal, activities—details mined, in part, by Withers.[22]

The FBI's "vacuum cleaner approach"—sucking up broad swaths of information—was typical then. Stymied by the courts, which had limited Hoover's efforts to prosecute and blacklist suspected subversives, the agency undertook secretive, at times illegal, efforts to undermine activists extrajudicially.

"They would pretty much take everything. My theory is because you just never know," said Kenneth O'Reilly, author of *Racial Matters: The FBI's*

Secret File on Black America, 1960–1972. "If you don't collect it in the first place you don't have a chance of using it later. That's what a police state does."[23]

IF WITHERS LOOKED in his mirror as he pulled away from Clayborn Temple that afternoon, King's last afternoon, he might have seen James Bevel walking from the curb, up a short flight of steps and through the arched church doorway, into the buzz of the crowd.

Never had the movement in Memphis been so alive. There'd been sit-ins here. And a great push for school desegregation. But, overall, the volatile reformation of Birmingham and Montgomery and Albany had bypassed Memphis. Until now. The city's inhuman treatment of the sanitation workers, nearly all of them black, had sparked a flaming fire. As Bevel mingled in the crowd in the late afternoon, he could see youths singing; he saw circles of striking workers huddled in the pews, talking, and a throng of activists, the curious and others, just milling about.

And he saw a tall, slender militant in a dark suit—one of the Invaders—Marrell McCollough, who agreed to drive him back to the Lorraine.

A MOMENT OF PEACE

THE SUN WAS SINKING FAST now as Marrell McCollough pulled his sporty blue Volkswagen Fastback into the parking lot below the Lorraine's balcony, below Dr. King, who was standing along the railing like a lone soldier on a parapet.

For years, questions followed: Why was King here—out in the open? Why didn't he get a more secure room? Was he lured here?

Many of the questions—the accusations, really—would focus on McCollough, the well-dressed college student down in the lot.

At twenty-three, the former military policeman was making a name in the blossoming student movement at Memphis State University, where he'd enrolled that winter. More recently, he'd become a militant. He joined the Invaders, a group of young Memphis men trying hard to emulate the rhetoric of H. Rap Brown, the self-styled revolutionary who was credited with saying, "Violence is necessary. It is as American as cherry pie."[1]

The Invaders sent chills through Memphis's old, conservative order.

McCollough quickly found acceptance in the group. Few of the young Invaders had cars. With his stylishly contoured 1967 Fastback, so unlike the common, bug-like Beetle, he found an instant rapport with the militants, who only half-jokingly dubbed him their "Minister of Transportation."[2]

He found rapport, too, with the younger members of King's staff, men like Bevel and the bearish, three-hundred-pound Rev. James Orange, both of whom he'd met days earlier at the Lorraine. McCollough had spotted the two Southern Christian Leadership Conference aides that afternoon at Clayborn Temple, where Withers had dropped off Bevel an hour earlier, and he agreed to drive them back to the motel.*

Watching from the firehouse, MPD's officer Richmond spied them through his field glasses as they arrived.[3]

Richmond knew McCollough—and knew he was no militant.

He was a former patrolman, now an undercover cop working under a code name, Max, assigned as part of a joint FBI–MPD operation to infiltrate—to eviscerate—the Invaders. But its aim reached far beyond that. Like Withers, McCollough helped keep watch on Memphis's budding New Left, on its student activist and peace movements, even the old-guard civil rights struggle, all deemed to be riddled with Communists and dangerous radicals.[4]

Coupled with the unrest that plagued King's previous visit—as well as old suspicions about his commitment to nonviolence—the operation shifted into high gear. As Withers and McCollough floated in and out of the Lorraine and detectives peered through binoculars from across the street, another dozen or so uniformed policemen and sheriff's deputies patrolled the immediate area. Even the Lorraine's meek owner, Walter Bailey, was conscripted into service. Using an alias, "Mr. Smith," police regularly phoned him through the switchboard to learn who'd checked in and out of the motel. Down at police headquarters, a small squad of army intelligence officers in business suits cluttered the hallways, almost tripping over themselves for bits of news to phone back to Washington.[5]

*McCollough testified to a congressional committee a decade later that he met Reverend Orange at Clayborn Temple and took him shopping "the whole afternoon." The two then returned to the church before heading to the Lorraine around 6:00 p.m. with Bevel.

As Bevel and the others piled out of McCollough's Volkswagen, the rangy undercover policeman stepped onto the pavement and looked around. King was still up on the balcony, talking. He was joking and laughing, shouting down to Jesse Jackson and others in the parking lot. It was 5:55 p.m.

In six minutes King would be dead.

AFTER DROPPING OFF Bevel at Clayborn Temple, Withers drove to Beale Street. It'd been a long day. He'd spent most of it up in federal court, listening to lawyers wrangle. Mayor Henry Loeb desperately wanted to stop King from leading another march, and he'd filed for an injunction to stop it. A segregationist, the tall, pasty Loeb had fought the sanitation strike at every turn. His constituents were tired of it: Garbage piling up in the streets. Lawless rogues tossing rocks and bottles at the few trucks running. And now King. But Judge Bailey Brown would have none of it. An appointee of President John F. Kennedy, Brown hardly was a gushing liberal, but he respected constitutional guarantees: King would march next week, he ruled, under tight restrictions—no weapons and with a fixed number of marchers per row.[6]

Already, Withers had spent the better part of four days with members of King's staff. Now, it seemed, there'd be more—the march was scheduled for the coming Monday, April 8.

Withers had passed along a range of details to Lawrence so far. Sitting through long-winded strategy meetings and late-night conversations, he'd picked up on a certain intensely militant tone: Here was Jesse Jackson, then twenty-six, tall and imposing, speaking of economic boycott, of halting trucking by one of the city's biggest manufacturers, Plough Inc., makers of St. Joseph aspirin. There was Hosea Williams. He seemed awfully cozy with some of the city's young militants. Withers reported that the activist was meeting with John Burl Smith, a leader of the Invaders, who'd worked up a crowd of garbagemen earlier that spring, getting them up on their feet when he shouted from the pulpit, "You'd better get your guns!"[7]

King, too, was meeting with the Black Power militants, Withers said. He'd seen him lunching with three of them just yesterday, on April 3, in the Lorraine's diner.[8]

The FBI's stated objective in investigating King involved preserving

civil order. The irony was that the civil rights leader aimed to do just that, to *prevent* more violence. Many people had blamed the disruption of the last march on the Invaders. King knew he needed to pacify these young firebrands—control them—if he hoped to put on a peaceful march. Withers didn't hold that back. He said the Invaders were demanding money—trying to extort King, promising peace in return for cash. They are trying to "drop a pigeon" on the SCLC, he told Lawrence. He reported this from Bernard Lee, King's personal assistant: "We won't be blackmailed by them."[9]

These were real-time bits of intelligence that helped the FBI assess the rapidly developing events.* Not only was the situation on the ground in Memphis changing—King was too. He'd adopted a series of increasingly militant positions over the previous two years. The King we celebrate today—the Dreamer, the champion of equality, the apostle of nonviolence—wasn't the King many saw in April 1968. He'd become a deeply polarizing figure. Nearly three in four Americans—almost half of African Americans—disapproved of King's position on the war. Even some of his closest advisers considered the Poor People's Campaign, to be launched as soon as King could disengage from the sanitation strike, a gross miscalculation. They feared chaos, possibly even battles with police. New York socialite Marian Logan, a key SCLC fund-raiser, worried King would not "be able to preserve the nonviolent image and integrity" of his organization.[10]

Undeterred, King seemed to almost invite that possibility. He'd dismantled legal segregation. Now, he eyed an even bigger foe: America's wealthy elite. This was class war. And King viewed the Poor People's Campaign as a sort of desperate last stand.

"If it fails, nonviolence will be discredited, and the country may be plunged into holocaust," King wrote in *Look* magazine. ". . . It must be militant, massive nonviolence, or riots." His militancy did more than enrage Hoover—it shocked Middle America. One slim week before King's rousing March 18 speech in Memphis, protestors had heckled him in Michigan as a "Commie" and a "traitor."[11]

*Part of the FBI's continuing skepticism involved younger members of King's staff. Commanders at MPD told Lawrence its source at the Lorraine—most likely undercover officer Marrell McCollough—heard SCLC staff member James Orange say "he would be willing to work" with the Invaders. Orange also supposedly urged the militants to work with an Illinois-based pastor staying at the Lorraine, whose violent rhetoric included encouragement to commit arson. As Orange made return visits to Memphis that year, Lawrence secured a photo of the activist that Withers had shot at the Lorraine, evidently moments after the assassination.

Special agent Lawrence saw King pretty much the same. A resolute Cold Warrior, he viewed the peace movement and much of the country's social unrest as communist inspired. He didn't see much difference between a "super-militant nonviolent" activist like King and a "super-militant violent" one like Huey Newton or H. Rap Brown. King's methods of civil disobedience were like a "Chinese water torture," Lawrence liked to say, drop after drop of marching in the street, attracting lawless elements looking for an excuse to rob and loot and riot. But the thing that really burned him was King's position on the war—and Bevel.[12]

Bevel was no lightweight—his militant tone had to be viewed seriously. A veteran of the Nashville sit-ins and the Freedom Rider movement, he had orchestrated King's Children's Crusade in Birmingham in 1963, dispatching waves of innocent schoolchildren into Bull Connor's fire hoses and snarling police dogs, a risky calculation credited with accelerating Jim Crow's demise. More recently, he'd helped convince King to come out against the Vietnam War. Lawrence fumed at the image: King and Bevel—and Harry Belafonte, too. On a gray afternoon a year earlier, the trio had led thousands of war protestors to the United Nations in New York. Many in the crowd burned their draft cards. No, this couldn't be ignored. When Lawrence wrote his report on Bevel's searing Black Power talk, he sent copies to FBI offices in Chicago, Atlanta, and Washington. Copies went, too, to the U.S. Attorney, the Secret Service, and military intelligence, a pattern Lawrence would repeat over and over throughout the sanitation strike and across the entire, turbulent era.[13]

Even now, up in the federal building, the agent was busy dictating a memorandum for broad distribution. Dated April 4, 1968, the report cited more intelligence from Withers, reporting that "some of the more militant potential troublesome Negro elements are beginning to move into the strike situation." Lawrence sent copies to the FBI's Atlanta, Chicago, Washington, and Detroit offices and to the army's 111th Military Intelligence Group.[14]

IT STILL ISN'T clear how Lawrence and Withers managed to talk for so long without anyone catching on. Both men had the other's home phone number. That helped. Perhaps Withers also called now and then from the

seclusion of a phone booth. Often, they'd meet face to face, careful to not be seen—on a side street, maybe, or out in Memphis's largely white suburbs.[15]

Still, there were close calls. In January, a young activist accused Withers of snitching. The incident blew over. Then came February—the pressure on undercover operators increased. A day after police routed protestors with Mace and clubs during a march on Main Street, strike organizers held an emotional rally in North Memphis, where supporters detected an undercover policeman in the crowd. They were furious. They seized him. They hustled him to the stage. There, as the crowd buzzed, a circle of men stripped him of his revolver and his Mace canister.

"He was then taken outside," a report said. "Negro women at meeting helped protect him from strikers. He was not hurt and was released to other officers of Memphis PD."[16]

Again, in March, word went out: don't snitch the movement.

It happened as Rev. H. Ralph Jackson, short, thickset, a heretofore unremarkable African Methodist Episcopal preacher who'd never been involved in the civil rights movement—who'd been labeled an "Uncle Tom"—became a militant activist almost overnight, virtually taking over the leadership of the strike. Jackson had been furious ever since he was sprayed in the face with Mace during the Main Street melee back in February.

"They would not have Maced white ministers," he repeated over and over.[17]

Jackson was furious, too, about the constant spying, about the "police snitchers." If he found any undercover officers or informants at these rallies, the preacher railed from the pulpit, he "would not stop them from being beaten up." Withers sensed the hostility. He told Lawrence the spying had inflamed the already searing tension. "The Negro community is particularly bitter because the Police Department has sent many Negro officers in plain clothes to strike support meetings and several of them have thus far have been exposed," Lawrence wrote after debriefing his informant.[18]

Withers was playing a dangerous game.*

*Despite Lawrence's efforts to hide the relationship, there were times, it seems, when he and his source got sloppy. Withers's old friend, Mark Stansbury, says he recalls meeting Lawrence once in Withers's studio, sometime around 1962. "I only saw him that one time," Stansbury told the author in 2017. He said he never knew that Withers passed information to the agent. When the story of Withers's informing first broke in 2010, surviving friends and family expressed near-universal surprise. Close friend

SHADOWS STRETCHED ACROSS downtown as Withers arrived on Beale Street, shortly before the shot sounded, before King fell.

There, along the famous corridor, he eyeballed the familiar sights, the rowdy clubs where he'd spent long nights snapping shots of B.B. King, Howlin' Wolf, and so many other great bluesmen; the professional offices, the shoppers, and the assorted street characters hanging about. In a few years, nearly all the windows here would be boarded. But for now, it bustled still. Within a block of his office were two barbershops, two pool halls, the Stardust Club and the Blue Stallion Lounge, and the old Elks Club where he once covered the grisly slaying of a prominent socialite; there was a tailor, a watch repairman, and the street curb where on his last day as a policeman seventeen years earlier he was arrested and kicked off the force for bootlegging. The rocking New Daisy Theatre was directly across the street, near the law offices of Hosea T. Lockard, later to become one of Tennessee's first black judges.

Withers shared space with a dentist at 327 Beale.

Under a brightly lit, overhanging sign emblazoned with a red-white-and-blue Pepsi logo and a flourishing inscription, "Withers Studio," the photographer stepped past baby pictures, military portraits, and wedding poses, into his office. He was forty-five. His worries were every man's worries—money, family, mortality. A taste for home cooking was challenging the former high school quarterback's once-sharp contours, and his wallet, as always, was overstretched. He had a mortgage and loved ones who depended on him—he and his wife Dorothy's youngest child, Rosalind, their eighth, was only ten. They had four more at home and three grown sons in the military, one in Vietnam.

Many years later, when his secret finally came out, speculation would swirl about why he did it—why he collaborated with the FBI. Was it the cash? Or maybe patriotism? A World War II veteran, he was ten to twenty years older than many activists in the movement—a conservative, really—and he wasn't sold on the more militant stuff, the marching in the streets, the confrontations. Or maybe it was his long desire to be a cop again. A

Joe Crittenden, who marched with Withers and traveled with him, said he never saw the photographer with FBI agents. "I never did," he told CNN, shaking his head. "I never did."

decade after the civil rights era waned, he would become a policeman again, a gun-toting liquor agent for the state of Tennessee, a job he thought would finally bring financial security.

But for the moment, at least—as Marrell McCollough stood in the fading sunlight in the parking lot back at the Lorraine, as officer Richmond watched from the fire station, as a sniper poked a rifle out the window of a nearby rooming house—Withers's worries dissipated. He'd been running hard now for several days, and he was tired. He put his feet up on his desk.[19]

He'd be running again, soon. Before the sun rose on April 5, he would huddle with King's grieving staff up in room 306 at the Lorraine, he would shoot the first pictures of King in his satin-lined casket, he would even hold a piece of the fallen civil rights leader's skull in his hands in a funeral parlor morgue room.

But for now, in his office, surrounded by his many prints and negatives, his pictures of King and Abernathy, of Roy Wilkins, Fannie Lou Hamer, James Forman, Medgar Evers, and so many others, he found a few moments of peace.

PART TWO

THE DISCOVERY

THE AGENT'S TALE

FALL 1997

H E SAT DOWN AWKWARDLY ON the sofa and eyed my notebook with a hint of contempt. Jim wasn't used to this sort of thing. Over his long career in the FBI he was the one who asked the questions—he was the one who made the other squirm with discomfort. Threats, coercion, pleasantries, he'd used them all. Anything to keep the subject talking. Still, he was at peace. He'd resigned himself to this. Probably twenty to thirty researchers had contacted him over the past three decades, he said, each asking about Dr. Martin Luther King, Jr.,'s assassination and the belief by many that the FBI somehow had a hand in it.

He had turned them all down—until now.

"I didn't want to have anything to do with that. But I see no great danger now," Jim said in a soft, flat baritone. My hopes jumped with his pronouncement. I hoped to get a big story out of this. But like a bottle rocket on

the Fourth of July, my spirits soared, crackled, then quickly fizzled back to Earth. Jim made it clear this interview was not for attribution. It was background only; I couldn't quote him. My newspaper would have no scoop.

"Most of this stuff, I'll probably deny if you ever put it in print," he advised sternly. "I don't want to get anybody hurt."

Secrecy was a habit Jim* found hard to break. He'd retired fifteen years earlier; his hair had grayed and his face hung in fleshy pouches at the jowls. Yet even now—1997—he acted like a Cold War spy. He arranged for us to meet at a neutral site, a modest frame house in a marginal neighborhood of weedy lawns and weathered cars on the north edge of Memphis. Jim answered the door with a nod and a stoic half-smile. Like many of his colleagues, he went into private security after he left the Bureau. I came to wonder if it was boredom that led him to talk. Maybe he'd longed for a moment like this, when a reporter would ask about his glory days as an intelligence agent—doting on his every word—before luring him, like forbidden fruit, to break his vows and tell what he knew.

One thing was certain—Jim's life once was a whole lot more interesting.

Back in the 1960s, he was attached for a time to the FBI's security investigation of Dr. King and his circle of advisers. Tapping King's phones and bugging his hotel rooms, the FBI waged one of the most notorious inquisitions in history, trying to prove that the leader of the American civil rights movement was a traitor to his country. It would get nasty. Under the leadership of FBI's curmudgeonly director, J. Edgar Hoover, who detested King and assailed him as a "degenerate," a "Tom cat," and "a liar," the Bureau invested enormous resources trying to prove that King was not only a Communist but a wife-cheating philanderer as well.

It's difficult to comprehend today. On the third Monday in January, Americans take a day off from work to celebrate the birthday of Martin Luther King, Jr., a national holiday. Schools and streets are named for him; colleges teach courses on him. Years after his death, the personal papers of the martyred civil rights leader would fetch $32 million. Even the most arch-conservative had to concede that the FBI had landed on the wrong side of this history. It was a sore spot that Jim eased into ever so gingerly.

*Not his real name. Jim feared repercussions and wanted his identity protected.

"They're making him into a saint. I mean, he was anything and everything but a saint," Jim said, hinting at King's legendary weakness for women and repeating the FBI rationale that his inner circle was populated with Communists and dangerous militants. "There was a definite fear among the government that he might swing his organization into the Communist Party. We didn't know which way he was going to go."

Though he wouldn't go on the record, it was amazing to me that Jim was even talking. He didn't trust reporters. He'd used plenty of them, though. Back in the day he'd plant stories with them, aiming to discredit the target of an investigation, someone the government couldn't pin a specific crime or illegality on yet still wanted to "neutralize" through negative publicity. Maybe he hoped to use me, too. I never would know for certain why he agreed to meet. But in the news business, sources always have an angle. You take them as they come.

Warily, we circled like boxers, sizing each other up. If Jim was Muhammad Ali—dancing, bobbing, laying back on the ropes as he feigned injury and prepared to spring—then I was Joe Frazier, straightforward and direct. I wanted to know what happened in Memphis. King was shot and killed there by a sniper on April 4, 1968, as he tried to rally the city's striking garbagemen, a collection of poor, black city workers who'd suffered years of abuse. I knew my skill as a reporter wasn't enough to get Jim to talk. But I had something else going for me: timing. The assassination was back in the news—and Jim was deeply agitated by it.

ALL THROUGH THE spring and summer of 1997, and now into the fall, the news in Memphis was dominated by the scintillating King assassination story, driven by a series of pleadings before the Criminal Court. King's convicted assassin, James Earl Ray, was trying to win release from prison. Shriveled and slowly dying of liver disease, Ray, sixty-nine, made a case for medical hardship. And, he claimed, he had new evidence. He was framed, he said—the rifle found with his fingerprints on it was planted. In court papers, Ray even named the man he said masterminded it all—a hunched, retired autoworker named Raul who had immigrated here from Portugal and retired to the suburban sprawl north of New York City. Ray demanded

a new trial, and he wanted to live out his final months at home, in the care of family.

Ray's claims would have gone nowhere—the evidence against him was overwhelming—if not for a publicity-conscious judge named Joe Brown. A handsome, bearded, quick-witted man who bedeviled prosecutors by entertaining a long chain of defense motions and who would go on to star in his own television show, *Judge Joe Brown*, he claimed an expertise in firearms. Skeptically, he questioned whether the bullet that killed King actually came from Ray's rifle. Brown ordered the gun to be retested. As news cameras whirred, the high-powered Remington deer-hunting rifle that Ray bought in Alabama a week before the assassination boomed again as men in white coats fired it in a crime lab in Providence, Rhode Island. Scientists later examined the bullets under a powerful electron scanning microscope at the University of Pittsburgh.

Brown gave prosecutors nightmares. But I certainly couldn't complain. When I approached him at the bench after a hearing one day, he signed an order on the spot granting my photographer and me exclusive media access to the rifle testing. Wearing sound-insulating earmuffs, we watched in a tiny lab room as Ray's .30-06 pump-action rifle roared into a giant water tank.

"This is the kind of thing the newspaper should cover," Brown said with a giant, toothy smile.

As the story snowballed, I interviewed Ray in his prison cell in Nashville, where he repeated his claims of innocence from a wheelchair.

"No, I didn't [do it]," the pale convict said meekly. Meanwhile, his lawyer, William Pepper, pitched a much-criticized book he wrote that suggested several government agencies and individuals—the FBI, the CIA, the army, the Memphis Police Department, even President Lyndon Johnson's White House and retired autoworker Raul—played roles in a massive conspiracy to kill King.

The news grew all the more unbelievable when King's family embraced Pepper's accounts. The slain civil rights leader's younger son, Dexter, visited Ray in prison. On television screens all over the world, Dexter King—handsome, mustachioed, and very much the spitting image of his father—was seen shaking Ray's hand. "I believe you," he told Ray. "And

my family believes you. And we will do everything in our power to see you prevail."

Now, here was Jim, snickering and sneering, fed up with it all.

"These people are nuts," he scoffed. "They just couldn't stand the thought that some little punk like Ray could have killed King just like they couldn't stand the thought that some little punk of a Communist would have killed Kennedy. They've got to make a conspiracy out of it."

"Everyone says it had to be a conspiracy because he couldn't do this by himself," Jim would complain over a series of meetings. He mocked the oft-cited conspiracy argument that Ray, an escaped convict, lacked the means or intelligence to flee the country and make it all the way to London, where he eventually was arrested. "Anybody in prison with any sense, that knows anything about the system, knows you can get a passport for sixty or even twenty-five dollars anywhere in the world."

Jim was right—Ray was guilty. Ray admitted buying the rifle in Birmingham. His fingerprints covered the gun and related items found near his sniper's nest, and evidence indicates that he stalked King through the South before catching up with him in Memphis. It would take pages to cover all the evidence against him; in fact Ray's typed guilty plea involved fifty-six separate stipulations of material fact spread across dozens of pages. Ray was the gunman, no doubt.

But it would have been all but impossible to get Jim to consider the second finding of Congress's official examination of King's murder: that while Ray shot King, he likely didn't act alone. Reopening the investigation of King's murder in 1977–1979, the U.S. House of Representatives' Select Committee on Assassinations found evidence of a $50,000 bounty that a group of racist St. Louis businessmen put on King's head. Ray might have acted on the offer, which circulated among inmates at the nearby Missouri state prison in Jefferson City while Ray was housed there in 1967. Complicating matters, the committee found that while the FBI had conducted a thorough fugitive investigation to find King's killer, it failed to conduct an adequate conspiracy investigation.[1]

But this was touchy stuff for Jim. So we didn't go there, we stuck to what he knew. And that was domestic intelligence—the FBI's secret spying on American citizens.

A GREAT FIRESTORM erupted in Memphis in 1976. Its cause wasn't faulty wiring or a smoldering cigarette left on a nightstand, but something far more combustible: a lawsuit filed by the American Civil Liberties Union against the Memphis Police Department alleging widespread, unlawful political surveillance. But before the ACLU could get its claims before a judge, Lt. Eli Arkin struck a plan—and a match. The head of MPD's just-exposed domestic intelligence unit, the dark-haired, mustachioed Arkin emptied the drawers of ten filing cabinets containing scores and scores of paper files MPD had assembled since the 1960s on local citizens: Vietnam War protestors, civil rights advocates, student activists at Memphis State University. Before ACLU lawyers could even serve city officials with legal papers, he burned most of the evidence.[2]

Despite the incineration, the ACLU won a landmark consent order forbidding MPD from engaging in future political surveillance. No longer could the police agency compile data on citizens' beliefs, opinions, associations, or their exercise of First Amendment rights. Eventually, the larger story emerged: MPD didn't conduct this surveillance alone. As in other cities, the FBI had assisted local police in Memphis in creating a secretive domestic intelligence unit, sometimes called the Red Squad, to help keep watch on citizens whose political beliefs frightened the government. This shared duty involved cataloging a storehouse of information: dossiers of photographs, newspaper articles, and internal reports detailing the activities and associations of these "subversives."[3]

Part of this effort involved something even more sinister.

The public first learned of the FBI's counterintelligence program—COINTELPRO—in 1971, when an anonymous group of daring activists broke into an FBI office in Media, Pennsylvania, and stole armloads of files. Through news reports and congressional hearings over the next several years, the ugly details would emerge: the Bureau kept files on civil rights activists and Vietnam War protestors, using often illegal measures to spy on some and target others in a "dirty tricks" campaign. It included smearing leaders with embarrassing details leaked to the press or trying to break up marriages or get individuals fired from jobs—anything to weaken or derail their movements. An extreme case often cited by FBI critics involves Fred

Hampton, a black militant Chicago activist shot dead in a police raid after a Bureau informant sketched out the floor plan of his apartment.

First launched in 1956 against the American Communist Party, COINTELPRO was designed to protect the country's domestic security and guard against subversion, violence, and disorder. It did this by identifying the root causes of disorder—or potential disorder—and then working to counteract them. The program was illegal from its very inception—it lacked any legislative or executive branch authority. That it persisted for so long demonstrates the FBI's view of the program as an effective tool in protecting domestic security. At the height of the Cold War, when most Americans viewed communism as a palpable threat, the FBI used COINTELPRO to smash the party's inroads here. The Bureau later unleashed COINTELPRO to splinter and deflate the Klan and other white hate groups. [4]

But in the court of public opinion the FBI never overcame the initial images of secret-agent sabotage of innocent college students exercising First Amendment rights to protest the Vietnam War and black Americans fighting for basic rights.

"We did the same thing with the KKK—infiltrated them, got to know everything about them," Jim grumbled. "They . . . became so mistrustful of each other with letters we would write: 'Your wife is shacking up with so and so,' you know that sort of thing, which I think is good tactics. They did not trust, they just fell apart as an organization. People had made it into, I don't know, like it was some terrible subversive plot to destroy different people. In a way it did work that way. And we destroyed the boys in Mississippi, [through] the COINTEL program, broke up the White Knights down there . . . Anything you could do to disrupt them, anything you could do to create mistrust. I don't see anything wrong with that."

Still, COINTELPRO wasn't as virtuous as Jim presented it. Perhaps nothing about the counterintelligence program shocked the American conscience more than the revelations of the FBI's fierce, five-year campaign against Dr. King. The agency began its investigation of King in 1962 after an informant told agents of King's connection to New York attorney Stanley Levison, a former Communist Party fund-raiser who acted as a speechwriter and adviser to the civil rights leader. The Bureau convinced then–attorney general Robert Kennedy to wiretap King's phone. The investigation never

yielded any evidence of communist activity by King, yet it morphed into an obsession with the leader's sex life. Bugging his hotel rooms, the FBI produced a composite audiotape of the married Baptist minister telling off-color jokes and entertaining women. Agents mailed a copy of the tape to King's Atlanta office, along with an anonymous letter that seemed to strongly suggest he kill himself.[5]

"King, there is only one thing left for you to do. There is but one way out for you. You better take it before your filthy, fraudulent self is bared to the nation," read the letter, opened by King's wife, Coretta, in January 1965, just weeks after the civil rights leader's crowning achievement—the Nobel Peace Prize, which he accepted to worldwide acclaim in Oslo, Norway. By 1967, when the FBI launched official COINTELPRO initiatives against a range of civil rights organizations it had labeled extremist "hate groups," King's moderate Southern Christian Leadership Conference was included as a target.[6]

Loathe as Jim was to admit it, it was this history that fueled the very conspiracy claims he now ridiculed. Alarm over the FBI's campaign to "neutralize" King grew so intense that when the U.S. House of Representatives voted in 1976 to reexamine the assassination, its chief suspect was the FBI. Exploring the question—did Hoover's animosity toward King somehow morph into an assassination plot?—the committee searched for a link between the FBI and Ray, subpoenaing agents, interviewing Ray's criminal associates, and reviewing informant files to see if the dots connected. They never found a link, but the search set nerves on edge in the Bureau.

Despite the scare, Jim stood by the FBI's intense scrutiny of King and his organization.

"We did that with all organizations—the KKK, the Muslims [Nation of Islam], the National Rifle Association, you know, any organization that had the potential for violence and could expound violence," he said. "Hell, that was one of our jobs as defenders of this country. That was what we were supposed to do, to make damn sure what their aims were, where they were going and who their members were and where they were coming from . . . The big problem we had with King was not with King himself, but with some of the people who surrounded him."

AS JIM GREW more comfortable I sensed an opening. What I really wanted from him was an accounting of the technical surveillance—the phone taps, the hotel bugs. The FBI had zealously pursued King with these tactics for years in cities all over the country. Tapping an informant inside King's SCLC offices in Atlanta, skinny-tied FBI agents regularly had his itinerary, beating him to hotel rooms to plant listening devices. The Bureau had taps on his home, office, and hotel phones.

Yet, in what remains one of the assassination's lingering mysteries to many, the technical surveillance stopped before Memphis. In testimony before Congress, agents insisted there was no technical surveillance of King in Memphis in the days before his murder there. Were they lying? If not, how did they keep an eye on King? There was a possible story here, I felt, and I pushed Jim on it.

"Did you use any electronic surveillance on King when he was in Memphis?" I asked.

Jim shook his head.

"No. No. There was none. None by us or the Police Department," he said. Agents didn't need any technical surveillance, he explained: they had Memphis covered with informants. "We had too many good sources. We felt like we were getting complete, factual information verified from four or five different sources, plus the Police Department sources. They all jibed."

One of those sources stirred a panic within the FBI on the day of the assassination. He was caught in news photos kneeling over King's body on the motel balcony where King fell. The source was Marrell McCollough, the undercover cop posing as a Black Power militant. Standing in the parking lot when the shot rang out, McCollough rushed to the balcony and was kneeling over King when his picture was taken. He raced to King to assist him—to staunch the bleeding. But conspiracy theorists saw something else: evidence of a government assassination plot. The undercover agent was there to spot King for the shooter, they argued. To make sure he was dead. When Congress reexamined the assassination a decade later, McCollough, by then working for the CIA, was called to testify, triggering conspiracy tales that still reverberate today.[7]

With the FBI on trial, the secret identities of other informants were in jeopardy. The identity of a key Atlanta informant in King's SCLC offices was revealed; the committee's staff dug through the confidential files of more than a dozen others.

"We had to divulge the name of one Memphis informant," Jim said, shaking his head.

My heart rose. Would Jim really give up the name of an informant? I wanted to ask, but hesitated. Every reporter, whether he works for *The New York Times* or *The Salt Lake Tribune* or the *Key West Citizen*, has a moment like this while on the hunt for a big story. There's a fear—and a thrill. If I dared to ask, Jim might clam up. My inquiry would be over. Maybe, though, he'd tell me something huge. I swallowed and decided I'd never know if I didn't ask.

"Who was it?" I prompted.

Jim hesitated.

"Ernest Withers."

Withers? The name floored me. Ernest Withers had been the premier photographer of the civil rights era. He was a Memphis legend. He was in his seventies now and still kept an office down on Beale Street, where a building was named for him. A nearby brass Blues Note commemorates Wither's his photographic contributions documenting the blues scene, Negro Leagues baseball, and black life in Memphis. On any given day passersby might catch a glimpse of him, gray now and typically sporting a kufi, a brightly colored African cap, as he waddled through his old haunts down the cele-brated street, now adorned in touristy neon.

I recalled a striking photo Withers once took of Dr. King reclining on a bed at the Lorraine. The great man was at ease, almost oblivious to the pho-tographer. Clearly Withers was an insider, someone with incredible access.

Jim tried to move on, but I brought him back to Withers. Was he really an informant?

"Oh, yeah. He's been an informant," Jim confirmed. "He's the one that furnished all the photographs. He was a good informant. But other than that, I've got problems with this. And a lot of things I'm not supposed to talk about."

Jim sensed his mistake. He grew stern again. He gave me the FBI hard line on informants: they are protected—always. Whether he'd slipped up or

whether he deliberately wanted me to know about Withers, I couldn't tell. But he was crystal clear on one point: he wouldn't go on the record. The whole thing put him in jeopardy, he said. He raised the prospect of a prison term and a financial fine for revealing the name of a confidential informant.

"The names of informants—that can come back and hurt you in the end. So we don't even talk about that."

Now, I had no choice. I acquiesced. Jim moved on to the day of the assassination. Yes, the FBI watched King in Memphis, he said. But agents were more concerned with preventing any violence against King, the city, or the country.

"The greatest fear that I had was that some S.O.B. would kill him," he said as he described precautions the FBI took to prepare for King's visit to Memphis. "We had that place pretty well controlled. Now, we started the next day looking into the various houses [around the Lorraine Motel] and people around there. We always do, see, if we had a potential problem. And we didn't finish the job."

"What do you mean?" I asked.

This was truly interesting ground. Jim was describing how the FBI had failed to thoroughly canvass the neighborhood around the Lorraine, to make sure no crazy person or white supremacist would try to kill King. But I had a problem—I was still stuck on Withers. Now, that was a story. All this conspiracy stuff was crap, a bunch of circular stories that went nowhere. But writing a story that outs an informant? It just isn't done. Especially an informant so steeped in such rich history. As Jim continued, I couldn't shake the thought.

"The guy who ran that investigation said there was only one [place from where someone might take a shot at King], in that flophouse, and just one bathroom window," Jim said as I scribbled and tried to focus. "And supposedly when he asked the proprietor about that window, the guy said, 'You can't see anything out of it because it's too high.'"

I couldn't help myself. I swallowed and stopped Jim again.

"And Withers was paid?" I asked, worried that this time he'd toss me out.

Jim looked me in the eye.

"Let me tell you something," he said. "Ernest was in it for the money."

A BOLD PHOTOGRAPHER

IRENS PIERCED THE MIDNIGHT AIR as smoke billowed from a dozen dying fires across Memphis. From the chaos, Ernest Withers stepped into the morgue room of the R. S. Lewis Funeral Home, cameras dangling from his neck, pursuing the biggest story of his career.

Dr. Martin Luther King, Jr., was dead.

Police finally had curtailed the rioting. But Withers's work was only beginning.

As a standout photographer for America's black press, the bold newsman often went places where technically he had no right to be. It was almost a sense of entitlement, really, as if he innately understood his special place in history. He'd covered the civil rights movement from its very dawn in Mississippi in 1955 with the murder of Emmett Till. He'd shot so many of the big stories—Montgomery, Little Rock, Ole Miss, the lynching of Mack Charles Parker and the assassination of Medgar Evers in Jackson, Missis-

sippi, where Withers was manhandled by police—that years later the move-ment's thankful leaders knighted the underpaid newshound with his own precious but informal title, the "Original Photographer of the Civil Rights Movement."[1]

So it was in the late-night madness of April 4, 1968, that Withers nav-igated Memphis's riot-torn streets, determined to see King one last time.

He made his way from the Lorraine Motel, where King was shot, tag-ging along with the fallen leader's grieving party, with Ralph Abernathy and the others, to the Lewis Funeral Home, a stately, two-story frame house adorned with a red-tiled roof and a columned porch overlooking the mas-sive Foote Homes public housing project, home to one of America's largest concentrations of poor families. There, he found King's unclothed body on a cold embalming table.

"I just took it on my own and went to the morgue and walked in and there he was," he would recall years later.[2]

Nothing in Withers's thirteen-year career had prepared him for this.

As he readied his camera in the morgue room, arranging to take the first news photos of King in death, he found himself looking at someone—at *something*—he hardly recognized.

Jagged, white bone protruded from a large bullet hole in King's jaw. There was an even larger wound in his neck—this one big enough to poke a fist into.

The injuries came in a horrific, one-two punch when a sniper's bullet whistling at 2,900 feet per second spiraled through his jawbone, exited under his chin, then reentered his body at the neck. Tumbling end over end on its reentry, the lead slug cut like a ripsaw through his upper spine, severing it, before finally coming to rest just under the skin behind King's left shoulder blade.

But the greatest horror came at the sight of King's head. The top of it was gone—completely missing. Autopsy surgeons at St. Joseph's Hospital had sawed out an 8-by-5-inch oval section of King's skull to remove and examine his brain.

Withers saw the severed skull piece on the embalming table next to King's body. He picked it up. It was soft and fuzzy on one side where the hair and scalp still clung to the bone. In this surreal moment, cradling the

head crown of America's greatest civil rights leader in his fingers, Withers gazed into the open cavity. Then, ever so gently, he fitted it back on top of King's head.

"His head was full of paper," Withers would recall years later, describing in his peculiar, singsong voice how "I put his skull back in his head."[3]

Withers didn't take any pictures—not yet. He could have photographed the gore and profited from it. But he opted instead to wait on undertaker Robert Lewis, who'd known Withers for years and who approved his visit to the morgue that night. It was only after Lewis completed his work, dressing King in a dark, silk suit and fleshing out the horrendous injuries, that Withers snapped pictures of King in his casket—the very first of many media pictures taken of King's body in the aftermath of his shocking murder in Memphis.

"I didn't take any pictures until Mr. Lewis got him dressed because I thought, ethically, I had no business totally in there," Withers said. "And so I wouldn't embarrass the undertaker by taking pictures within his private morgue room."[4]

WITHERS TOLD THIS most sensational story at different times over his life and it intrigued me. I can't recall when I first heard it. But the more I learned about him the more curious I became. If Jim was right about Ernest being an informant, it seems the FBI couldn't have found a more resourceful person for the job.

Since its early years in the 1920s the FBI had taken a very jaundiced view of the country's African American population. Because so many black Americans were impoverished and oppressed, Hoover saw them as ripe for subversion—potential rebels who needed to be watched. In Memphis, the FBI had Withers. He monitored local politicians and activists, Jim said, and logged the comings and goings of outside agitators—anyone agents deemed as potential trouble.

It certainly seemed the perfect cover. As a Beale Street studio photographer who shot baby pictures, weddings, and family portraits, the friendly, quick-smiling Withers doubled as a freelancer for the local black newspaper, the *Tri-State Defender*, making it his job to know every cop, politician, activist, preacher, undertaker, banker, barber, bartender, and bluesman in Memphis.

"He did a tremendous job for us," Jim said. "Anybody of any importance he got photos and reports on."

I was interested in pursuing this as a news story, but there was little to go on. In a series of conversations on a range of topics in the fall of 1997, Jim weighed the possibility of going public. But his instincts ruled it out.

"He's the one person," Jim said flatly, "I wouldn't want to be quoted on."

Though eventually I would assemble thousands of pages of records pursuing this matter over a course of years, in the beginning there were only Jim's not-for-attribution allegations and some old stories to sift through, accounts Withers passed on through general media interviews and later through books he released on his career in photography.

One thing, however, was absolutely certain: Ernest Withers enjoyed one of the longest, most productive careers in the history of American photography. His massive portfolio of black life in the South, shot over the course of sixty years, is poignant and substantial. Though he remains obscure to many, arguably Withers is one of the pivotal photographers of the twentieth century.

BORN IN 1922 as one of six children of a cleaning woman and a postal worker, Withers came of age in the Great Depression, when political boss E. H. Crump ruled the city through coercion and stuffed ballot boxes. Memphis was one of the few Southern cities that tolerated widespread voting among blacks. Yet those votes often were bought or coerced, sometimes with a bottle of whiskey. Withers witnessed the city's political machinery up close—his father, Earl, was a Republican ward boss who registered voters on the family's front porch in North Memphis. Crump let blacks vote, yet he kept most locked in unrelenting poverty. Their best options involved menial labor—cleaning the city's bathrooms, taking out its trash, working in its steaming kitchens.[5]

Withers's prospects were better than most. He fully expected to follow his father into the relatively easy life of a letter carrier—but then he discovered photography. He got his first inkling of his future career as an eighth-grader at Manassas High School in North Memphis when Marva Louis, wife of then–heavyweight boxing champion Joe Louis, visited the school.

Armed with a Brownie box camera he had gotten as a gift from his sister, Withers assertively worked his way to the front of the school theater and, to the jeers of classmates, took Mrs. Louis's picture. "I was a student. I didn't have any business up there," Withers said. "From that day forward I was somewhat identified as a photographer."[6]

He learned the trade of photography while in the army during World War II. He was a jeep driver in a road-building regiment until he learned of an opening in the army photography unit. There, he learned to mix lab chemicals and shoot in the field. Withers soon learned he could make money on the side. Stationed in Saipan, he collected two cents from servicemen for a picture they could mail home. "It just grew to be a commercial business," he said.[7]

Coming home to Memphis in 1946, Withers got a business loan through the G.I. Bill and opened his first photography studio in the shadow of the Firestone tire plant in North Memphis. But he soon found that people who took the trouble to dress in their Sunday best for family portraits and wedding and anniversary pictures preferred to go downtown. So, Withers moved his shop there, opening the first of a succession of studios he would own on Beale Street, the bustling hub of business and social life in black Memphis.

But the picture business was a tough one and Withers, who had a wife and eight children to feed, found that to survive he needed to be as much of a hustler as a photographer.

By day he shot studio photos and by night he meandered through the street's rough-and-tumble juke joints, aiming his camera at bawdy bluesmen and their patrons and hawking the photos to anyone who would buy them. He did much the same out at Martin Park, home of Negro League baseball's Memphis Red Sox, snapping photos of the players and selling them in the stands for twenty-five cents, fifty cents, or a dollar. Although he achieved international fame late in life, he found monetary success elusive and never strayed from the modest, three-bedroom house he bought in 1954 for $7,900, near an industrial area south of downtown Memphis.[8]

For a time, he pursued photography as a second job while working an ill-fated stint as a policeman. The city of Memphis hired Withers in 1948 along with eight other African Americans who comprised the Memphis Police

Department's first black recruit class. He walked a beat on Beale Street and the surrounding neighborhoods, forging bonds with citizens like Robert Lewis, who would let Withers into his morgue room years later to shoot pictures of Dr. King's body. Withers didn't last long in the job, however. He was fired in 1951 after an internal investigation found he'd consorted with a bootlegger in yet another venture to supplement his income. From that point, Withers focused on his photography.

Passing out business cards bearing his slogan, "Pictures Tell The Story," Withers eked out a living while assembling one of the most unique and historically priceless portfolios in America: portraits of a fresh-faced Elvis and B.B. King embracing on Beale Street; Jackie Robinson and Larry Doby appearing in Memphis after cracking the color barrier as the first two African Americans to play in Major League Baseball; young Aretha Franklin relaxing at the Lorraine; a high-energy performance by then–little known Ike and Tina Turner; and thousands of others. Withers joked that he shot as many as 12 million pictures in his life; archivists say they can account for at least a million—many found on faded negatives or well-worn prints scattered like so many gold nuggets in boxes and drawers throughout Withers's cluttered Beale Street studio.

BUT NOTHING WITHERS shot stood out quite like his coverage of the civil rights movement. In 1955, Withers covered the murder of Emmett Till, a case that touched a nerve in black America as few had. A fourteen-year-old African American youth from Chicago, Till was visiting relatives in Money, Mississippi, when he reportedly made the mistake of whistling at a white woman. He was abducted from his bed that night, savagely beaten, shot, and his mutilated body dumped in the Tallahatchie River. His killers, two white half-brothers, were acquitted by an all-white jury. Months later, they admitted to the murder in a paid interview with *Look* magazine.

During the trial, Withers, then a trim and handsome thirty-two-year-old, ignored the judge's order banning picture-taking and surreptitiously photographed Till's wizened great-uncle, Moses Wright, on the witness stand. Withers depressed the shutter as Wright rose to his feet and pointed a bony, accusing finger at the two defendants. Even on high-profile assign-

ments like this, Withers had to hustle. "They paid very sparingly," he said. So he sold the photo of Moses Wright on the side. "A man walked up to me and he gave me $10 to give him that picture," Withers said. At the time he got no credit for the picture. After the trial, Withers produced a booklet—selling it for a dollar a copy—that helped draw attention to the Till case and its gross injustice.[9]

Repeatedly, Withers would deploy such resourcefulness and timing.

Rising before sunrise on December 21, 1956, the day a U.S. Supreme Court order ended the Montgomery bus boycott, Withers took that famous picture of King and Abernathy, victoriously riding one of the city's first integrated buses. Years later Withers would talk about the photo and laugh that King wasn't really the first black man to ride Montgomery's integrated buses—he was. Up by 4:00 a.m., Withers rode a bus all over the city until midmorning, when King and Abernathy finally showed up.[10]

As the movement spread, Withers found regular freelance work with the Sengstacke family, publishers of the *Chicago Defender*, and the *Tri-State Defender* in Memphis. His pictures ran all over the country, in news organs that catered to black readers, publications like *The Pittsburgh Courier*, the New York *Amsterdam News*, and the Cleveland *Call & Post*. His bosses dispatched him to every major civil rights event within striking distance of his home base in Memphis. He covered the Little Rock school crisis in 1957, the integration of Ole Miss in 1962, and the 1963 assassination of his friend, National Association for the Advancement of Colored People field secretary Medgar Evers.

Often there was danger. Getting the story could require venturing into rural, white Mississippi to cover voting struggles, oppression, and murder. Many a time Withers stood out as the sole black man among a sea of white faces. Police beat him in Jackson, Mississippi, in 1963, and yokels harassed him a year later in nearby Neshoba County following the murders of three civil rights workers.

"Somebody had to go forward and ask a question," Withers would say years later with a shrug when asked about the courage required to do what he did. "And it was our duty to be forward as people of the press. The freedom of the press gives us that right, you know. I mean . . . there were hundreds of black men lynched and never anything ever done about it. There

were never any stories, but whatever little picture story that ran in the paper, but it wasn't nothing."[11]

In the days before James Meredith was admitted as the first black student at the University of Mississippi in September 1962, Withers helped hide the courageous twenty-nine-year-old in Memphis. He followed Meredith's federally guarded caravan down to Oxford, Mississippi, where white mobs tore apart the Ole Miss campus and shot several marshals before order was restored and Meredith was finally admitted.

Four years later, after Meredith was wounded by a sniper in 1966 while on a solitary "march against fear" down the spine of Mississippi, Withers again inserted himself into a tense scene. He took intimate portraits of King, who stepped in for Meredith to lead hundreds of marchers from Memphis down through the stifling, humid Mississippi Delta. During the march, Withers's camera captured King conferring with Stokely Carmichael, the fiery young Black Power advocate, on the side of a country road.

IT WAS AN ironic twist that Withers's great resourcefulness and timing betrayed him two years later, when King was shot and killed at the Lorraine. Withers had been at the Lorraine less than two hours earlier but left to run errands. He missed the picture of the century. But he didn't miss its aftermath. Hustling back to the Lorraine with his cameras swinging from his neck, he undertook what arguably might be one of the most prodigious nights in the history of American news photography. In addition to shooting the first pictures of King in his coffin, Withers, then forty-five, tapped his unmatched access to King's staff to capture the evening's raw emotion: King's personal aide Bernard Lee, disheveled and his tie undone, venting his anger; Andrew Young raising his outstretched palm, trying to keep order; Benjamin Hooks and Harold Middlebrook gazing hollowly at King's attaché case. Withers shot a close-up of the open case, a picture that documented the pain and shock of that night without showing a single human face—just a shaving kit, a change of clothing, and copy of King's 1963 book, *Strength to Love*.

Out on the balcony, he photographed the pool of blood, dried now in a thick, flaky paste splashed across the concrete like a grisly, abstract paint-

ing. Withers even retrieved a pill bottle from King's room and scraped up some of it for posterity. But as he would say years later, it rotted in his refrigerator and he had to toss it out.

Later that night, in his studio, a visitor overheard Withers on the phone. Was he talking to the FBI? Over time, others had had these sorts of encounters—odd moments that left them scratching their heads, curious about his motives.

"Anytime he'd see us, he'd start snapping," said Charles Cabbage, a young Black Power activist, who took a room at the Lorraine the day King died and whose politics became the focus of an intensive FBI investigation. "C'mon man. We weren't that interesting. Why would he take our pictures constantly?"[12]

ON THE OTHER hand, why would Withers jeopardize his standing in the movement to work with the FBI as Jim claimed? It was truly puzzling. Jim said it was all about money. Withers did have eight children to feed. But I couldn't push Jim to go deeper. He offered solid objections: fines, even criminal penalties, that could be brought for revealing the name of an informant.

"That can come back and hurt you in the end," he said. So I was left to speculate. The more I thought about it over time, the more his urge to return to police work seemed like a sound explanation.

Despite getting fired from the Memphis Police Department in 1951, Withers continued to flirt with a career in law enforcement, tapping political connections decades later to land police jobs. In 1974, as the civil rights era waned, he was elected Shelby County constable, an unpaid position with little actual power. A year later, Withers won a patronage job as a gun-toting liquor agent for the state of Tennessee. And in 1977, after President Jimmy Carter took office, local Democrats put Withers on a shortlist for possible appointment as the U.S. Marshal in Memphis.

Withers's return to law enforcement was a particularly touchy subject for Jim. It soon became clear why: just as Withers had lost his first police job at MPD amid corruption allegations, his next paid police position ended in disgrace. This time, Withers was sentenced to prison.

"He took a bribe once," Jim said, holding up his hand to fend off fur-

ther questions. As I would later learn, Jim's dour response only hinted at something much bigger. When Withers pleaded guilty to extortion in 1979 as a corrupt state policeman, he played a pivotal role in exposing a massive conspiracy within Tennessee's executive branch to sell inmate pardons and commutations. For as little as $10,000, murderers, robbers, and other serious offenders bought their way out of prison. The resulting investigation netted convictions of more than a dozen state officials and political insiders and led to the eventual imprisonment of Tennessee governor Ray Blanton.

I couldn't help but marvel at Withers's biography. He seemed wrapped up in one giant story after another. And I couldn't help notice that Jim seemed just a bit too amused.

"Ernest should write a book," he said with a big grin.

He did do a book—four of them, actually. Over the years, Withers would publish glossy, coffee-table-styled picture books that displayed his rare photos of Negro Leagues baseball, the Beale Street blues scene, and life in the segregated South. They were pretty and they were artful.

But they didn't involve the adventures and intrigue Jim was talking about.

"NO ANGEL"

JULY 1978

HE SLID INTO THE BACKSEAT of the limousine, sinking into the cushioned upholstery. As the Cadillac's door clicked shut, Ernest Withers inhaled the sweet smell of success: Plush, grain leather. Finely aged Chivas Regal. The faint scent of Arabian horses from the moneyed countryside east of Memphis. He had never known anything like it.

He was fifty-five years old, graying at the temples. If he stopped to reflect, he could look back at his life's trek and marvel. Raised in the Great Depression, in the shadow of the smoke-belching Firestone tire plant in dreary North Memphis, he had navigated through the bustle of Beale Street, through the many long, lazy summers of baseball at Martin Park, through the turbulence of his brief police career, the great civil rights struggle, the mesmerizing moments spent alongside Dr. King, Howlin' Wolf, Jackie Robinson, and so many others. Now, on this steamy July night in 1978, life had

deposited him into this chauffeured limo, into the companionship of one of Memphis's most powerful men.

Most powerful—and most corrupt.

His host in the backseat, Art Baldwin, ran a chain of topless strip joints in Memphis called the Playgirl Clubs. An Arkansas native who grew up in the Delta cotton country across the river, Baldwin first came to Memphis to work as a stock clerk in the city's then-thriving music recording business. He became entwined with unsavory characters. No one is sure exactly how Baldwin got involved in organized crime. But he moved to Seattle, where he learned the topless dance trade while working for the Colacurcio crime family. He introduced his newfound livelihood to the "Bluff City" when he returned in 1974. His operations became the business model mimicked in Memphis for years: Nude or semi-nude "Go-Go" dancers—some who wore no top; others who wore nothing at all—performing on a raised stage to swirling lights and pounding rhythms. For a fee, they gave private "table" dances on the side. There were drugs and sex for sale.

Opening and maintaining such an operation in the heart of the Bible Belt required certain, flagitious, skills. And Baldwin, a pale man with scraggly blond hair, a scruffy beard, and icy blue eyes, proved more than adept.

Convicted of assault, attempted bribery, income tax evasion, and cocaine distribution, he paid off the police with cash, girls, and booze and took care of the politicians with large, off-the-books campaign donations. Suspicion swirled around him. Just this month, his former business partner and current rival, David McNamee, had been found murdered. More than a few people in Memphis thought Baldwin might have had a hand in it.

And more than a few of the city's elite could have cared less whether he did it or not.

Baldwin had money, the ticket to inclusion in class-conscious Memphis. He kept his own stable of purebred Arabian horses on the farm of a respected local businessman, and sipped bourbon with a circle of police and public officials.

"Anything that you want to do can be done for a price," he was fond of saying.

Now, as his chauffeur navigated the urban decay of the Memphis back-

streets, Baldwin focused his attention on his backseat guest, his latest friend on the public payroll: Ernest Withers, state liquor agent.

A decade after the civil rights era waned, Withers was a cop again. Sporting a business suit, a badge, and a gun, he worked as an agent for the Tennessee Alcoholic Beverage Commission—the state liquor board—regulating nightclubs selling liquor by the drink. Baldwin had plied Withers for months with small inducements—drinks and cash—to keep the board off his back. The pair often met in seedy motel rooms or at Baldwin's Brooks Road club amid the industrial sprawl near the airport. But today their discussion veered from the picayune into the heart of venality.

Withers had a hand in something far more nefarious than petty protection money, something much bigger than simply ignoring liquor violations. He served as a foot soldier in a rogue unit of state government that sold pardons and commutations to inmates. A cabal of officials inside the administration of Gov. Ray Blanton had put the state's justice system up for sale. For as little as $10,000 and as much as $80,000 or more, murderers, robbers, and other serious offenders could buy their way out of prison. Withers's role was small but vital: he found leads on the street and passed them up to confederates in the State Capitol in Nashville who had the power to convert them into profit.

Now, Baldwin had such a lead.

In the backseat of the Cadillac, the scruffy nightclub owner tantalized Withers with an offer certain to whet his bosses' appetites. He said he had an affluent friend who was willing to pay good money to free his son from jail. The family desperately wanted him out. No problem, Withers answered. But it will come with a price—$15,000. As the two men negotiated, Withers sensed he was about to land a big score.

But there was a problem—a huge problem that not only would spell legal trouble for Withers but would shake Tennessee's political landscape for years to come.

The Cadillac wasn't really Baldwin's. It belonged to the FBI. The chauffeur was an undercover agent. And Baldwin, who had recently been convicted of drug offenses that threatened to put him in prison for the next eighteen years, had a secret: he was working with the FBI as an informant.

As the two men discussed their pending deal, a hidden FBI tape recorder captured the conversation.

"That's a lot of money," Baldwin balked.

"Not if you want the man out bad enough," Withers responded.

"What happens if the deal goes bad?"

"The deal ain't going bad. If the money's right, the man's as good as free."[1]

AS I RESEARCHED Tennessee's 1975–1979 pardons scandal, known to many as the "Clemency for Cash" case, I began to sense the reasons for Jim's discomfort. If Withers indeed had been a paid civil rights–era informant as Jim claimed, his involvement in this no doubt would have ignited some severe heartburn within the FBI.

Still, it was rather confusing.

An informant setting up an informant? Just how does that work? Jim wouldn't talk about it. There were people around Memphis who knew the details, he said. But it was a hollow gesture. Jim wasn't going to put himself out there to help on this. My options for information were limited: a couple of books written on the case and the "morgue" files of old news accounts housed in the newsroom library at *The Commercial Appeal*, the daily paper where I work. These were the days before the Internet took off. Background research was done by hand, and it often went slowly.

Fat, dusty news clip files told how corrosive corruption had infiltrated and collapsed Governor Blanton's administration like the swarms of country termites he'd known as a child. Blanton grew up the son of a sharecropper in rural Hardin County along the border with McNairy, where legendary sheriff Buford Pusser fought his one-man war on moonshiners and backwoods pimps, not far from the Shiloh battlefield, one of the turning points of the Civil War. Blanton's family was so poor they kept egg-laying hens under the floorboards of their cabin. They worked their hardscrabble land with a mule-drawn plow.

Ambitious and arrogant, Blanton discovered politics as a ticket out of poverty. He worked as a schoolteacher and a state road construction con-

tractor before serving three terms in Congress and then winning election as governor in 1974. He would go down as the most corrupt governor in Tennessee history—known to this day as the "Hillbilly Nixon."

Selling inmate pardons and paroles was just one of several rackets. Blanton's administration also engaged in bid-rigging, selling liquor licenses, and passing surplus state cars to political cronies. When the investigations ended, more than a dozen people in the governor's inner circle went to prison, including his brother, his legal counsel, and his special assistant over regulatory boards. Blanton, a Democrat, served twenty-two months in federal prison for his role in a liquor license–selling scheme. To the very end, he blamed everyone but himself: The FBI—they were out to get him. The media. They smeared him. The public. They didn't understand.

"They are stupid," Blanton coldly told reporters near the height of his troubles in 1977, "and you haven't done your homework."[2]

THE FBI'S NASHVILLE office first opened its case file on the Clemency for Cash probe in September 1976 after Marie Ragghianti, the bold, dark-haired chairwoman of the Tennessee Pardons and Paroles Board, came forward with some sensational allegations. She told a local district attorney she suspected someone within the administration—maybe Blanton's legal counsel, Thomas Edward "Eddie" Sisk, maybe even Blanton himself—might be selling executive clemency. When her account made it to the desk of Hank Hillin, the hard-charging if moralistic FBI agent assigned to the case, he soon fleshed out a half-dozen examples in which money or politics seemed to have influenced a reduction in a prison sentence or helped gain other leniencies.

One case involved Roger Humphreys, convicted of murdering his ex-wife and her lover. He was sentenced to twenty to forty years for killing the couple. He did it by firing eighteen bullets from a two-shot Derringer, a horrific assault that required him to stop shooting and reload eight times. Within months of his imprisonment, however, Humphreys, the son of a leading Blanton supporter, was transferred to work release—assigned as

a photographer to the Tennessee tourism department where he received a hundred dollars a month, a state car, and a credit card for assignments that included shooting pictures at ceremonies in the governor's mansion.[3]

Another inmate, Eddie Dallas "Rusty" Denton, shot and killed a man in a barroom gun battle waged over a botched drug deal. In the melee, Denton's partner in the affair, Jackie Layman, shot and killed two others. Convicted of roles in three murders, Denton received sixty years, yet quickly secured a transfer to medium security and began receiving weekend furloughs. Ineligible for parole until he served at least ten years, Denton nonetheless won favor with the Pardons and Paroles Board, which after eighteen months recommended that his sentence be reduced to time served. Agent Hillin later wrote that Denton boasted to fellow inmates that "his people" had paid $85,000 in exchange for his release from prison.*

Hillin found the going rough as he tried to build a solid, provable case of quid pro quo—money paid directly in exchange for an official action. It came, he believed, in the case of Billy Gene Cole, a large, bearded man convicted of robbing a Red Star grocery in Chattanooga. Under an offer of immunity, he told an incredible story.

Sentenced in January 1974 to twenty-five years, Cole wasn't eligible for parole until 1984. Yet he was released in October 1975—after just twenty-one months. As Hillin dug, he found Cole had received a visit at the state prison in Nashville in May 1975 from Bill Thompson, a reputed gambler and bootlegger with dark, slicked-back hair and bushy, Elvis-style sideburns.

Thompson had ties to the governor's office.

He was friends with Eddie Sisk, the governor's former campaign coordinator and current legal counsel in charge of reviewing all applications for executive clemency. Thompson told Cole he could get him out of prison—for $10,000. Cole's wife took out a bank loan and paid $5,000. Suddenly, that August, Cole's sentence was cut from twenty-five to ten years. Cole then

*Blanton eventually pardoned Humphreys to storms of protest. Despite payments Denton allegedly made through intermediaries, he wasn't released. Three days before his term was to expire, Blanton put Denton on a list of inmates to be pardoned. However, in a move orchestrated by U.S. Attorney Hal Hardin and executed with help from the FBI, Blanton was locked out of his office and his successor, Lamar Alexander, was sworn in as governor three days early. The move, most certainly illegal, went unchallenged and is believed to have blocked Blanton from pardoning Denton and a host of others.

paid another $5,000. Nine days later, on October 17, 1975, Cole walked away from prison on parole.

Hillin traced the scheme right back to Sisk. It happened when a second convict, Tommy Prater, said he, too, had been paying Thompson. This time there were witnesses. One watched as Thompson allegedly handed Sisk $3,000—all in hundred-dollar bills stuffed into a white envelope—at a motel directly across the street from the stern-faced lawyer's state office.[4]

By the summer of 1977, Hillin, who'd amassed stacks of evidence in large files labeled Operation TennPar—shorthand for Operation Tennessee Pardons and Paroles—believed he'd cracked the case.

"I was ready for the next step, which, I felt, would be indictments," he later wrote.[5]

BUT THEN IT all caved in. That July, Blanton publicly attacked the FBI. With narrowed eyes, he told reporters the probe amounted to a political "witch hunt" orchestrated by one man—agent Hank Hillin. Days later, Hillin received a visit from a high-ranking supervisor—the investigation had been held "in abeyance." Then, after months of delays, the Justice Department's public integrity section in Washington decided a conviction couldn't be sustained. "Hank, the case is dead," Justice Department attorney Andy Reich informed Hillin in January 1978.[6]

Despite a DOJ review later requested by Hillin, the case imploded. That March, Reich called Hillin again.

"I've got bad news again and this time it's final," he said. On April 11, 1978, the Justice Department sent a letter to Sisk's attorney. "Please be advised that this matter is no longer under active investigation," it read. "Absent the receipt of additional information, we have determined that no further evidence will be presented to the grand jury."[7]

Hillin would later learn that Blanton had personally spoken by telephone on three occasions the previous fall with President Jimmy Carter's attorney general, Griffin Bell. Among other things, Blanton asked if he had any personal criminal exposure or if any of his staff members—specifically Sisk—might be facing charges. Additionally, attorneys representing Sisk had met in Washington with the Justice Department's public integrity unit.

They said Sisk had an excellent reputation and even displayed family photos of Sisk with his wife and young son.

"I never felt so cynical about politics in my life," Hillin would later write. "We were foolish to think we could indict the lawyer for the Democratic governor, with a Democratic president in the White House."[8]

THE FBI'S CLEMENCY for Cash case almost certainly would have died on the vine if not for two men: state liquor agent Ernest Withers and strip club owner Art Baldwin. It's a story overlooked or underplayed in the official accounts of Tennessee's pardon-selling scandal. It's buried in a mound of FBI paperwork, in the memories of a few prosecutors and Bureau agents, and on the voice recordings of covert wiretaps sealed away in FBI vaults collecting decades of dust.

It's the real story of how Ray Blanton was toppled.[9]

Around the time Blanton and Sisk reached out from their state offices in Nashville for help from the Carter administration in Washington, Baldwin sought help, too. Two hundred miles to the west in Memphis, the once-swaggering businessman was desperately working a deal with prosecutors to stay out of jail. On August 22, 1977, Baldwin was convicted in federal court of cocaine distribution following a sensational trial that revealed how he'd regularly shot dice with police monitoring his clubs and plied others with booze, dance girls, even dinner certificates he passed out at Christmas. Now Baldwin faced serious trouble. Already convicted in Seattle of income tax evasion, as a second-time offender, Baldwin expected to be sentenced to as many as eighteen years. On the advice of counsel, he struck a deal. He agreed to tell federal prosecutors what he knew of official corruption in Memphis.

In a series of secret meetings that autumn, high in the eleven-story federal building overlooking the Mississippi River harbor in downtown Memphis, Baldwin spilled his story to lanky Mike Cody, the newly appointed United States attorney, and his stocky, bulldogish assistant prosecutor, W. Hickman Ewing. Under oath, with a court reporter taking down his every word, Baldwin told how he'd funneled large amounts of unrecorded cash campaign donations to Juvenile Court judge Kenneth Turner, who was

running for mayor, and how he'd cosigned a home mortgage for financially struggling county commissioner Minerva Johnican.* He gave at least $800 cash to a young, cocky state senator named John Ford.[10]

Several of Baldwin's accounts revolved around a mustachioed, slick-talking hustler named John Paul "Speedy" Murrell, known to political insiders as J.P. An African American businessman who owned a liquor store and ran a gambling operation on the side, J. P. Murrell funneled under-the-table cash to white politicians and helped deliver Memphis's large black vote to Blanton, landing him in the governor's mansion. Blanton, in turn, put J.P. on his patronage team, a statewide network of advisory committees—one in each of the state's ninety-five counties—set up to screen applicants for state jobs. Each and every adviser on these committees was a Democrat. Murrell wielded exceptional power in Shelby County. Anyone in Memphis's African American community who wanted a state job came through him.

"J.P. is as big a man as there is in Memphis as far as the governor is concerned," Baldwin said.[11]

As Baldwin spoke of Murrell, his story meandered to Withers. He told the prosecutors how Murrell and Withers once offered to secure his release from the county penal farm. He declined. Another time, he gave the pair cash—as much as $5,000, he thought, he couldn't recall the exact amount—when they visited his Raines Road strip club. The two were inseparable, he said. Baldwin said Withers often even worked the cash register at Murrell's liquor store on Crump Boulevard near the Mississippi River bridge. [12]

He knew, too, of gatherings that a prominent wholesale liquor distributor hosted at his plush offices, where he mixed business and pleasure with a pool table and a wet bar. Guests included agents with the state Alcoholic Beverages Commission, the agency that regulated his businesses. One was Ernest Withers. At first, Baldwin's stories seemed to go right past the prosecutors. They knew Withers, the affable news photographer. But they didn't realize he'd hung up his cameras to work for the ABC.

"You remember Ernest Withers being there?" Ewing asked with seeming astonishment.

*Johnican, now deceased, was an elected member of the Shelby County Court, the governing body that later became known as the County Commission.

"Yes," Baldwin replied without hesitation. "He is J.P.'s bag man now, on the ABC payroll."

"He is on the ABC payroll?"

"Um-hmm. But he spends all of his time running errands for J.P.," Baldwin said. In fact, he said, Withers acts almost as if he is Murrell's secretary, deciding who meets with him and who doesn't. "Withers is screening everybody for J.P."[13]

SIX MONTHS LATER, the FBI's notoriously slow-moving public corruption unit began investigating Withers. In April 1978, just weeks after the Justice Department shut down agent Hillin's clemency probe out of Nashville, agents in Memphis strapped a wire on Baldwin.* Soon, with a hidden FBI recorder rolling, Withers demanded three cases of liquor from Baldwin for a political rally Murrell was hosting. The impact resonated immediately with agents monitoring the conversation: here was a state policeman soliciting alcohol from a man whose nightclubs he was assigned to regulate. It would get much worse.

When Baldwin baited Withers by seeking his help releasing a young friend named Steve Hamilton from prison, the photographer-turned-cop didn't hesitate.

"Let me go to Nashville and talk to my people," Withers said.[14]

Now, the FBI intensified its investigation. It put Withers under photographic surveillance—an odd image considering what Jim had said about him shooting pictures for the FBI during the '60s. Agents wired Baldwin with a bulky Nagra body recorder strapped under his shirt and sent him after the photographer-cop. The Bureau even obtained a limousine to increase Baldwin's allure as a man of substance and supplied an undercover agent to pose as his chauffeur. The tape-recorded conversations mounted:

Withers and Baldwin plotted to let others out of prison and even joked about the killing they could make. As their rapport grew, Withers let

*In a December 13, 2011, interview with the author, prosecutor W. Hickman Ewing said the FBI initially was very reluctant to investigate. Bitten by a series of national scandals, the agency balked at working with Baldwin despite the obvious crimes he knew about. "I'm having to talk the FBI into what a crime would be," Ewing said incredulously. After some persuasion, agents relented and found Baldwin to be "a gold mine," he said.

Baldwin in on a secret: his contact in Nashville in the Clemency for Cash schemes was Fred Taylor, a pudgy highway patrolman assigned as the personal driver for the governor's brother, Gene Blanton.[15]

Now the FBI was getting hot. Withers's schemes ran right back to the governor's office.

At the urging of the FBI, Baldwin pushed Withers to arrange a face-to-face meeting with Taylor. On a hot, sticky Labor Day weekend, Taylor flew to Memphis. Baldwin's undercover chauffeur picked him up and took him to a local strip club and then, at Withers's instructions, to room 523 of the tony Hilton Inn. Agents listened in from the room next door. When the conversation turned to Steve Hamilton, the young inmate Baldwin was trying to free as part of the FBI's sting, Taylor and Baldwin agreed on a price: $15,000. The Hamilton family would pay the money. Baldwin said he wanted to keep $5,000 for himself. Taylor said that was fine as long as an associate—someone he called "my man" in Nashville—got the rest.[16]

Baldwin got Withers to set up a second meeting with Taylor, this one in a hotel near the airport.

"The greatest potential for a major breakthrough in these matters currently exists," the FBI's Memphis office wrote* in an ecstatic Teletype to headquarters that trumpeted the anticipation.[17]

DRESSED IN A three-piece suit, Taylor flew in from Nashville, oblivious to the FBI agent who boarded the plane alongside him and who later watched as Taylor climbed into Baldwin's limo and arrived at the motel. As FBI agents watched live via closed-circuit TV in the next room, Taylor and Baldwin sipped Chivas Regal and Jack Daniel's and began to negotiate.

"We'll put him on a work-release program down here," Taylor said as an FBI video recorder rolled, ". . . with guaranteed parole." As special agent Hillin describes it in his book, *FBI Codename TennPar*, Baldwin pulled a wad of cash from his wallet and peeled off $2,000—all in hundred-dollar bills supplied by headquarters in Washington. It was a down payment, good-

* During the author's initial research in 1997 of the Clemency for Cash case, the FBI reports referenced in this chapter were unavailable. The accounts in those reports, obtained since 2009, are presented here for the purpose of efficient storytelling and they represent more than the author knew in 1997.

faith money to get Taylor moving on the deal. The two men then watched *The Newlywed Game* on the television before Taylor scooped up the $2,000 from a table and retired for the night.[18]

Tarnished by months of scandal, Blanton opted not to run for reelection. Republican gubernatorial candidate Lamar Alexander won a huge victory at the polls that November. Details trickling back to the FBI had it that Blanton planned to pardon multiple inmates before leaving office. In fact, on November 13, his legal counsel, Eddie Sisk, prepared a list of thirteen inmates considered appropriate for executive clemency. Among them were Steve Hamilton and a second inmate whose release Baldwin and Taylor had begun negotiating.

In a final push to break the case, the FBI gave Baldwin $50,000 in marked hundred-dollar bills—"show money"—that he flashed to Taylor in a November 28 meeting in another Memphis hotel room. The money was his if he'd release yet another inmate, a convicted robber named Larry Ed Hacker. Baldwin sweetened the pot by telling Taylor he'd pay another $20,000 for the release of two additional inmates. When they met again on December 13, Baldwin handed Taylor $10,000 in an envelope toward the release of the pair.[19]

On December 15, 1978, as Blanton's extradition officer Charles Benson walked through the Nashville airport on his way to Memphis with a briefcase containing executive clemency papers, FBI agents surrounded him.

"Charlie," long-suffering agent Hillin said with satisfaction as Benson turned around. "You're under arrest."

In Benson's wallet, agents found thirty-three hundred-dollar bills with serial numbers that matched the cash Baldwin had given Taylor.* Serving a search warrant, agents also arrested Sisk in his Capitol Hill office. They found thirteen hundred-dollar bills in his pocket—twelve with serial numbers matching the Baldwin cash.[20]

ROLLING FOG HUGGED the black loam around Maxwell Air Force Base Federal Prison Camp in Montgomery, Alabama, on December 13, 1979, the

*Benson later was acquitted at trial. Taylor and Sisk each pleaded guilty to racketeering and served terms in prison.

day Withers was ordered to begin serving his term. Twenty-three years earlier that very month, not ten miles away in downtown Montgomery, Withers had taken his famous photo of Martin Luther King, Jr., riding one of the first integrated buses. Now he returned, a felon.[21]

"I ain't been no angel," Withers said years later, reflecting on his life.

Still, he was fortunate. Sentenced to a year in prison—with six months suspended—he could have faced years behind bars. Named as an unindicted co-conspirator, Withers was caught on a phone tap soliciting bribes to release a convicted murderer. Evidence implicated him in two other Clemency for Cash deals as well.* In the end, he served just five months, thanks to good behavior and an incredibly generous deal with prosecutors in which he agreed to testify in two trials.[22]

Nothing in the official court record indicates Withers got any leniency for serving, as Jim had claimed, as a 1960s civil rights informant. In return for his testimony, Withers wasn't charged in the Clemency for Cash prosecutions. Instead, he pled guilty in a spin-off investigation—he and J. P. Murrell had extorted $8,500 in payoffs from a nightclub owner. At Murrell's trial, Withers told how the patronage chief got him the fateful job as a state liquor agent and how he became ensnared in the most notorious episode of corruption in Tennessee history.[23]

"I had, let's say, a police background," Withers testified, a reference to his brief stint from 1948 to 1951 as a Memphis police officer. Withers didn't offer that he'd lost that earlier job for bootlegging.

"Mr. Murrell asked me maybe did I want the job," Withers testified. It offered a regular salary, health benefits, and a pension—security he never knew in the photography business. "I felt getting older in the picture business I would really want to get a job and would be in a retirement-type level," he said. Withers soon learned the job involved very little actual police work. In an early meeting in Nashville with ABC director Lee Hyden, who would also go to prison for extortion, Withers received his marching orders. "In the meeting there it was decided that I would be an Alcoholic Beverage agent and that my off time, or during my normal course of work, that I

*Withers's involvement in soliciting cash in three failed bids to release felons—a murderer, the wife of a Los Angeles drug dealer, and a convicted robber—are discussed in chapter 7.

would be required to assist Mr. Murrell in his area, work as a patronage man for the governor."[24]

After serving his five months, Withers was released on May 23, 1980, returning to his family in Memphis to begin serving a year of probation and six months of community service. A judge also ordered him to pay a $2,500 fine. Authorities had a hard time getting the money out of Withers. They threatened more than once to revoke his probation for nonpayment.[25]

For all his hustling, for all the seminal photos he'd shot over the years, Ernest Withers was broke. As Murrell's bagman, Withers had handled tens of thousands of dollars in cash. It's unclear how much, if anything, he ever kept for himself.

BUT FOR ONE shining moment, at least, it may have seemed worth it.

In 1977, two years after he started working for Blanton, Withers and his wife, Dorothy, received a once-in-a-lifetime invitation: they attended a state dinner at Jimmy Carter's White House. Dressed in a smart tuxedo and his wife in a flowing gown, the handsome couple reveled in the company of the nation's political elite. As a photographer for *Jet* magazine shot pictures, they witnessed stirring performances by the Metropolitan Opera company and the Marine Corps Band. They met the president and his guest of honor, West German chancellor Helmut Schmidt, who rose at one point to lead the Marine band in a heartfelt rendition of Beethoven's *Ode to Joy*. The Witherses' son, Ernest Jr., worked on the staff of Democratic National Committee deputy chairman Benjamin Brown, a prestigious assignment that spoke well of Ernest Sr.'s own political connections and one that undoubtedly opened the door for the elder Witherses at the White House that summer day in 1977.

It was a solitary, perfect day, forever frozen in the pages of *Jet*, one that neither politics nor the pursuit of money nor Withers's own inner demons could ever take away.[26]

6.

INTO THE SHED

SOME PEOPLE HAVE A HARD time understanding how sweet, good-natured Ernest Withers could get involved in something like the Clemency for Cash scandal. Those people don't know Memphis. Once you know it, you'll understand.

I came to Memphis in 1989, seeing it first through the acrylic pane of a jetliner window. It was bright and clear, and from five thousand feet even a white-knuckled aviophobe like me could sense the splendor: the great sweep of the Mississippi River, half a mile wide as it passes downtown before snaking over the horizon on its way south to New Orleans; the jeweled Memphis skyline; Liberty Bowl Stadium; the broad railyards; the dense, green canopy of oak, sweet gum, and poplar that covers the city like a country forest. H. L. Mencken called Memphis the buckle of America's Bible Belt. From here, you see exactly what he was talking about: churches, everywhere. They dot the cityscape, steeples reaching skyward, pretty as a postcard.

But like a Siren's call, Memphis can be treacherous. Rampant blight, crushing poverty, unforgiving racism, entrenched corruption—these are as much a part of the city's infrastructure as any road, bridge, or utility line.

Up close, it can appear as a city in chaos.

In my very first week in town, an intruder robbed and raped a woman as she dressed for church in her home on a Sunday morning; the local congressman prepared to stand trial for bank fraud; the superintendent of schools fretted over his romantic affairs, which were about to explode in front-page allegations that he'd traded sex for promotions.

Over the next twenty-nine years, I saw scores of public officials convicted of corruption offenses—more than a hundred in one eight-year span alone: legislators taking payoffs; cops dealing drugs or robbing motorists; councilmen, clerks, and county commissioners steering funds into their pockets. One, Councilman Rickey Peete, went to prison—twice—for taking bribes. He served time, got out, got reelected, then went *back* to prison—again, for bribery. Now they call him Rickey "Re-Peete." Another, Joe Cooper, tried for a hat trick. An affable man with a quick smile and a set of gnarled teeth, he went to prison as a commissioner and again as a back-slapping lobbyist doling out graft. He escaped from the middle of a third probe when two other suspects—a venal businessman and a bribe-taking judge—*both* died unexpectedly of natural causes, spinning the case apart.[1]

At times it's incredibly easy being an investigative reporter in Memphis. Like shooting fish in a barrel, as they say. I've written stories about a real estate developer who gave a state senator a $75,000 diamond-encrusted Rolex watch; about government clerks who sacrificed their careers for payoffs as small as five dollars; about day care owners who redirected hundreds of thousands of government dollars intended for poor children to buy Caribbean cruises, fancy cars, and expensive homes. It may be unfair to characterize Memphis as a corrupt town. There are plenty of honest officials. They work hard to provide efficient services. Yet every ten or fifteen years, in cycles as regular as cicadas awakening from their subterranean slumber, all screeching hell breaks loose: the city's latent, decades-old culture of corruption releases another wave of contagion.

I wasn't surprised to learn of Ernest Withers's criminal record. Though it seems irreconcilable—this sweet, soft-spoken man, so full of kindness,

so identified with that righteous movement—it made sense. It made sense knowing what I'd come to learn of Memphis. Even some of the best-intentioned are swept into the city's great current of corruption. "It takes a tremendous amount of morality and self-control to stay out of the attraction of money," Withers once said.[2]

That defines it better than anything: desperation. Memphis started as a hard-knocks river town, populated over the decades by dirt-poor share-croppers, black and white, forced off their land in the Mississippi Delta; by wretched, penniless laborers fleeing hardscrabble West Tennessee and Arkansas in search of opportunity. What emerged was one of the most con-centrated pockets of poverty in America. Despite heroic reform efforts, year after year Memphis remains at or near the top of those often-dubious but reputation-harming "Worst" lists: worst in violent crime; worst in infant mortality; in failing schools; bankruptcy; child abuse; hunger; obesity; in predatory lending.

Corruption is simply an inevitable by-product.

STRANGELY, ALL THESE "negatives" lured me here. For an issue-hungry reporter raised in middle-class Wisconsin and schooled in the sterile, ideal-istic halls of the University of Minnesota, Memphis provided a joyful chaos: wonderful music, history, and an endless cast of colorful characters.

After working at small papers in Minnesota and Florida, I came to *The Commercial Appeal*, Memphis's venerable, then-150-year-old daily newspa-per, at an editor's suggestion: A great paper. A big news budget. They had over 220 employees in the editorial department alone (now there are fewer than 40), buzzing like honeybees in their third-floor hive in the newsroom at 495 Union Avenue. In all, more than 1,100 people labored to keep the Mid-South informed from the paper's five-story, contoured glass headquar-ters. The news staff included six librarians, scores of reporters, and a crew of copy clerks who ran errands, from serious stuff like delivering source material, to the whimsical fetching of pizza and dry-cleaning tickets.

These were newspapering's end times—the sunset on the heyday before technology, the Internet, and Wall Street took the wheel and steered Ameri-ca's great dailies into the ditch, into that great dark void of instability.

Yet even now, amid the empty offices—after all the decimating layoffs—Memphis mesmerizes.

Every morning on my way to work I drive past Sun Studios, where young Elvis Presley first recorded "That's All Right Mama"; I park around the corner on Beale Street and walk over to the newspaper offices. If I look to the west I see the glittery Beale Street Historic District, where B.B. King, Bobby "Blue" Bland, and so many other legendary bluesmen got their start. A short drive toward the river takes you to the Lorraine Motel—now the National Civil Rights Museum—where Dr. King was shot. Not far to the southeast is Mason Temple, the cavernous sanctuary where he gave his last speech, during a thunderstorm, the night before the assassination.

Memphis is sometimes described as America's biggest small town. It was especially true in my early days there. Just walking down the street I'd run into singers like Rufus Thomas, famous for the "Funky Chicken" and "Walking the Dog." Wave, and Rufus waves back. I once got in a heated argument with Isaac Hayes over a story I wrote on his interest in Scientology, and, more memorably, had a friendly chat with James Meredith during a chance encounter at the airport. By then, the once iconic, fresh-faced Meredith, the black student who had integrated all-white Ole Miss in 1962, was gray-bearded. Ironically, he now worked for arch-conservative Republican senator Jesse Helms. He took a beating for it in the press, but he could have cared less. "Politicians are all part of the same club," he told me with a shrug. "They're all the same."

My first assignment for *The Commercial Appeal* involved a six-month stint as its one-man news bureau in Greenville, Mississippi, in the heart of the Delta. There, I learned as much about Memphis as I would over the next two decades up in Memphis proper. This was ground zero: The share-cropper culture. The hard life. The shacks. The cotton fields. The brutal, unvarnished racism—it was all here. Everything that triggered the Great Diaspora, pushing poor white and black farmers off their land to Memphis and points north, sat here, nearly untouched, like a time capsule.

There was so much to discover. I was single then and tied to nothing. Roving the Delta in my '67 Chevy Caprice, my collie Lena on the seat beside me, I found opportunities to write about voting rights, poverty, and the death penalty. In June 1989 I interviewed condemned inmate Leo Edwards

the day before his execution. Convicted by an all-white jury, Edwards, a thin, bespectacled thirty-six-year-old African American, told me he didn't get a fair trial.

"You know how I felt when I saw the jury?" he said in shackles as hulking prison guards looked on. "I said, 'I'm dead.'"

His trial definitely seemed rigged. The district attorney who prosecuted him confessed afterward that his ideal juror was "a forty-five-year-old white male with a crew cut and white socks who welds for a living." He had cherry-picked Edwards's jury. Even in the 1980s, Mississippi's old ways held fast. Yet prosecutors had no need to railroad Edwards. They could have convicted him fair and square; the evidence was that strong. Found guilty of three separate murders, Edwards got his death sentence for shooting a helpless convenience store clerk during a robbery. This was the muddled nature of justice in the South: a horrific crime tainted by a rigged trial, an obvious disrespect for black life, and an ancient rite of unsettling, irreversible retribution.[3]

Compelling stories never waned. My travels took me to places like Nelson Street—Greenville's gritty version of pre-touristy Beale Street—where I saw singer Little Milton perform at the fabled Flowing Fountain, and to Parchman, Mississippi's infamous maximum-security prison farm. One humid afternoon there I tailed B.B. King behind the prison walls, where, in a scene reminiscent of Johnny Cash's Folsom Prison Blues performance, he played a hard-luck concert for the inmates. To cheers and whistles, King sang to their souls:

> *Nobody loves me but my mother.*
> *And she could be jivin' too . . .*

MISSISSIPPI TAUGHT ME much about Memphis, yet my single greatest lesson in the city's legendary corruption came in the form of a brilliant, philandering, foul-mouthed politician named John Ford, the bad apple of one of Tennessee's most prominent political families. I spent years investigating him. I first wrote about him in 1995 when he put one of his lovers on the county payroll in a highly paid, but, as far as anyone could tell, do-little

job. As a flamboyant state senator who had fathered thirteen children with six women and who once confided to an FBI agent on an undercover tape played in federal court, "When they make pussy a state or federal crime, then I can go to jail happy," Ford dizzied Memphis with his constant antics.[4]

Once, in a rage, he threatened a group of city utility workers with a loaded shotgun. "If you don't leave, I'll blow your . . . brains out," he yelled at them for blocking his driveway. Despite multiple witnesses, prosecutors agreed to drop all charges.* When he got a parking ticket one night at the airport, he allegedly shoved the citation back into a female officer's chest. "You cannot do a damn thing to me," he told her. He was right—no charge. Pulled over another time for driving 94 in a 65 mph zone, he yelled as the trooper's audio recorder rolled. "You better not lay a *fucking* finger on me," Ford shouted, refusing the officer's command to step out of the car. When the trooper's supervisor arrived, Ford declared "legislative immunity." After filing a complaint alleging police misconduct, he paid a $112 fine.[5]

Another time, when I questioned him about an auditor's contention that he'd tried to interfere with a state audit, Ford exploded in a twenty-minute rant. "You done got caught in your own damn trap!" he yelled, threatening to sue me when he got the auditor to retract what he'd said—a bluff he never followed through on.[6]

John Ford could be frightening.

IT TOOK JAY Leno to finally bring him down. It was 2005, and the comedian made a joke about the rascally state senator on his nationally broadcast *Tonight Show*. It came after a story I wrote about a woman who had sued Ford for child support. Trying to limit his court-ordered payments, Ford testified he already was supporting two other families in expensive homes he owned miles outside his senate district. In fact, Ford said, he lived in both homes, alternating between two women whose children he had fathered. "I live back and forth," he told an astonished Juvenile Court judge. On his show, Leno rehashed Ford's living arrangements and his women, delivering

*Charged with five counts of aggravated assault following the February 1997 incident, Ford received administrative diversion. He served two years of probation and two hundred and fifty hours of community service, after which the charges were dismissed.

a punch line: Ford deserved "a Jerry Springer lifetime achievement award."[7]

But this time, Ford would be more than just the butt of a joke. The judge overseeing his child support case ordered him to deliver his tax returns to Shelby County Juvenile Court to help determine how much he could pay. A source then handed them to me. The returns showed he'd received at least $237,000 he'd failed to disclose on his state conflict-of-interest forms. I tracked the payments to something called Managed Care Services Group, a shell used to funnel Ford money from TennCare, Tennessee's Medicaid program. Ford sat on a committee that oversaw the program. Finally, the Senate Ethics Committee acted. All through the spring of 2005 the details dribbled out in hearings packed with reporters and TV cameras: Ford had taken more than $800,000 in "consulting fees" from two TennCare contractors while advocating on their behalf, trying to obtain higher provider rates and win other concessions.

Soon, he'd have even greater troubles.

IN MAY, IN the middle of the ethics probe, Ford was indicted in Memphis. In the initial news flash it seemed the charges involved the TennCare probe.* But as FBI agents led Ford from the capitol grounds in handcuffs along with four other arrested legislators, it became clear this involved something even bigger. It was then the public learned of the Tennessee Waltz bribery sting, an undercover FBI operation that had been grinding on in stealth for two years—a second case unrelated to the TennCare scheme.

Now it roared into court. Charged with bribery, extortion, and two counts of witness intimidation, Ford played the starring role in the prosecution's undercover tapes, raging bigger than life on oversized courtroom video screens, thundering over courtroom speakers.

"Let me ask you a question. You ain't working for none of them *moth-*

*Ford resigned from the senate days after his indictment. Consequently, the ethics case against him was never resolved. Ford maintained the case was bogus, that he was a professional consultant and that his business was legal and didn't conflict with his duties as a part-time senator. Indeed, his biography in the *Tennessee Blue Book* listed him as a consultant, an occupation he developed over the years after starting out in life as a mortician for his family's funeral home. Nonetheless, Ron Ramsey, the Republican chairman of the Senate Ethics Committee who would later become speaker of the senate, said if Ford hadn't resigned, the committee would have filed six charges of violating the chamber's ethics code and would have recommended that the Senate oust him.

erfuckers?" Ford menacingly asks a lobbyist whom he suspects of being an informant. "If you are just tell me. I got a gun." Grainy videotapes showed the debonairly dressed senator pocketing stacks of cash—in hotel rooms, in parking lots, once even in his Nashville senate office. Ford accepted a series of payments—$55,000 in all—from an undercover agent posing as a corrupt businessman.

Months after his Memphis indictment, Ford was indicted in Nashville for the TennCare kickbacks. After years of unaccountability he now faced separate criminal charges two hundred miles apart. He bounded back and forth to pre-trial hearings. Yet, when he finally stood trial in Memphis in April 2007, it looked as though he might once again revive the old Ford magic. The jury acquitted him on two counts and deadlocked on a third. But on the one remaining count—bribery—they found him guilty. He was sentenced to five years in prison.

JOHN FORD WAS one of many distractions that led me away from Jim's tip about Withers. But even when it was fresh, it seemed unworkable.

Jim wouldn't go on the record. Over three or four conversations I had with him in 1997, he even said he'd deny it. I felt Withers would, too.

I reached this conclusion in the public library, where I located the published volumes of the House Select Committee on Assassinations. Jim said the committee learned of Withers's identity as a paid informant while investigating King's murder. Searching for clues, I found a passage that described an informant who fit Withers's profile. My hopes rose—this person was interviewed in secret by committee staff. But, when asked, the informant declined to let the committee reveal his identity publicly. The condemnation from the black community over such a revelation would simply be too great, it seemed.[8]

In any case, the Withers story never connected directly to my focus over that long summer and fall of 1997: Dr. King's assassination. As James Earl Ray's conspiracy circus played out in court, my editors allowed me to work several angles we believed would untangle fact from fiction and advance the public's understanding of this momentous historical event. Jim was one of a number of former law enforcement and intelligence agents I contacted

while exploring Ray's specious claims. This months-long effort resulted in a groundbreaking story that fall that raised serious doubts about a popular conspiracy claim endorsed by King's family: that elements of the U.S. Army had stalked the civil rights leader and played a role in his murder. Then, in early 1998, we published a series of stories I wrote that added new insight into the congressional committee's theory that Ray might have shot King hoping to collect a $50,000 bounty offered by St. Louis–based racists.[9]

Ray never did get out of prison. His lawyers tried in vain to arrange a liver transplant, but the state of Tennessee would have none of it. The confessed assassin died in prison on April 23, 1998, six weeks after his seventieth birthday and thirty years and nineteen days after he found King's face in his crosshairs and squeezed the trigger. He died professing his innocence.

After months of writing exclusively on the King assassination, I was tired of it. So were my editors. There would be no Withers story. It was just another of many tips that go nowhere. After Ray died, I boxed up my notes and research materials and packed them into the small Morgan building—the shed—in my backyard. There they'd stay collecting dust for the next ten years.

INFORMANT ME 338-R

OCTOBER 2007

S HADOWS STRETCHED ACROSS DOWNTOWN MEMPHIS as the funeral procession turned onto Beale Street. It moved to a slow, mournful beat, toward the Withers photography studio.

Rudy Williams pressed his trumpet to his lips and blew. Decked in a flamboyant white top hat and a somber dark suit, Williams, sixty-six, the graying "Mayor of Beale Street," led a brass band marching at the head of the procession. Next came the motorcade—the hearse followed by a line of white limousines. Tenderly, the band began to play.

"*Precious Lord,*" the music wafted, "*take my hand.*" It was Dr. King's favorite song. But today it would honor another.

Ernest Columbus Withers was dead.

It seemed he would live forever. At eighty-five, Withers had still made regular appearances at his studio, so cluttered now in 2007 with six decades of photographs, picture frames, and assorted junk it looked more like a

rummage store. It was a photography business still. Yet at times it seemed more like a community center. Tourists, students, curiosity seekers—all stumbled down the long, darkened hallway now and then to the cloistered studio, so unlike the rest of glittering Beale Street.

The place screamed history. Here was a portrait of Medgar Evers, the slain NAACP executive. There was Aretha Franklin, the queen of soul. A banner depicting Dr. King hung from the ceiling, emblazoned with his famous words, "I Have A Dream." Photos of countless others cluttered the walls—local politicians, preachers, a portrait of Withers as a young city police officer. When he ran out of room on the walls, he stacked more photos on the floor, propping oversized prints up against sofas and piling others, loose and frameless, atop filing cabinets or cramming them into corners to collect years of dust.

Withers was synonymous with Beale Street, yet his up-and-down fortunes meant he couldn't always keep an office there. He ran a series of studios on Beale from the 1940s to the '70s. But by the '90s he'd been gone for years, driven out by the economic decline of the once-bustling black business district. It's said Beale never fully recovered from the disorder that erupted during Dr. King's 1968 march. Like a runaway beer truck, the downturn was swift and violent, bowling over all in its path. One by one, the street's once-great venues were shuttered: the New Daisy Theatre, the Hippodrome, Harlem House, the Elks Club, the Palace Theatre.

The city of Memphis finally halted the blight in the '80s, reviving Beale with an infusion of federal redevelopment funds. The street would never be the same. The city created the exuberant row of nightclubs and restaurants that today attract tourists from around the world. But gone forever was a culture, a way of life. The city's black Main Street was history.

The street's newfound prosperity initially bypassed Withers. In the early '90s, misfortune led him to South Memphis, where he ran a photography studio from the hull of an old dry-cleaning business. There, on a cold winter's day, Beale Street real estate developer John Elkington rediscovered him. A personable smooth-talker, Elkington had secured a lucrative contract to manage the city-owned Beale Street Historic District and he was recruiting tenants. He'd heard of Withers and his rare photo collection, so he figured he'd take a look for himself. What he saw startled him. The pho-

tographer's historic prints and negatives were in tatters; some had suffered water damage.

Elkington made a pitch: come back to Beale Street. He'd set up the photographer in a modern studio—charging just a dollar a year in rent—on the west end of the historic district. That end continued to struggle even after Beale's recovery, but business was picking up and Withers had no better offers. He accepted.

"If we hadn't got him out of there and moved him onto Beale Street no one would have ever heard of him," Elkington said. It was the start of an Ernest Withers renaissance.[1]

In 2000, the Chrysler Museum of Art published *Pictures Tell The Story*, a glossy, 192-page coffee table book of Withers's civil rights photos, one of four Withers picture books that would be published. Exhibits of his photos made national and international tours. Withers became a much-in-demand speaker at symposiums where he'd entertain audiences with graceful, poignant, and often humorous stories.

"There are a number of photographers that go around the country and say they were Martin King's official photographer. Well, Martin King didn't have no budget to hire no photographer," Withers said to great laughter before a crowd in Boston in 2004. "I was the official photographer of Negro newspapers and they paid a very *l-e-a-n* bit of pay."[2]

He continued working at a brisk pace through much of 2007.

Then, in September, Withers suffered a stroke, and quickly deteriorated. His final days were spent at the Veterans Administration hospital, where, on October 15, he died.

The funeral was an eclectic affair. As a World War II veteran, Withers received military honors, with an American flag draped over his coffin.

But it was hardly a traditional military ceremony.

Punctuated by the beat of Nigerian ceremonial drums played by men in flowing African gowns, the services at Pentecostal Temple Institutional Church of God in Christ wound on for four hours. The service was offbeat; the length was not. Anyone who's ever attended a Memphis "home-going" funeral knows to calendar nothing else that day. The service is simply too long. There is music—and cheering. It's a celebration, after all. The deceased has gone home to heaven. Speaker after speaker pays tribute; a speech sched-

uled for two minutes soon becomes ten. And if the deceased is a celebrity, like Withers, then that goes double.

Mayor Willie Herenton, a six-foot-six former Golden Gloves boxer, delivered the eulogy. He called Withers "a giant and a genius," telling the gathering, "They don't put just anybody's obituary in *The New York Times*."

As local television news crews filmed, the service ended at last. The funeral procession pulled down Linden Avenue, past the stone tower of St. Patrick's Catholic Church and nearby Clayborn Temple, where Withers shot his famous "I AM A MAN" photo in 1968 of striking city garbagemen lined up to march, dressed in their Sunday best. It wound over to Beale, past Withers's studio one last time, before heading to Elmwood Cemetery, the city's oldest active burial ground.[3]

FOUR MONTHS AFTER the great photographer died, I thought again of Jim. More than ten years had passed since we last talked. I'd been so busy with news I never looked back. Pressure never abated for stories to fill the paper—feeding the beast, they call it. But now, in February 2008, I had time to reflect. John Ford's Memphis trial was out of the way. His second trial, set for the summer in Nashville on the TennCare kickbacks scheme, was still months off. There was time to think.

As I cleared mounds of paper from my desk, I remembered the banker's boxes in my shed, filled with materials from my James Earl Ray coverage. I'd taken copious notes of everything, including my interviews with Jim. At home that night, I rolled up my sleeves and dug through the boxes in the Morgan building in our backyard. I unearthed a blue three-ringed binder, about three inches thick, containing typed notes from interviews with retired police, intelligence agents, and others connected to the government surveillance surrounding Dr. King's visits to Memphis in March and April 1968.

About halfway in I found Jim.

"Ernest was in it for the money," he said from the dry, smooth pages.

For a moment again I saw that cynical smile.

"Ernest should write a book."

Writing a story on any of this still seemed nearly impossible. But I

had nothing to lose. Journalists and researchers regularly file Freedom of Information Act requests after historically significant people die. Privacy rights diminish with death. If federal agencies like the FBI hold records on a deceased individual they often must release them, though they may withhold certain pieces of information pursuant to exemptions protecting national security, the privacy of living persons, and other interests.

Like most things these days, filing a FOIA starts with the Internet. Between news assignments I logged on to the FBI's FOIA web page, downloading and printing a form, scribbling my request in a field slugged "Purpose": Mr. Withers was a famous Memphis photographer who'd recently died, I wrote. I attached a copy of his obituary. My research aimed to inform the public that Withers had "doubled as an FBI informant" during the civil rights movement, I wrote. Months passed before I heard anything.

IN NASHVILLE, JOHN Ford's second trial got under way in July. This time, he was a beaten man. He'd been in prison several months already following his Memphis conviction. He looked horrible. He wore the same loose-fitting brown suit every day—no Armani jackets or Gucci shoes this time. His hair was flecked with gray. One of the restrictions of federal prison is that inmates can't dye their hair. Now sixty-six, Ford was a shell of his old self.

Day after day he sat slouched at the defense table as prosecutors unfolded their case: since 2002, Ford had accepted a steady flow of secret payments from two TennCare contractors, failing to report any of that income on senate disclosure forms. A flow of witnesses told how egregious it became: while taking the payments, the senator openly advocated on behalf of the contractors, urging higher reimbursement rates and running interference with regulators. The jury found him guilty of two counts of honest services wire fraud and four counts of concealing material facts. Judge Todd Campbell sentenced Ford to fourteen years to be served consecutively with his five-year Memphis sentence.

Barring any reversal on appeal, he'd be eighty-five before he got out.*

*On April 14, 2011, the U.S. Court of Appeals for the Sixth Circuit overturned Ford's six-count Nashville conviction. The case was doomed a year earlier when the Supreme Court curtailed use of the

WHEN I RETURNED to work following a week's vacation after the trial, a letter was waiting on my desk. It was from the FBI. More than five months had passed since I filed my FOIA request on Withers. Excited, I opened it.

"To promptly respond to requests, we concentrate on identifying main files in the central records system at FBI Headquarters," the letter read. "*No records responsive to your . . . request were located* by a search of the automated and manual indices." I read it over several times. Finally, it sunk in. The FBI had taken five months to announce it had no records on Withers, and that it had only conducted a partial search. They'd checked only headquarters records and not any field office records.

Surely, there was some type of file. Withers was prosecuted, after all. It didn't add up. Frustrated, I called the Memphis FBI office. Having written on Memphis corruption for so many years, I knew some of the agents there, and felt we were on the same side. Patiently, legal counsel C. M. Sturgis heard me out: five months of waiting, and nothing, I complained. There have to be files. Sturgis agreed that if I faxed him my request, the local office would re-file it with Washington.

So I sent it over—and proceeded to wait another eight months.

Finally, in April 2009, a reply came—fourteen months after I first filed. As I approached my desk near the back of *The Commercial Appeal*'s cluttered, fluorescent-lit newsroom, I found a thick, letter-sized envelope in my chair, the return address dancing from its face: the FBI's records management division in Winchester, Virginia. Inside were dozens of pages and a cover letter. David M. Hardy, chief of the records dissemination section, said the FBI had enclosed a redacted copy of Memphis field office file 194-ME-16, the portion of the FBI's Clemency for Cash investigation that focused on Ernest Withers. Opening with a memo dated September 14, 1977, it contained 115 heavily redacted pages (four pages were withheld entirely).

honest services fraud statute, which makes it a crime for a public official to conceal a conflict of interest. The effort to gut the law was led by Justice Antonin Scalia, who decried its overuse. Convictions under the honest services law now must include an underlying crime of bribery. Though Ford's case included elements resembling bribery, prosecutors chose to not charge him with that offense. The failure to file bribery charges remains a divisive point of contention among law enforcement officials connected to the case. Meanwhile, Ford's Memphis bribery conviction was upheld on appeal.

PAGE BY PAGE, the case against Withers unfolded:

"I can't tell you a lie," the photographer-turned-state-liquor-agent says in a transcript of a secretly recorded conversation. An FBI phone tap captured him trying to "walk" an inmate—sell his release.*

"I ain't never walked nobody," he said. "But I have the contact to do so."

On the phone with Withers was Sammye Lynn McGrory,† a lonely Memphis widow who'd fallen for a convict she desperately hoped to spring from prison. Withers offered to help—for a fee—but she became distrustful and turned to the FBI. Agents convinced the lovelorn McGrory to let them tape her call after hearing her incredible story.

She said she met Withers through a third party weeks earlier when he made a compelling offer. For $2,000, he said, he could get McGrory's boyfriend moved from "the hole"—solitary confinement—at Fort Pillow State Prison and possibly into a work-release program. That was step one. Step two was much bigger—and pricier. For $12,000 to $16,000, Withers said he could get the inmate completely out of prison and back on the street.

But it wouldn't be easy.

McGrory's boyfriend had a long and violent record. Convicted of armed robbery, Clarence Jerry Cook had been serving a forty-five-year sentence when he escaped in 1973, only to be re-arrested and sent back to prison for killing a man with a shotgun while he was loose. As Withers and McGrory negotiated Cook's release for cash, the inmate faced sentences totaling 150 years. Even in Tennessee's thoroughly corrupt system, "walking" someone with such a record was problematic.

Yet, as an FBI tape recorder whirred, Withers indicated he could pull it off.

"I just happen to know some people that are in that area that can do these things," he explained in his soft, gentle voice.

*Through subsequent FOIA requests, the author obtained digital copies of the actual audio recording made by the FBI on September 13, 1977. On the scratchy audiotape, Withers is heard in his peculiar, sing-song voice offering to arrange the release of a convicted killer for as much as $16,000.

†Although the FBI redacted her name and her comments from the transcript, the accounts in the FBI files match those in news clippings that identify her as Sammye Lynn Cook aka McGrory. The clippings from public trials in 1979 show McGrory testified about her encounter with Withers.

". . . I have made the necessary contact."

The job must be done in phases, Withers said. First, Cook would be moved to a minimum-security Correctional Rehabilitation Center. That could "set a stage" for him to qualify for executive clemency.

When an impatient McGrory complained that wasn't quick enough, the usually mild-mannered Withers grew testy.

"We can't—*Fuck!*—we can't accomplish it without it coming into the proper phases," he says in the eighteen-minute conversation, advising that he'll need at least a thousand dollars as a down payment to take to his contact in Nashville. Then, he told McGrory, he can quote an "exact figure" for Cook's release.

". . . The kind of prison record that he has, just doesn't allow the door to open on him right away."[4]

In all, the FBI taped three phone calls between McGrory and Withers that September and October, six months before topless-bar-owner-turned-informant Art Baldwin began recording the photographer while wearing a body wire. But Withers got spooked and aborted his discussions with McGrory after a friend happened to see her in a downtown Memphis meeting with Corbett Hart, the tall, mustachioed FBI agent who convinced her to cooperate.

The friend then tipped off Withers. *

WITHERS'S ROLE IN the Clemency for Cash schemes ran astonishingly deep. As the FBI released more records,[†] his involvement came into focus: A Memphis contractor told agents he gave the photographer a series of cash

*In the two subsequent phone conversations, Withers seemed to want nothing to do with McGrory. "Maybe you should just deal with a lawyer and not with me. Because I don't want to get in no hassle about trying to do a favor," Withers says at one point. Withers's altered tone poses a question: Did he have a pang of conscience? The answer seems to be an emphatic no. Retired FBI agent Hank Hillin writes in his book, *FBI Codename TennPar*, that Withers was tipped off by a private investigator. FBI records provide a name for the investigator: Renfro Hays, Withers's friend. (Coincidentally, Hays worked in 1968 for the defense of assassin James Earl Ray, and Withers once reported him to the FBI, suspecting he might have had a hand in King's murder.) In a May 1, 2014, interview with the author, retired agent Corbett Hart offered more: he said he was meeting with McGrory when Hays, whom McGrory had hired, happened upon them. Hays then alerted Withers.

†The FBI eventually released hundreds of pages connected to Withers's involvement in the Clemency for Cash probe. Nearly all of it came after the author and *The Commercial Appeal* filed a FOIA suit in federal court.

payments in hundred-dollar bills—$5,000 in all—hoping to secure the release of his son from a thirteen-year sentence for robbery.[5] A Los Angeles drug dealer said he paid $65,000 to Withers and others in a failed bid to free his wife from a Tennessee prison.[6]

It was fascinating reading, but what I really wanted was a clue—any clue—that might shed light on Jim's assertion twelve years earlier that Withers had been an informant during the civil rights era. I searched line by line through each repetitive page, through blocky, black type and photocopy blur.

Then I saw something.

At first it seemed to be just another report. Dated September 23, 1977, the three-page Teletype from the Memphis field office to headquarters in Washington rehashed the taped phone calls and Withers's offer to help release Sammye McGrory's boyfriend for cash.

Near the bottom of the second page the narrative took a turn. It walked through some background information on Withers. Then—*Bam!* There it was: "Ernest Columbus Withers was formerly designated as ME 338-R," the report said.

ME 338-R. It danced off the page. This had to be Withers's code number, proof that he'd been an informant. Good Lord. All these years—and now, there it was.

Jim was right.

THE FBI USES such informant numbers or code numbers—technically known in the business as source symbol numbers—to protect the identity of informants or confidential sources who supply sensitive information to agents. Many of these sources are criminal informants—snitches who help law enforcement catch drug dealers, counterfeiters, bank robbers, and the like. Others may assist national security investigations or help target terrorists. Their work can be perilous. That's why their identities are closely guarded.

What little I knew at that point came from obscure histories I'd read about the civil rights movement. Every now and then an FBI document

from that period would contain such a number, referencing an individual who had supplied information on a group of activists or a mass march. Normally, these source symbol numbers are redacted. But sometimes the censors make mistakes.

ME 338-R fit the pattern. ME clearly stood for Memphis. The rest, 338-R, was the actual code number, the unique cipher assigned to Withers. The "R" indicated that Withers was specifically employed to inform on racial matters.

It all fit—but the report offered more. This time it wasn't what was written, but what wasn't.

A gaping redaction followed the reference to ME 338-R. FBI censors removed nearly a line of type. Immediately following the omitted type came this phrase: ". . . captioned 'Ernest Columbus Withers; CI.'"

CI?

That had to be FBI shorthand for confidential informant. This must be a reference to an FBI file, I thought. And not just any file: a file titled "Ernest Columbus Withers; CI"—his informant file.

It seemed convincing, but my euphoria soon gave way to doubts. Journalistically speaking, it wasn't much. What could I write about it? At best I had maybe a weekend story. Perhaps it would be a page-one story on Sunday, the paper with the biggest readership of the week for a daily newspaper.

But it would be short—and incomplete.

A story at this point would raise more questions than answers. What exactly did Withers do as an informant? When did he start? How long did he serve? Was he paid? Did he take pictures for the FBI? Why would he do it?

The level of detail I had didn't answer any of those questions. And where could I turn for answers? I couldn't count on Jim. He'd just deny everything.

No, all I had was a mound of paperwork, none of it helping to unravel the mystery of Withers's secret life as an informant.

None of it except that one page—that one, single reference—mentioning ME 338-R.

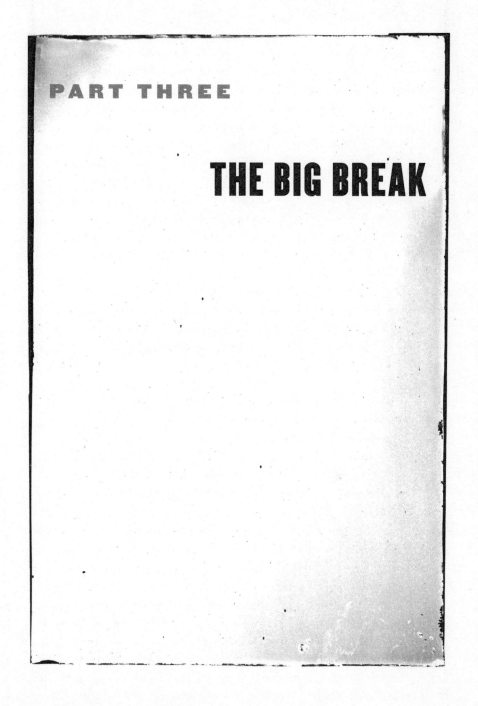

PART THREE

THE BIG BREAK

UP ON THE RIDGE

NOVEMBER 2010

A BROODING GRAY SKY HUNG OVER Asheville as I walked up Hillside Street, into a damp, November wind. Already, winter was here. It snarled across western North Carolina, stripping leaves from the maple and tulip trees, strangling the last of autumn. But it couldn't squelch this Appalachian city's mesmerizing beauty: its bustling artist colony, its vibrant architecture, the Blue Ridge Mountains rising majestically on one side to the east, the Great Smoky Mountains on the other, stretching in a haze over the western horizon into Tennessee.

There were plenty of distractions, but I was here for one thing—to learn more about what Withers did for the FBI.

I flew here to meet Betty Lawrence, the daughter of long-deceased FBI agent, William H. "Bill" Lawrence. Over two and a half decades, from 1945 to 1970, he was the Bureau's chief spook in Memphis. He ran its domestic intelligence operations there. In a long and colorful career that could have

inspired a spy novel, Lawrence tracked suspected Communists, helped bust up the Ku Klux Klan, and hounded militant civil rights and peace activists whom the government viewed as dangerous subversives. He worked for a time with Clarence M. Kelley, later appointed FBI director by President Nixon, and he received training in the detection of Soviet Bloc espionage under Mark Felt, later revealed as Woodward and Bernstein's "Deep Throat" in the Watergate scandal.[1]

Lawrence created an intelligence unit at the Memphis Police Department, a sort of FBI Lite, criticized for its widespread spying. When it was finally exposed in 1976, the unit burned thousands of files it had kept on Memphians before a federal judge shut it down for illegal political surveillance.

He was a legend in Memphis.

Bookending his tenure there were two pivotal moments in the long-running American conflict between national security and individual civil liberties:

In 1954, he arrested Junius Scales, said to be the only American ever to go to prison simply for being a member of the Communist Party. For this, Lawrence received a personal commendation from Director J. Edgar Hoover. The arrest made national news and demonstrated the Justice Department's commitment to stemming the tide of communism, which many Americans believed was inundating their government and vital institutions.

And in 1968, he kept tabs on Dr. Martin Luther King, Jr., in his final days before he was shot in Memphis.

Many thought that the FBI had killed King. In fact, though the murder allegation was baseless, Lawrence would be called years later to testify before Congress to account for his spying on the civil rights leader.

As a reprieve from his work, the tall, lanky agent took summer vacations driving up the Blue Ridge Parkway past Spruce Pine, North Carolina, not far from Asheville. When he and his wife, Margaret, retired to the area in 1971, their two grown daughters followed. Now, only the daughters survived. And what they'd been telling me over the phone hooked me.

"My father was always very careful not to talk about business. But, yes, I knew Mr. Withers. I knew that my father knew Mr. Withers," the elder of the two sisters, Nancy Mosley, a retired librarian, said in the helpful tone of one who'd dedicated her life to assisting others.

What she offered next knocked me to the edge of my seat.

"One time," she said, "Mr. Withers came to our house. And he took a portrait of our family."

Good Lord. If I was hearing this right, the family might actually have records linking Withers to special agent Lawrence.

"You wouldn't still happen to have that picture, would you?" I asked.

"Oh, yes," Nancy said from her home in Charlotte. "Betty has it."

When I called Betty Lawrence, an attorney in Asheville, she was every bit as sweet and helpful as her sister. Yes, she said. She has the picture.

"I got it out and put it on the piano this morning," she told me.

As we chatted, I worked up the nerve to ask—could she send me a copy?

"Sure," she said without hesitation. I couldn't believe my luck. She agreed to scan it and e-mail it to me. Shortly thereafter, I had it:

A color photo of Bill Lawrence, square jawed, bespectacled, smiling; dressed in a dark suit and resting in an armchair. On either side were his daughters, sitting on opposite armrests, each with a hand on one of their dad's shoulders. Behind them stood their mother, Margaret, Bill's wife.

When I showed it to Jeff McAdory, *The Commercial Appeal*'s no-nonsense picture desk editor and an experienced photo archivist who had worked with Withers, he scoffed. Withers always shot in black and white, Jeff said. True—for the most part. But at times Withers took film to color photo labs to be processed. And when I ran Jeff's concerns by the Lawrence sisters, they wouldn't budge. They had no doubt Withers shot this picture: he came to their home in the Memphis suburbs at Christmastime in 1967, they said, and took the family's portrait in their living room.*

"This was a fellow Daddy worked with," Betty said. "And he was introduced to us as Mr. Withers. He was Daddy's black photographer friend."

THE LAWRENCE SISTERS were talking now because of the news. On September 12, 2010, *The Commercial Appeal* published a seven-page special report in which I broke the story that beloved civil rights photographer

*Nancy originally recalled that the photo was taken in the summer of 1968, when Betty was home from her first year of college in Florida. However, Betty recalled it being taken during Christmas break of her freshman year. The issue was laid to rest when they examined the back of the picture, which read, "Christmas 1967." More of Withers's color photos are discussed in chapter 20.

Ernest Withers had secretly doubled as an FBI informant. *The New York Times* picked it up, running its own front-page article. Major television networks, including CNN and NBC, also broadcast the news.

My story reported that from at least 1968 until 1970 Withers operated under a code number, ME 338-R, helping the FBI monitor Memphis's volatile sanitation workers strike as well as a range of civil rights activists, including Dr. Martin Luther King, Jr., when he was in town.

The story was a huge breakthrough—solid and factual—yet it raised as many questions as it answered. The FBI refused to release key records—most critically, Withers's informant file. Because of that, parts of my story amounted to more of a circumstantial case than one of direct evidence.

In fact, the whole thing involved some rather creative detective work.

After finding the passage in the 1977 Clemency for Cash report that said, "Ernest Columbus Withers was formerly designated as ME 338-R," I scoured thousands of pages from other FBI reports. The principal body of reports I found was written between 1968 and 1970. Just as I'd hoped, FBI censors repeatedly had failed to redact the ME 338-R code number from them, too. Using those reports, I was able to pinpoint dozens of specific acts Withers performed for the FBI.

Among them, he passed on details from inside civil rights strategy meetings; he handed over financial reports; he snapped pictures of militant activists and their supporters, including a group of Catholic priests. He monitored political candidates, jotted down license tag numbers, and may have passed on political gossip from Dr. King's funeral in Atlanta.

In several cases, I located photos Withers shot, helping to corroborate his presence at certain scenes and to confirm his identity as informant ME 338-R. As backup, I consulted two leading authorities on FBI surveillance during the civil rights era who vouched for my findings. Yes, they said, ME 338-R is Withers. Yes, he did all these things for the FBI and likely got paid, too.

Nonetheless, several of Withers's surviving relatives and associates were understandably skeptical.

"While the FBI was using him, he was using the FBI," King's close associate Rev. Joseph Lowery told *NBC Nightly News* with Brian Williams. "I still would like to think that he understood that there was nothing he could do to give the FBI, that could be used, to hurt us, to hurt the movement. I believe that about Ernest."

Ernest's daughter, Rosalind Withers, didn't buy any of it. She doubted her father had been an informant and argued that the FBI code number, ME 338-R, could not be credibly tied to him.

"We as a family, none of us have ever heard anything like that. I don't believe it," she said. "I think this whole thing is based on just one thing, which is a number. And do we know that number was assigned to him? Where's the proof of that?"[2]

BUT BETTY LAWRENCE didn't share their skepticism.

"I have no doubt. I think you've got the proof," she told me.

In a series of phone conversations, Betty kept hinting she had records from her father—records that identified Withers as an informant. She even suggested she had independent corroboration about Withers's code number, ME 338-R.

Yet, when I pressed her on these points, she backed away. She allowed only that she'd recently found boxes of her father's records. She found them, she said, after her mother passed away. Margaret Lawrence had died the previous year, in late 2009, at age eighty-seven, having survived her husband by nineteen years. Ironically, I'd called Mrs. Lawrence several times in the months before her death. The phone rang and rang. No one answered.

After she passed away and my story ran, I contacted her daughters, Nancy and Betty. I'd like to think my skill as a reporter got them talking. But more likely it was the national news buzz and the fact that their father's secrets couldn't hurt anyone anymore; the principal players had passed on. The balance of their sympathies, it seemed, had swung to history, to helping make sense of this troubled period, the 1960s.

I was grateful for their help. But it was incredibly frustrating, almost like a tease. Betty knew more, but she wouldn't say what. She would only hint at it.

"You've already proved it," she said, dismissing my inquiries.[3]

I decided to take a chance. I booked a flight to North Carolina. Technically, I went there for other research. The library at the University of North Carolina at Chapel Hill was the nearest to Memphis holding a collection of the FBI's COINTELPRO files. I wanted to review the records

to broaden my understanding of the Bureau's inner workings in the '60s.

While I was "in the neighborhood"—220 miles from Asheville—I contacted Betty.

"It is a four-hour drive from Chapel Hill to Asheville, and I seriously doubt it would be worth your while," Betty wrote, answering my e-mail. Another roadblock.

But then she surprised me.

"I am attaching something I think you will find interesting," she wrote. "[It's a] transcription of my father's 1978 notes detailing a conversation with Mr. Withers concerning their respective testimonies before members of the House Committee on Assassinations."

Whoa. Jim had told me all those years earlier that Withers's identity as a confidential informant was revealed in the late 1970s to members of a congressional committee re-investigating King's assassination. It was devastating for the FBI, Jim said. Withers's secret identity nearly went public. I'd read agent Lawrence's testimony before the House Select Committee on Assassinations. But there was no record in the committee's published reports that Withers had testified. In fact, I could find no public reference to Withers at all. If he testified it had to have been in executive session—behind closed doors.

I eagerly opened the Word file attached to Betty's e-mail, a verbatim transcription she'd made of handwritten notes her father scribbled in November 1978. In part, it read:

> "I told 338 R—that in his testimony to guard against being so
> taciturn or evasive that he could inadvertently commit perjury—
> By denying that he had ever furnished info which I attributed to
> him and had so reported.—For if he chose to do so—no matter
> what his motive, (one of self-protection—and fear of retaliation,
> physical injury or harassment etc.) that it would nevertheless
> create a situation indicating that He or I had perjured ourselves in
> that I said one thing—and he another."

I couldn't believe what I was reading. There was no turning around now. The next morning I got a rental car and drove to Asheville.

BETTY WAS EXPECTING me. She'd finally relented. She invited me over.

With great anticipation, I parked outside her house, along a ridge overlooking downtown Asheville. I walked up the street but didn't see her home, just a thicket of trees, then a clearing. Uncertain, I stepped off the sidewalk and tentatively followed a ribbon driveway up into the woods. Two paved tire tracks blazed through the grass and up over a rise.

Then it came into view: an ancient, weathered, two-story frame house. It was huge and rambling, one of the oldest in Asheville, built as a farmhouse before the Civil War and expanded over the years in fits of pioneering enterprise. From the yard, it whispered tales of country ghosts, lost causes, and mystery. I stepped across the porch, swallowed, and knocked.[4]

Betty's grown son, William, opened the door and let me in.

"Mom's upstairs," he told me, then left me standing awkwardly by the door.

What a place. Austere but beautiful: wood floors, aging plaster, high ceilings that only encouraged the late-autumn chill seeping in from outdoors. It was a place of true character, a history buff's dream. As Betty would later explain, the beams were all hand-hewn; the rafters were pole logs with bark still attached. Etched into the first-floor windows were the names of Jane and Dolly Sevier, members of a prominent family who had lived here in the 1870s. Following the custom of the time, they had used their diamond engagement rings to memorialize their names in panes of glass.

Another longtime occupant, Paul Ayres Rockwell, an American journalist and war adventurer who fought in the French army in World War I, left his French Legion of Honor medal behind. Betty found it in the garage and returned it to the late swashbuckler's daughter.

Turning around I noticed a large metal rack holding dozens of old vinyl record albums. Much of it was jazz from the 1940s and '50s, legendary pianists like Count Basie, Mary Lou Williams, and Dick Wellstood, the clarinetist Bob Wilber, various Dixieland artists, and big bands led by the likes of Kay Kyser and Benny Goodman. Even the mawkish, bubble-music Lawrence Welk resided in the rack.

Jim. Doggone. He was right again.

He'd told me years earlier that Bill Lawrence loved jazz. In fact, Jim said Lawrence's enthusiasm for it once helped him recruit a key source of information within the civil rights movement, Memphis NAACP leader Vasco Smith, who held a huge jazz collection of his own and who swapped records with the G-man.

"We converted Vasco early on," Jim had told me. He said Smith cooperated, in part, because he believed in the FBI, but also because he and Bill Lawrence shared a mutual interest in the likes of Louis Armstrong and Duke Ellington.[5]

When Betty came downstairs, the record collection was an immediate conversation starter.

"They were Daddy's," she confirmed. *Daddy*. Spoken like a true Southerner.

She recalled her father working long hours, from six in the morning to six at night. Once home, he'd collapse in an easy chair with his files, a cigar in his mouth, and his beagle, Boots, on the footstool before him. At times a baseball game blinked from the television set. Other times, he immersed himself in *The Daily Worker*, the Communist Party news organ he subscribed to under a thinly veiled alias, William Harvey, or the *National Review*, conservative William F. Buckley's news magazine. But, always, soothing jazz syncopated from his walnut stereo cabinet.

Bill Lawrence wasn't always easy to live with. He could be strict. Even grouchy. The long hours took their toll. When the Vietnam War broke out and Betty went away to college, it caused trouble in the Lawrence home. "I protested the Vietnam War. And my father didn't like that one bit," she said.

Betty wasn't at all what I'd expected—not judging by her sober résumé. She practiced environmental law and estate planning, and had worked for a time on Wall Street. Recently, she'd represented a client in filing an ouster petition against Mike Nifong, the Durham County district attorney disbarred for pressing bogus rape charges against members of the Duke University lacrosse team.

No, I had expected someone stern. Someone grave. Someone more like how I'd imagined her father.

She was none of that. She was sixty-one, hazel eyed, with an easy, impish smile and a deep, playful voice. I detected a bit of the bohemian in her. That,

and a down-home friendliness. Over the course of several hours, as the fireplace crackled in her study, she opened her father's world to me, his world as she had understood it as a child.

"You're sitting in the chair," she laughed.

The chair. The very upholstered easy chair her father sat in when Ernest Withers snapped their family portrait back in 1967. It was much older now. And a bit worn. But it was unmistakably *the chair*.

She sugarcoated nothing as she handed me a series of documents she'd found among her father's keepsakes: letters of commendation from J. Edgar Hoover, photographs, and news clippings, including one from 1978 reporting that Withers had been indicted for public corruption.

Most intriguing of all were various sets of handwritten notes.

"If you read this, you'd think Daddy hated Dr. King," Betty said a bit sheepishly.

She handed me a book of notes her father had scribbled in retirement. It was an odd little artifact, thirty-two pages of lined paper torn from a pocket notebook that Bill Lawrence had frugally bound together by driving five staples into a makeshift spine. On the cover, in black ink, he scrawled a title, "BLACK POWER—MEMPHIS & M. L. KING—Aspects prior & after 4-4-68." Below that, in blue ink, he wrote a subtitle: "Martin L King, Background Subversion & Black Power info Memphis."

It weighed perhaps a few ounces, yet I felt the heft of history in my hand. Here were the personal, handwritten thoughts of the man who oversaw the government surveillance of Dr. King in Memphis in the days before his assassination. For anyone who believes the FBI murdered King, and there are many, this little booklet was a bombshell. Personally, I knew better. I'd studied the assassination enough to realize the enormity of evidence against James Earl Ray. A career criminal, he may have shot King for money. But he didn't do it for the FBI. There were no documented ties between the Bureau and him; Congress had investigated that thoroughly.

At the same time, the notes reveal the depth of the FBI's animosity toward King—and Lawrence's own distaste as well.

"If the subject of Dr. King came up, the thing Daddy always said disapprovingly was he was unfaithful to his wife," Betty said.

Jim had said the same thing. He'd even implied once, without any evi-

dence, that King had sex with a prostitute at the Lorraine Motel the night before he was shot.

But Lawrence's notebook said nothing about King's personal life. It was entirely focused on his politics. And Lawrence left little doubt that, at best, he considered King a dangerous militant; at worst, a traitor.

Reading like an official FBI monograph, the booklet retraces King's final year and his opposition to the Vietnam War. Lawrence contends in his notes that King's antiwar position was influenced—if not directed— by Communists. Lawrence records how Diane Nash, the courageous civil rights activist and wife of King's close aide James Bevel, traveled to Hanoi, the North Vietnamese capital; how Bevel then took leave from his post at the Southern Christian Leadership Conference and, with King's "full support," took charge of the Spring Mobilization Committee to End the War in Vietnam. King, Bevel, and entertainer Harry Belafonte led hundreds of thousands of demonstrators on a march from New York's Central Park to the United Nations, where many in the crowd burned their draft cards.

Lawrence captured the outrage within the government and the general public at King's actions, writing that President Johnson "flushed with anger" when he read about King's famous speech at New York's Riverside Church on April 4, 1967, when he came out against the war, and how LBJ's adviser John Roche had shouted, "King, you've given a speech on <u>Vietnam</u> that goes <u>right down the Communist</u> line!"[6]

Lawrence underscored key words and phrases with heavy ink. His underlining intensified as he discussed King's seemingly growing allegiance with militants like Stokely Carmichael and with black-separatist and Black Power groups such as the Student Nonviolent Coordinating Committee and the Congress of Racial Equality.

Quoting a *New York Times* editorial, Lawrence wrote, "King had once sworn off any allegiances with these groups as long as they espoused racial separation—But now he seems to feel that the Peace effort outweighs other considerations." Lawrence noted that King predicted there would be more rioting in major U.S. cities. He wrote that "less disciplined persons" viewed such statements "as an encouragement to riot."

Those forces descended on Memphis during the 1968 sanitation work-

ers strike, Lawrence wrote, describing how King's first march through downtown on March 28, 1968, a week before his murder, "broke out in violence." Despite a temporary restraining order barring a second march, there was "a real possibility that King would not obey it." Police reports told of "Negroes buying guns," Lawrence wrote, and how Memphis youths were given "instructions on how to make Molotov cocktails and Fire Bombs" in advance of King's second march.

By his account, violence was certain.

But then, before the march could be organized, King was shot.

IN HIS BOOKLET, Lawrence devotes fewer than seventy-five words to the assassination, noting simply that James Earl Ray was identified as the killer and that he later pled guilty. He sums up his booklet on the final two pages under a heading, "After thoughts." He writes:

"Dividing line between Super-militant nonviolence & Super-militant violence is often very thin—King tried to straddle & Bridge the two—Success depended on the charisma of one man (King)—His concept that each man had the right and or moral duty to accept or reject laws that met with his favor or disfavor—confused the ignorant and confused and gave a license to those prone to violate the law anyway—young impressionables. It led to irresponsible permissiveness & chaos, a sort of Chinese water torture, drop after drop of daily demonstrations, confrontation & of planned crises—Had its toll on the Blacks—But also upon the citizenry, including the police—making it well nigh impossible for some municipalities to govern selves."

Now I understood Betty's initial reservations. Her father's antipathy for King was clear. It wasn't a personal animosity, however. Rather, it reflected the huge gulf at the time between conservative, old-school America and the dissent spreading across the country. In a way, Lawrence's booklet amounts to a rather eloquent critique of King's blooming militancy in his final year, a side of him history often overlooks and one distantly removed from his 1963 "I Have A Dream" persona that we now embrace.

King aside, Betty said her father always supported civil rights. Though

they made Memphis their home, her parents were Yankees, both from Ohio, raised without any cultural bias against blacks. Betty recalled her father making numerous trips into rural West Tennessee and North Mississippi to investigate voting rights violations and discrimination in public accommodations. He did so eagerly, she said, especially following the passage of the Civil Rights Act of 1964.

"Daddy was gone pretty much that whole summer," she said. "The agency itself I had seen as a friend to civil rights . . . And Daddy never left the slightest doubt that the discrimination was wrong. He and my mother, they raised us right."

For Bill Lawrence, the enemy wasn't civil rights.

It was communism. It was subversion. It was those disloyal to their country. And agitators. Much the same could be said for the FBI as a whole.

There is a popular misconception today that Hoover's FBI was out to break the civil rights movement. Not so. It was out to break fragments of the movement, elements it perceived as Communist-influenced or prone to violence or simply dangerous for the country. The tragedy lay in the agency's excesses—in its unconstitutional targeting of political activists for their beliefs and associations, in its illegal "dirty tricks" program, in its immoral campaign to destroy Dr. King and others.

BUT NONE OF this was enough to determine how Ernest Withers fit into the bigger picture—not until Betty finally handed over the handwritten notes she'd tickled in her e-mail the day before. They seemed so strange: sheets of 8½-by-11 typing paper, roughly ripped in half, each now about 4-by-5 inches, all stapled into a seven-page booklet. Her father's scribbling appeared in dark ink across each page; on the back there was faded blue type from old, mimeographed reports. Betty said the reports came from East Tennessee State University in nearby Johnson City, Tennessee, where her father taught a criminal justice course in retirement. The frugal Lawrences kept such booklets of scratch paper hanging by the phone.

Dated November 21, 1978—the day Lawrence testified before the House

committee reviewing Dr. King's murder—the first page revealed a desperate, urgent scrawl in black ink.

"Called 338 late Tues Nov 21 per his request . . . in Wash w/ his son," the notes read. ". . . I tried seven times."

Then, the next morning, he wrote this:

"Finally located ECW (on) AM of Wed—Nov 22 . . . <u>going</u> before <u>committee</u> <u>this AM</u>."

THE SECRET OF THE NOTES

NOVEMBER 22, 1978

BILL LAWRENCE WAS ON EDGE. He called seven times last night. No one picked up. He tried again this morning. Still, no answer. Now he was truly worried.

This had become a most nerve-racking game of telephone tag.

It started yesterday as Lawrence rode the train back from Washington, where he'd just testified before a congressional committee investigating Dr. Martin Luther King, Jr.'s assassination.

That's when Ernie called Bill's home in North Carolina. He left a message with the ex-agent's wife, Margaret—Withers was up in Washington. He, too, had been called to testify. He was staying with his son, Ernest Jr., who worked for the Democratic National Committee, and he gave Margaret his phone number.

But when Bill got home he couldn't reach Withers—in Memphis or Washington.

Lawrence didn't need this. He'd been retired now for eight years. It was 1978 and he was a month shy of his fifty-ninth birthday. His life was uncomplicated—and rewarding. He worked part-time at a community college, volunteered for the Special Olympics, and taught a Sunday school class in Spruce Pine, where he and Margaret had built a cozy retirement home in the blue mountains he loved so much.

Then the subpoena came.

A select committee of the U.S. House of Representatives wanted his testimony.

And now, it seemed, they wanted to expose one of his key informants, too.

He was quite put out, his daughter Betty would later recall: all of this because some "liberal congressmen" had a cockamamie idea that the FBI might have had something to do with Dr. King's murder.

At the hearing, a congressman asked an audacious question: Did he have any knowledge of FBI involvement in the assassination?

"I can only answer that . . . with a sense of moral outrage," the graying ex-agent had said. "Why people will make such statements, I cannot understand."

Conspiracy buffs still conjecture whether John Wilkes Booth shot President Lincoln, he told the panel in his flat baritone.

"There are people who do not believe that Jesus Christ was actually crucified or have different conceptions than we have learned through our Christian teachings," he said. "You will always have that. Naturally one resents it. But this is a free country."[1]

LAWRENCE APPEARED CALM and collected under the crystal chandeliers of the Caucus Room in the colonnaded Cannon House Office Building. But the scene must have troubled him. In this very room thirty years earlier the House Un-American Activities Committee had pursued Communists and subversives, people Lawrence and his patriotic FBI colleagues had zealously investigated for disloyalty.

Now, it seemed, his government was after him: after the good guys. After the FBI.

For good reason, many thought.

These were the days after Watergate. Never had public opinion of traditional government institutions been so low. The public learned of CIA plots to assassinate foreign leaders. Investigations exposed the FBI's harassment of political activists—how it had bugged Dr. King's hotel rooms, tapped his phone, and waged a dirty tricks campaign to destroy him, how it had gone after others, too, using similar underhanded tactics.

Still, Lawrence couldn't see how any of that involved him. He'd never participated in dirty tricks against King. There'd been little chance.

The civil rights leader visited Memphis sparingly in the '60s, and the FBI's local security file* on him never grew very thick there.[2]

Lawrence did press his racial sources once about an extramarital affair King was rumored to have had, but nothing came of it.[3] But the congressmen interrogating him didn't seem to know or care much about any of that.

It was a Tuesday, two days before Thanksgiving 1978. Perhaps they were tired. Perhaps their minds already had drifted home for the holiday. They stuck largely to the assassination and to the surveillance surrounding it.

No, Lawrence told them. There was no electronic surveillance of King in Memphis. Lawrence never used such stuff. He used informants. Though he had many unpaid confidential sources providing bits of information, he said he had just four or five "racial informants"—controlled, paid sources—continually reporting on the strife surrounding Dr. King's visits to Memphis in March and April 1968.[4]

Now, those handful of paid informants were at the center of the committee's investigation.

One by one, their files were examined. Under an arrangement with the Justice Department, their names were excised from paperwork to protect confidentiality agreements. But the details of their work were laid bare, as the committee explored a widely circulated conspiracy tale.

As the story went, the FBI had planted "agents provocateur" among the marchers in that disastrous, March 28, 1968, mass demonstration Dr. King led through downtown Memphis. It erupted into violence. Windows were smashed. Stores were looted. When King came back a

*The security file involves the FBI's investigation of King's alleged ties to communism and subversion. These are materials involving his political and personal life, separate from the large files assembled on the investigation of his assassination in Memphis.

week later to show he could lead a peaceful march, he was assassinated.

As certain "assassinologists" tell it, the FBI planted saboteurs—men in dark sunglasses and Afro hairstyles posing as young militants—who incited the crowd to violence. They aimed to embarrass King, to lure him back to Memphis, like a moth to a flame, to lead a reputation-saving, peaceful march—right into the crosshairs of a sniper. The story stood on shaky ground; no credible evidence seemed to support it.* Yet the committee felt duty-bound to investigate it to its ends.[5]

FBI agents and ex-militants were interviewed. Stacks of paperwork from informant files cluttered the committee's staff offices.[6]

Congressional investigators came to focus on one informant who appeared to have influence over the young militants in question, the homegrown Black Power group known as the Invaders. Lawrence testified that he met virtually daily with this informant, that he gave him specific instructions and assignments. Committee staff then approached the FBI. They wanted to interview the informant. He agreed. Lawrence's secret source would meet behind closed doors only. Asked to go public, he declined, evidently fearing repercussions.[7]

The informant was never named—but the handwritten notes Betty Lawrence found identify him as Ernest Withers.[8]

Those notes reveal more than just the frustration and desperation that gripped Lawrence as he learned that his valued informant was about to go before the committee. They show he also offered Withers a healthy dose of witness coaching when he finally reached him on the telephone at his son's Washington home at 8:15 on the morning of Wednesday, November 22, 1978, as the photographer was headed to a closed-door meeting with the committee.[9]

"I told him . . . that I had never revealed or disclosed his identity & did not know <u>how</u> committee learned of his identity," Lawrence wrote in his distinctive, doctor's-prescription scrawl.

In winding, even artful, run-on sentences he wrote:

"I would <u>Not</u> tell him what to say—However, <u>IF</u> his confidential rela-

*The story was popularized in a docudrama, *King*, broadcast on network television in the fall of 1977. In it, an actor portraying a young militant says he and others were paid to disrupt the march. Asked who paid them, he responds, "The FBI."

tionship with me had been based on and motivated by his concern for the peaceful and effective preservation of the Civil Rights movement; a concern aimed at trying to prevent or deter its exploitation and possible counter productive destruction or diminution of effectiveness, that he should say so. —And that if the fact that he had been a former law enforcement officer & thus cognizant of the need for peaceful and orderly attainment of goals vis a vis attainment by force & violence as the only permanent & lasting solution, that he should say so. And that if his purpose in cooperating with FBI was to detect and deter violence—either by furnishing info or by counseling (when & where possible against advisability of force & violence) that he should say so; And if his cooperation was based on patriotism and concerns of civic morality—aimed at protecting his family, race and community from destructive violence, and not for mere monetary gain, that he should say so . . ."*

The Commercial Appeal published Lawrence's notes along with another expansive narrative I wrote on December 19, 2010.

By then, we'd filed a lawsuit against the FBI. We sued in U.S. District Court in Washington, pursuant to the Freedom of Information Act, seeking access to Withers's informant file. The odds were against us. The laws protecting identities of informants were just too strong. That went for all informants, even dead ones like Withers, whose long-dormant work arguably had more to do with politics than law enforcement.

Indeed, the FBI gave no ground when we sued. Its lawyers fought zealously. Despite Lawrence's handwritten notes and all the other evidence we made public, attorneys for the Justice Department suggested in pleadings that Withers hadn't served as an informant at all. Nothing we put in the public domain seemed to matter.

*A critical issue the author faced before publishing the notes was authenticating them. Betty Lawrence had been immensely helpful in sharing her father's papers. But what if she was a kook? What if she forged them? The author explored that frightful possibility through various tests. First, the handwriting seemed to match known samples of Bill Lawrence's handwriting appearing in margins of FBI documents. Historical dates lined up, too. For example, information matched perfectly with the date of Lawrence's testimony before Congress. Details about an unknown informant interviewed by the committee's staff synched as well. The clincher came when the author contacted the public library at the District of Columbia. A helpful librarian there located a copy of the 1979 DC phonebook. He scanned and e-mailed a page listing Ernest Withers, Jr.'s phone number—(202) 232-1517—the same as in Bill Lawrence's notes. Betty Lawrence was no kook. She eventually gave *The Commercial Appeal* a sworn affidavit attesting to her discovery after the paper filed suit against the FBI for access to Withers's informant file.

Still, it was clear to me and my editors that Withers was an exceptional FBI source. He was paid. He met almost daily with Lawrence. He received instructions and assignments.

Less clear was how it happened. Why did he become an informant? What precisely did he do for them? What motivated him? How did he and Lawrence meet? When did it all start?

We were nowhere close to answering those questions.

It's odd. Even screwball conspiracy stories* can lead to something legitimate. This story brimmed with troubling questions about government surveillance and its potential abuse of individual rights. Whatever Withers was doing for the FBI, it clearly involved some intensive snooping, and we felt it was an important piece of recent untold history worth pursuing.

Despite advice to the contrary, Chris Peck, editor of *The Commercial Appeal*, agreed to push forward with a suit. It wouldn't be cheap. Chuck Tobin, a media-law attorney we retained in Washington, told us we could expect to pay a large sum—money precious to a paper that had laid off half its news staff amid seven years of declining revenue. But Peck, a gaunt, eclectic Westerner with a droopy cowboy mustache, a degree from Stanford, and Big Sky–sized ambition, always was a bit of a dreamer.

I like to think, too, he could see the big picture. To him, the emerging image of shutterbug Ernest Withers—chronicler of the blues, Negro Leagues baseball, and the movement, friend to King, Medgar Evers, James Meredith and so many others, and, now, it seemed, an FBI informant, too— was nothing short of spectacular.

Like so many compelling tales, the story of Ernest Withers started simply: in a cramped, four-room house in North Memphis, two generations removed from slavery.

*Official investigations found no credible evidence supporting the alleged sabotage of Dr. King's march in Memphis. Yet the story survives in recent writings on the assassination. We likely can expect new embellishments. Some may come with the revelation that Withers worked as an informant who reported on the Invaders. Another new wrinkle involves statements Withers made late in life that he had used a power saw to cut the 2-by-2 wood sticks that organizers attached to placards for the demonstration. Youths removed those sticks during the march and smashed storefront windows, igniting the melee.

A TARNISHED BADGE

SILAS WITHERS'S FINAL, HORROR-FILLED MOMENTS came in the muck of a Mississippi cypress swamp. No one knows much about what happened. Or even much about Silas.

Born a slave around 1825, it's believed he worked west of Holly Springs on land owned by Albert Quarles Withers, an early nineteenth-century settler from Virginia. By 1860, the enterprising pioneer had built a thriving plantation, a medium-sized cotton operation with fifty-four slaves, in North Mississippi's bucolic Marshall County. According to family legend, Silas fled as General Ulysses S. Grant's liberating army made its march from Shiloh through Holly Springs, down to its fateful siege of Vicksburg.

The runaway Silas joined the Union Army, but returned to the plantation after the war to visit family.

He was never seen alive again.

Reportedly, he was lynched for his disloyalty somewhere in the dreary

mist of Pigeon Roost Bottom, a boggy stretch between Holly Springs and Memphis, once so thick with passenger pigeons that the sky blackened and tree limbs were said to break under the birds' weight. An obituary published in 1970 upon the death of Silas's grandson, Earl Withers—Ernest's father— retold the family legend about how searchers scoured the trail to Memphis but could find only "bits of clothing" Silas had worn.[1]

THE STORY OF Silas's descendants and how they escaped the brutal Mississippi society that killed him is the story of many Memphians.

At first, Silas's son, Christopher Columbus Withers, made a go of it in Marshall County, working as a tenant farmer in the blistering heat of Reconstruction. Sketchy records provide few details. But all available evidence suggests it was a miserable life: plowing fields behind a mule, picking cotton under the oppressive Mississippi sun, sharing the modest profits of his sweat with the white owner.

In 1876, young Withers, who went by his middle name, Columbus, married Medora "Dora" Falkner.* They had as many as ten children. Among them was Ernest's father, Arthur Earl Withers—called Earl—born in 1889 in the gently rolling hills some ten miles west of Holly Springs. By 1900, it had become too much, and so they moved, heading up dusty Pigeon Roost Road, bound for the greener grass of Tennessee.[2]

They settled just north of Memphis in the undulating countryside near Millington. The family prospered. Columbus learned to read and write. Son Earl attended nearby Woodstock Training School, the celebrated rural institute that became the first high school for African Americans in Shelby County. He learned his ABCs and a keen work ethic that benefited him the rest of his life.†

By 1917, the mild-mannered Earl had moved to Memphis, working as

*Ernest Withers would say years later that his roots lay in the "Faulkner herd in Mississippi," an indication that his grandmother may have been a slave held by Col. William Clark Falkner, great-grandfather of the renowned author, William Faulkner. A marriage certificate from 1876 spells Dora's surname without a *u*, just as Colonel Falkner spelled his. Still, the connection is tenuous. Bobby Joe Mitchell, the unofficial historian of Marshall County, told the author he doubts any connection to William Faulkner, whose roots lay miles away in Tippah and Union counties.

†Earl Withers's obituary says he attended Woodstock Training School, but details remain obscure. The school opened in 1913 when Earl Withers was twenty-four. It's possible he attended as a young adult or perhaps earlier, when Woodstock maintained only elementary and middle schools.

a porter and a truck driver. There, at twenty-eight, he married Pearl Davis, a city girl, and joined the army as the United States was drawn into World War I. He shipped out across the gray Atlantic with the 368th Regiment of the all-black 92nd Infantry Division, the famed "Buffalo Soldiers" that saw action in the Battle of the Argonne Forest in France.[3]

Once back in Memphis, Earl went to work raising a family. He and Pearl had four children in four years. Their fifth, Ernest Columbus Withers, was born August 7, 1922, in North Memphis, where the family bought a small, four-room house in the heart of a thriving black middle-class neighborhood surrounded by a sea of poverty and chaos. Here, Ernest grew up, coddled and secure, learning the social skills he would deploy with great effect the rest of his life: an engaging personality; a gentle, easy manner; a disarming, ubiquitous smile.

ALL AROUND HIM he saw success. His neighbors included a physician, an insurance executive, a pastor, a barber, several porters, and a range of workers employed at well-paying industrial plants such as General Motors and Memphis Hardwood Flooring Company. Years later, Ernest would reflect with fondness on the "good and decent people" here in Amos Woodruff subdivision, popularly known as "Scutterfield," a neighborhood platted in the 1880s by white land developers and built out in the early twentieth century as an oasis of black middle-class prosperity.[4]

Life offered plenty of adventure for a boy in Scutterfield. Ernest and his neighborhood pals roamed the oak-lined streets, engaging in spirited games of football and baseball on vacant lots, running free through the green, open fields that stretched north to the Firestone plant and Manassas High School, the local Negro school. On hot summer days they'd walk over a mile to swim at the city's segregated Colored Pool, or saunter down busy Manassas Street to see Ernest's grandmother, who treated him to gingersnaps and other sweets.

The hikes fueled more than childhood adventure: they provided valuable life lessons for an African American youth growing up in Jim Crow Memphis in the 1920s and '30s.

A simple walk, however, came with complications, even danger. Ernest's

grandmother lived several blocks to the south. To get there, he passed Humes High, the all-white school from which Elvis Presley would graduate in 1953. It sat six blocks south of Ernest's Manassas School, attended in the early '60s by famed funk and soul singer Isaac Hayes. Though just a mile apart, the two schools operated in different worlds. Ernest's grandmother took care to keep those worlds separate. When she walked the boy home, she avoided Humes and its surrounding white neighborhoods, navigating along side streets, through the reassuring familiarity of black North Memphis.[5]

For good reason.

In the 1920s the Ku Klux Klan emerged from its rural cloisters as an open and ominous force in Memphis. The terrorist organization even ran candidates for political office. One, future congressman Clifford Davis, won election as a Memphis city judge in 1923 running on the official KKK ticket.[6]

Edward H. Crump, the wild-haired political boss who controlled public affairs in Memphis for decades, despised the Klan, but not necessarily because he held vastly divergent views on race. A segregationist born in Holly Springs, not far from the Withers plantation, Crump believed in opportunity for blacks—just not equal opportunity. He employed ruthless methods to keep them, as he said, "in their place." Despite his ties to the Klan, Davis was Crump's pick as police commissioner in 1928, a position he held until 1940, when the equally harsh Joseph "Holy Joe" Boyle took over.[7]

Davis's goons beat and nearly killed black labor leader Thomas Watkins as he tried to organize workers along the riverfront. Boyle's cops drove African American businessman J. B. Martin into exile in Chicago.[*]

Crump's oppression extended even into the arts. Lloyd T. Binford, chairman of Crump's Board of Censors, protected Southern sensibilities by routinely banning Hollywood films that portrayed African Americans in

[*]The story of Martin, a physician, drug store proprietor, and co-owner of Negro League baseball's Memphis Red Sox, illuminates Crump's racial and political intolerance. During the 1940 elections, Martin hosted political rallies featuring speakers who criticized the Crump regime, including its rampant police brutality. In response, Crump stationed police officers outside Martin's South Memphis Drug Store for weeks, frisking customers as they entered and left. Martin fled to Chicago when police began investigating his long-known side occupation as an unlicensed bondsman. He was arrested during a return visit in 1943, when he was told to leave town for good. For a detailed discussion of Crump's harassment of Martin, see Elizabeth Gritter, *River of Hope: Black Politics and the Memphis Freedom Movement, 1865–1954* (2014), 141–50.

a positive light. He edited silver screen appearances by Lena Horne, Cab Calloway, and Louis Armstrong, and banned the showing of black boxer Joe Louis's heavyweight championship victory over German rival Max Schmeling. Binford once publicly opposed a petition calling for the deportation of black Americans to Africa, quipping "I wanted to go with them. Otherwise, where would I get servants?"[8]

YET FOR ALL his tyranny, Crump allowed African Americans who danced to his tune to thrive: To vote. To ascend in business. To share, if only in small degree, in political patronage.

Such opportunities opened to the Withers family in the 1920s.

A truck driver, Earl Withers landed a job delivering mail for the Post Office. As a branch of the federal government, it paid the same wages to both white and black employees, something local government and most private businesses refused to do. These were patronage jobs. The ticket to such a good-paying position for an African American in Memphis came through Robert Church, Jr., a wealthy, black Republican Party leader who oversaw much of the local spoils system for the Republican-dominated White House of the Roaring Twenties. In turn, Earl Withers became a cog in the local political machine.

A Republican ward heeler, postman Withers registered voters on his tiny front porch in Scutterfield. Unlike many Southern cities, Memphis tolerated widespread voting by African Americans. Yet it often was a dubious affair. Voting in those days involved paying poll taxes. Both Crump's ruling Democratic Party organization and Church's Lincoln League covered the taxes of impoverished voters who couldn't afford them. The subsidy typically came with an unequivocal suggestion to vote for certain hand-picked candidates, a directive often sweetened by additional enticements, like a bottle of liquor.[9]

Precisely what role if any Earl Withers played in the shenanigans is uncertain. But he clearly benefited from his involvement as a political foot soldier, and his family prospered.

Staying in Scutterfield, they moved in 1927 down the street into a freshly built house at 1062 N. Manassas. Pearl worked as a maid, and that second

income helped the couple afford the $750 mortgage. With six children (Ernest's younger brother Jake was born in 1924), it was terribly cramped—just four rooms and no indoor toilet. But it was new and it was theirs. At the time, only a quarter of black Memphians owned their homes.

Much of the family's life was dominated by Gospel Temple Baptist Church, an imposing, double-spired white brick sanctuary located just five doors down. From the time he was small, Ernest witnessed the church's fervent worship and mass baptisms, conducted at times outdoors in mud holes, under the blue heavens.[10]

Life was good.

But on December 19, 1930, Ernest's world would change forever. His mother, Pearl, his "sweet mama" who so often had held him in her lap on the floor in joyful hugs, died following a bout with influenza. She was forty-two.

He was eight.

Years later he would reminisce about her death, parsing every detail: how the women from Gospel Temple held an all-night vigil in his home; how the undertaker came and took apart his mother's bed; how the workmen sprayed sanitizer through the house as if it were just another routine treatment by pest control.

"My brother and I were in the bed and . . . we wet all over the bed, over both of each of us," Withers recalled of his loss.

They buried her four days before Christmas.[11]

WITHIN A YEAR, Earl married Minnie Bouldin, a seamstress. The family hardly missed a step. Big-hearted Minnie took up where Pearl left off, caring for the children; seeing to their education. Ernest's stepmother was tender but firm. She sewed for prominent white families. She was a bit of a perfectionist, Ernest recalled, dispatching her stepkids on errands to buy colored threads—red, blue, green, turquoise—precise details that couldn't be fudged.

"If it didn't match," Withers later recalled, "we had to go ten blocks back to make sure that the thread matched."[12]

At Manassas School, Ernest thrived. He followed in older brother Earl's footsteps, playing quarterback on the football team. Minnie stitched

together the blue-and-gold uniforms for the school's drum and bugle corps.

His pivotal moment, though, came in the eighth grade. His sister had given him a Brownie camera. He took it to school one day, when heavyweight champ Joe Louis's glamorous wife, Marva, was visiting. To hoots and catcalls, Withers found the nerve to walk to the front of the school auditorium and take her picture.

"I got out of the back, the very back end of the auditorium . . . The children laughed. I sniggled, but went on," he later recalled of a certain boldness that would color his long career.[13]

Graduating from high school in 1941, his future remained uncertain. He aimlessly took a job as a shoeshine man and a messenger. Then two life-altering events redirected his trajectory:

He married his high school sweetheart, Dorothy Mae Curry, in a ceremony performed by the reverend L. A. Kemp, the same mud-hole-dipping Gospel Temple evangelist who had married his parents, Earl and Pearl, twenty-five years earlier.

And the Japanese attacked Pearl Harbor.

Two months after his first child, Ernest Jr., was born in February 1943, Ernest mustered into the army, landing in Camp Butler, North Carolina, where he was attached to the 1319th Engineer General Service Regiment as a clerk and jeep driver. There, he got a monumental break. Driving for the company commander, he learned of a vacancy at the army's photography school in nearby Camp Sutton. He received permission to fill it.

Not only did he receive technical training, he learned how to run a business—including the crucial life skills of hustling and turning hardship into opportunity.

Shipped out to the Pacific Theater, to the island of Saipan, Withers discovered that homesick servicemen were willing to pay him to take pictures to send home to their families. First, though, he had to overcome obstacles—like a shortage of photography supplies. Withers's unit had none. But a nearby Air Force photography lab did. Withers had no money to pay the lab for supplies, but he did have beer. Every week, soldiers in his unit received a ration of six cans of beer; Withers didn't drink his, he traded them for supplies. He found through bartering he could get more beer from

others to trade for even more supplies. In time, he built a business, charging soldiers—black and white—to take their portrait beside a palm tree or a jungle bush.[14]

Discharged in 1946, he returned to Memphis, as uncertain of his future as ever.

As the FBI's Bill Lawrence settled into his new digs on the Sterick Building's twenty-fourth floor, looking to rid Middle America of communism, Ernest Withers pounded the pavement for work.

Already, he and Dorothy had three children. For a time, Withers thought his fortune lay outside Memphis, up north or on the coast. It's a path all his siblings would take: Earl left for Washington, D.C., where he became an accountant for the Department of Defense; sister Alice married and moved to California; Vivian relocated to Chicago; James went to Howard University and became a pharmacist. Little brother Jake, too, would leave for Washington, serving as a deputy U.S. Marshal. In early 1946, Ernest hopped a train to Chicago to scout a new life, leaving his wife and kids temporarily behind. He considered photography school. He didn't last long—by April he was back.

Taking advantage of his G.I. Bill benefits, he and brother Jake opened a photography studio in a duplex in North Memphis, not far from their father's home. Business was slow. Studio photography in Memphis's black community was dominated by established downtown businesses: the Hooks Brothers on Beale Street and Blue Light Studio. By 1948, Withers closed shop. His father urged him to take a job with the Post Office.[15]

Once again, uncertainty clouded his future.

Finally, in July 1948, opportunity came from an unlikely source: Boss Crump. The graying leader bowed to political pressures and allowed the Memphis Police Department to hire a small contingent of African American officers. The spark for this monumental addition to the city's all-white force involved the savage beating of a meek Firestone employee, Eli Blaine, who had complained to police brass that two patrolmen stole ten dollars off him. As Blaine confronted the pair at police headquarters, one punched him in the eye, breaking his eyeglasses—right in front of police supervisors. Ordered to take Blaine to city-owned John Gaston Hospital,

the officers beat him so severely on the ride over, his eye had to be surgically removed.[16]

The two cops testified that Blaine injured himself while trying to escape from the moving squad car, tumbling out the door onto the road. Charged with assault with intent to murder, one of the patrolmen was acquitted. The all-white jury convicted the other of simple assault and battery and fined him $51. The local black community newspaper, *The Memphis World*, ran photos of the disfigured Blaine on its front page and editorialized about other injustices, including the alleged rape of two young women by patrolmen.[*]

Civic leaders argued that such atrocities could be minimized by assigning black officers to patrol African American neighborhoods. Other Southern cities already did that, including Atlanta, Nashville, Chattanooga, Charlotte, Houston, and Dallas.

When Memphis agreed to join their ranks, more than 160 young black men applied, Withers among them. The struggling twenty-six-year-old photographer survived a large round of cuts as the city shortlisted the applicant field. Police brass sent him to three weeks of training at the police academy along with fifteen other candidates. Nine finished—including Withers. On November 4, 1948, the city issued him a badge and swore him in as one of the "Original Nine," the city's first black policemen in the twentieth century.[†]

Not since the advent of Jim Crow in the late 1800s had there been African Americans patrolling Memphis streets.[17]

ERNEST STRUCK A dashing figure in his dress blues and cap, his badge number—278—emblazoned in gold on the crest. The popular patrolman walked the night beat past rowdy juke joints and pool halls on Beale Street; he came to know its patrons and shopkeepers well, along with its hustlers, dice men, and streetwalkers. He once twisted an ankle chasing down a purse snatcher. He cor-

[*]Despite compelling evidence against them, the officers were acquitted by an all-white jury. Nonetheless, as in the Blaine matter, the case evidenced a growing willingness by white authorities in Memphis to buck prevailing attitudes and pursue white-on-black crime.

[†]Withers owed a measure of his achievement to his father, Earl. His personal references included two powerful black Republican Party luminaries, insurance executive Lt. George W. Lee and banker J. E. Walker. He got help with the written test, too. "My father had paid a lady to train me," Withers said years later, explaining how a tutor helped him study as his father pushed him to take a job with the Post Office. "It was just a stroke (of luck) in life that I had been boned up to pass the civil service examination."

ralled drunks, thugs, and confidence men. In time, he got a patrol car, making the rounds in the black-majority Orange Mound neighborhood, where he and his partner, slender Wendell Robinson, became beat cop heroes.[18]

"We feared the white policemen, to be honest. And it was a breath of fresh air to see Negroes or African American policemen patrolling Orange Mound," said University of Memphis communications professor David Acey, who was a young boy when MPD's color barrier fell. "It was almost like Joe Louis winning the heavyweight championship."[19]

If Withers's police activity brought him into contact with Bill Lawrence, then entering his fourth year with the FBI in Memphis when Withers joined MPD, there is no record of it. Though the young G-man's anticommunist work increasingly took him into Memphis's black community, there was limited opportunity for interaction. Black officers could not arrest white suspects; they could only hold them until white officers arrived to cuff them and haul them to jail. Many of the white cops resented their new colleagues.[20]

But the young black officers felt a sense of fraternity—and pride. They rode together to and from work. They took their wives out on collective picnics. When Withers and his wife, Dorothy, had their fourth child in 1950, they named him Wendell, after Ernest's beloved patrol partner.

"We were like a family," recalled Jerry Williams, who, at twenty-one, was the youngest of the black policemen. Withers was like an older brother. He took Williams under his wing. Looked out for him. "He was a good policeman," Williams said in his old age. "He knew what he was doing."[21]

YET, IN THE type of astonishing twist that would define his life, Withers's police career came to an abrupt halt in the early morning darkness of August 25, 1951. Williams watched in disbelief that day, when, around 3:00 a.m., officers placed Withers, still in uniform, into the back of an MPD paddy wagon on Beale Street. He was under arrest.

A police supervisor alleged he'd caught the young patrolman red-handed as he divided up illicit cash profits with a local bootlegger. The incident would haunt Withers for decades.

His arrest followed a weeks-long investigation by Lt. Lee "Big Red"

Quianthy, a gruff and ambitious officer with a pasty white complexion who made a name on the force for helping capture George "Machine Gun Kelly" Barnes in 1933 and for other daring arrests, including once knocking a pistol from a murderer's hand with his nightstick.

When Quianthy reported his suspicions about Withers to a major, he was told he needed to catch the photographer-turned-cop "in the act." According to police reports, he did just that. Quianthy followed Withers to the home of Lyncha Adolphus Johnson, a bootlegger with a minor police record. The red-headed lieutenant entered the living room with his pistol drawn as the pair divided up a night's profits from selling whiskey on Beale Street.[22]

For years afterward, Withers said he was set up. A biography produced in 1995 by the local public television station in Memphis reported he'd "been framed." Withers told an interviewer in 2003 he was targeted by "a mean lieutenant." In *Pictures Tell The Story*, Ernest's glossy coffee table book of civil rights photos published in 2000, he contends his dismissal stemmed from jealousy over his photography business, which he operated on the side—and racism. "Apparently, Ernest was set up in a way that made it appear that he was taking money from bootleggers," F. Jack Hurley writes in an essay in the book based on interviews with Withers.[23]

Given the degree of racism on the force and in Memphis at large, his claims cannot be dismissed out of hand.

However, the balance of evidence points strongly to Withers's guilt. His police personnel file shows that Chief J. C. Macdonald held a speedy hearing, interviewing five witnesses, including alleged bootlegger Johnson and his mother, both of whom said Withers shared in the profits from whiskey Johnson sold. Withers denied he was a partner in the scheme, but admitted to Macdonald that he had loaned Johnson money on two occasions to buy half-pints of Old Hickory and Heaven Hill whiskey from a liquor store that the unlicensed Johnson then resold at concerts at the Hippodrome, the famed Beale Street ballroom and skating rink.*

*The first incident occurred in April 1951 when Withers purchased twelve half-pints of Old Hickory whiskey at Midway Liquor Store at the corner of Fourth and Beale, arranging for Johnson to pick up the booze later that night. Johnson told police he sold most of the whiskey at the Hippodrome during a concert by jazz man Earl Bostic and then split the proceeds with Withers. Johnson said the August sale netted $15—roughly $142 today. He was dividing the money with Withers in his home when Lee

"Withers, as a police officer did you know you were aiding and abetting Johnson in bootlegging?" the intense Macdonald asked him.

"Yes sir," Withers answered. "I knew."[24]

THE CASE AMOUNTED to petty corruption. Withers wasn't charged with a crime. But he was dismissed from the force for "conduct unbecoming an officer." In one of his many varied explanations, Withers told an interviewer in 1975 that Quianthy, by then deceased, targeted him because the young patrolman had inadvertently jeopardized the lieutenant's own illicit affairs.

"I arrested a bootlegger he was protecting," Withers said. "It wasn't so much a racial thing. It was politics."[25]

Withers's friend and fellow black patrolman, Jerry Williams, validated that assessment. Though he eventually retired as assistant police chief, Quianthy, too, was bootlegging, Williams contended.

"Fifty percent of the department was corrupt," he said. Indeed, Memphis police had a long history of taking payoffs from bootleggers. At the same time, Williams made no excuses for his friend. It was well known Withers was taking kickbacks—a common practice among enterprising officers in need of extra cash.

"Ernest brought it on himself," Williams said.[26]

Regardless of how it went down, Withers was done as a cop. He was shamed; and hurt financially. The loss of the regular income and benefits was a critical blow to his growing family.

But he was hardly finished. Once again, he focused on his photography.

As it turns out, losing his job as a police officer might have been the best thing that ever happened to him.

Quianthy burst in. "Withers flashed his flashlight about the room and Mr. Lee came in with his pistol drawn," Johnson told Chief Macdonald.

AN ACCUSING FINGER:
THE EMMETT TILL CASE

CRICKETS CRIED IN A MOONLESS night as the men drove past rows of ripening cotton and towering cedars, rolling to a stop at Moses Wright's darkened home.

Car doors popped open. Boots shuffled across the sagging porch.

"Preacher!"

The voice outside cracked with rage and fury. It was the sort of voice—a white man's voice—that sent chills through Wright, a wispy, graying African American sharecropper who doubled on Sundays as pastor of a hole-in-the-wall country church.

"Preacher!" the voice came again. "I want to talk to you and that boy!"

It was two in the morning.

As he opened the door, Wright made out the figures of two men.* One,

*Moses Wright later testified he saw a third man, who appeared to be black, because he "stayed outside" and did not come into the house. His account supplements those of other witnesses who said J. W.

large and imposing, held a pistol in one hand and a flashlight in the other. A smaller man, the one who'd been shouting, identified himself as "Mr. Bryant"—Roy Bryant, who ran a small grocery up the road in Money, Mississippi. Now, Bryant let the big man do the talking.

"You have two boys here from Chicago?" asked J. W. Milam, Bryant's half-brother.

"Yes, sir," Wright answered compliantly.

Milam asked about two, but he and Bryant came for just one: Emmett Till, Wright's fourteen-year-old great-nephew, who was visiting from Chicago. A couple days earlier, Till and some local teenagers had been at Bryant's store in Money, a small, isolated crossroads in the heart of cotton country. It was said he'd made imprudent overtures toward Mrs. Bryant, Roy's young wife; that he'd asked for a date and whistled at her as she ran him and his cohorts out of the store.

It was all play for the youthful Till.[1]

But this was 1955 in the Mississippi Delta. Till was black. Carolyn Bryant was white. There was no way her husband and his half-brother would write it off as simple adolescent indiscretion.

"I want that boy that done the talking down at Money," Milam said coldly in the doorway.

Moses Wright already had heard about the incident at Bryant's store. He figured trouble was coming. But he just couldn't figure a way out of it. Standing six-foot-two and weighing over 230 pounds, the bald, muscled Milam dwarfed the diminutive Wright. He offered no resistance. The bulky white man ambled into the home, illuminated only by the flashlight he held.

He found Till in bed, got him dressed, and led him out of the house.

As he loaded the teen into his vehicle under the towering cedar and persimmon trees outside, Milam gave Wright a stern admonition.

"Preacher, do you know any of us here tonight?" he asked in the code of a white Mississippian speaking to a "colored" man.

"No, sir," Wright answered. "I don't know you."

"How old are you?" Milam inquired.

Milam brought black workers with him that night, possibly to help identify the youth, Emmett Till, who reportedly had talked "dirty" to his sister-in-law, Carolyn Bryant.

"Sixty-four," he answered.

"Well, if you know any of us here tonight, then you will never live to get to be sixty-five."[2]

ERNEST WITHERS WAS thirty-three when Emmett Till was murdered. He'd been off the police force for four years. He worked as a full-time photographer now, self-employed. He had no regular salary. No pension. No benefits.

He struggled to find his niche.

He and his wife, Dorothy, had six children; a seventh was on the way. To make ends meet, the ex-cop hawked pictures of ballplayers at sprawling Martin Stadium, where the Negro Leagues' Memphis Red Sox played. He shot pictures of babies and newlyweds at a makeshift studio he rented above a pool hall on Beale Street; at night he prowled its bawdy clubs, shooting photos of sweaty bluesmen and their patrons for cash.

Four years earlier, in 1951, he'd undertaken another venture. He went to work as a freelancer for the Sengstacke family, owners of the *Chicago Defender*.

In November that year, three months after Withers was fired from the Memphis Police Department, the Sengstackes started the *Tri-State Defender*, a Memphis-based weekly newspaper patterned after their Chicago flagship, specializing in news, issues, and commentary affecting African American readers in West Tennessee, East Arkansas, and North Mississippi. Ernest had a new calling card: he was a newsman.

Much of it was routine. In the weeks before the Emmett Till trial, the *Tri-State Defender* ran uninspired photos Withers shot of the hundred-member Jubilee Choir posing for their upcoming performance at the National Baptist Convention that Memphis was hosting; of dignitaries arriving for the convention on the train; of conventioneers milling about on the sidewalk outside a rambling church.[3]

But what Withers lacked in experience he more than made up for with preternatural timing.

His entry into the news business coincided with a great awakening in the American South. More and more, news interests focused on the injus-

tices of Jim Crow—on lynching, on segregation, on oppression at the ballot box. The civil rights movement was dawning. And ex-cop Ernest Withers, hungry for a paycheck—with a wife and six kids to feed—was there on the front lines to chronicle it.

"They paid very sparingly," Withers complained years later. "But it was still an opportunity to get your name in the paper and to draw a little money as well."[4]

Withers covered his first big story in May 1955, three months before the Till murder. Rev. George Washington Lee, fifty-one, a civil rights pioneer who fought to register blacks to vote in Belzoni, Mississippi, was shot and killed from a passing convertible as he drove his Buick sedan down a dirt road. Days earlier, he'd been warned to remove his name from voting rolls. A shotgun blast nearly tore his face off. His car careened into a nearby house, caving it in.

The murder in the heart of the Delta received little attention in the white media, but it resonated in the black community, where the *Tri-State Defender* flexed its young, journalistic muscle.[5]

Under a banner front-page headline, "'KKK' Strikes; Minister Slain Gangland Style," the paper cited "reliable sources" who said a carload of whites had ambushed the "prominent and militant" Reverend Lee. The newspaper's analysis labeled the killing the "first grave act of violence in Mississippi since the formation of the White Citizens Councils," organized a year earlier in response to the Supreme Court's landmark *Brown v. Board of Education* decision legalizing integration of public schools.[6]

Withers's contribution to the story was small. The *Defender* ran a photo he shot—a posed picture that showed the newspaper's executives discussing the case with NAACP leaders—in follow-up coverage on page two.

But the experience gained him access to a new social world, and he thrived in it.

As the NAACP pressed for an FBI investigation,* the photographer

*Humphreys County sheriff Ike Shelton reluctantly investigated the murder. He initially attributed Lee's death to trauma from the car crash. He later contended Lee was a womanizer who'd possibly been killed by a rival. A federal probe came to focus on two local white men. FBI agents even confiscated a shotgun owned by one of the men. But the Bureau didn't believe it had enough evidence of a racial motive to make a civil rights case. Agents turned evidence over to state prosecutors, but no one was charged. The murder remains unsolved.

mingled with many leaders of the budding civil rights movement, princi-
pally Medgar Evers, the handsome young field secretary who also would be
horribly assassinated by a racist in 1963.[7]

Withers and Evers became fast friends. As the civil rights struggle deep-
ened, Evers visited Withers at his Memphis studio, which often served as a
gathering spot for activists.[8]

Withers wasn't just learning the news trade. He was networking—
employing his considerable people skills to interact with the movement's
luminaries, with its mid-level organizers, and its many foot soldiers.

STILL, WHEN THE Till story broke, Withers remained on the *Defender*'s
"B" team. The initial crush of coverage following the teen's August 28, 1955,
disappearance involved little from the former policeman.

The *Tri-State Defender* ran photos of Moses Wright's plain country
home, the still-unmade bed from which Till was abducted, and the small-
town grocery where the boy had allegedly whistled at Mrs. Bryant—pic-
tures attributed to staff writer Moses J. Newson, later executive editor of the
Baltimore Afro-American. On the front page, it ran an unattributed photo
of Till's mutilated face. Some recently have credited Withers with shoot-
ing one or more of the grotesquely iconic Till death photos that triggered
worldwide outrage, sparking the civil rights movement.* Yet, barring any
additional evidence, the claim appears shaky at best. Withers didn't take
credit for any of the Till photos in his book about his civil rights work, *Pic-
tures Tell The Story*. And, at the time of Till's much-publicized funeral in
Chicago, where the death photos were shot, he was more than five hundred
miles away, covering the Baptist convention in Memphis.[9]

As interest in the case exploded, however, Withers got an assignment.

A grand jury indicted Bryant and Milam for murder, and a speedy trial
was set to begin September 19. More than seventy newsmen from across the
country descended on Sumner, Mississippi, a town of about five hundred
that ironically promoted itself as "A good place to raise a boy." It was home

*Till's Chicago funeral drew thousands of mourners, who were horrified by the open-casket presenta-
tion of the mutilated teen. Publicity surrounding the case escalated when *Jet* magazine ran sensational
photos of Till's body in the morgue room of a Chicago funeral home.

to the courthouse in Tallahatchie County, where Till's body had been fished from the coffee-brown waters of the Tallahatchie River. The *Defender* publications sent an eight-man coverage team, including its Memphis freelance photographer, Ernest Withers.[10]

The Delta's double-faced charm and harshness pervaded from the start.

Held in the un-air-conditioned second floor of a graceful brick courthouse with arched windows and a clock tower and a stone statue of a Confederate soldier on the front lawn, the week-long trial grew oppressive and hot. Reporters were frisked for weapons. Clarence Strider, Tallahatchie County's gruff, pot-bellied sheriff, made it clear: segregation was the law in Mississippi. It would be the law in his courtroom, too.

"We don't mix down here," the sheriff told a gathering of newsmen. "And we don't intend to start now."

Strider seated twenty-two white reporters inside the bar below the witness stand and more still behind them in the middle of the courtroom. He placed black reporters, then known as the "Negro press," at a card table in a far corner. Each day, Strider, who took the most unusual step of testifying for the *defense* and who blamed the NAACP for the negative publicity surrounding the trial, greeted the African American newsmen with a cheerful, "Good morning, niggers." He placed Till's mother, Mamie Till Bradley, at the "Jim Crow table," too, along with Congressman Charles Diggs, who'd come down from Detroit to observe the proceedings.[11]

Yet for all his humiliations, Strider unwittingly created an opportunity for Withers to take one of the most powerful photographs of the twentieth century.

Judge Curtis Swango had forbidden news photographers from taking pictures during testimony. But pushed to the side as he was, away from the center of the action, the *Defender*'s freelance photographer sensed an advantage.

When he thought no one was looking, Withers seized the moment as diminutive country preacher Moses Wright took the stand to testify about his great-nephew's abduction.

Few expected him to actually testify. The tiny sharecropper had been too terrified that night to stand up to Milam and Bryant. Days after the murder, his wife, Elizabeth, fled. She was in hiding. For good reason, too.

Deputies had summoned Wright that day Emmett's body was pulled from the river; it was left to the preacher to identify the boy. Wright looked in horror as Till lay in a boat with the barbed wire the killers used to tether him to the river bottom still wrapped around his neck. He'd been beaten almost beyond recognition. His right cheek was caved in. Teeth were knocked out. Before big J. W. Milam finished the boy with a bullet to his temple as the Sunday morning sun rose over the muddy Tallahatchie, he glared at young Till and told him coldly, "You still as good as I am?"*

Now, in the courtroom, Milam glared at Wright. Dressed in his Sunday best—a white button-down shirt, suspenders, and a skinny blue necktie—Wright fidgeted before three hundred mostly white spectators and news representatives who would broadcast his words to the world.

"What did you see when you opened the door?" the stern-faced district attorney Gerald Chatham asked as he quizzed Wright about the abduction.

Ceiling fans whirred overhead, flitting impotently at the 95-degree heat. Spectators sipped bottles of Coca-Cola or dragged on cigarettes. Now, they froze.

All eyes were on the preacher.

"Well," Wright answered, "Mr. Milam was standing there at the door with a pistol in his right hand. And he had a flashlight in his left."

"Now stop there a minute, Uncle Mose," Chatham said. Though the prosecutor willingly took the unpopular role of accusing whites of murdering a black person, he didn't betray his paternal Delta etiquette.† Chatham was white. Wright was black. The prosecutor didn't address his witness with a courtesy title. Throughout the examination he was simply, "Uncle Mose."

"I want you to point out Mr. Milam," the prosecutor prompted Wright. Then it happened.

The small man stood from the elevated witness chair and, on his tiptoes, thrust his right arm forward, pointing a long, bony finger down at the

*After their acquittal, Milam and Bryant told their story in a paid interview published January 24, 1956, in *Look* magazine. The men contended they'd planned to only whip and frighten Till, but the defiant youth refused their demands to say he was inferior. "I'm tired of 'em sending your kind down here to stir up trouble," Milam recalled telling Till. "Goddam you. I'm going to make an example out of you."
†Many believed the trial was rigged from the start. For one, authorities conducted no autopsy of Till's body.

smoldering Milam. Some Northern reporters heard Wright say in his thick sharecropper accent, "Thar he," or "Dar he."

The trial transcript records it simply as, "There he is."

Far to Wright's left, Withers stood with his camera. There wasn't room to sit at the Negro press table, crowded as it was with big-name journalists of the day like Simeon Booker of *Jet* magazine and Withers's boss, L. Alex Wilson, legendary news writer for the *Tri-State* and *Chicago Defenders*. So he stood along the edge. A camera hung from his neck.

Before testimony got underway, Judge Swango had let the many photographers roam the courtroom to take pictures. They climbed on benches and elbowed through the throng. Withers joined in. His fellow African American journalists were amazed by his ease—and his nerve. When a white man coldly told him not to take his picture, Withers kept his cool.

"Don't worry," he answered wryly. "I'm only taking important people today."

He put his fellow black journalists on edge.

"Man, you'll get us lynched down here," Booker said. Withers was unfazed.[12]

When Wright stood to point out Milam, Withers confidently took aim.

He couldn't have known then that he'd just taken one of the most powerful images of the civil rights struggle: a black man defying centuries of custom, publicly accusing a white man of a most horrific injustice.

The photo is a bit blurry, slightly out of focus. Clearly, Withers fired off a rapid shot. In the foreground in the uncropped version, a white man is facing Withers. He appears to be reprimanding him, trying to block the shot.[13]

The photo was nearly lost to history. Though it appeared that week in various newspapers across the country, including *The Pittsburgh Courier*, Withers never got credit for it. As he would recount years later, he sold his film on the spot when a man from a wire service approached him.* The cash-starved photographer gladly took the money—between

*The photo is now owned by Corbis Images of New York. The author attempted to track the picture's path to the photo gallery without success. A Corbis representative said its archives don't reveal the photo's origin. One possibility is that the firm obtained the rights when it acquired photos of the Bettmann Archive, which in turn had acquired United Press International's photo archive. John Herbers, ninety years old when the author interviewed him in 2014, who covered the Till trial for UPI, distinctly

ten and thirty dollars, by his accounts—as he'd received just $35 pay from the *Defender* publications for a week's work covering the trial.[14]

WHEN HE WASN'T freelancing news photos, Withers hustled a living with his camera in other ways. As a patrolman, he'd doubled as photographer on Beale and found unusual access to its clubs. As he later told an interviewer, he sensed a connection between "good times and money." He discovered there were dollars to be earned taking portraits of patrons out having fun. "You're always out to make money," he said. "I used to make forty, fifty, sixty dollars a night, maybe a hundred."[15]

While still a policeman, Withers rented a studio with a partner at 322 $^{1}/_{2}$ Beale above a rough section of the street that included a pool hall and a liquor store. Between shooting pictures of babies and ballplayers, to whom he often paid a small commission, he found he could clear another $50 to $75 a month—as much as $686 in today's money. A really good month might bring in $125.* He wasn't getting rich. But it supplemented his police income—and it paid the bills after he was dismissed from the force.[16]

In a particularly rough stretch, the photographer ran his business out of his cramped North Memphis home. His darkroom was the bathroom. Back then, he used a large "4-by-5" camera, a bulky contraption that collapsed and expanded on an accordion-like slide. He developed and washed his film in the bathtub. He'd produce 4-by-5- or 5-by-7-inch prints of ballplayers that his wife Dorothy dried on ferrotype plates in the kitchen oven.

"Every one that I would dry, I'm thinking that we gonna get some money," Dorothy once recalled. "A dollar, a dollar and a half, and I'm planning my budget from those pictures. But sometimes he'd come back, he wouldn't have but thirty dollars or something like that because he couldn't sell them all."[17]

recalled the "Thar he," photo but didn't know who shot it.

*These are amounts Withers reported to his supervisors at MPD. Years later, he suggested his Negro Leagues photos were more lucrative. In *Negro League Baseball*, a 2004 book featuring Withers's baseball pictures, he told essayist Daniel Wolff he could make $35 a day selling photos at Martin Stadium— and as much as $150 on good days. "Compare that to the Red Sox players getting around three hundred dollars a month, and Withers saw his baseball photographs making 'a lot of money,'" Wolff wrote.

Withers started shooting Negro Leagues games in 1946 when he came home from the war. In the waning days of baseball segregation, before Jackie Robinson broke the color barrier, the Memphis Red Sox regularly drew seven thousand or more fans to old Martin Stadium, where a parade of stars flowed through: Robinson, Willie Mays, pitching phenom Satchel Paige. He assembled a large collection of rare and historically valuable photographs: a teenage Mays celebrating under the Martin Stadium grandstands with his Birmingham Baron teammates after winning the 1948 Negro American League Championship; Paige posing with the photographer's sons in the stadium's infield; future National League MVP Roy Campanella enjoying a night out at a diner off Beale Street.[18]

Withers did much the same at night on Beale, selling patrons photos of themselves as keepsakes as well as pictures of the stars they came to see: nationally known performers like William James "Count" Basie and Lionel Hampton, who toured Memphis on the so-called "Chitlin' Circuit"; local bluesmen like honey-voiced Junior Parker, Bobby "Blue" Bland, and the legendary B.B. King.

By 1954, his fortunes were looking up. He and Dorothy had enough money to build a modest, three-bedroom home with a big yard and more room for his growing family in a developing neighborhood south of the massive Johnston Rail Yards along the industrial river port.[19]

PICTURES OF BASEBALL and the blues put food on the table, but it was his news photos that earned him an intangible yet just as valuable reward: public trust.

The Till trial helped secure a promotion to the *Defender*'s "A" team. More and more, he got choice assignments covering politics and crime. When the black community threw its support behind progressive white mayoral candidate Edmund Orgill in a wide-open campaign following the death of Boss Crump, Withers was there with his camera. When a civic leader was found robbed and murdered in a lounge at the Elks Club on Beale Street, Withers shot the gruesome crime scene.[20]

And when public demand grew for news of racial violence on the Mississippi Delta, the young photographer met it with his startling

photos.* Withers's pictures of the half-naked corpse of an eleven-year-old boy found with a broken neck on a Mississippi plantation road ran across the top of the *Tri-State Defender*'s front page in the weeks after the Till trial.[21]

Withers shot more photos when martyred civil rights icon Rev. George Washington Lee's NAACP colleague Gus Courts was shot in his Belzoni, Mississippi, grocery. Given the huge reader response to Till, the *Defender* knew this could be a big story. Withers took photos of Courts in his hospital bed and another depicting his bullet-riddled store. Courts survived.[22]

As the civil rights struggle blossomed following the Supreme Court's 1954 *Brown v. Board of Education* decision, the *Defender* increasingly paired Withers with writer L. Alex Wilson. The two traveled in 1955 to Hoxie, Arkansas, where segregationists from around the region rallied to thwart the local school board's decision to integrate the schools. A year later, Withers and Wilson hid in a darkened filling station in Clinton, Tennessee, riding out the storm of a white mob that rioted to obstruct school integration efforts there.

They traveled that December to Montgomery, Alabama, to record an incredible moment in history.

The bus boycott that had started a year earlier when Rosa Parks refused to give up her seat to a white man was drawing to a triumphant close. Now, the Supreme Court found the city's segregated buses unconstitutional. The *Defender*'s two-man news team arrived in Montgomery on December 20, 1956, as Martin Luther King, Jr., rallied the faithful inside cavernous Holt Street Baptist Church. A year earlier, as the boycott began, King had preached from this very same pulpit, under the overflowing balcony and the magnificent stained-glass windows, sweeping away the doubts of decades of Jim Crow second-class citizenship.

"If we are wrong, then the Supreme Court of this nation is wrong," he'd told the cheering throngs that spilled out the doorways onto the street.

*The tabloid nature of the *Defender*'s treatment of the death of Tim L. Hudson, eleven, stemmed in part from the reverberations of the Emmett Till murder. Not wanting to underplay what might be the next blockbuster racial murder of a child, the *Defender* seemed uncertain of what it really had. "... did he die by accident?" writer L. Alex Wilson asked in the *Defender*'s front-page story. "That is the big question in the latest mysterious death of a Negro in Mississippi."

"If we are wrong, the Constitution of the United States is wrong! If we are wrong, God Almighty is wrong!"[23]

The scene was much the same the night Withers and Wilson arrived. The church pulsed with electricity. Shouts sounded. *Yes sir! Amen!* As King addressed the crowd again, he delivered news of victory. He read a decree ending the boycott. Though a seasoned newsman, Wilson, forty-eight, was moved to his core. Tall, bespectacled, studious, he captured the night in his notebook—the voices, the faces, the electricity of the crowd—along with the momentous events of the following morning:

> MONTGOMERY, Ala.—I saw this city, "The Cradle of the Confederacy," give enforced birth to integration on local buses Friday.
>
> It was an inspiring and exhilarating experience to observe true, Christian democracy function deep in the heart of bias-ridden Alabama and deep in the heart of Dixie . . .
>
> At a mass meeting Thursday night, I saw hundreds of united, foot-weary Negro citizens, as a result of the High Court's order, give a rousing, standing vote to return to the buses on a non-segregated basis . . .
>
> By 6 a.m. Friday morning, when it was time for many to leave home for various duties, the excitement had mounted in intensity in the Negro neighborhoods. In the hearts of many, too was the prayer, deeply impassioned, offered by Rev. H. H. Johnson Thursday evening at the mass meeting:
>
> "You have kept us in your hands . . . Oh Lord . . . Now keep your arms of protection around us . . . We need you . . . Right now . . . Tomorrow morning."
>
> At 6:30 a.m., I boarded a bus, along with my photographer, Ernest Withers, at S. Jackson and High St. There were only two Negro women on the bus and they were seated on the first seat, left of the vehicle.[24]

Years later, Withers recalled that morning with humor and affection. He and Wilson stayed in a small hotel near a bus station. They rose early that morning, at 4:00 a.m.

"C'mon here, boy. Let's go," he recalled Wilson telling him. They got on the first bus at six. They rode about two hours before they finally found King downtown.[25]

Wilson ordered Withers to shoot photos as the two-man news team approached the still somewhat obscure preacher on the street. The young shutterbug dutifully obliged, aiming and clicking as Wilson and his subject walked side by side, each wearing a broad-brimmed fedora and a business suit, King barely reaching the six-foot-four newsman's shoulder.

Then, another great moment of serendipity arose. When Withers ambled onto a bus, he found himself alone with King and his small entourage. Then he shot it—that remarkable photo of King and Abernathy sitting near the front of the bus, all those white faces behind them. But the version that the *Tri-State Defender* ran was so tightly cropped, it lost its ironic beauty. It ran in a panel of four otherwise ordinary pictures documenting the evening rally at Holt Baptist and the tumultuous morning of integration.[26]

At the bottom of the front page lay another gem: a lone white demonstrator who came to protest the court decision had screamed racial slurs as a black man boarded a bus and sat in a frontward seat. Withers approached the man and took a photo of him as he got in his sedan to leave. It ran under a simple caption: "An Agitator."

Withers was becoming a bold photographer, a trait that would serve him well through the rough years ahead.

THE BREAKTHROUGH

L. ALEX WILSON FELL TO HIS knees. As a mob of angry white men closed in, the newsman hung his head. A leather shoe struck his rib cage with a crushing thud. Another landed on his spine.

He had hoped to talk his way out of this. Now, he would be lucky to get out alive.

Wilson came here to Little Rock on this sultry September day in 1957 with photographer Ernest Withers determined to cover the next big story: the integration of Central High School. In answer to the Supreme Court's landmark *Brown v. Board of Education* decision three years earlier, the local school board adopted a conservative plan. It involved slow-walking integration into the public schools by enrolling just nine gifted African American students—the so-called Little Rock Nine—at Central High.

When white mobs resisted even that glacial pace, Gov. Orval Faubus

joined them, calling in the Arkansas National Guard to keep the black students out. The situation soon grew ugly.

The mob surrounded Wilson as he approached the school on foot with three other black journalists. Perhaps it was inevitable that the thugs would target him. He was hard to overlook: Six-foot-four. Dark-skinned. Somber-faced. A broad-brimmed fedora on his head.

Despite his pleas—he was a newsman simply reporting on developments, he told them—they closed in. Wilson was punched. Kicked. Knocked to the ground. Some witnesses said they saw a man with a brick deliver a vicious blow to his head.

Wilson's wife would always believe his death five years later was somehow connected to the awful beating he took that day.

"He refused to run," said Moses Newson, Wilson's former employee, who was there that day reporting for the *Baltimore Afro-American*. As Newson recalled, he and James Hicks of the *Amsterdam News* sprinted to safety. They couldn't convince Wilson to do the same. Wilson had run once from a mob in Florida. A proud man, he never felt right about it.

"He promised himself he would never run again," Newson said.[1]

Wilson wrote courageously in the next edition of the *Tri-State Defender* about his attack that morning, September 23, 1957:

> Any newsman worth his salt is dedicated to the proposition that
> it is his responsibility to report the news factually under favorable
> and unfavorable conditions . . .
> I decided not to run. If I were to be beaten, I'd take it walking if
> I could—not running.

Withers had already left for Memphis when it happened, on his way to deliver film to the *Defender*'s offices. But he returned the following day for a major development. Inflamed by the mob chaos, and the beating of Wilson, President Dwight D. Eisenhower mobilized the Arkansas National Guard. He also called in units of the elite 101st Airborne Division—the "Screaming Eagles"—in a display of overwhelming force. Now, instead of repelling the nine black students, the soldiers escorted them.[2]

Withers positioned himself that morning in front of the school as a dark

army-owned Country Sedan pulled up with The Nine aboard. When three female members of the group apprehensively climbed out of the car, they saw a sea of hostile white faces—their classmates—staring from the school steps across the yard. In that tense moment, one of The Nine, Minnijean Brown, absent-mindedly dropped a sheet of paper. Wearing a crisp polka-dot dress, she stooped over to pick it up off the pavement—just as Withers depressed his shutter. It was the perfect balance of malice and innocence: a schoolgirl, lost in a moment of everyday tedium, even as treachery awaited her.

He had taken another picture for the ages.[3]

LITTLE ROCK OFFERED more than just another big story for Withers. It opened up another sideline job—this one with the FBI.

It was here, a year after the integration of Central High, that Withers's first known interaction with Bureau agents took place.

This is how it happened:

By the fall of 1958 the school crisis had escalated. Though Central High was nominally integrated, Governor Faubus won passage of a law that would allow him to thwart desegregation altogether. Under an act passed by the state legislature, he could close schools and lease them to private companies that would reopen them as nonpublic schools. That September, a year after the initial crisis, Central and the rest of Little Rock's high schools sat largely idle—students stayed home as authorities tried to sort out the mess.

Withers was back in Little Rock covering the developments. There, on September 28, he paid a visit to the local FBI office. Though the full context of the meeting is lost to history, records make it clear he discussed two black activists—one from New York, the other from Chicago—who were believed to have ties to communist organizations.

By then, the photographer was stringing for *Jet*, the popular weekly news magazine that had first published the graphic photos of Emmett Till's mutilated face. The pocket-sized magazine would become known as "the Negro Bible" for its searing, comprehensive coverage of the budding civil rights struggle—many of its stories accompanied by photographs shot by Ernest Withers.

According to an FBI report memorializing the incident, Withers showed

up at the Bureau's Little Rock field office in the company of *Jet*'s Washington bureau chief, Simeon Booker, whom he'd met covering the Till trial. Also along was Charles L. Sanders, a gifted pianist and a writer for the Cleveland *Call & Post* newspaper, who later became managing editor at *Ebony* magazine. The focus of the visit: recent activity in Little Rock by Louis Burnham, a writer for *The National Guardian*, a leftist newspaper published in New York. Traveling with Burnham was James Forman, then a little-known activist. A fiery Chicago schoolteacher, Forman would become one of the pillars of the movement. He built a name by constantly slipping south: To rally Freedom Riders. To coordinate protests. To aid sharecroppers kicked off their land for registering to vote. But on this day, he was still an unknown—just another suspected communist agitator causing trouble.[4]

Withers and his two fellow newsmen complained to agents that Burnham and Forman "were not representing magazines or publications as they claimed" but used "legitimate news people" to get into news conferences and to interview students.[*]

DURING THE VISIT, Booker reportedly passed on a particularly dim view of Burnham. He said his employers at Johnson Publishing Co., the Chicago firm that operated *Jet* and *Ebony* magazines, knew Burnham as a communist associate.[5]

"Booker said that his boss, Robert Johnson, managing editor of 'Jet' magazine, told him that Burnham was a former head of the Southern Negro Youth Congress and that he had worked closely with James E. Jackson, then of New York, who was an indicted member of the Communist Party," the report said.[†]

[*]Although their credentials were questioned, Burnham and Forman both worked as journalists. Before joining *The National Guardian*, Burnham edited *Freedom*, the Harlem-based monthly newspaper founded by the actor, singer, and social activist Paul Robeson. Forman freelanced for the *Chicago Defender* while in Little Rock.

[†]The author attempted in 2015 to interview Booker, then ninety-six, but his wife, Carol McCabe Booker, said he didn't recall the incident. Nonetheless, the Little Rock report raises the possibility that Withers's introduction to the FBI might not have come through the Memphis office at all but rather through Booker. Starting in 1957, *Jet*'s Washington bureau chief forged a relationship with Cartha "Deke" DeLoach, who later became number-three in power at the Bureau. Booker was quoted in *The Washington Post* in 2007 as saying the FBI "maybe . . . looked at me as some kind of informer," and some have speculated on the nature of his FBI relationship. However, there is no credible evidence to date that he was coded as an informant or that he was paid. Booker wrote in his 2013 book, *Shocking the Conscience: A*

Burnham's presence in Little Rock rattled the anticommunists in the FBI. The veteran activist, who'd long been a voice for the underprivileged editing Harlem's *Freedom* news magazine, had once served in the Young Communist League. He worked, too, as executive secretary of the Youth Congress, founded by the aforementioned James E. Jackson, an early civil rights pioneer and a Communist Party member indicted in 1951 under the Smith Act. As the report noted, the Youth Congress was listed as a suspected subversive organization under Eisenhower's Executive Order 10450.

Forman, too, concerned the Bureau. An intense, studious man, he'd begun appearing at civil rights skirmishes across the South. Over time, Withers would pass photographs of Forman to agents and give updates on his activities as he passed through Memphis. In Little Rock, the FBI meticulously tracked Forman and Burnham. Agents checked registration papers at the hotels where they stayed, interviewed innkeepers, and debriefed school officials with whom the pair had contact.[6]

Years later, Booker discussed the general contours of his relationship with the FBI. "How do you think *Jet* and *Ebony* got all those stories down South?" he told *The Washington Post* in 2007. "I know what all the civil rights people have said about Hoover and the FBI. But the FBI was of great help to me . . . When I left for the South, I always told the FBI where I was going. I wanted to get back home! The FBI was really a kind of co-engineer with us. *Jet* and *Ebony* never would have been what we were without the FBI."[7]

Booker's outlook might have influenced Withers. Then too, Withers might already have begun a relationship with the FBI. Nine months before his Little Rock visit, the FBI's Memphis office considered the photographer as a PCI—a Potential Confidential Informant.* Again, the detail is sketchy. Yet it happened at a critical moment. As the civil rights struggle spread, agents increasingly reached out to leaders in the black community—min-

Reporter's Account of the Civil Rights Movement, that DeLoach never asked him to inform on anyone "or share any information that I wouldn't publish." As his FBI press contact, DeLoach advised Booker about potential dangers when reporting in the South and once helped arrange a jailhouse interview in Mississippi.

*Records suggest the FBI first attempted to make Withers an informant in January 1958. The Memphis field office sent a memo that month titled "Ernest C. Withers, PCI," the designation for a Potential Confidential Informant, to the identification bureau at headquarters seeking a background check, an early step in clearing an individual as an informant. The outcome of that effort is unclear.

isters, politicians, and journalists—seeking their assistance in identifying Communists, radicals, and individuals suspected of sowing subversion.[8]

"They were building relationships," recalled newsman Newson. He never was approached while at the *Tri-State Defender* but received visits several times from agents in the 1960s when editing Baltimore's *Afro-American*. Newson said he had little to tell them; the agents eventually left him alone.[9]

Did agent Lawrence reach out to Withers? Did he plant the seed in Memphis before the photographer walked into the Little Rock office that day?

And why, when so many other recruits managed to become only fleeting sources, did Withers get in so deep?[10]

Many questions remain, yet this much is clear: we know of Withers's 1958 Little Rock meeting because of the lawsuit my newspaper filed in 2010 following my initial stories. A record of it appears among a trove of documents the FBI released through our suit—thousands of pages of previously censored reports and hundreds of photographs that Withers shot for the Bureau. Our long-shot lawsuit paid off.

THE STORY OF this revelation runs through the inner office of a federal magistrate judge in Washington, D.C., the eclectic Alan Kay. It was autumn 2012. I sat in Kay's chamber gazing at his bookshelves. Beside a large collection of law books is a mannequin head. It stares lifelessly from behind a pair of bushy-eyebrow Groucho Marx glasses. But it was the string of colorful beads dangling from its neck that caught my eye. Nervously, I focused on them as we waited for Kay to join us. It was odd, even absurd, that it had come to this. But finally, after so many years, the details of Withers's secret work for the FBI seemed about to unfold.

I sat with my attorney, Chuck Tobin, a brainy former news reporter, who now practiced media law at the Washington office of Holland & Knight, a firm that expertly represents journalists around the country. At my other side sat Dave Giles, corporate counsel for Scripps, the Cincinnati company that owned *The Commercial Appeal*, and also a former newspaper reporter. I couldn't help but chuckle as I recalled what John Ford said when he'd threatened me all those years earlier, "I've got five *damn* attorneys!" Well, I

had two, anyway. And another back at Holland & Knight's offices. We were ready for this.

We had assembled here for court-sanctioned mediation, a most unusual step for a FOIA lawsuit. It followed an astonishing series of decisions we'd won in U.S. District Court. We kept winning—but the FBI kept fighting.

Its lawyers filed repeated motions for reconsideration. They threatened an appeal. Just when it appeared hopeless, a breakthrough came.

Judge Amy Berman Jackson, the Obama appointee who presided over our suit, suggested mediation—and the FBI jumped at it. To oversee our deliberations, she appointed Magistrate Judge Kay, a graying veteran jurist who'd gained attention for some fiercely independent rulings against the Bush administration that gave Guantanamo Bay terrorism detainees speedier access to attorney representation.

Things definitely were looking up.

We blinked across the mahogany table at four government lawyers: Two from the FBI. Two from the Department of Justice.

I've often thought that if they knew how desperate we were they never would have agreed to this. Two years after filing the lawsuit, we'd shelled out hundreds of thousands of dollars in legal fees. The math didn't add up on this one: Amid a nationwide crisis in the newspaper industry, *The Commercial Appeal* had laid off half its news staff over the previous eight years, and the cutbacks kept coming. An appeal could add years of litigation and thousands of dollars more in costs.

If this were a game of strip poker, then we on the news side were sitting at Kay's table in our underwear.

But the government was naked.

AS WE'D DISCOVER, the FBI was extremely distressed over the state of the Withers litigation. If Judge Jackson's rulings held up on appeal, the integrity of its confidential informant program could be jeopardized. Future litigants might build on our precedent to penetrate confidentiality the FBI had promised its informants.

Ironically, the case turned against the FBI as it employed a powerful yet little-known hammer in its government-secrets tool chest, the so-called

exclusions to the Freedom of Information Act. These exclusions allow officials to hide certain records and even mislead a FOIA requester seeking information involving confidential informants.*

This tactic gave us fits at first.

From the very start, they hid records using one of the exclusions—we just had no clue what they were doing.

When I first filed a FOIA request in 2008 seeking details about Withers's activities as an informant, the FBI responded saying, "no records *responsive* to your . . . request were located." "Responsive" was the critical word. It has special meaning in FBI parlance. We just didn't know it at the time. When we later filed suit in November 2010 seeking his informant file, we got more shaded answers. We contended in our suit that Withers served as an informant and that the FBI held documents concerning his involvement in domestic surveillance. The Bureau's lawyers replied that this was our "subjective characterization" and that "the FBI is without knowledge or information sufficient to form a belief as to the truth of the . . . allegations."

"The allegations are therefore denied," they responded.

Again, when we asserted that released documents already confirmed Withers was an informant—specifically the one bearing Withers's informant number, ME 338-R, and another listing him as a "Conf. Infor.," FBI shorthand for confidential informant—the Bureau gave a flat denial.

"The FBI denies the allegations. . .," its lawyers wrote.[11]

It seemed they were saying our front-page assertions simply weren't true: Ernest Withers had never been an FBI informant.

MY BOSS, CHRIS Peck, was greatly disturbed. He'd stuck his neck out on this. Way out. Not only did he publish a story picked up by *The New York Times* and network news—a story that some readers took as proof that Withers betrayed the civil rights movement—he'd persuaded his bosses at Scripps headquarters to finance a lawsuit. I'll never forget the day we met

*In an article published after the Withers litigation closed, the author's attorneys, Christine N. Walz and Charles D. Tobin, called the exclusions the government's "license to lie" because they allow it to essentially deny the existence of certain records even when they in fact exist. For a further discussion of this, see endnote 13 in this chapter.

in Peck's office in early December of 2010, days after the FBI's response. I'd never seen him like this. He shot me a look of skepticism as he spoke with Tobin, our Washington counsel, on speaker phone.

"The concern I have is they seem to flat-out deny this," Peck complained. "Is that a legal tactic, or are they saying in truth he wasn't a confidential informant?"

Tobin wasn't sure.

"I don't have the answer for you on that because of the way it's worded," he said. "I can't answer the murkiness."

These were rocky days. As our litigation dragged on, Withers's family grew increasingly antagonistic.

They were threatening a suit of their own.

"The sons of famed civil rights photographer Ernest Withers are 'lawyered up.' They're prepared to defend their father's legacy in a courtroom, if necessary," the local NBC affiliate, WMC-TV Channel 5, reported. The news station's story featured Withers's two surviving sons, Joshua "Billy" Withers and Andrew "Rome" Withers, who came to the Channel 5 studio, a lawyer at their side.

"What is being portrayed is a 180-degree difference than what we actually know," Billy Withers said. His father's photography work, he said, included periodically interacting with law enforcement—with police and the FBI—as newsmen often do when working stories. But that journalistic routine was made to look as though Ernest Withers was "just an informant," he said. The brothers' lawyer, J. Stephen Toland, offered a stern warning: if this distorted portrayal continues, it could interfere with the Witherses' efforts "to carry on good works in the community" through a foundation they'd started, he said. In that case, "we will address all those grievances in court and seek those remedies we're entitled to."[12]

All this increased the pressure. If our lawsuit failed—if we never got another record out of the FBI—the question about Withers's involvement with the agency would be forever muddled. Despite the many details the newspaper had already laid out, critics would always contend we'd misinterpreted what Withers did. We'd overplayed it, twisted it.

We had no formal admission from the FBI, no record that directly

stated, "Ernest Withers worked as an informant." In fact, what we had were a lot of statements from the agency that collectively seemed to deny any connection to the photographer.

Then, suddenly, it all began to change.

THE FIRST BIG break in our litigation came in June 2011, seven months after we sued. It resulted from a cunning move. Our lawyer, Chuck Tobin, had filed a motion for summary judgment back in January, *before* the government got a chance to file one of its own. Typically, the government goes first. The move forced the FBI into a defensive stance. And when their attorneys finally responded, on June 15, it paid off. We finally figured out what they were doing.

The government revealed it was relying on an obscure provision in the law, one of the so-called FOIA exclusions that allows it to completely obscure certain information involving ongoing investigations as well as details involving confidential informants and foreign intelligence.

"Plaintiffs are not entitled to Withers' alleged informant file, even if such a file exists," the FBI's lawyers wrote, citing a statute, 5 U.S.C. 552 (c) 2). Passed in 1986, it maintains that information about an informant is not subject to FOIA if the FBI has not first "officially confirmed" that individual as an informant. Essentially, this powerful law allows the government to treat these records as if they don't exist—they are excluded from the requirements of FOIA.*

Even Tobin, a veteran media-law litigator, hadn't heard of this before. He went to work to learn about it. Spreading the government's papers across his spacious office overlooking the Washington skyline, he and his young associate, Christine Walz, discovered the (c)(2) provision was passed as part of the Reagan-era Anti-Drug Abuse Act. They quickly formed an opinion

*The exclusions differ from the nine exemptions to the FOIA statute. The exemptions, which allow the government to withhold information for reasons ranging from national security to the protection of trade secrets and individual privacy, can be challenged in court. An agency invoking an exemption must indicate the volume of information withheld, such as the number of pages, and must cite a category under which the redaction was made. Courts can conduct a document-by-document review if necessary to determine if the agency acted properly. Exclusions, on the other hand, are not acknowledged. When an agency has information it claims falls under an exclusion, the law permits officials to simply deny they have those records. As Tobin and Walz write, they are used "to completely hide even the existence of certain information."

that the government was abusing this provision in regard to Withers, a deceased political informant whose work for the FBI had ceased forty years earlier. Reviewing the congressional record, the lawyers found the provision was crafted for extraordinary circumstances involving sophisticated drug cartels that might use FOIA to uncover ongoing investigations and informants snitching on them. In 1987, a year after the provision passed, then–attorney general Edwin Meese issued guidance to invoke the exclusions in "certain specified" and "especially sensitive" circumstances—a limitation we believed the FBI overstepped.[13]

As Tobin and Walz looked for holes in the FBI's case, they focused on those two peculiar words in the (c)(2) exclusion, "officially confirmed."

What did it mean?

"Whenever informant records maintained by a criminal law enforcement agency under an informant's name . . . are requested by a third party," the statute says, ". . . the agency may treat the records as not subject to the requirements of (FOIA) unless the informant's status as an informant has been *officially confirmed.*"

Images come to mind of the FBI formally revealing an informant's identity at a news conference—or on a gold-embossed press release. But it would never do such a thing. The FBI does, in effect, "officially confirm" an informant who is compelled to testify in court. But short of a courtroom admission, which is rare, there is little to rely on in defining "officially confirmed."

TOBIN AND WALZ came to focus on the document I'd discovered linking Withers to his informant number, ME 338-R. They argued that in releasing this, the FBI had officially confirmed Withers as an informant.

The FBI zealously pushed back.

The release of the informant number was a mistake, the government's attorneys said, not official confirmation: "To the extent plaintiff Perrusquia claims that the FBI's release of Withers' public corruption files disclosed information from which he could deduce Withers' alleged status as a confidential informant, any such disclosure would have been inadvertent." In their pleading, they also added this classic line: "Logical deductions are not . . . official acknowledgements."[14]

It certainly was a mistake.

But then the FBI made another—and it cost them the case.

Attached as an exhibit to an official court pleading, the agency re-released the document listing ME 338-R. Once again it redacted the words that followed that number. We always believed the missing words identified Withers's informant file. This is how the passage appears:

> Ernest Columbus Withers was formerly designated as ME 338-R
> (*white-out redaction here of about six to eight words*) captioned
> 'Ernest Columbus Withers; CI.'

As before, the FBI again cited FOIA exemption 7D, which protects identities of confidential sources. This time, though, the Bureau added additional detail: the subcategory of 7D it relied on protects "confidential source *file numbers.*"[15]

It was another eureka moment. In essence, the FBI had "officially confirmed" the existence of Withers's informant file—in a court pleading, no less. Tobin was ecstatic over the phone. He was beginning to rout the government's lawyers, and I could tell the former newsman was thoroughly enjoying it.

BY THE FOLLOWING January, Judge Jackson had seen enough.

"The FBI persists in its position that the informant's status has not been confirmed," she wrote in January 2012, ruling that Withers's status as a confidential informant, in fact, had been officially confirmed. "This argument is not worthy of serious consideration and it insults the common sense of anyone who reads the documents."

Citing the reference to ME 338-R in the FBI document and two others listing Withers as a "CI," and a "Conf. Info.," she ordered the FBI to produce a Vaughn index* that would lead to the public release of at least a portion of his informant file.[16]

*In FOIA litigation a government agency produces a Vaughn index to allow a judge to make a document-by-document review to determine what information may be properly withheld. In her ruling, Jackson said, "The Court does not hold that the informant file must be produced—only that if the FBI has relied on the (c)(2) exclusion to treat the records as outside the scope of FOIA, that exclusion is no longer available in this case." She ordered the agency to review Withers's file and "either produce the responsive documents or provide a Vaughn index identifying the specific exemptions under which any responsive documents have been withheld."

Finally, that July, after all its many denials, the FBI admitted in court papers that Withers had worked for the agency as a confidential informant.

"The FBI . . . located records relating to Withers' service as an informant at both FBI Headquarters and the Memphis Field Office," the agency said. "The FBI did not initially identify these records to plaintiff Perrusquia as *responsive* because, in its view, those records are not subject to the FOIA."[17]

Still, despite its admission, the FBI wasn't quitting. In filing a Vaughn index, the agency didn't itemize documents in Withers's informant file. Instead, the agency merely listed categories of FOIA exemptions it said shielded the records from disclosure. The fight continued.[18]

The FBI fired back with a series of filings: It asked Judge Jackson to vacate her order. It filed an affidavit—ex parte, for the judge's eyes only—by FBI in-house historian Dr. John F. Fox, Jr., hoping to persuade Jackson to reverse her ruling. When none of that worked, it filed a motion for reconsideration. Finally, it filed a notice of appeal to the District of Columbia Circuit Court.[19]

In the meantime, a final star aligned: Judge Jackson suggested mediation. On August 28, 2012, with attorneys from both sides gathered before her, she noted this "is the 49th anniversary of the 'I Have a Dream' speech on the steps of Lincoln Memorial just down the street." She acknowledged the government's desire to protect the privacy of what it characterized as lawful criminal investigations and national security investigations Withers took part in. She noted, too, with an obvious tone of skepticism, no one believes anymore that the FBI's harassment of Dr. King amounted to a lawful investigation.

"The reason I scheduled the status hearing today is it seems to me that this case cries out for some sort of solution that is structured by the parties rather than a litigated result," she said.[20]

Much to our surprise, the FBI agreed. Following a joint motion to stay the proceedings, we were on our way to the negotiation table.

BETSY SHAPIRO WORE a bright red Washington Nationals baseball jersey and held a pair of tennis shoes in her hand. As the celebrated lead attorney for the Department of Justice's government information section, she

came to Judge Kay's chamber for our much-anticipated mediation session. But clearly her heart was elsewhere on this warm October afternoon. A long-suffering baseball fan, she was heading after the meeting to Nationals Park to watch the first home playoff game in Washington since 1933. But first she had some business to conduct.

Looking back now, I realize the Ernest Withers settlement wouldn't have happened without Betsy Shapiro representing the FBI. She stepped into a bad predicament and made the most of it. Tough, charming (as an ice-breaker at one session she presented me with a black-and-white coffee mug from the Newseum bearing the inscription, "Trust me . . . I'm a reporter"), and capable, she took charge. She did her best to protect the government's interests, simultaneously working, in the spirit of compromise, to unfold this hidden history from one of America's most troubled periods.

Minutes into our first session, Shapiro indicated that the government was ready to negotiate. First, she had a word of caution.

"We're not afraid to appeal," she advised sternly. The FBI isn't going to produce Withers's informant file, she said flatly. There were just too many sensitive details there: such files can contain records detailing pay and recruitment and assignments received from agents, even reports written by the informant himself.

But she offered a compromise: The FBI had identified reports in Withers's informant file that were copied to about one hundred and fifty separate investigative files—cases starting in the late 1950s and running into the '70s in which Withers had provided anything from small tidbits to large swaths of information. Over the years, these files had been transferred to the National Archives and Records Administration (NARA). The FBI would produce a list of these files. From that list I could pick thirty-five files.

NARA would then release all materials related to Withers in these thirty-five files. Shapiro and her colleagues agreed they would not redact any reference to the photographer, including his name or his informant number, ME 338-R. As Shapiro talked, I masked my enthusiasm. This was nearly as good as reaching into Withers's informant file.

"There's a bonus," Shapiro explained. Few if any photographs were retained in Withers's file. The FBI routinely routed photos he took to the

individual case files. An FBI attorney with a security clearance had reviewed a sample of the files at NARA—the pictures indeed are there, she said.

At our request, Shapiro personally reviewed one of the largest case files Withers had worked on, the FBI Memphis field office's 1968 to 1970 investigation of Dr. King's Southern Christian Leadership Conference. "There are photos in there," she advised.

Over the weeks, the deal got sweeter. We convinced the government to let us tap 70 of the 150 files.* All material related to Withers in those files would be released in intervals over two years. Best of all, as far as my ailing newspaper was concerned, the government would reimburse most of our legal costs. The FBI agreed to pay *The Commercial Appeal* "the amount of $185,943.90 for attorney's fees, costs, and litigation expenses." It was unbelievable.[21]

WE WOULD NEVER have all the answers. Because we couldn't tap his informant file, we'd never know specifically *why* Withers agreed to work with the FBI. We'd never know the many specific instructions he'd received or how much he was paid for specific assignments; we'd never get any reports he wrote in his own hand.

But we would know much, much more than before. As part of the deal, we secured a written statement from the FBI indicating the agency paid him nearly $20,100[†] over the years. It wasn't a huge amount, but for the tight-fisted FBI it was considerable. Most informants never got a dime. Considering inflation, Withers's payments from the FBI were equal to about $140,000 or $150,000 today, depending on when he received them.

What did the FBI get out of the deal? First and foremost, there was no court ruling. No legal precedent was set for future litigants to build on. And,

*During mediation, the government revealed that some files containing Withers's reports are retained by the FBI and have not been accessioned to NARA. Some are the files of other informants. One involved the Memphis field office's file on the Nation of Islam. The existence of this file came to light when the author spotted a reference in unrelated reports. Under the agreement, the FBI agreed to release this file. The identity of other files in the FBI's possession may never be determined.

†The statement, attached as an appendix to the settlement, says, "As reflected in the confidential informant records, the FBI was authorized to pay Ernest Withers a total of $20,088 from the period of April 1958 to April 1976, which may have included compensation, reimbursement for expenses, or costs. The FBI is unable to confirm the amount of payment actually received by Withers."

as Shapiro said, the arrangement allowed the FBI "to save face." The agency would not have to reach into a confidential informant file.

A huge wave of satisfaction filled me as I rode the train from Washington to Baltimore, on my way to catch my plane back to Memphis. As the countryside whizzed by to the lulling clickety-clack of the tracks, I thought again of Jim, of those grand early days at *The Commercial Appeal*, of my lingering belief that despite the many troubles plaguing journalism we could still deliver important public-service investigations.

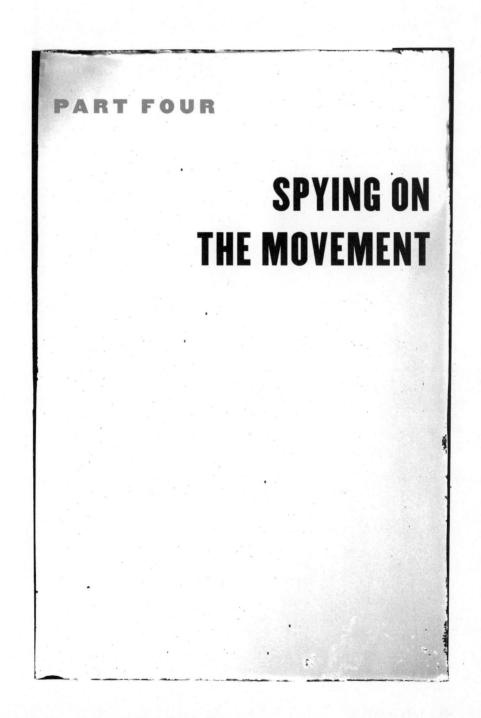

PART FOUR

SPYING ON THE MOVEMENT

ASSIGNMENT: TENT CITY

ERNEST WITHERS AIMED HIS CAMERA across the cold, brown stubble of a harvested cornfield. In his viewfinder he saw a row of large canvas tents rising like a battlefront bivouac above the hardened earth outside Brownsville, Tennessee. Men in winter coats trudged in and out. Some wore work gloves. Others carried tools. They paused here and there, driving wooden stakes into the turf with axe butts or running wires to electrical outlets mounted inside on makeshift walls.

This was no campout. It was the last resort for a group of impoverished African American tenant farmers who had been kicked off their land for trying to vote—a political refugee camp in the heart of Dixie.

For them, a hard life was about to get even harder.

A refugee already had been shot in a sister camp in neighboring Fayette County, wounded in the arm as he slept when hooligans fired indiscriminately from a roadway into the tents. These sharecroppers knew harassment

well. Insurance policies they carried suddenly were canceled; bank loans dried up. Merchants wouldn't sell to them—all because they wanted to vote.

Ostensibly, Withers came here sniffing out a news story. But the photographer from the *Defender* newspapers and *Jet* magazine had a different agenda today.

He was hunting Reds—Communists, Socialists, and their associates.

Withers ventured on this chilly winter morning in 1962 into the "Tent City" camp in rural Haywood County, an hour's drive northeast of Memphis, on a scouting mission for the FBI. Special agent William H. Lawrence had been grooming the shutterbug for over a year now as a PCI—a Potential Confidential Informant—handing him a variety of assignments. This one involved snooping on civil rights workers affiliated with the New York–based Socialist Workers Party—four men Lawrence had been tracking across West Tennessee. He believed they'd infiltrated this makeshift settlement.

Withers never found them.

But the photos he took on this overcast morning of February 1, 1962—eight black-and-white pictures depicting the camp's bleak conditions and the undefeatable, upbeat faces of its denizens—landed in a file labeled, "Racial Situation In Tennessee, Fayette and Haywood Counties—Racial Matters," along with the transcript of an account Withers gave updating reports of outsiders recently seen in the area.

"Withers is a commercial photographer, self-employed," Lawrence wrote in a report on the assignment. "He has news credentials for 'Jet' magazine, a Johnson Publishing Company publication. He has previously done news-picture stories for 'Jet' in both Fayette and Haywood Counties and was the first newsman to do a story re the Fayette County 'Tent City' one year ago . . . Thus he would have a logical entrée and pretext to make inquiries around the current 'Tent City', where it is understood . . . suspected Socialist Workers Party supporters and advocates, are living and where they are infiltrating the Negro community in Civil District No. 9, Haywood County."[1]

Ever the Communist hunter, Lawrence found Withers a godsend, a potent tool for what would become one of the most inflammatory inquisitions in American history: COMINFIL, code name for the FBI's secret war on Communist infiltration of the civil rights movement.

To many, it was the great witch hunt of the 1960s.

Like the Red Scare of the late '40s and '50s before it, this was a political purge. Communists again were targeted. But this time the FBI set its sights on an ever-expanding range of "subversives," investigating, as the attorney general reported, "the entire spectrum of the social and labor movement in the country." On its face, COMINFIL targeted Communist Party attempts to infiltrate domestic civil rights groups, but "in practice the target often became the domestic groups themselves," according to the Senate Select Committee to Study Governmental Operations with Respect to Intelligence Activities. Better known as the Church Committee, after its chairman, Frank Church of Idaho, it uncovered wide abuse in hearings in 1975 and 1976. Among the findings, it reported that director J. Edgar Hoover had greatly exaggerated the extent of communist influence in the movement. By 1964, it reported, the FBI had opened nearly a half-million subversion files—it would open thousands more through the end of the '60s—undertaking "massive" data collection "on lawful political activity and law-abiding Americans."[2]

This is the thing my original FBI source, Jim, didn't seem to get. In the name of national security, the FBI retarded the movement. It expended enormous resources investigating constitutionally protected dissent, abusing individuals whose politics were unpopular or because they made the government nervous. The best-known case of this is Hoover's infamous bid to destroy Martin Luther King. Yet for every well-known figure like King there were thousands of faceless others who labored in the movement's trenches, fighting for equality, only to be kept under the suspicious watch of their own government: their mail tracked, their associations inventoried, their attendance at meetings and rallies transcribed in covert files.[3]

The FBI helped create a hostile environment in which crimes against civil rights workers often went unprosecuted. Activists were left to battle on two fronts, against violent racists and the deleterious inquiries of their own government.

But Jim had his points, too. Much of the history of the FBI's treatment of the movement has been written by the Left. Often overlooked or underemphasized in these histories is the very palpable Cold War fear shared by millions of Americans that the enemy—the communist insurrection—was

at the doorstep. Fear grew following devastating race riots in Watts, Newark, and Detroit. Violence and disorder in the mid- to late-'60s intensified the FBI's incentive to monitor the movement as well as larger black America. As Hoover's agents kept watch on that "entire spectrum" of the movement, Withers assisted, providing personal and political details on a range of activists, from reformers and idealists to moderates and true extremists, including members of a militant street gang that reportedly committed acts of arson, extortion—even a sniper attack on a policeman—toward the end of the decade.

His work produced a voluminous record.

Over time, as the FBI kept a suspicious eye on leftist "agitators" pouring into rural West Tennessee to assist the nascent civil rights struggle there, the affable newsman became a prolific source. He provided agents with scores of photographs.* Intelligence he gathered, either through photographic prints and negatives or through spoken or written information he passed to agents, appears in 102 separate reports the FBI produced on the unrest in Fayette and Haywood counties between 1961 and 1969—from political plans and mundane gossip to handwritten letters he received or intercepted from activists.

Whether he betrayed the movement, as some insist, or acted out of a sense of patriotic duty or some profound lust for adventure, or he simply needed the extra money, this much, too, is clear: records released through the 2013 settlement of *The Commercial Appeal*'s lawsuit establish Withers as a valued, long-term asset for the FBI inside the civil rights movement. His work in Fayette and Haywood counties comprises just a corner of an eighteen-year relationship that started in 1958 and contributed more than 1,400 photos and written reports to the files of the FBI's massive domestic intelligence vault.[4]

As anticommunists beat the drum of dogmatism and civil rights activists stepped from the margins to challenge decades of rigid social order, the movement came under intense, even jaundiced, scrutiny. Who is loyal?

*The author counted references in reports to as many as 144 photographs Withers supplied the FBI from Fayette and Haywood counties. The FBI released seventy-one actual photographic prints from "Tent City"–related files. The rest are missing. The FBI's Memphis office at times shipped prints shortly after they were shot to other field offices to facilitate identification and intelligence gathering. Others simply weren't released despite the government's legal settlement with *The Commercial Appeal*.

Who is an enemy? Who would sow seeds of subversion? Promote violence? Or insurrection? These were the questions the FBI sought to answer as Withers aimed his camera at the movement.

Though he reported on some of the big names of the movement, most of Withers's work for the FBI focused on its unsung foot soldiers, little-known activists like Danny Beagle, a wavy-haired twenty-one-year-old Columbia University graduate of Jewish descent who came to Fayette County in 1964 to help lead a series of marches, boycotts, and voter registration drives. Withers befriended Beagle and his comrades in the West Tennessee Voters Project, shooting numbers of pictures, including one depicting Beagle, smoking a cigarette, holding a teenage African American girl in his lap.

It was innocent enough.

Shot outdoors, Beagle and the young lady are surrounded by colleagues, sharing a laugh. But the FBI seemed intent on twisting its meaning. Lawrence found it intriguing enough to send a copy to Washington along with two other pictures. He directed them to the personal attention of William C. Sullivan, the FBI's head of domestic intelligence operations—the same man who mailed the audio sex tape to Dr. King along with an anonymous letter suggesting he kill himself. "I thought these photographs might be of personal interest to you," Lawrence wrote, noting they were shot by Withers, "who has gained the confidence" of the civil rights workers.[5]

"It's creepy to be honest with you," Beagle said years later of Withers's snooping. "It's creepy. I mean, you want to tell him, Ernie, get a life. I'm sure you have other things to do besides watch me. I'm not that interesting. You know, I'm not a threat to anybody. I'm just an idealistic young kid trying to do the right thing.

"And what are you doing?"[6]

IT'S STILL UNCERTAIN when Lawrence and Withers met. Yet it's clear their relationship blossomed during the racial unrest that gripped West Tennessee's Fayette and Haywood counties.

Ringing Greater Memphis on the east, this rural sliver of the Deep South shared more in common with Mississippi than its relatively progressive neighbors in Tennessee. On a map, the two counties rise from North

Mississippi like a virtual appendage jutting north from the twenty-five-mile border Fayette County shares with that southernmost state. The politics and culture were the same on either side of the state line.

Cotton was king. Jim Crow ruled.

No black resident had voted in either county for more than fifty years until the Department of Justice filed suit in 1959 accusing local officials of excluding African Americans from voting in local primary elections.* A consent agreement the following spring opened widespread voter registration. Yet the trouble only deepened. White merchants blacklisted African Americans, refusing them groceries, farming tools, and other necessities. Landlords forced longtime tenant farmers off their land.

By the end of 1960, as evicted sharecroppers heaped children, tools, beds, wood stoves, and other meager possessions onto open trucks, teetering into tent camps like so many Okies fleeing the Dust Bowl, the Justice Department filed two additional lawsuits. The government charged scores of whites in both counties with violations of federal election law.[7]

Withers jumped on the story. With his news cameras, he shot gritty pictures of the squatters in "Freedom Village," the first of the Tent City camps. It rose from a twenty-acre field just south of Somerville, the Fayette County seat, days before Christmas. There, snake-bitten men like wiry Wyatt Williams, sixty, huddled against the 15-degree chill in military surplus tents, blanketed with children, grandchildren, and family dogs.

"We's a fighting family," *Jet*'s Simeon Booker quoted Williams as saying. "We ain't scared and we ain't begging. We want to be citizens."[8]

Tensions had mounted over the previous summer as hundreds of African Americans registered. They stood for hours in lines that spilled out the doors of the brick courthouse in Somerville, winding across the sun-scorched lawn. Ladies shielded themselves with parasols; others fended off insults from passing motorists or dodged hot coffee poured from second-story windows. As many as 1,200 blacks voted that November in the presidential election—said to be the first votes cast by any person of color in Fayette County since Reconstruction. By December, hundreds were evicted.[9]

*The suit was one of the first brought under the Civil Rights Act of 1957. Congress's first civil rights legislation since Reconstruction, the law gave the federal government new powers to prevent suppression of voting rights, and created the U.S. Civil Rights Commission to investigate voting discrimination.

THE FBI BALKED at an initial request by the Justice Department's Civil Rights Division to investigate the sharecroppers' claims. Kenneth O'Reilly describes this resistance in his book *Racial Matters: The FBI's Secret File on Black America, 1960–1972*, telling how Civil Rights Division chief Harold R. Tyler, Jr., found the FBI's General Investigative head, Alex Rosen, to be "very uncompromising."

"He was stifling the lawyers in the Division, choking everybody with paper," O'Reilly quotes Tyler as saying. Rosen penned "lengthy memos detailing the political affiliations of movement people in Tennessee and elsewhere," O'Reilly writes, noting how Rosen's views mirrored those of boss J. Edgar Hoover. "For Hoover, anyone who caused trouble for the Bureau was a subversive."[10]

In the face of mounting political pressures, however, the FBI relented. It conducted extensive field interviews.

Among agents dispatched into the rolling countryside east of Memphis was the square-jawed Lawrence, then in his sixteenth year with the local field office. The forty-one-year-old G-man bounced along dirt roads in his Chevy sedan, traversing cotton fields and mud holes. On a hiatus from internal security work—the gathering of intelligence on real or potential domestic enemies—he and longtime partner Hugh Kearney interviewed penniless, semi-literate tenant farmers in their weathered shacks. It was tedious work. For a time, the pair explored the mundane case of two African American sisters jailed in Fayette County, who couldn't pay fines for letting hogs run loose in their white landlord's cultivated fields. The NAACP believed the women's incarceration came in retaliation for voting. True or not, available records indicate the FBI found no evidence to support the claim.[11]

Lawrence and Kearney explored numbers of other voting discrimination leads, too, and their path soon overlapped with Withers's.[12]

The two G-men encountered the photographer while, ironically, examining the allegations of an elderly white woman. Katherine Rawlins Davis said she'd been victimized with tactics generally reserved for Haywood County's black underclass: she'd been blacklisted. A critical witness in court, the wizened landlady said merchants refused to sell her fertilizer and other goods after she failed to fire black tenants on her farm. One, Melvin

Dotson, was treasurer of the Haywood County Civic and Welfare League, an organization established to encourage voter registration.

Lawrence and Kearney helped identify Dotson through a photo Withers had taken. The picture, a most ordinary black-and-white photograph, shows the sharecropper dressed in his Sunday best, smiling meekly as he posed with five others while visiting a Memphis law office. Attached to a December 23, 1960, report, it is the earliest-known occasion of Withers turning over a photo to the FBI.* Unlike later reports, this one doesn't refer to the photographer as a confidential informant or source, but simply as "free-lance photographer Ernest C. Withers," with a business at 319 Beale Street.[13]

WITHIN WEEKS, THE agents began testing out Withers as an informant.

Lawrence interviewed him on January 20, 1961, asking about the recent appearance on Beale Street of an exotic religious sect founded by African American activists in the urban North: the Nation of Islam. Better known as Black Muslims, members of the group had been congregating in a rented hall a few doors down from Withers's studio. The FBI considered them a potential security threat. Listing the photographer as a "Prospective PCI (Racial)"—essentially a candidate for Potential Confidential Informant or a probationary informant reporting for the Bureau's Racial Matters program—the agent learned the Black Muslim group had pulled out of the building at 343 Beale just before Christmas. Still, Withers said, members remained on the street, openly hawking *The Herald-Dispatch*, a Los Angeles–based African American newspaper that ran a column by Elijah Muhammad, the Chicago-based leader of the Nation of Islam.

In a pattern repeated over and over across the 1960s as Lawrence investigated a range of organizations and individuals, Withers helped the agent flesh out details of the group's leadership and connect dots to sympathizers. He identified the father of one leading member. He also identified the Muslim's live-in female friend—details the agent retained in files labeled

*The author located the photo in the University of Memphis Special Collections. The picture appears in the Tent City Collection, among Justice Department records released via FOIA. There was no effort to redact Withers as the source of the photo and no indication that Lawrence was using him as an informant at that point.

"NOI"—FBI shorthand for Nation of Islam. "Withers will continue to be on the alert for information regarding the NOI and will attempt to specifically identify individual followers thereof," Lawrence wrote.[14]

Four days later, on January 24, Lawrence returned with his partner, Kearney. Lawrence headed many of the Memphis office's key subversion investigations, but Kearney took the lead on a variety of collateral security investigations, including the Nation of Islam. The two conservatively dressed agents showed Withers a photograph. They ran a series of names past him. He knew very little. But he did know this: he could identify a woman who lived with a leading Nation of Islam activist. The young lady, who Withers named, had tragically lost two young children in a house fire a year earlier, he said. Determined to flesh out their biographies—to catalog the Nation's local members and supporters—the agents pushed for details: Where do these people work? Where do they live? Who are their associates? Are there any identifying pictures?

"Withers said that he thinks he has photos of [the Muslim leader's female friend] which he took for the *Tri-State Defender* after her children burned in the fall of 1960. He will look for the picture," Lawrence wrote.[15]

Withers knew of another self-professed Black Muslim, too: Robert Walker, a solidly built amateur boxer living in South Memphis. "He will endeavor to specifically identify Robert Walker," Lawrence wrote. Later that day, Withers called back. He knew where the Black Muslims were meeting since leaving Beale—a rented space on Kentucky Street south of downtown Memphis.[16]

LAWRENCE MOVED QUICKLY. By February he sought approval to make Withers a full-fledged confidential informant. But it wouldn't be so easy. The photographer's checkered past as a policeman came back to haunt him.

Doing a background check, Lawrence paid a visit to J. C. Macdonald, the Memphis police chief who had fired Withers ten years earlier for splitting illicit profits with a bootlegger. The gruff police boss unceremoniously admitted his dislike of Lawrence's Potential Confidential Informant, calling him "untrustworthy"—an "opportunist" who "required an excessive amount of supervision." He allowed only that Withers "might be coopera-

tive with any governmental agency if he thought it would be to his advantage to do so."

"In view of the above, it is not believed that Withers can meet the Bureau's reliability requirements as a PCI (RAC) wherein his activities can be directed or controlled," Lawrence wrote in a February 7, 1961, memo.* But he wasn't ready to give up on his promising source, either.

"However, because of his many contacts in the racial field, plus his indicated willingness to cooperate with this Bureau, as attested by his recent furnishing of information, it is recommended that Withers be considered as a PCI," Lawrence wrote. "He will be contacted regarding general criminal matters. If in the course of these contacts he volunteers any information relating to security matters or racial matters, it of course will be accepted. It will be understood, of course, that his activities will not be directed in any manner with regard to racial matters or security matters."[17]

LAWRENCE'S MEMO WAS something of a ruse. Despite limitations it set, the special agent nevertheless gave Withers cash and assignments, at times directing him as he would a controlled, confidential informant. He made the photographer a Potential Confidential Informant, reports show, keeping him in that probationary status—a PCI—for as many as two years before temporarily downgrading him to the lesser rank of "Confidential Source."[†] By 1967, he'd found a way to make him a full-fledged racial CI—a directed Confidential Informant reporting on "Racial Matters," the FBI's program monitoring unrest in black America.[18]

Withers became an integral component in the broad intelligence network the FBI built in and around Memphis—an invisible sieve of surveillance that filtered the flow of activists, politicians, and civil rights soldiers of every stripe who passed through. In the name of national security, the FBI policed their politics. With his camera and his notebook, Withers pulled

*PCI is the FBI's shorthand for a Potential Confidential Informant; RAC designates a subcategory, racial informant. PCI also can designate a Potential *Criminal* Informant. Throughout the Withers papers, however, the term confidential—not criminal—is used.

†Generally, a Confidential Source is a variety of informant who is not controlled and who does not seek out information but who supplies information on demand—details "readily available" to the person through his or her work. Confidential sources can include bankers, telephone company employees, police officers, and landlords, among others.

double duty as a photojournalist and an FBI informer who helped identify and inventory a series of individuals and organizations answering the call of Eleanor Roosevelt, who wrote of the plight of the oppressed West Tennessee sharecroppers in her nationwide newspaper column. Danger loomed—not only for volunteers but for newsmen like Withers, too.[19]

"These roads that he had to travel [were] deep, dark. And in some cases, the FBI was the only protective" force, Withers's son, Billy, would say years later, defending his father. Protection from racists—often, the local police—definitely might have factored into Withers's FBI relationship. Its precise origin—who approached whom—may never be known. But, Billy Withers offered, his father may have felt he had little choice. Once an FBI agent starts asking questions "it's like an obligation to discuss it," he said.[20]

Available records don't say how Lawrence convinced his supervisors to allow the clever balancing act that made Withers an informer despite failing a reliability test. But if connivance indeed was a factor, a precedent already had been set: Withers might have been working with the FBI in an unknown capacity for as many as three years when Lawrence first attempted to sign him as his personal CI. FBI records first identify the photographer as a PCI in January 1958. Likely, he wasn't working then in racial matters or internal security but simply as a regular criminal informant.* It's difficult to say for certain what, if anything, the FBI had him doing between 1958 and 1961; the government released only a handful of records from this period.[21]

But the three-year gap in Withers's file is bookended by a singular topic: James Forman, the bold, militant civil rights activist whose trailblazing work would land him a place in the pantheon of the movement's greatest heroes.

*A key indicator of Withers's possible initial role as a criminal informant, rather than a security or racial informant, rests in the designation of his original file, No. 137-907. A 137 designation is the FBI classification for a criminal informant. His file was renumbered as 170-70 in 1964, when the FBI created the 170 classification for "extremist informants"—racial and security informants reporting on radical political organizations and activists.

TRACKING JAMES FORMAN

BLOOD RAN IN CRIMSON STREAMS down James Forman's forehead. Standing in a daze, he could make out a large white man—and the barrel of a shotgun aimed at his face.

A crowd assembled behind him. There were hundreds of them. Some waved Confederate flags. Others carried signs: "Nigger Lovers," and "Open Season on Coons." They were yelling.

"Kill him!"

"Kill the nigger!"[1]

By all accounts, the events of that steamy Sunday afternoon of August 27, 1961, outside the courthouse in Monroe, North Carolina, were as tangled and complicated as they were brutal. The day's developments would jump-start the FBI's deepening interest in Forman, a middle school English teacher from Chicago, whose intellect and disaffection led him into the front lines of one civil rights skirmish after another.

"James Forman seems to have a penchant for showing up and getting involved in racial incidents throughout the South," agent Bill Lawrence wrote to headquarters from Memphis ten days after the North Carolina incident. Forman had operated largely under the FBI's radar until then. But now, Lawrence's report highlighted Forman's flourish of activity: a trail winding across five states, from Memphis to Little Rock and its 1957 school crisis, back over to racially tense Fayette County, down to Jackson, Mississippi, where Freedom Riders had been beaten and jailed, and, finally, covering six hundred miles to the east, to Monroe, a city of about 11,000 people nestled in the rolling countryside along the South Carolina border, home to the ultraconservative Jesse Helms and a thriving Ku Klux Klan klavern. The twelve-page memo stitched together those isolated incidents, opening what would become a bulging dossier that tracked the resolute activist's movements and eventually landed him on the Security Index, the FBI's list of radicals deemed most dangerous to the country's internal stability.[2]

Lawrence pieced together his report with help from a stable of informers, most significantly an amiable news photographer he'd been courting alongside the sharecropper shacks and refugee camps in Fayette County named Ernest Withers.

In the FBI's archived files, Lawrence read how Withers had first shared details about Forman in September 1958 in Little Rock during the unrest surrounding the desegregation of schools. The civil rights advocate had come under passing suspicion then because of his association with a suspected Communist.* It would be the first of at least five incidents in which Withers informed on Forman. The rest came in 1961, as Lawrence resolved to learn more of the turbulent voting struggle in Fayette County and of Forman, the articulate Chicagoan who had thrust himself so prominently into the middle of it.

Withers came through for Lawrence in a big way. He delivered photos and relayed details about the teacher-turned-activist's political views and plans, as well as particulars of Forman's role in a deepening fissure that was developing within Fayette County's once-unified black leadership.

Withers "could not help but conclude that Forman . . . had some ulte-

* See chapter 12 for a discussion of Withers's September 28, 1958, visit to the FBI's Little Rock field office, where he and other newsmen reported suspicions about Forman and leftist writer Louis Burnham.

rior motive; otherwise, he would not have come all the way from Chicago, Illinois, to Fayette County," Lawrence wrote following a March 16, 1961, meeting with his fledgling photographer-informant. By then, Forman had become a key adviser to local movement leader John McFerren, a wiry, outspoken grocer who ran a small store outside Somerville, the Fayette County seat, and whose life had been in constant danger since leading the first voter-registration drives there in 1959. Picking up on infighting among Tent City leaders, Withers told Lawrence that some in the Fayette County movement felt Forman was "hoodwinking" McFerren.[3]

While privately echoing criticisms of Forman, in public, Withers seemed to support the Chicagoan.

Weeks before meeting with Lawrence, the photographer hosted a press conference in his Beale Street studio. There, before both black and white news crews, McFerren defended Forman, rebutting insinuations by rivals that the pair had been siphoning relief funds intended for evicted sharecroppers.*

The incident does more than illustrate the two faces—one public, one private—of Withers. It shows him as the consummate insider he'd become. In the ten years since he'd left the police force and focused on photography, he'd become widely known and trusted, a fixture in the budding civil rights movement comfortable with controversy and the range of activists who often congregated from across the country in his cluttered offices. His position of trust—and his willingness to talk—were gold to the FBI.[4]

IT'S IMPORTANT TO consider Withers's informant work in the context of the times.

Forman was an outsider—an "agitator"—a suspected subversive with purported ties to Communists at a time when such an association couldn't have been more unpopular.

*Fayette County movement leader Scott Franklin alleged McFerren issued unauthorized checks from a sharecropper relief fund and failed to give an accounting of supplies. Franklin was quoted in a January 28, 1961, report by *The Commercial Appeal* as saying McFerren and Forman "have disrupted our meetings" and "have never given an accounting of the food and clothing received and distributed." McFerren denied the allegations. He countered that he was legally authorized to sign the checks and that rivals were working to destroy the civil rights organization they established in 1959, the Fayette County Civic and Welfare League.

Ninety miles off the U.S. coast, Cuba had fallen into communist hands. President Kennedy was about to launch the disastrous Bay of Pigs invasion he hoped would topple Fidel Castro. All that winter in Memphis, the American Legion pushed its "Crusade on Communism," a program featuring a frightening film that warned of foreign invasion, *Communism on the Map.* It was shown to thousands of Mid-South schoolchildren, citizens, and civic leaders, even to a rare joint session of the Tennessee General Assembly. The film found a zealous co-sponsor in the hometown newspaper, *The Commercial Appeal*, which published a series of articles trumpeting the need "to make the public aware of the extent of communist encirclement and infiltration of this country." That spring, a civil defense exercise complete with blaring air-raid sirens warned of a five-megaton Soviet atomic bomb that if dropped here would blast "a 750-foot deep hole" in Memphis and unleash "a lethal dose of radiation."[5]

For Withers, then thirty-eight, a war veteran and a former cop, cooperating with the FBI to weed out subversives wouldn't have contradicted his values, or those of many Americans, for that matter. Indeed, Lawrence found plenty of other informers of one level or another in the black community: among the leadership of the NAACP, on local college campuses, in the business community, and on the streets.

Yet for all the negative assessments he was getting from Withers and others about Forman, the activist's reputation in the larger black community couldn't have been more different.

"The great Civil Rights fighter, James Forman, a Chicago school teacher, was in Memphis this week," the *Tri-State Defender* reported a week before the North Carolina incident. "He was en route to Jackson, Mississippi, for the trial of the Freedom Riders and offered his services as a special correspondent."[6]

Forman built that reputation while volunteering in late 1960 in Fayette County's Freedom Village. He huddled there under the stars with its denizens and battled the Christmas season chill next to campfires, listening to their hard-luck stories.

A part-time journalist and a writer working on a novel about racial oppression in the South, he wrote tenderly of campers like Georgia Mae Turner, a middle-aged sharecropper "not thin and not fat, with a smooth,

dark skin" and hands weathered "like a man's from years of heavy labor." Georgia Mae had worked in the cotton fields since she was eight—living in the same leaking shack for thirty-eight years—only to be evicted because she registered to vote. She left with a few possessions, three children, and a suffocating personal debt typical "of white cheating under the system of sharecropping, a modified form of feudalism," Forman wrote. With equal passion, he condemned those he saw as his people's oppressors—"white racists, southern sheriffs, countless police pigs, FBI agents, government officials"—articulating a worldview shaped by the racism he faced as a youth and at least two wrongful arrests, one with a vicious beating by police that drove him to the brink of insanity.[7]

WHITE AMERICA EVENTUALLY came to know and fear a militant version of Forman, with his thick Afro and bib overalls symbolizing his identification with the downtrodden—the Forman who yelled into a microphone during a civil rights rally in a Montgomery church in 1965, "If we can't sit at the table, let's knock the fucking legs off!"[8]

But in the winter of 1960–1961, when he came to Fayette County, he still wore the button-down shirts and pressed slacks of a schoolteacher.

He was dressed thus, in a stylish topcoat and with a cigar in his mouth, when Withers shot his picture. There in Freedom Village, alongside the surplus army tents and huddled sharecroppers, Forman unwittingly became part of J. Edgar Hoover's vast covert photo archive.*

Withers sold seven copies of the full-length photo for a dollar each to Lawrence, who was under pressure from his bosses to make a positive identification of the suspected subversive. The agent promptly shipped copies to headquarters and to FBI offices in Chicago, New Orleans, and Charlotte.[9]

Forman went to Fayette County with backing from the New York–based Congress of Racial Equality, or CORE, one of the so-called "Big Four" organizations at the forefront of the civil rights movement. CORE sponsored the Emergency Relief Committee, which Forman helped coordinate, one

*Withers's photo is believed to be the first the FBI obtained of Forman. According to FBI reports, it was shot "in the Fall of 1960," and turned over to Lawrence a year later, on November 30, 1961.

of a number of charities funneling money, food, and supplies to the evicted sharecroppers.

After a fallout with McFerren, Forman left in July 1961 for Nashville on a trip that would alter his life's course—and that of the civil rights movement.

He spent time with Diane Nash, her future husband, James Bevel, and members of the Nashville Student Movement, the group that had led the successful sit-in demonstrations to desegregate lunch counters in Tennessee's capital city a year earlier. Teaming with the Student Nonviolent Coordinating Committee, another Big Four organization, the Nashville students had boldly resumed the Freedom Rider campaign to desegregate interstate bus and train transportation—an effort CORE had abandoned that spring after racists firebombed a Greyhound bus in Anniston, Alabama, and savagely beat activists with fists and metal pipes in Birmingham. Escorted by National Guardsmen, the activists managed to get buses through Alabama and into Jackson, Mississippi, where numbers of the young Freedom Riders—black and white—were arrested and shipped to Parchman, the state's sepulchral work farm. Now, working with the older Forman, the student leaders considered new campaigns for the Freedom Riders.[10]

Forman traveled to Atlanta with Nash and Bevel. There, he conferred with Ella Baker, executive director of King's Southern Christian Leadership Conference. King gave a letter of endorsement to Forman's companion, Freedom Rider Paul Brooks, to investigate the racial tension gripping Monroe, North Carolina, where controversial movement leader Robert F. Williams was engaged in a summer-long fight to integrate public swimming pools. President of the local NAACP, Williams had helped rouse international political pressure three years earlier to release two black boys, ages eight and ten, who'd been jailed on molestation charges after they traded kisses with a white girl during an afternoon of play. Though the "Kissing Case" drew attention to Williams and the injustice faced by blacks in racially oppressive Monroe, the leader's militant rhetoric—he called for armed resistance to the Klan-backed violence local blacks encountered—became an embarrassing point of controversy for the budding nonviolent civil rights movement.[11]

Arriving on August 5, 1961, Forman received a startling introduction to Williams's "meet violence with violence" philosophy of self-defense: facing

death threats, Williams, a burly, ex-Marine, had assembled an arsenal, as many as forty rifles, stacked in his living room. Forman and Brooks spent the first night of their visit with guns in hand, keeping watch on Williams's front porch.* In an arguably ill-advised decision, Forman and Brooks consented to Williams's request that a team of integrated Freedom Riders join the Monroe protests.[12]

Forman left by train on August 8, heading west to Mississippi to sign up Freedom Riders to bring back to Monroe and the eventual disaster awaiting them. But first, he made a quick swing up to Chicago. He passed again through Memphis—through agent Lawrence's intelligence gauntlet.

*Tension had been building since June when Williams alleged that a Klansman in a fast-traveling automobile tried to kill him by bumping his Volkswagen from behind into a ditch along a highway. Williams reportedly gave police a license tag number, but they never arrested anyone.

A PROLIFIC INFORMANT: SUMMER 1961

WEEKS BEFORE FORMAN RETURNED TO Memphis, Ernest Withers was arrested. It happened in the sit-in demonstrations downtown. As protestors vied for seats at the segregated lunch counter at Walgreen's Drug Store, the ubiquitous photographer aimed his boxy Rolleiflex camera. The store manager objected—he'd forbidden press pictures. Soon, policemen arrived. They took Withers and his photography partner, George Hardin, to jail.

A judge fined them $26 each.[1]

It was no small sum for a man raising eight children, his youngest still just two years old. But, it didn't slow him a bit. Withers shot a series of striking photos of the protests that summer: Young women in pressed skirts and blouses picketing outside a restaurant. They smile faintly. A young white girl passes. Placards hang from their necks—"Communists can eat here. Why can't we?" and "This Store Integrates Your Money, But Segregates You." Then,

there's this masterpiece: A man pushes a small girl in a stroller. A police cruiser pulls up—right next to him. The cops and the father trade suspicious stares. He totes a hand-crafted sign—"Daddy, I Want to be Free, Too."

Withers wasn't just shooting news pictures. He was aiding the movement.

"I assisted Freedom Riders when they got back to Memphis," he said years later of that momentous summer when the movement began awakening. "But we didn't go down there [to Mississippi] photographing the Freedom Riders because they wanted to be unescorted and unidentified by the press, by the black press, because this would draw more attention for us to be there taking their picture."[2]

But he did more than aid Freedom Riders—he informed on them, too.

On July 19, Lawrence placed an urgent call to his fledgling informant: a Greyhound bus had left Chattanooga with Freedom Riders onboard. It was rumbling toward Memphis, the agent said. He wanted details. Bracing for possible racial tension, the Bureau had already learned the bus was carrying five Freedom Riders, including two Jewish rabbis. Agents knew little else. Where were they headed? Did they plan to stay overnight? Most Freedom Rider buses departed from the operation's base in Nashville, heading due south—into Alabama and Mississippi. They bypassed Memphis. This was unusual. But when Lawrence phoned Withers he caught the photographer cold—he knew nothing.[3]

No problem. Withers agreed to check into it. He called Lawrence back—an employee at the NAACP offices told him the Freedom Riders would spend the night in a dormitory at Memphis's historically black Owen College. Carloads of police and federal agents followed the activists' taxicab from the bus station to the school that night. The show of force adds intrigue to a bitter contention that spread across the era: lawmen often were eager to investigate Freedom Riders and other "outside agitators" but wouldn't offer to protect them. Unlike some Freedom Rider excursions, no angry mobs awaited this group. They passed through Memphis without incident.[4]

Lawrence paid Withers $15 (roughly equivalent to $120 in 2018) for the intel.* He was proving his worth. Repeatedly, the agent turned to the in-the-

*Lawrence's payment to Withers is a critical detail. Following *The Commercial Appeal*'s initial 2010 report, some of the photographer's supporters contended he was not an informant—he merely sold photos to the FBI. Yet repeatedly, and overwhelmingly, evidence says otherwise. Key to this discussion is a July 28, 1961, report released as part of the Withers settlement. The report, an FBI Form FD-209,

know photographer that summer as CORE, the Black Muslims, and other nontraditional organizations began opening shop in Memphis, and as individual Freedom Riders returned home from their excursions.[5]

WITHERS SECURED A mother lode of information on August 13, a Sunday, the day James Forman passed through Memphis on his fateful trip back to Monroe, North Carolina. But as he kept an eye on Forman's visit, he also visited a makeshift mosque belonging to another subject of FBI interest—the Nation of Islam.

With cameras in tow, Withers attended the small operation, located in a frame house in the thriving, middle-class African American neighborhood surrounding Kentucky Street and South Parkway—the same place he'd tipped Lawrence and Kearney to six months earlier. There, the enterprising photographer gave the FBI its first fly-on-the-wall glimpse inside the sect's Memphis activity.

He shot a series of posed photographs, two depicting NOI cleric Bolden Lawson intensely jabbing a finger, as if preaching, as he stood behind a wooden pulpit bearing Islam's crescent moon and the hand-painted inscription, "There is no God but Allah." The exotic images from inside the mosque—labeled "the temple" in FBI reports—no doubt kindled curiosity in Lawrence, a Baptist turned Lutheran, and his devoutly Catholic partner, Kearney. Among the photographic prints—each ink-stamped on back with Withers's imprint and slogan, "Pictures Tell The Story"—is one depicting eleven women and girls. Standing shoulder to shoulder or sitting side by side in folding chairs, each wears a hijab, or Islamic headscarf. Another picture depicts six men and boys, dressed in ties and suit jackets, ceremoniously clasping hands around the pulpit.[6]

In a sharp scrawl on the backs of the prints, Lawrence recorded identities of those pictured: names, addresses, occupations. Blood relationships also were noted. Lawrence didn't get these details from Withers. Instead,

documents monthly or periodic informant contact. (Agents were required to contact informants at least once a month.) It says Withers "was paid $15.00 for info furnished 7-19-61 re Free Bus Riders." Pay records were not something the newspaper was to get as part of the settlement. But here, in an isolated incident, Lawrence copied the pay record into his Freedom Riders file, and it became subject to the settlement. Additionally, scores of reports record Withers passing oral intelligence to the FBI.

another secret informant—listed in Lawrence's notes by a code number, ME 170-S—identified the participants a week later.[7]

In a pattern Lawrence would follow that summer and across this entire volatile era, he cut up some of Withers's group portraits into face shots he then divided into individual files. He constructed hundreds of such dossiers. The vast data collection was aided by regular, periodic meetings between Lawrence and Withers. In lean times, the two might talk every couple weeks or so. During the eventual chaos of the 1968 sanitation strike it became virtually a daily routine. The resolute internal security agent had no doubt the program played a vital role in U.S. national security.[8]

"We had a duty to protect the country as best we could through finding out those who were potentially or actually dangerous," he later testified to Congress. "We had a concomitant duty to detect and so report those who were innocently involved as being dupes or through other unconscious connections which they may have had."[9]

IT WAS MONDAY before Withers and Lawrence spoke about Forman's brief appearance in Memphis the day before. It's unclear who called whom. But when they finally compared notes, they seemed to share a deepening suspicion.

"Foreman [sic], on August 13, 1961, said he had just arrived in Memphis, Tennessee, from Monroe, North Carolina, where he had been in contact with the controversial Negro leader Robert Williams," Lawrence wrote after debriefing his photographer-informant. The agent noted Williams has "advocated violence to gain racial desegregation." Lawrence's report recounted an even more alarming fact: Williams had visited Cuba a year earlier, after it had fallen to Castro.*

Forman quickly was becoming a hot item at FBI headquarters—and Lawrence was delivering critical, real-time intelligence on the activist's movements, courtesy of his newfound informant, Withers.

"Foreman was somewhat evasive regarding his contacts with Williams

*According to the *Encyclopedia of African American History*, Williams visited Cuba three times between 1960 and 1961. His visits helped foster a camaraderie between militant African American activists and Cuban revolutionaries.

but did say he wanted to return to Monroe, North Carolina, by Tuesday night, August 15, 1961, to attend some big rally, of an unknown nature, in which Williams is allegedly to participate," Lawrence wrote.[10]

Withers evidently spoke with Forman as the activist attempted to get press credentials from the *Tri-State Defender* to cover the Freedom Rider trials in Jackson. It was one piece of a puzzle. Agents tracked Forman's every step through Memphis. They obtained a local phone number he used. A crisscross directory listed it to a yardman in Memphis's Orange Mound neighborhood.* The man, a family friend, denied knowledge of Forman's activism. Withers, in turn, characterized Forman as "an enigma," one who "always seems to make appearances at trouble spots," Lawrence wrote.[11]

Withers's work on Forman set a tone for the constructive relationship he and Lawrence shared for another nine years, through the very heart of the civil rights movement, until the agent finally retired in 1970.

First, it established the photographer's reliability.† Despite his past at the Memphis Police Department, despite Chief J. C. Macdonald's crushing criticism, Withers could be trusted. At the time, the FBI desperately wanted to figure out Forman. The Bureau wasn't even sure if the James Forman observed at all these different civil rights skirmishes was in fact the same person. Withers tied it together for them. Yes, he told Lawrence: this is the same James Forman he observed in Little Rock in 1958, traveling with suspected Communist Louis Burnham; the same Forman who injected himself in the Tent City struggle; the same one who is now headed to Monroe to protest with suspected subversive Robert Williams.[12]

Second, it demonstrated hustle. When outspoken Freedom Rider Daniel Horne came to Memphis that August to launch a chapter of CORE, Withers used his insider knowledge to dig up essential information: Horne is lodging at the YMCA, he told Lawrence; he's "loafing" on Beale Street. In the field of civil rights, CORE posed the first real challenge in Memphis to the NAACP, the old-guard organization whose local board included at least three FBI

*Lawrence's report of his August 14, 1961, conversation with Withers, which lists him as a "confidential informant," indicates the photographer as the likely source of the phone number, though the report is not entirely clear on this point.

†In two reports that July, Lawrence listed Withers as a "former PCI," indicating he might no longer be considering the photographer for a spot as a full-fledged confidential informant. But following the flow of details Withers supplied on Forman, the Black Muslims, CORE, and Daniel Horne, Lawrence began listing him again as a PCI.

informers. Lawrence had cause to keep increasingly militant CORE out of the city. Withers reinforced his view. The photographer said "conservative Negroes" see Horne as an opportunist, Lawrence wrote. Withers reported the young activist's biting criticisms: the NAACP is "too conservative," he said; it moves "too slow."[13]

Third—and perhaps most significantly—it established Withers as an authority in "racial matters." Lawrence had good sources in the black community. Few, however, were as well-versed on so many fronts—politics, the movement, religion, law enforcement, the media—or knew so many people. The truth was that the lily-white FBI understood little of what it meant to be black in America. It needed an interpreter. Withers's opinion, quoted voluminously in FBI reports throughout the era, mattered.

"Foreman [sic] has never made any pro-communist or anti-American statements in the presence" of Withers, Lawrence wrote. It was an objective observation that helped assess Forman's puzzling and dangerous flirtations with the movement's radical fringes.[14]

But things were developing quickly.

WHEN THEY RETURNED to Monroe, Forman and Brooks brought seventeen Freedom Riders with them—fifteen of them young, white idealists from the North. It was an uneasy alliance. The Freedom Riders planned to make a moral stand for nonviolence; Williams hoped to use the young activists to force police to arrest the Klansman who'd tried to kill him earlier that summer. For days, mobs harassed and beat members of the integrated protest group as it peacefully marched around the Union County Courthouse in downtown Monroe. One was even shot with a pellet rifle. By Saturday, August 26, local youths began to fight back. They threw stones at advancing whites. They pulled a driver from a car and beat him.[15]

The tension reached a peak on Sunday.

When the Freedom Riders showed up at the courthouse that afternoon some 2,000 screaming counter-demonstrators—many of them Klansmen—stood waiting. As Forman began evacuating the protestors, a man with a shotgun struck him with the gun barrel, opening a deep gash on his forehead. Clearing the scene, police arrested Forman along with twenty-six

Freedom Riders and their colleagues, plus a newsman, charging them with inciting a riot. No one in the white mob was charged, though they continued to riot.

When armed whites and some police began shooting, Williams mobilized his neighbors. A policeman was wounded in the thigh. Despite police barricades, a white couple, Bruce and Mabel Stegall of nearby Marshville, North Carolina, wandered into the neighborhood and were held for two hours. Williams allowed them to call police, then walk from the neighborhood. Nonetheless, police soon began characterizing the development as a "hostage situation." Sensing arrest, Williams fled that night to a safe house in Harlem. He eventually made it to Canada, then Cuba.[16]

The FBI descended on Monroe. Its response to the "race riot" and "kidnapping" embittered Forman. The Bureau had told the Monroe protestors repeatedly it couldn't offer them protection; that wasn't its job. Neither did Williams's complaint about the Klan's attack on him in June spur the FBI into action. But now, federal agents went door to door in a massive manhunt for Williams as an all-white state grand jury indicted him on kidnapping charges.*

"The FBI was, and is, the enemy of black people," Forman later wrote. "It wasn't going to arrest any local racists who violated any and all laws on the statute books. Instead, it would play a game of taking notes and pictures. The files in Washington must have been growing thick even then with documents from the civil rights movement and with photographs of us all—doing everything but screwing and maybe even that."[17]

MONROE BECAME A public relations disaster for the nonviolent movement. Because King had given Brooks a letter of endorsement, the civil rights leader did some serious backpedaling. A statement by the SCLC condemned the violence by both blacks and whites in Monroe. "Any perpetrator of violence, regardless of his stated purpose, contributes to the shame

*Despite the official charges, the judgment of history is largely scornful of the kidnapping allegation. Timothy B. Tyson writes that Williams "rescued the two whites from the mob." The couple met two police officers on their way home but didn't report an abduction. Mrs. Stegall later said, "at the time, I wasn't even thinking about being kidnapped . . . the papers, the publicity and all that stuff was what brought in that kidnapping mess."

of America," SCLC executive board member Kelly Miller Smith said in the statement.[18]

Williams spent several years in exile in Cuba. There, he broadcast his views across the South though his "Radio Free Dixie" program. Though the government viewed him as a terrorist, much of the movement embraced him. Folksinger Pete Seeger lauded him in a song, "Ballad of Monroe." Williams returned to the United States by 1970, living out his days in Michigan. The state of North Carolina eventually dropped all charges. He was buried in 1996 in Monroe, where nonviolent movement icon Rosa Parks, his longtime friend and a militant activist in her own right, eulogized him, praising "his courage and his commitment to freedom."[19]

Forman, too, survived his tactical error. Despite the Monroe fiasco, which he called "a nightmare I shall never forget," he was hired that fall as executive secretary for the Student Nonviolent Coordinating Committee (SNCC), working directly across the street from SCLC headquarters in Atlanta. From his windowless office he inspired hundreds of young civil rights volunteers who fanned out across the South.

Among them was a small platoon headed to Fayette County, where Bill Lawrence and his energetic informant, Ernest Withers, were waiting.

COMMUNISTS, SOCIALISTS, BLACK MUSLIMS, AND ASSORTED DO-GOODERS: 1962–1965

IT STRUCK WITH A SICKENING *crack!* In an instant Ed Bromberg fell, clutching his bleeding stomach. A sniper had shot him with a pellet rifle as he marched in a picket line before Monroe mayor Fred Wilson's dental office. It was only a flesh wound. But it could have been worse. Like Heath Rush worse.

A gangly college student, Rush staggered in a daze after thugs beat him to the ground. For all their trouble, the two Freedom Riders, one shot and the other beaten, were thrown in jail, charged with inciting a riot. Still, they survived. They fled the hostile North Carolina foothills for the Northeast, where Bromberg, twenty-seven, returned that fall to his native Massachusetts, and Rush, twenty, to New Hampshire, working for a time with his stepfather, a Quaker farmer. Soon, the itch returned. In a matter of weeks they were headed back south, answering the call to aid the struggling tenant farmers in Fayette and Haywood counties outside Memphis.

Lawrence's surveillance network soon began buzzing. It was hard not to notice when they arrived sometime that November of 1961. The pair, accompanied by two other young men, all of them white, moved in with a series of poor, black farm families living around New Hope Missionary Baptist Church, a weathered country chapel tucked between cotton fields south of Brownsville, the Haywood County seat. Reports of sightings trickled through the local African American community, over to Ernest Withers in Memphis, who relayed them to the FBI.

"Rush, Bromberg, et al., had formulated plans to have the ignorant and easily led Negro tenant farmers in Haywood County to picket the Haywood County Courthouse in order that they would get arrested," Lawrence wrote after speaking with Withers. Listed as "Memphis Confidential Informant T-1" in this February 12, 1962, report, the photographer had picked up details about the white outsiders from a pair of black professionals—a preacher and a schoolteacher—active in the Haywood County movement.* "By the same token, they had no plans to make bond for these [sic] arrested. Thus it was all a publicity gimmick, using Negroes as tools."[1]

As was the case with so many of the FBI's reports on outside "agitators" who came to aid the movement in Haywood and Fayette counties throughout the '60s, the document is filled with hostile assessments. Lawrence suspected the pair of being sympathizers of the Socialist Workers Party, a leftist organization that supported the pro-Castro Fair Play for Cuba Committee and had been placed on the Attorney General's List of Subversive Organizations. He made no concession to their sacrifices or their contributions to the civil rights cause—no mention of Bromberg's shooting or Rush's beating or their outrageous arrests for "inciting a riot" in North Carolina, or their harsh treatment in Mississippi weeks before, where they were imprisoned for the "crime" of escorting a young African American coed into the segregated waiting area in the train station in Jackson.[2]

The pair had returned South in answer to another call from CORE. The organization was working in Haywood and Fayette counties alongside other relief groups, including the Ohio-based Operation Freedom. The FBI

*The designation T-1 was not a permanent informant number. A T-designation is a temporary label used to identify an informant within a single report only.

viewed both with equal suspicion. Operation Freedom was led by Maurice McCrackin, a Presbyterian minister imprisoned once for refusing to pay income taxes on the grounds they financed America's war efforts—a man Withers once summed up for Lawrence as a "crack-pot" pacifist. Also heading the group was Virgie Hortenstine, a tireless Quaker peace activist. Withers would follow her across the '60s. Operation Freedom provided cash, loans, food, and supplies to local sharecroppers. But what really irked the people of conservative Haywood County was its open protests and acts of civil disobedience. McCrackin and Hortenstine both went to jail there, engaging in public fasts to protest Jim Crow. [3]

Like numbers of other civil rights activists who passed through the Memphis area, neither Rush nor Bromberg, McCrackin nor Hortenstine could be tied even remotely to any violence, sabotage, or subversive plots. Yet the FBI expended great resources investigating their politics—their militancy, their associations, and their ties to suspected Communists.

"It is felt that if this Bureau is to properly discharge its security matter and racial matter responsibility that we must keep abreast of this situation and insure that any pertinent information is properly and promptly disseminated," Lawrence wrote when dispatching Withers to Haywood County. Writing that his informant "will clear with this office before going," Lawrence said the photographer will "do a 'picture story' re this operation" and "on a strictly confidential basis, he will endeavor to learn as much as possible about the activities, plans and evidences of influences being exerted by Rush and Bromberg."[4]

"He will be alert for any information regarding Heath Rush, Edward Bromberg, and any other possible subversive influences and will be alert for any connection of these two with McCrackin . . . and Hortenstine," the agent wrote.[5]

Though Withers grew familiar with Hortenstine and McCrackin, he never did find Rush or Bromberg. Out of funds, the pair had left West Tennessee by the end of January. Years later, Rush would say he never knew the FBI had such an interest in him. He was no threat to national security—simply an idealistic young man exercising his lawful right to assist the needy, to organize dissent.

"It's really ludicrous that they could be so stupid. And so misinformed. And so prejudiced," a seventy-four-year-old Rush said in 2015. "Their fear of the Communists is so great that it clouds their thinking."[6]

THE YEAR 1962 was a great one for Withers. His photography business flourished. So did his family. His father Earl basked in his retirement from the postal service; Perry, Ernest's second-eldest son, was bound for Howard University, where he would march with its champion Air Force Reserve Officer Training Corps drill team. Meantime, Withers continued making vital contributions to the civil rights struggle.[7]

Demonstrating his commitment to the movement—and his photography business—he played a key insider's role that fall in James Meredith's admission as the first black student at the University of Mississippi. He helped hide the targeted scholar with relatives in tiny Cascilla, Mississippi, and in Memphis. He took pictures as Meredith relaxed on a living room sofa to watch Dr. King speak in a nationally televised interview and as he chatted with his attorneys. Withers and *Jet* associate editor Larry Still followed a heavily guarded caravan down to Ole Miss, where, despite a federal order, Gov. Ross Barnett refused to admit Meredith. Then, he got another tip: Meredith would be air-lifted onto campus from the Naval Air Station in Millington, Tennessee, north of Memphis. There, Withers shot pictures of armed troops surrounding a military helicopter awaiting the flight down. Back down at the Ole Miss campus he braved rioting mobs, documenting the aftermath of a night of gunfire and tear gas.[8]

"We were in the Lyceum building when all of that shooting went on down there," Withers recalled years later. "They confiscated hundreds of rifles." He shot the piles of firearms seized from the rioters as two FBI agents stood watch, gazing stoically into his camera.[9]

During this period, Withers's photography studio became a gathering place, not just for movement figures but for Black Muslims, too. They often congregated on Beale Street to worship or sell newspapers, at first *The Herald Examiner* and later *Muhammad Speaks*, the sect's official news organ. They liked Withers; they trusted him. They told him secrets—secrets he often passed to the FBI.

Among his many tips, Withers told Lawrence of the opening of another mosque in a Beale Street storefront in 1964; he reported the arrival from Birmingham of minister Nathaniel Meadows, handpicked by the Nation of Islam headquarters in Chicago to run its Memphis operations; he passed along Meadows's car tag number. He told Lawrence about plans to open a Muslim restaurant downtown; he said Black Muslims now are driving taxicabs. He passed on the names of individuals selling *Muhammad Speaks*. He reported the sect's involvement with a drummer and a trumpet player in Doodad's Orchestra, a popular Memphis jazz and blues band; he noted the comings and goings of out-of-town Muslims. He reported that two NOI members had paid a visit to Fayette County activist John McFerren.[10]

Some reports read almost like a community newsletter, chock-full of seemingly ho-hum developments. A June 1964 report, for example, records Withers saying that one Robert Hunt had applied for a janitorial job at the public library; his wife was working in a school cafeteria. Withers said that Nathaniel Meadows had made two recent trips to Birmingham.[11]

The reports seemed trivial—but they were highly intrusive. The broad sweep of the FBI's collection of personal data in the black community was staggering—an effort that reached far beyond the Nation of Islam. In one meeting in November 1961, Withers reported that Freedom Rider Carl Bush was back in Memphis and working as a salesman; that another Freedom Rider was staying at the YMCA; that many blacks now support conservative white police commissioner Claude Armour; that the Nation of Islam had been particularly quiet. In September 1963, he provided the names of three civil rights activists at odds with the established NAACP; he told how the trio had participated in Dr. King's march on Washington. He reported that a pastor had plans to picket a local supermarket; he said he'd shot pictures of a recent NAACP parade and could make copies available as needed; he reported that a local Black Muslim was now working as a pastry cook. He handed Lawrence five copies of the *Mississippi Free Press*, a controversial pro-integration newspaper, and provided the Memphis address where it was printed. In November 1964, he discussed a range of political personalities vying for leadership in the black community, sardonically reporting that "they will begin to backbite each other and dissent among themselves in their jockeying for power."[12]

Withers provided powerful insights into the thinking of the Nation of Islam's leadership. Minister Meadows told Withers he believed the FBI had tapped his phone. Was it paranoia? Available records don't say. But two things are clear: Meadows had deep-seated worries. And he trusted the personable Withers with those secrets. Once, the minister confessed that "actually he does not hate all white people as he preaches in his sermons," but only does so to manipulate his followers, to keep them "interested and enthusiastic."[13]

Much of the personal detail Withers collected is redacted from FBI reports.* But the documents make clear that when Meadows and his cadre of twenty-five to thirty followers didn't readily reveal information, Withers could find a way to get it. So it was with NOI recruit Jim Lynch in 1964. "Withers recently took a surreptitious photograph of Lynch but as yet has not developed same," Lawrence wrote. "It was made at night and may not be too clear. He feels, however, he can 'con' Lynch into having a photograph made and Withers will furnish a copy thereof to the Bureau."[14]

It was around this time that the longtime Memphis radio personality Mark Stansbury got to know Withers. He was a kid then, just nineteen. He'd dropped out of college and needed a break. He asked Withers for an internship at his studio. The photographer agreed and it changed Stansbury's life.

"He knew everybody," Stansbury later recalled. "He introduced me to everybody from the chairman of the board to the janitor. He got me back in school." Withers tapped his connections to secure recommendations from *Tri-State Defender* editor Thaddeus Stokes and WDIA disc jockey Nat D. Williams to enroll Stansbury at Lane College in Jackson, Tennessee—to get him a scholarship. "I didn't have a dime," he said. "I don't have nothing but good things to say about Ernest."[15]

But Stansbury recalls a day, too, around 1962 or 1963, when a thin white man in a suit came into the studio. "Ernest introduced me to him," he said. It was Bill Lawrence. Stansbury recalled little else of the encounter; he believes the agent stopped by to pick up some pictures. He never saw him again. Stansbury didn't think much of it. Lawrence might not have either. The agent often appeared in public—on his way to secret meetings or to

*Under *The Commercial Appeal*'s agreement in settling its suit against the FBI, it could not appeal any redactions.

interview a witness. Ernest never mentioned the FBI again, and Stansbury says he never had a clue his boss was working with them.

"He never did say anything about that."

AFTER ITS INITIAL burst in 1960 and 1961, the civil rights movement quieted in Memphis. Withers the newspaperman still scouted for big stories—finding many in the wider region, miles from Memphis. In 1963, he covered the funeral of slain NAACP field secretary Medgar Evers in Jackson, Mississippi, where police arrested him on a baseless charge and roughed him up. "My feet were half in the air and half on the ground as they hustled me to the truck," Withers told *The Memphis World* of his arrest. "I was trying to hold onto my camera and trying to duck the blows all at the same time."[16]

Increasingly, as the movement slowed in Memphis, it picked up in rural West Tennessee. There, Lawrence used Withers and others to zealously pursue tips involving outside agitators. In a pattern that would bedevil the movement in and around Greater Memphis for years to come, the agent swapped information with military intelligence, local sheriffs, and city police—a critical detail revealing the FBI's unvarnished view of the movement.[17]

Some civil rights activists known to have been informers have said they cooperated with the FBI because they saw the federal agency as a safe alternative to racist local police. Yet, unknown to many, the FBI frequently collaborated with those same police, fostering a hostile environment for civil rights workers, especially those of the wrong political pedigree.[18]

One such target was Eric Weinberger, a gaunt, somber-faced New York native who came to Brownsville in early 1962 to launch the Haywood Handicrafters League, an economic empowerment program. It produced jobs for impoverished African American women who made leather purses sold nationally as "Tote Bags for Integration." By the time Weinberger left eighteen months later, he'd been jailed four times and allegedly beaten repeatedly. The wayward son of a New York attorney, Weinberger, then an occasional carnival worker and years later an advocate for the poor in Boston, was directed to leave town or face prison on tenuous charges of assaulting a sheriff's deputy.[19]

A member of CORE, SNCC, and the New England Committee for

Nonviolent Action—groups the FBI viewed with great suspicion—the bohemian Weinberger drove a beat-up Chevrolet station wagon and reportedly lived with a black woman, vexing local mores. The FBI's New York and New Haven, Connecticut, offices were instructed to search their indices for Weinberger's "personal history data or subversive references" to share with Memphis.[20]

On the ground in Tennessee, Withers passed on tidbits he picked up from the movement grapevine: He learned of Weinberger's tote bag operation as CORE's suave national field director, Richard Haley, passed through Memphis in early March 1962.* He gleaned some of Weinberger's political leanings from Brownsville movement leader Odell Saunders.[21]

Withers gave Lawrence a firsthand account of Weinberger's release from the Haywood County Jail on March 22, 1962, a development significant to Lawrence because CORE covered the activist's bail. Accompanying *Tri-State Defender* editor Thaddeus Stokes and Memphis attorney Shepperson Wilbun, Withers shot photos depicting the pale Weinberger as he walked from a two-week jail stint to a room above Saunders's laundromat, where the smiling tote bag ladies were busy making purses. In his typically enterprising fashion, the photographer pulled double duty, selling Lawrence nine photos that the agent retained in files "for possible future reference" and peddling two others to the *Defender*. The pictures published by the newspaper omitted Weinberger but accompanied an article crediting the New York activist for the bag-making operation, noting his incarceration on a "trumped up charge of speeding." He'd been "beaten and jailed twice," the paper reported.[22]

WITHERS AGAIN PROVED his shrewdness as an intelligence collector in October 1963 when New York feminist Marjory Collins passed through Memphis. She paid Withers a visit—already, he'd cemented his standing as a must-see resource in movement circuits. A gifted photographer in her own

*Withers is listed as the sole source of Lawrence's March 9, 1962, report, though phrasing indicates others could have contributed. One possible contributor is an unnamed Memphis lawyer who refused to provide legal services for Weinberger because he was "somewhat suspicious" of the militant CORE.

right, Collins, forty-one, was writing for the leftist *National Guardian* as she made a sweeping bus tour of the South. She was chronicling poverty, civil rights abuses, and repression. Lawrence zeroed in on her politics. In a fourteen-page report labeled "Communist Influence In Racial Matters" and circulated to headquarters and a variety of field offices, the agent summarized Withers's meeting with Collins and a typewritten letter in her possession.[23]

It's unclear whether the letter, sent special delivery from Cincinnati to Memphis during Collins's stay, was purloined, given to Withers, or simply misplaced.* But it was rich in detail. Reproduced verbatim in Lawrence's report, the letter from Operation Freedom, the sharecropper relief agency, provided a range of leads the agent deemed worthy of pursuit. It named contacts in the Memphis area—people the FBI viewed with suspicion—including Rev. James Lawson, the articulate war protestor and Nashville sit-in leader who'd recently begun pastoring a church in Memphis. Pamphlets in the envelope drew links between Collins, Operation Freedom, and the Southern Conference Educational Fund, or SCEF, a New Orleans–based civil rights organization viewed by the Bureau as a communist front. But the best lead of all came in a handwritten note on the back of the envelope: a New Orleans phone number and a name—Dombrowski.[24]

SCEF's executive director, James Dombrowski, cofounded the Highlander Folk School, a training camp for organized labor and civil rights activists situated in Middle Tennessee's rocky Cumberland Plateau. The state of Tennessee shut down the school in 1961 following years of complaints from segregationists who branded it a training ground for Communists. Days before Collins passed through Memphis, Dombrowski, a Methodist minister and one-time Socialist Party member, was arrested in New Orleans, charged along with two others with violating Louisiana's Subversive Activities and Communist Control Act. The men had refused the

*Though it's possible Lawrence could have obtained it through other means, indications point to Withers. The photographer is listed in the first line of the November 15, 1963, report as the source of the subsequent information. In discussions over two successive days, Withers identified persons mentioned in the letter and addressed handwritten notations on the envelope. Though there is no direct evidence, one must consider the possibility, however, that the FBI seized the letter (Collins kept her belongings in a locker at the Greyhound bus station) and then used Withers as a sounding board. Regardless, Withers had a history of handing private letters to the FBI. One was a January 25, 1962, letter addressed to him from Quaker activist Virgie Hortenstine, who foretold a protest in Haywood County, where activists intended to get arrested for civil disobedience.

law's requirements that they register as pro-communist subversives. They were arrested—their homes searched at night at gunpoint.[25]

Withers later received a follow-up letter from Collins, mailed October 27, 1963, from New Orleans, where the liberal activist had traveled to write about Dombrowski's arrest. She reported in her letter that the charges against the three men had been dismissed.[26]

Now, Collins was ecstatic.

"Don't think the wire services even carried the story so you may not have seen it," Collins wrote, enclosing a press release. "Get the story around! It's really an important victory." The photographer did get the story around to at least one person. He gave this letter, too, to Lawrence.[27]

FIFTY YEARS LATER, it's hard to grasp the FBI's thinking. None of these outside "agitators" that Withers helped track—college student Heath Rush, do-gooder activist Eric Weinberger, liberal intellectual Marjory Collins—posed any real threat to their country. They were simply trying to help the less fortunate. Nonetheless, each serves as a chilling reminder of the paranoia of the time. By harassing many Communists and their associates, the FBI played into the hands of the segregationists, retarding the growth of civil rights.

The Communist Party was civil rights' greatest ally in Memphis in the 1940s and '50s, before Lawrence and his partners at the FBI obliterated it by shadowing activists, tracking their mail, sabotaging their employment, and driving its members to flee to other cities.

It was classic overreach stirred by palpable fear.

Daughter Nancy Lawrence Mosely recalls her father's fervor following the Cold War's earth-shattering events—the Soviets stealing America's atomic bomb secrets, China falling to the Communists, American boys dying in the Korean War.

"The atheist aspect of communism, for him that might have been as strong a reason as anything to be fearful of them," she said of her stern father, who was raised Baptist in Ohio but converted to Lutheranism in Memphis. "He never did trust a Communist."

One of Nancy's earliest memories as a child in the early 1950s

involved nighttime drives with her father in his indistinguishably ordinary black Chevy sedan. "Do you want to go by a house?" the agent would say. Nancy and her sister Betty would erupt in giggles of joy. Even as children they understood. Daddy was a G-man. He collected evidence. He watched people.[28]

Years later, they put it all together: from the shadows along the curb, their father was snooping on meetings, writing down license tags.

He was tracking Communists.

"It looked pretty ordinary. But we kind of knew he was trying to pick up some information," Nancy recalled. "It was always evening, after dark. It's always exciting going with your father."

ONE PERSON ALMOST certainly attending those meetings Lawrence observed from the shadows was William E. "Red" Davis, a stocky, auburn-headed riverboat deckhand and Communist Party organizer for Tennessee who drew special attention as an ex-Marine trained in military weaponry. Lawrence and his FBI cohorts trailed him through the city, watching his house, logging names of his visitors, and placing a mail cover on his postal address to ascertain his correspondents. This was done pursuant to an initiative called DETCOM—shorthand for Detention of Communists—that aimed to identify Communist "shock troops" and round them up in the event of a war or political crisis involving the Soviet Union.[29]

Over an intrusive, six-year security investigation, the FBI found no evidence of violence or stockpiling of weapons by Davis. But the boatman was forced from his position as port agent for the National Maritime labor union, and he fled his native Memphis for St. Louis.[30]

His brother-in-law, Larry E. McGurty, paid a heavy price, too. A labor activist who joined the Communist Party in 1946, the gangly McGurty was driven from Memphis by anticommunists in the government, media, and business. "I couldn't get a job," the raspy-voiced McGurty testified during a U.S. Senate hearing on communism in 1957. "I couldn't hold a job."[31]

McGurty and Davis both openly supported civil rights in a place and time when such ideas were immensely unpopular.

The FBI's thick files on Davis show agents followed him in 1949 to a

meeting at the segregated, black-only Abe Scharff YMCA; that he had ties to the Civil Rights Congress, a blacklisted organization on the Attorney General's List; that he had been arrested protesting the execution of Willie McGee, an African American electrocuted by the state of Mississippi for raping a white woman in a case many consider a wrongful conviction. Neighbors and coworkers told agents Davis once said, "Negroes are our brothers," and that his wife referred to her apartment building janitor as "Mr. Jamison," stating, "He is just as good as she is."[32]

McGurty tried to join the local branch of the NAACP, but was blocked—compliments of Bill Lawrence and the FBI. Several times, McGurty mailed membership fees to the organization, but they were returned at Lawrence's instruction.

"I sent him his money back," said H. T. Lockard, a prominent African American lawyer who began receiving regular visits from Lawrence at his Beale Street law office after becoming local NAACP president in 1953. The FBI agent had warned Lockard to be on the lookout for McGurty and other Communists who might try to infiltrate the organization.[33]

By the early '60s, when Lawrence latched onto Withers, the Communist Party had been so thoroughly cleansed from the Memphis area there were few leftists other than itinerant activists to watch. A September 1964 memo the Memphis office sent to headquarters defending its lack of counterintelligence actions against Communists speaks to this absence. The memo reminded the bosses in Washington that the Communist Party hadn't been active in the Memphis area since 1957, a void that grew in part out of the FBI's cooperation in sensational public hearings with segregationist Mississippi senator James Eastland and also from Lawrence's November 18, 1954, arrest of communist leader Junius Scales. The arrest fostered such fear and suspicion within Communist Party-USA that its Memphis chapter collapsed.[34]

FOR ALL THE mileage he got out of Withers, Lawrence made a change. He converted Withers's status in March 1963 to Confidential Source, a classification where he'd parked other key movement informers, including NAACP leaders Vasco and Maxine Smith. Withers stayed in that classification for

four years. As a Confidential Source—a "CS"—he was a much-tapped reference on racial matters. He still received some assignments during this time. But, more often than not, he simply picked up information during the normal course of his business. Similarly, as the decade unfolded, Withers's reporting on the Nation of Islam became irregular. The FBI tapped other unnamed informants as well as undercover officers in the Memphis Police Department for in-depth surveillance—covertly attending mosque gatherings and collecting copies of membership rosters, receipts, and minutes of meetings.[35]

The FBI's pursuit of the Nation of Islam filled a hole left by the absence of a true communist threat.

Founded in Detroit in 1930 by Wallace Fard Muhammad, the Nation preached an inflammatory theology of black superiority and disgust for the white race—the "White Devil." It also subscribed to a creation account deemed bizarre by many Christians and Muslims alike: a satanic figure, Yacub, an evil black scientist, created the white race in a misguided experiment that used murder, deceit, and lies to keep the black race—the Original People—from reproducing. The Nation's reputation for enmity mushroomed under its charismatic leader, Elijah Muhammad. ". . . The Nation of Islam (NOI) is a closely knit militant organization. It is blatantly antiwhite and a constant and relentless critic of our present form of government," reads an October 1969 FBI report citing the group's "hate-filled propaganda" as a reason "to be considered as a potential threat to the internal security of the nation." Even today, the venerable civil rights organization, the Southern Poverty Law Center, considers the Nation a "deeply racist, anti-Semitic" extremist group.[36]

Despite such assessments, historians now believe the FBI greatly overestimated NOI's threat. Unlike militant groups such as the Black Panthers, whose platform included vague aims to overthrow the government, the isolationist NOI was apolitical. Violent rhetoric aside, it posed no real threat to the white population, says leading civil rights–era historian David Garrow. "This is what is so hard for white folks to get," Garrow told me in 2013 as I prepared the first news article about Withers's work for the FBI in monitoring local Nation adherents. Arguably, the Bureau's biggest mistake was failing to understand the attributes that made the sect appealing to many

African Americans: its emphasis on black pride, faith, family, and self-reliance. That appeal surged with the national profiles of professed Black Muslims such as Malcolm X and boxer Muhammad Ali.[37]

In Memphis, the FBI gave little deference to individual rights as it kept suspicious watch on the Nation's adherents. Photos Withers shot in the mosque on Kentucky Street document little more than the lawful practice of religion—an intrusive overreach by the FBI. The many bits of intel revealed no terrorist plots. No one was the wiser. Years later, one longtime Memphis Muslim marveled when I told him some of what Withers had been doing.

"Everybody more or less knew him. He was Brother Withers," Muhammad Ziyad told me in 2014 over a plate of vegetables at The Cupboard, the venerable Midtown eatery. "And he would walk into a meeting and you would just relax.

"Who's going to turn Brother Withers down?"[38]

The soft-spoken Ziyad bristled when I asked him what consequences Withers might have faced had his informing been found out back in the day.

"To be frank with you, I think there would have been some very detrimental, harmful reactions. Not from me, now," he said with a slight grin, "but from the people he was informing on. It could have been harmful."[39]

THE ELECTRIC CROSS:
THE FBI GETS TOUGH, SUMMER 1965

VICKI GABRINER ROLLED A SHEET of stationery under her typewriter ribbon. Already, winter was setting in at the University of Wisconsin. As an icy wind rattled outside on the isthmus separating the choppy waters of lakes Monona and Mendota, she pecked out the date, December 2, 1965.

Raised in Brooklyn, in a politically active Jewish family, the idealistic, twenty-three-year-old graduate student had matriculated from Cornell University, where she first answered the call of civil rights, marching in picket lines and tending to the poor in Harlem. By the time she and her husband, Bob, enrolled at UW in 1964, they were immersed in radical politics, eventually becoming deeply involved in the budding antiwar movement in Madison, home to the National Coordinating Committee to End the War in Vietnam. But on this day her thoughts were far away, in rural Fayette County, Tennessee, where she'd spent the previous summer living among

poor black families; where she had helped lead a divisive voter registration drive.[1]

Where she'd met a photographer named Ernest Withers.

"Dear Ernie," Gabriner typed. "I'm looking at your card now and it says, 'Pictures Tell The Story,' and I remember that spread you had in your window of that guy who was killed in Viet Nam. Do you still have it up? By this time, Memphis has probably lost many more of her sons in that war."

In her letter, Gabriner offered to buy copies of a photo Withers had shot. It showed her smiling sweetly on the steps of the "Freedom House," a non-descript, cinder-block building where she and her fellow civil rights workers headquartered during that hot, liberating summer of 1965 in conservative Somerville. The town was home to a year-round electric cross that greeted visitors from atop the city water tower and to young white thugs who roamed the patchwork of winding dirt roads, dispensing vigilante justice to anyone who challenged the unforgiving Jim Crow code. Together with three to four dozen college-aged colleagues, Bob and Vicki Gabriner pushed hard against the local white establishment. Pushback came with equal force. Several of the young activists had been kicked, punched, spit upon, and threatened with death—one stabbed, another struck with a baseball bat—as they tested public accommodation laws in local restaurants, sitting together, black and white, demanding service. They marched. They registered voters. They organized a boycott of the segregated schools.[2]

Withers was there with his cameras to chronicle much of it. The youthful workers considered the older "Ernie," then forty-two, a colleague in the cause. Some visited his Beale Street studio in Memphis. One even spent the night at his house. He liked his picture of Vicki so much he hung it on his wall in Memphis.[3]

"Have you been out to Somerville at all since the summer?" she typed. "There is still a small group working in the area . . . Bob sends his regards. Yours in freedom, Vicki."

WHATEVER SENTIMENT HE might have felt for Gabriner, it conflicted with a greater allegiance: Withers handed her letter over to special agent

Bill Lawrence. Hungry for even the slightest news on their activities and associations, the FBI was assembling large files on the Gabriners.[4]

"Withers said he has sent the photographs of Vicki Gabriner to her and asked her for any news concerning other West Tennessee Voters Project personnel," Lawrence wrote in a February 1966 report sent to the FBI's Milwaukee office titled, "Vicki Gabriner, SM-C"—FBI jargon for Security Matter-Communist. "To date he has received no reply."

Lawrence had made Gabriner and her colleagues one of his big projects of 1965. He worked intensely that summer cataloging the backgrounds, activities, and associations of volunteers working for the West Tennessee Voters Project, a civil rights initiative launched by activists at Cornell that had been staging actions to assist the movement in Fayette and Haywood counties since 1963.

Ostensibly, Lawrence's investigation aimed to determine whether the Communist Party had infiltrated the group of young idealists. But just as the U.S. Senate's Church Committee later uncovered wide abuse in the FBI's scrutiny of communist influence in the movement, Lawrence's probe dug deeply into the personal lives of the Voters Project volunteers. The agent traced lawful political activity among the volunteers and their family members, at times reaching back decades. He also invested considerable resources exploring relationships among white volunteers and local black youths.

There's no evidence he directly sabotaged political support for the group, yet newly released records show his close working relationship with black leaders in Memphis helped ensure that the NAACP and other, more mainstream, civil rights groups would not assist the Voters Project as it fought against racist attacks, dubious arrests of its members, and public condemnation.

Lawrence assembled large dossiers on the group by utilizing Withers and a handful of other informers on the ground in Tennessee and New York and by gleaning details from the files of other FBI offices and law enforcement agencies. He authored an indexed, ninety-five-page monograph distributed to headquarters and nine field offices in the South, Midwest, and Northeast, where the volunteers lived or studied. The document and a series of related reports detailed the probe's findings: As many as fourteen

of the project's forty or so volunteers had "subversive references in vary-ing degrees." One was identified as a Communist Party member; two as "daughters of CP members." Several others were "active members" of the W.E.B. DuBois Clubs of America, a Communist-sponsored student organi-zation. Lawrence warned that the group's leftist leaders "are trying to build a cadre of young Negro teen-agers" in Fayette County. He feared the group had sent one particularly bright high school boy to Chicago for some type of "pro-Communist training."[5]

He warned, too, of the dangers posed by "amorous" relationships that had developed among some volunteers and local black residents. "This tends to inflame the emotions and sensibilities of the whites and many of the Negroes," he wrote.[6]

WITHERS'S ROLE AT first was modest but vital. He passed on bits of information he picked up from contacts in the African American commu-nities around Somerville and Brownsville. But his covert activities acceler-ated following a violent confrontation in downtown Somerville. Racists had attacked peaceful demonstrators there as they engaged in sit-ins choreo-graphed by the West Tennessee Voters Project. Days later, Lawrence and Withers met to discuss the developments. Much remains clouded about their May 13, 1965, meeting, yet this much is clear: it didn't involve investigating civil rights abuses. Rather, the focus involved targeting demonstrators—the "agitators" from the North who had staged the protests.

Records show Lawrence advised the photographer of the FBI's "internal security responsibilities and intelligence responsibilities," sharing his fear that Communists again were influencing the Fayette County movement. Part of the discussion involved local movement leader John McFerren and his ties to white Louisville, Kentucky–based civil rights activists Carl and Anne Braden. Segregationists had smeared the couple for years as commu-nist sympathizers, and the FBI kept large files on them.[*]

[*]The Bradens faced repeated reprisals for their civil rights work. The couple was charged in 1954 under Kentucky's sedition law after helping a black family obtain a home in a white Louisville suburb. Con-victed, Carl Braden served several months in prison before the Supreme Court invalidated the law. He was imprisoned again for contempt of Congress in 1961 for refusing to testify before the House Un-American Activities Committee, which he and Anne considered a major enabler of segregation.

According to the agent's report, Withers said, as far as he knew, McFerren wasn't pro-communist. But, because of his "ignorance," he could be "an easy dupe." The Bradens "have completely ingratiated themselves" with McFerren, Withers told Lawrence. His evidence: the couple had helped McFerren obtain a $12,000 business loan for his grocery, he said. "For this reason," Lawrence wrote, summing up Withers's statements, "no one could logically convince [McFerren] that the Bradens or any of their associates were security risks."

Nonetheless, Withers, planning another picture story in Fayette County for *Jet* magazine, agreed to pursue the agent's leads.

"He will be alert for the identities of outsiders who are infiltrating Fayette County," Lawrence wrote.[7]

WITHERS WAS PARTICULARLY busy in 1965. His studio boomed. And he was chronicling another Memphis music renaissance. Stax Records opened in 1957. Through the 1960s, the label had a string of hits, broadcasting Memphis soul to the world. Withers knew and photographed all the big stars—Rufus Thomas, who bawled his gravel-voiced "Walking the Dog"; Rufus's daughter, Carla ("Gee Whiz" and "Cause I Love You"); house band Booker T. and the M.G.s; and the biggest of them all, Otis Redding and Isaac Hayes. His Stax contacts included founder Jimmy Stewart and Al Bell, the eventual co-owner, the man who took the label into the '70s with acts like the Staples Singers, soothing America's wounded soul with classics like "Respect Yourself" and "I'll Take You There."

"It was just changing times," Withers told an interviewer years later about Memphis's mid-'60s Stax scene. Changing musically—and politically, he told the FBI.[8]

Over the next years, he'd pass on a string of tips: Al Bell and singer Al Green ("Let's Stay Together"; "Tired of Being Alone") made cash donations to an arm of the radical Black Panthers, he said. A Stax executive donated to a wing of the Communist Party; Bell paid a lot of attention to a militant activist-singer, John Gary Williams; Stax provides "some financial support" to the Black Arcade, an African culture clothing store viewed with suspicion by the FBI. He told Lawrence about an evening he spent at Stax

owner Jimmy Stewart's house, where comedian-activist Dick Gregory was visiting.

"Gregory described J. Edgar Hoover as a willing stooge of all presidents under whom he has served," the agent wrote after debriefing Withers, who provided pictures, too. "He attacked Hoover's personal views, and attacked him for having never married, saying that he therefore must be a homosexual."[9]

But he found time that summer to venture out to Fayette County on news assignments, again doubling as an intelligence gatherer in rural West Tennessee. As Lawrence put it, his picture-taking informant met and "gained the confidence" of the Voters Project's white volunteers, a development that filled FBI files with swaths of political intelligence: gossip, biographical details, summaries of strategic plans—and photographs. As many as forty-nine photos Withers shot appear in the Memphis office's files on the Voters Project. Some are posed; others capture activists marching or picketing; still others are candid pictures shot behind the scenes.

In one, Memphis community leader O. Z. Evers, then forty, puffs a pipe as he huddles alongside a parked white sedan with four young activists: two white, two black. Evers became a local civil rights hero in 1958 when, like Rosa Parks, he successfully challenged Memphis's segregated public buses. Withers had trumpeted Evers's fame then, shooting a gritty news photo on the steps of the federal courthouse in Memphis depicting the activist's victorious attorneys. This photographic print, however, shot in rural West Tennessee, was bound for the FBI's cloistered intelligence vaults—Evers had grown increasingly militant in recent years, forming a chapter of CORE, branded by the FBI as a "black nationalist hate group."*

Withers's picture of a long line of marchers carrying placards reading "Freedom Now!" and "Black and White Together" ran on the front page of the *Tri-State Defender*; an identical photo landed in the Voters Project files. Again, Lawrence scrawled in key details: Leading the march was local CORE leader Rev. James Edward Smith, a fedora-sporting African Ameri-

*Withers's informing on Evers was substantial. The author counted twenty-two separate reports between 1963 and 1969 in which the photographer relayed intelligence involving Evers. Withers also handed the FBI three photos of the activist. As early as 1963, the informant described a rift between the local NAACP and Evers, who criticized the organization as "conservative" and "indifferent" to the struggles of the poor.

can minister; and Stuart J. Mitchell, a tall, white Cornell student from New England with smoke-black sunglasses. A couple steps behind, Jerry Jenkins, a black teenager from Somerville, walked under a broad straw hat. He became the focus of a months-long inquiry.[10]

Jenkins attended academically stifling Fayette Training School, where black youths received vocational and agricultural instruction. The school's academic term started in August and recessed in the fall for the cotton harvest. Protesting the split term and degrading conditions, the CORE-Voters Project team organized a crippling boycott. It kept four of every five black schoolchildren at home, threatening the closure of Fayette County's "Negro" schools before the boycott finally lifted. But Jenkins didn't return. He caught a ride north to Chicago. Word filtered back to the FBI through Withers and others that he was living there with a white family, suspected subversives. "It tends to appear substantially that pro-Communist oriented persons in the WTVP have singled out Jerry Jenkins for further training hoping to use him as a tool," Lawrence wrote, theorizing "they may be planning to subversively indoctrinate this young Negro." Agents in two states checked school records and interviewed witnesses.[11]

"They were way off track," Jenkins said decades later. Yes, he spent a year in Chicago. He went up with a white couple from the Voters Project. But he didn't do it for communist training. He left fleeing Fayette's inferior schools and his mother's financial troubles. Authorities cut her from welfare rolls after she registered to vote, he said. "I was very adamant about trying to get a decent education. An opportunity was afforded me," said Jenkins, who eventually left Fayette County for good for a long career in the army. "And that was really the end of that story." Despite persistent contentions in Lawrence's reports that Voters Project volunteers might be teaching Marxist principles to Fayette County's black youth, Jenkins said he never saw any of that. "They organized the students in protests against white supremacy. Protests of Jim Crow. And discrimination," he said. "That's it."[12]

HEEDING LAWRENCE'S DIRECTIVE—ESTABLISH the identities of the "outsiders"—Withers shot numbers of individual portraits: Here is Cornell graduate Bob Gabriner, in his shirtsleeves, huddled with a couple of local

African American activists. There is a close-up of his wife, Vicki, beaming into the camera, her hair drawn up in a bun. The Gabriners are under suspicion for their ties to the Bradens and for a tenuous connection to the W.E.B. DuBois Clubs of America. Another picture shows a young man sitting on a stool wearing large, horn-rimmed glasses. Henry Balser, Lawrence notes, was among students who'd disrupted a Reserve Officer Training Program ceremony at Cornell in protest of the Vietnam War. Self-described "Jewish Quaker" Deborah Rib appears in several photos: relaxing under a shade tree; talking with a local black leader; gesturing to make a point.[13]

A recent graduate of the University of Wisconsin, the outspoken Rib stirred controversy as she organized the school boycott. Typically harsh in his assessments of suspected subversives, Lawrence recorded an informer's cruel observation that Rib "is a most unimpressive person, fat, ugly, and one who has a repulsive personality." Withers reported more that would rankle the conservative Lawrence. Spending time with the Voters Project volunteers, the photographer overheard Rib brag she'd once invited black separatist Malcolm X to speak in Madison. She also hoped to bring Black Muslims to Fayette County to teach African American history.* As Lawrence recorded it, Withers said Rib was "well aware" of "stories going around Fayette County" of "the brazen and open inter-racial sex life being promoted by WTVP leaders." Indeed, stories ran rampant. As Lawrence noted, some Voters Project workers "became openly demonstrative, in an amorous fashion with the young Negroes" during a public march. [14]

Not only did the incident trigger violent reprisals from Fayette County's Old South community, it helped foment a giant public relations disaster that would augur the Voters Project's ultimate demise. It's uncertain if the FBI's intense investigation into the black-white relationships helped undermine the Voters Project. Yet Lawrence's reports make it clear the FBI was at least *prepared* to undercut the group.

A disturbing example involves another of Withers's photos—a picture of Voters Project leader Danny Beagle, twenty-one, holding a teenaged

*Withers dutifully reported his personal contacts with Rib. The photographer told Lawrence in August 1965 that suspected subversive Rib was staying in Memphis at the Holiday Inn on Summer Avenue. The agent promptly contacted the hotel manager and checked Rib's phone records. When Rib later mailed Withers a holiday card over the Christmas season, Withers gave it to Lawrence along with the activist's new address and home and work phone numbers in New York.

African American girl in his lap. Lawrence sent it to headquarters, to the personal attention of William C. Sullivan, Hoover's director of COINTEL-PRO—its dirty tricks operations. "The fact that it was called to Sullivan's attention is, I think, very suggestive," said FBI surveillance historian Athan Theoharis, who reviewed the records. "They were really trying to find ways to contain these activists because they couldn't prosecute them."[15]

The photo—a group picture shot outdoors—is clearly posed. More than fifty years later, Beagle said he had no memory of it. But when he saw it, he questioned what Withers had been up to when he shot it.

"It looks flirtatious at the very least," he said. "And, also, what's clear is that he got us because we trusted him. He got us to relax and to just be goofing around in a way that looked like something that it wasn't."[16]

Theoharis concurred.

"Withers is no innocent," he said. "These people are caught off guard. What's he doing? He breaches that wall of privacy. He is no innocent. He knows what the Bureau wants."[17]

THOUGH THE VOTERS Project had enjoyed broad support among local movement leaders the previous summer, their alliance began dissolving in May of 1965, around the time the FBI began its intense focus.

Cornell professor Douglas Dowd, cofounder of the project, came down to Somerville that June hoping to mend fences. He thought he'd done just that. But after his return to New York a surprise awaited him. Whitacker Stokes, Jr., a Nashville attorney representing Original Fayette County Civic and Welfare League leaders John and Viola McFerren, wrote a letter published in *The Ithaca Journal* criticizing the project for "crimes" against the people of Fayette County, chiefly sexual immorality and deploying the "direct action" tactics of CORE and SNCC—sit-ins, marches, and the aggressive demand for equal access to restaurants, bathrooms, and other public accommodations.

In a blistering response, Dowd admitted some improper conduct, saying violators had been sent home. But he astutely focused on criticisms of the project's tactics.

"Don't you see that your accusations against the Project are exactly the

same as those leveled against the civil rights movement by the racists in the South?" he wrote. "The essential difference between the Project this year, and the six or so people in the League who are against the Project, is that the Project is trying to continue to work with the overwhelming majority of the people in the county who know that there is a long way to go if the people are to have freedom, and to have any kind of decent life; whereas you opponents think that everything is going to come out fine if you work with the whites in Somerville."[18]

The sudden, "drastic" shift "very much made me wonder what was going on behind the scenes with you and the others," Dowd wrote.

ONE THING GOING on behind the scenes involved Lawrence. He was working his many political contacts. Following the chaotic demonstration on May 1, the resolute agent reached out to the Memphis branch of the NAACP, the largest in the region. For the better part of a decade now he had enjoyed an amiable, even influential rapport with its leadership. When he spoke on May 7 with A. W. Willis, the venerable NAACP attorney who'd been elected the previous fall as the first African American member of the Tennessee General Assembly since Reconstruction, he learned they were on the same page.* The NAACP would not cooperate with the Voters Project.

In fact, Willis reported that Gov. Frank Clement and other state officials were so concerned about the "outside agitation," they were encouraging the liberal Tennessee Council on Human Relations to intervene—to quiet the unrest by halting the demonstrations. A wild card, Willis said, was McFerren. "He said he had never had too much confidence in Viola or John McFerren as they were too easily influenced by outsiders," Lawrence wrote of his conversation with Willis. "He felt, however, that if the whites in Fayette County will meet the Negroes 'half way' that much of the outside influence can be averted and sterilized."[19]

Lawrence checked with the Memphis Urban League. Like the NAACP,

*Willis's name is redacted in the report. However, his identity is easily discerned. He is listed as a "Negro," with an address at 588 Vance, and "a member of the Tennessee State Legislature." One person fit that description in 1965: A. W. Willis, Jr.

it, too, had been approached by the Voters Project seeking support. The agent was assured the Urban League wouldn't cooperate either.[20]

Though a small contingent of Voters Project volunteers returned the following summer, 1966, helping elect six African American candidates to the thirty-seven-member Fayette County Quarterly Court—the first blacks elected there since Reconstruction—the initiative ran out of gas. Touring the South in a rental car that August, organizers Bob and Vicki Gabriner made one last pass through Fayette County, where they bumped into their old friend, Withers, a meeting he dutifully reported to Lawrence along with a description of the couple's car: a brown Valiant bearing a Shelby County tag, AU-7927.[21]

JAMES LAWSON, CIVIL RIGHTS, AND THE PEACE MOVEMENT

THEY MARCHED IN SOLEMN PROCESSION. Pacing the Memphis streets, some carried placards—"War Is Wrong," "Peace Now," and "Make War on Poverty, Not on the Vietnamese!" Ernest Withers tagged along on this bright April afternoon in 1966, snapping pictures. One of the Mid-South's first large demonstrations protesting American involvement in Vietnam, it traversed the city, winding from a point near Memphis Theological Seminary in Midtown to the main Post Office downtown, some five miles. The amiable photographer blended with the crowd. Flashing his press cards, he conscripted a student to scribble notes for him as he took a series of broad crowd shots and tight, focused close-ups of the participants:

A young white couple sharing a laugh;

A bearded, professorial-looking man in a light-colored suit jacket smoking a pipe as he paused on the side of the road;

A thin African-American woman carrying a sign quoting progressive statesman Hiram Johnson: "In war, the first casualty is truth."

Truth definitely suffered that day. As Withers mingled with the crowd, he forged relationships with several of the forty or so demonstrators, convincing some he was a comrade in the cause. In time, he would receive invitations to coffees and small group discussions on the war. Once, he even offered his photography studio as a mailing address for a homegrown antiwar news publication under investigation by the FBI.

But Withers wasn't here to lend his support to the antiwar effort.

He was on a mission.

An army veteran with conservative views that aligned with most of Middle America when it came to Vietnam and the Cold War, he'd been given explicit instructions from agent Lawrence to help catalog the blossoming antiwar movement in Memphis. Days after the march, he delivered eighty 8-by-10 photographic prints, pictures he'd shot for the FBI.

"Ernest C. Withers . . . a Negro photographer who has a press card for *'Jet* Magazine' and who also has a press card for The *'Tri-State Defender,'* agreed to cover the proposed march . . . posing as a news man,"* Lawrence wrote in his after-action report, noting his informant agreed to "be alert to take photographs of every participant in the march including identification type photos; in other words, he would make every effort to get good facial views of the participants."[1]

ONE PARTICIPANT OF special interest to the FBI was Rev. James Lawson, the intellectual United Methodist minister whose long and distinguished résumé as an activist bridged the civil rights and peace movements. In the eyes of the Bureau, both these struggles posed threats to the nation's stability. But the FBI took a particularly dim view of the campaign to end the Vietnam War. As Hoover and foot soldiers like Lawrence saw it, this was

*Lawrence's characterization that Withers "posed" as a newsman is illuminating. Covering the march may have been the agent's idea, yet Withers often pulled double duty, shooting for the FBI and a news organization to maximize sales. This event appears no different. A photo of a marching James Lawson getting heckled appeared on the April 30, 1966, front page of the *Tri-State Defender*. Uncredited, the photo almost certainly is Withers's.

an anti-American crusade, a scourge brimming with Communists, traitors, and subversives doing the bidding of Moscow and Hanoi, giving aid and comfort to the enemy. And Lawson, a conscientious objector who went to prison in 1951 for refusing to report for the draft—a close adviser of Martin Luther King, Jr., credited with shaping his views on nonviolent struggle and his eventual opposition to the war—was seen as the very sort of dangerous radical the government needed to keep an eye on.

From virtually the day Lawson moved to Memphis in 1962, Withers began reporting the clergyman's doings back to Lawrence. Over the next eight years, the photographer passed on a stream of tips, telling Lawrence details of Lawson's personal life; of a trip he planned to take to communist-bloc Czechoslovakia; of doctrinal differences causing strife between Lawson and his congregation; of discontent among the city's conservative black leadership, who, Withers said, would prefer that Lawson leave; of the minister's plans to coach young men on ways to dodge the draft.

"If this is true, then Ernie abused our friendship," Lawson said in 2010 as I first reported Withers's secret role as an informant. Back then, we knew some of what the photographer had passed on regarding Lawson, but not much. When the FBI released more records after we settled our lawsuit in 2013, a fuller picture emerged: Withers had passed on nearly four dozen tips on Lawson between 1962 and 1970, all the while maintaining a personal and professional relationship with the clergyman.*

Yet when I shared these new details with him, Lawson seemed undisturbed. Somehow, his view had softened.

"I of course was not aware of his using our kinship for reporting to the FBI—and that he was being paid for it," Lawson said in a soft voice. With measured words, he condemned the FBI's snooping. Yet, good soul that he is, he offered only reconciliation to his old friend, Withers.

"Well, if I carried on a less transparent life," the retired clergyman proffered, "I suppose I might think then that a friend who did this would be abusive. But I'm not going to break kinship with Ernie Withers."[2]

*The author counted forty-seven separate reports containing information Withers passed to the FBI involving Lawson's personal and public life. The actual number may be higher. Though Lawson signed a privacy waiver authorizing the FBI to release his file to the author as part of the Withers settlement, the clergyman's file is one of several the government failed to produce. The author is working to reconcile the matter.

Lawson was eighty-six now, his full head of hair turned snow white. Though I'd interviewed him many times over the years, both over the phone and in person, he never ceased to amaze me. He was a legend. He had been a key adviser to the Freedom Riders. Vanderbilt kicked him out of its divinity school for leading the landmark Nashville sit-ins in 1960 that broadcast the nascent movement's fervor like so many plenteous seeds among a generation of young student activists across the South. And it was Lawson who invited King in 1968 to Memphis, where the civil rights leader was shot while mobilizing the sanitation workers.

His opinion carries significant weight.

As he saw it, Withers likely failed to grasp the FBI's purpose. In his clipped Northern accent that once was a familiar clarion call across his adopted South, Lawson blasted the FBI's intelligence gathering, which he called "a waste of government money that helped to create enmity towards me and the movement." But he refused to blame his old friend. His bottom line: the man he knew affectionately as Ernie simply had been used by people like Hoover.

THOUGH LAWSON KNEW of no specific act by the FBI to undermine him, records suggest the agency did just that, in a roundabout way: Lawrence leveraged his close working relationship with the Memphis branch of the NAACP to keep the minister's outspoken activism in check. It's long been known that young mavericks like Lawson had a tough go of it when they pushed the white establishment to end segregation. Less known, however, is how they often had to battle conservative black leaders, too. In Memphis, cooperation between the FBI and NAACP leaders seemed to turn on the mutual interest in fighting segregation gradually, within the system, favoring litigation over agitation and demonstration.

Lawrence had worked with the NAACP as far back as 1953, teaming with then–branch president H. T. Lockard to keep Communists from joining the organization. By the 1960s, the enterprising agent found three other recruits among the NAACP's leadership—executive secretary Maxine Smith; her husband, dentist Vasco Smith; and banker Jesse Turner, Sr., the local branch president. Historian David Garrow first outed the trio in his

groundbreaking 1981 book, *The FBI and Martin Luther King, Jr.: From "Solo" to Memphis*, explaining in the endnotes that the FBI's files listed each as an "extremist informant." The revelation caused quite a stir. The Smiths sued for libel—and lost. Late in life, Maxine remained vexed. Like Lockard, she said she was never paid—an important distinction considering what we later learned about Withers.[3]

"No one has ever offered Vasco and me one penny. No one dare say that," she told me in 2009 near her indoor pool in the couple's spacious home along South Parkway East, the tony neighborhood that's been home to Memphis's African American elite for the past six decades. Then nearly eighty, the First Lady of the Memphis movement grew fiery as she thought it over. Yes, she said. She and Vasco cooperated with Lawrence. But she came to regret it.[4]

"He used to come out here a whole lot—right here," she said, angrily thrusting a finger toward the living room floor. She related the same story Jim had told me all those years before, how Lawrence used the mutual love of jazz to build a rapport with Vasco.* It started sometime in the early '60s, she said. By then, Lawrence already was talking regularly with two NAACP board members, prominent civil rights attorneys A. W. Willis and Russell Sugarmon, she said. Perhaps it was unavoidable. The FBI was a power few could resist. Thurgood Marshall cooperated. The NAACP Legal Defense attorney and future Supreme Court justice occasionally passed confidential details to the Bureau in the 1950s, reportedly for a mixture of reasons: to help purge Communists from his organization, to secure help in investigating civil rights crimes, and to fuel his own personal ambition to connect with powerful people. NAACP leader Roy Wilkins cooperated, too, though allegedly for more suspect reasons, principally his jealousy of Dr. King.[5]

For the Smiths, the FBI posed a safe alternative to the Memphis Police Department, which had brutalized and harassed the black community for decades. "We thought it was for our own protection," she said. "We had nothing to hide." Her sentiment isn't uncommon. FBI files are filled with do-gooders and dupes—individuals who unwittingly were coded in Bureau files as informants because they answered the questions of a friendly agent. Having the Smiths and

*Jim also characterized the Smiths as unpaid sources rather than high-level informants.

Turner as allies was huge. Though younger activists often viewed the NAACP leaders dimly, they were accomplished civil rights warriors. At great personal risk, Turner had pushed to integrate Memphis libraries as early as 1957; Maxine Smith tried to integrate Memphis State the same year.[6]

What exactly the Smiths shared with Lawrence she wouldn't say. A few reports have come out. They show that during the combustible 1968 sanitation strike, Maxine and Vasco helped the FBI gauge the mood of the black community. They passed on news of plans, sentiments, and anxieties of insiders, as well as tidbits on petty rivalries threatening to undermine the movement. All in all, the details helped Lawrence gauge the struggle's direction. As extremist informants, the Smiths also no doubt helped identify at least some true "extremists." Yet, in the agent's skeptical view, extremists ranged from everything from revolutionary black nationalists to moderates like Lawson and King.[7]

Lawrence could now use Withers to help measure the effectiveness of his collaboration with the NAACP—and to help keep an eye on troublemakers who would disrupt the alliance's delicate balance.

Troublemakers like Lawson.

"James M. Lawson is in favor of as many mass racial demonstrations as possible, despite the fact that the local NAACP leadership is more conservative and is generally averse to demonstrations," the agent wrote in a July 12, 1963, report after speaking with Withers. Calling Lawson "a thorn in the side" of the city's traditionalist black leadership, the photographer said Lawson was "put on" the executive board of the Memphis NAACP branch, evidently as a way to placate him. Withers emphasized, however, that despite Lawson's NAACP membership, he "is primarily affiliated" with Martin Luther King, Jr.'s Southern Christian Leadership Conference.[8]

And that was a critical distinction in mid-1963.

Though it's popular today to side with King, the now-sainted martyr of civil rights, at that moment in history his tactics remained divisive within the movement, even in places like Birmingham and Memphis where segregation and police brutality were especially pernicious.*

*The World, the black weekly newspaper in Birmingham, opined at the height of the movement there that direct action was "both wasteful and worthless." Conversely, King argued the greatest obstacle to civil rights wasn't the Ku Klux Klan or the White Citizens Council but "the white moderate who is more devoted to 'order' than to justice."

The term most associated with King, nonviolence, didn't mean the same then as it does now. Many people today think of a nonviolent activist in its simplest form—one who opposes violence. The image of a peaceful proponent of change comes to mind. That image is often contrasted with the black revolutionary, the Black Panther, the advocate of force. Though it's a valid illustration for the late '60s, when ultra-militancy replaced the movement's early innocence, in 1963 nonviolence was code to many for something far different: An agitator. A troublemaker. An instigator of chaos.

Nonviolent action meant "direct action"—disruptive demonstrations, sit-ins, boycotts—rather than traditional means, such as suing in court and letting the slow wheels of justice grind.

So when Withers reported to Lawrence that Lawson was "a self-admitted advocate of non-violence," that he was traveling back and forth from Birmingham to assist King and that he was trying to orchestrate sympathy marches in Memphis—tips the photographer relayed over Lawson's first year in Memphis—these weren't attempts at praise or hollow bits of information. In the FBI's view, they were insightful nuggets of intelligence from a paid informant to help contain a potential security threat.[9]

"We represented a leadership that wanted to speed up the process of dismantling Jim Crow law and segregation and racism," Lawson recalled years later. "Conventional American leadership at that time in the white community and the black community was of the mind that if we played along, the stuff would disappear of its own weight."[10]

LAWSON FIRST STUDIED nonviolent direct action on a three-year Methodist Church mission in India. Teaching and ministering in Nagpur, on India's tropical peninsula, he endured long days of stifling heat by reading up on the Indian independence movement and the teachings of its recently assassinated spiritual leader, Mohandas Gandhi. He took particular interest in nonviolent resistance—*satyagraha*—or soul force, the Gandhian tactic of civil disobedience. He took his ideas with him when he left India in 1956, enrolling in graduate school at Oberlin College in northern Ohio—a trajectory that led to Martin Luther King, Jr.[11]

In his old age, Lawson could still recall the day he met King—February

6, 1957—reciting it with the familiarity of a birthday or an anniversary. King was speaking at Oberlin when Lawson introduced himself. They went out to dinner. "King and I hit it off immediately," he said. They were the same age, twenty-eight, both sons of preachers. "I mentioned to him that eventually when I finished graduate degrees I would probably work to get a United Methodist pulpit congregation in the Southeast. And King immediately responded by saying, 'Come now. Don't wait.'" The South needed him, he said. The movement needed him. Lawson took it to heart.[12]

He dropped out of Oberlin and took a job with the Fellowship of Reconciliation in Nashville. His boss there: Glenn Smiley, the Methodist minister who rode that first integrated bus in Montgomery with King and Abernathy—the white man in the fedora and black-rimmed eyeglasses who appears in the foreground of Withers's famous photo.[13]

As a FOR field secretary, Lawson zealously traversed the South, spreading word of the coming movement like a biblical prophet. He held workshops through the late '50s, teaching about soul force—the strategy of nonviolence. Gandhi had said nonviolence is misunderstood. It's not passive resistance, he said. It's not inaction or weakness. It's action. It's strength—forcing an oppressor to concede to the truth, to the right of the oppressed to be free. These were points Lawson emphasized as he organized workshops across the South, traveling to backwaters like Anniston, Alabama, and Savannah, Georgia, and to Dixie's urban outposts: Jackson, Mississippi; Charlottesville, Virginia; Columbia, South Carolina; and Little Rock, Arkansas.[14]

The seeds he planted finally took root and blossomed in 1960.

That's when the sit-ins erupted—the movement's second great mass act of nonviolent direct action. Lawson was its central architect.

The student-led sit-ins started February 1, 1960, in Greensboro, North Carolina. They reached Nashville, Lawson's home base, days later. Nashville's movement soon rivaled Greensboro's, branching out and inspiring dozens of similar efforts in cities across the South, including Memphis. Then a thirty-one-year-old divinity student at Vanderbilt University, Lawson had planned the sit-ins for weeks. Hollywood memorialized his role in the 2013 film, *The Butler*, dramatizing Lawson's now legendary workshops on nonviolent action. He instructed student activists at historically black Fisk University, Tennessee A&I (later renamed Tennessee State University), Meharry

Medical College, and American Baptist Theological Seminary on the power of soul force, the power to effect change through truth. He taught them, too, about what to expect when taking a seat at white-only lunch counters.[15]

In 1960, this was radical stuff—and dangerous, too. Several students were beaten. One Nashville activist's home was bombed. As Lawson would admit years later, the simple act of an African American taking a seat at a white lunch counter amounted then to "extremely militant behavior."[16]

For his role, the intense, bespectacled Lawson was arrested—charged with conspiracy to disrupt trade and commerce—and expelled from Vanderbilt. As police led him away from Nashville's First Baptist Church, past a marquee on the lawn that declared, "Father, Forgive Them," the world watched—including some disapproving members of his own race. Despite the Nashville Student Movement's success in desegregating the city's lunch counters and movie theaters, it remained controversial among black America's older, more conservative leadership.

Because of that, Lawson paid yet another price.

It's a point largely forgotten, but King wanted to hire Lawson in the wake of the sit-ins. However, the NAACP's Roy Wilkins blocked it. It happened like this: King offered Lawson a position on his executive staff at the Southern Christian Leadership Conference, where, as special projects director, he would recruit and train a "nonviolent army" consisting of hundreds of volunteers "on call" for ready deployment to trouble spots. But Wilkins wouldn't allow it. The NAACP had been lukewarm toward the sit-ins (leaders of the Greensboro movement had solicited help from CORE after the NAACP balked), and Lawson didn't help his cause when he publicly railed against the organization's "timid" reaction. Wilkins fired off a letter to King in response. He warned the civil rights leader of an impending "break between our groups" if Lawson was hired.[17]

The introspective divinity student took it hard. He retreated north, where he finished divinity school at Boston University, King's alma mater. He returned to Nashville the following year to join his former student trainees as they embarked on a greater, even more dangerous, venture: the Freedom Rides. Diane Nash and her student colleagues elected to resume the integrated bus rides CORE had abandoned following the brutal attacks in Alabama. Now, where even King hesitated, Lawson jumped in: he agreed to

ride. He was arrested along with other Freedom Riders on May 24, 1961, in Jackson, Mississippi, as they de-boarded at the city's segregated bus station. Together, they spent the next several weeks behind bars, first in the Hinds County Jail and later at Parchman Prison, suffering through crowded cells, stopped-up toilets, and the stifling summer heat.

None of it slowed him down. By 1962, Lawson was an ordained minister. The Methodist Church returned him to the South, first to a church in a small town near Nashville and then, that June, to Memphis.[18]

WITHERS REPORTED LAWSON'S arrival on June 28, 1962, emphasizing the "Freedom Movement" advocate's controversial past. Details Withers relayed that day came as part of an intelligence roundup, one in a series of sweeping updates on African American affairs that the photographer periodically gave Lawrence as a racial informant. This time, Withers had little to report: There was no new racial strife in Fayette or Haywood counties, he said. He knew of no planned sit-ins or "other Negro demonstrations in Memphis." On the Nation of Islam front, sect member Henry Kelly had left a new copy of *Muhammad Speaks* at Withers's studio while he was out; the photographer offered to re-contact the Muslim to ascertain his recent activities.

And there was this:

"Withers pointed out that as a matter of possible interest, Reverend J. M. Lawson, Negro, has been named as the new pastor of Centenary Methodist Church, 878 Mississippi Boulevard," Lawrence wrote. The agent put the brief, two-page report titled "Ernest C. Withers, PCI"—Potential Confidential Informant—in Withers's informant file and circulated copies to four other investigative files on racial strife and subversion.* He regurgitated a summary of Lawson's controversy—his role in the Nashville sit-ins, his expulsion from Vanderbilt, his ties to King—then wrapped up with a few biographical details. "He is married and has a baby son."[19]

*The report is one of several documents released in the settlement that provide a direct peek inside Withers's informant file, detailing his role as an FBI "listening post" in the black community. Though records in Withers's informant file weren't subject to the settlement, this one was released because Lawrence copied it to a case file titled "Racial Situation in Tennessee." Similar reports, including a form FD-209 discussed in chapter 15, are critical in understanding Withers's value to the FBI, not just as a photographer but as a prolific intelligence gatherer.

Over the months, as Lawrence kept a suspicious eye on the intense Methodist minister, Withers fed him a range of information: Lawson had been in Birmingham helping King in his fight there against Bull Connor's police dogs, the photographer said in May 1963; that November, Withers secured a letter that seemed to link Lawson to suspected communist sympathizer Carl Braden, the Louisville, Kentucky, civil rights icon. Withers reported the following March that Lawson and others had met with a wealthy New York couple viewed suspiciously for their ties to civil rights. Again that fall, the photographer helped gather information on meetings at Lawson's church. He confirmed that Freedom Rider C. T. Vivian had spoken at one event there but that Braden had failed to appear.[20]

The FBI hungered for news on Braden, the stalwart civil rights champion smeared for years as a Communist. Withers didn't disappoint. He reported this sketchy link between Braden and Lawson in June 1966: Making his rounds, the photographer had run across letterhead for Braden's Southern Conference Educational Fund, or SCEF, a civil rights organization branded by segregationists as a communist front. It listed Lawson's boss and close friend, United Methodist bishop Charles F. Golden, as a "key officer." Withers "pointed out that for this reason Lawson would be the type who would normally engage in any possible SCEF activities, should any occur in the Memphis area," Lawrence wrote after debriefing the photographer-informant.[21]

It was the sort of jaundiced, guilt-by-association assessment that had colored the McCarthy era. Nonetheless, it was the sort of tip Lawrence welcomed. In his world of conspiracy and subversion, such an act of "connecting the dots" was a useful tool. As he would later testify to Congress, the movement was like a bus. He needed to know what direction it was headed. He wanted to know who got on, who got off, who stayed for the long haul.[22]

While Lawrence likened his approach to a bus ride, preeminent FBI surveillance historian Athan Theoharis described it as more like a vacuum cleaner: sucking up as much information as possible for potential use later. So it seemed in October 1965 when Lawrence aimed his great intel sweeper and drew in an account from Withers about a schism at Centenary Methodist over Lawson's interpretation of the Bible.

"Withers said that members of Lawson's church are up in arms over the

fact that Lawson in a recent sermon raised an issue, questioning the virgin birth of Christ," Lawrence wrote in the two-page memo focused on opposition to the Vietnam War by Lawson and others.[23]

Fifty years later, Lawson said he had no idea the FBI had collected such information about him. If the Bureau ever used such detail to try to undercut his career or standing in the church, he wasn't aware of it.* Yet, even after the passage of five decades, the revelation stung. He called the FBI's interest in his doctrinal teaching a heavy-handed intrusion into his constitutionally guaranteed freedom of religion.

"I never really questioned Virgin Mary doctrine as such," he said, feeling compelled to defend himself against insinuations of sacrilege from a half century ago. The New Testament includes two virgin birth accounts, he explained, but also incorporates three other passages in which Jesus is "born in an ordinary fashion"—an inconclusive dilemma for the ever-questioning Lawson. "Why is this a bona fide dogma?" he asked.[24]

THOUGH WITHERS HAD failed his reliability test in 1961, as late as 1966 Lawrence still referred to him at times as a CI—a Confidential Informant—despite his status then as a Confidential Source, a sort of FBI reference desk in the black community. Still, records show Withers at times received assignments, reflecting a certain ambiguity about his status. Perhaps there was no great need then to push him into a full confidential informant position. The struggle in Memphis was moving at a slow pace, fostered in part by the FBI-NAACP alliance. Indeed, when the tempo changed, Withers's role ramped back up. He would return to the status of a confidential informant, as ME 338-R, but that wouldn't happen until late 1967 as unrest rocked Memphis.[25]

Though the FBI didn't release pay records as part of the Withers settlement, it seems logical that most of his pay came after his designation as ME 338-R.

So what motivated him in these lean years in the mid-1960s?

*Lawson said he doubted the FBI would have gotten far had it tried to undermine his ministry. "The congregation received me with unanimity of spirit and compassion and love, and adopted my family as such," he said. "So there would not have been much chance to divide the congregation from me."

Jim had said Withers did it for the money. Yet as a friend of the NAACP, his cooperation likely was forged, too, in the organization's more traditional, more conservative outlook. Historian F. Jack Hurley gives what might be Withers's only public account of his view of the direct-action movement—and of Lawson. Hurley writes in *Pictures Tell The Story: Ernest C. Withers, Reflections in History* that the photographer "reserved his strongest contempt for confrontationalists like the Reverend Jim Lawson, whom he considered a self-promoting troublemaker."[26]

So it seems, despite their friendship, Withers was motivated in part by his general disapproval—his dislike—of Lawson's tactics. Perhaps Withers wasn't the patsy Lawson thought he was.

Playing the role of an armchair psychologist, the photographer characterized Lawson in 1963 as a frustrated attention seeker who "has received very little publicity or recognition" since coming to Memphis.

"Lawson, in one sense, has an inferiority complex and at the same time has an extreme ego," Lawrence wrote in July 1963 after debriefing Withers. More than a year later, in November 1964, the photographer indicated that Lawson's ambitions had got him nowhere in Memphis—he and his supporters had been kept in check. "Withers does not feel, based on his contacts with Negro leaders, that there will be any demonstrations or difficulty in Memphis; that the leadership is currently firmly entrenched in . . . the leaders of the NAACP," Lawrence wrote.[27]

Even before Lawson arrived in Memphis, the city's leadership seemed set against him. NAACP leaders begrudgingly supported the 1960 sit-ins Lawson inspired from Nashville, but they didn't entirely embrace them. The organization paid legal fees for a group of black students from LeMoyne College arrested that March for defying segregation at the Memphis Public Library, even as its leaders urged the young protestors to stop. After relocating to Memphis, Lawson argued in vain for demonstrations to end school segregation: the NAACP opted instead to stick with a court-ordered plan that slow-walked integration and helped keep thousands of black children in inferior schools for decades. In August 1961, when thirteen black children from elite families were admitted to previously all-white schools, Withers shot a photo now famous around Memphis depicting a smiling

Dwania Kyles, daughter of prominent pastor Rev. Samuel Billy Kyles, on her way to school.[28]

As the photographer told Lawrence, Lawson had no momentum—no support—to take the larger black community's cause to the streets.

Lawson simply can "not go it alone," the photographer told Lawrence.[29]

Yet the militant pastor remained a force to be reckoned with—even feared.

"Withers said many leading Negroes fear Lawson, feeling he is too outspoken and too prone to criticize the U.S., but can do nothing to get him to leave Memphis, as he remains in Memphis at the pleasure of Bishop Golden of this district of the Methodist Church," Lawrence wrote in April 1966. "Golden is originally from Memphis and Lawson is one of his 'fair-haired boys.'"[30]

PERHAPS THE BEST testament to Withers's value to the FBI is a single black-and-white picture shot by *The Commercial Appeal*'s Fred Griffith in June 1966: with a camera hanging from his neck, Withers walks down a remote Mississippi road alongside Dr. King, black power militant Stokely Carmichael, and the immaculately dressed Lawson, defying the late spring heat in a suit jacket, smoke-black sunglasses, and his ever-present white clerical collar. This was the March Against Fear, a 200-mile campaign down the spine of Mississippi to protest the shooting of James Meredith.

Withers passed reams of detail about the march to Lawrence, including intel on Lawson's role in organizing it—a role made possible by the minister's close relationship to King. Lawson's return to the spotlight proved embarrassing to NAACP leaders who were forced into the margins, the photographer said.

Withers "pointed out that the march was given some impetus in Memphis by Reverend James Morris Lawson, Jr.," Lawrence wrote in a July 1, 1966, report. ". . . This was done by Lawson to the chagrin and disapproval of the main body of the NAACP in Memphis. Lawson allowed his church to be used as a sort of rallying headquarters for the marchers who came to Memphis to join the march and this developed considerable friction within his church."[31]

Lawson's connection to King, aired so publicly during the march, followed another collaboration the year before that went under the radar. Lawson had traveled to Vietnam in the summer of 1965 at King's request. Though the trip was widely reported in the media—Lawson was part of a fifteen-member interfaith delegation from the United States and Europe that spent two weeks in South Vietnam, Cambodia, and Thailand—what wasn't known is that King had asked the Methodist minister to go as his proxy.[32]

King would come out against the war two years later, but in 1965 he felt such an act was politically undoable.

"That's not a known story," Lawson told me in 2015. "King felt that he could not so identify himself with this public group of clergy from Europe and North America. So I agreed to do it."

What Lawson didn't know was that Withers offered to give the FBI a copy of the minister's written report of the trip. Though Lawson wrote the report for King, he offered in October 1965 to mail a copy to Withers after the photographer contacted him asking about possible war demonstrations in Memphis. "He said he had written a report regarding his June, 1965, trip to Vietnam and would mail a copy to Withers (who in turn will make it available to this office)," Lawrence wrote in the October 22, 1965, memo.[33]

Fifty years later, Lawson said he had no memory of Withers asking about the report; he believes the only copy went to King.

Increasingly, Lawson's opposition to the war became a focal point for the FBI in Memphis. And as black leaders in Memphis pushed Lawson away, he found camaraderie among white activists who shared his views on Vietnam.

"If any Negroes play a leading part," Lawrence paraphrased Withers in a 1966 report on Memphis's emerging peace movement, "Rev. James Morris Lawson, Jr., Pastor, Centenary Methodist Church, will probably be among them."[34]

THE WAR IN MEMPHIS:
DISRUPTING THE PEACE MOVEMENT

ITHERS BEGAN TRACKING MEMPHIS'S NASCENT peace move-
ment for the FBI as early as November 1965, nine months after Pres-
ident Lyndon Johnson began bombing North Vietnam. Rev. Jim Lawson
stood at the core of that first tip.

That month the photographer told Lawrence of a debate on Viet-
nam policy held at historically black LeMoyne College. Picking up details
through his African American network, Withers learned a tidbit "not gen-
erally known"—Lawson had arranged the event. It featured a controversial
speaker, William Jeffries, a visiting Quaker peace activist. Essentially giving
the FBI a seat inside a meeting that would have been hard for an agent to
attend without standing out, Withers said Jeffries received support from
two white professors at the school, but a third "took violent exception" to
the pacifist's statements.[1]

Over the next nine years, Withers passed on dozens of tips on the

peace movement. More than two hundred photos he shot relating to the war landed in FBI files, many used to identify protestors and to build personal dossiers chronicling political views, activities, and associations. He reported army deserters, aided efforts to undermine employment or community standing, and relayed details allowing the FBI to conduct warrantless searches of phone records.

IT'S NOT HARD to grasp Withers's position. By the mid- to late-1960s, the World War II army veteran was heavily invested in the military. He had three sons in the service—one in the front lines in Vietnam. Specialist Fourth Class Clarence Earl "Billy" Withers, twenty-one, arrived in An Khe in March 1968. One of his first nights there, his camp came under mortar attack. Three men died. That night, Billy decided to "take things as they are and put myself in God's hands," he wrote his parents. The family rejoiced when he came home safe a year later.[2]

But Withers's motives extended far beyond the military. They ran deep into Memphis politics and his shared interests with the city's conservative leaders. In 1966, the photographer ran for public office. At first, he considered a bid for county constable. But he ran for a seat on the eleven-member Shelby County Court, the taxing and policy-making board. White support was essential. Blacks comprised only a third of the county's voters. Running ads that depicted the smiling photographer, an American flag, and a slogan—"A man willing to serve"—Withers received endorsements from the *Tri-State Defender* and the *Memphis Press-Scimitar*, the white-controlled afternoon daily paper. He also won endorsements from the conservative Lincoln League and the progressive Unity League, whose leader, O. Z. Evers, was the subject of twenty-two separate tips Withers relayed to the FBI.[3]

"Ernest Withers is an excellent sample of Memphis' fine Negro community ... good-natured, reasonable, hard-working," the *Press-Scimitar* opined days before the election. "It is people like Withers in his race and their counterparts among white people who have provided the base for Memphis' progress—with good will—in racial matters."[4]

Withers came close, but lost in a crowded field. In a demonstration of Memphis's changing racial climate, another African American won a seat on the County Court's 2nd District—NAACP leader Jesse Turner.[5]

WITHERS'S BID FOR office did, however, elevate his profile, and his value to the FBI along with it. As white war protestors visited his Beale Street studio to purchase pictures he'd taken at marches and rallies, they confided in the trusted news photographer.

A group of pacifist students turned to Withers for help in May 1966 when conservatives pushed to purge a controversial antiwar newsletter from the Memphis State campus. The students, writers for a mimeographed newssheet named *Logos*—Greek for logic—faced vitriolic opposition and physical confrontations. When they explained their troubles—they'd lost their mailing address, for one—Withers offered to let the news organ receive its mail at his Beale Street studio.* In turn, he told Lawrence that two *Logos* writers had ties to the Southern Student Organizing Committee, a suspected communist front.[6]

Hanging around at downtown peace vigils in 1967, Withers grew friendly with two outspoken Memphis State professors who were pressured to leave the school that spring. One, Jean Antoine Morrison, had been a focal point of a series of updates Withers passed to Lawrence. The silent vigils produced the perfect cover for the affable newsman. Holding placards, protestors stood for hours in front of popular businesses like Goldsmith's Department Store, giving the chatty Withers ample opportunity to pick up bits of intelligence. He told Lawrence he was building "good rapport" with the left-leaning Morrison, reporting that the professor of philosophy and German language had taken a camera to one rally in hopes of producing "propaganda" photographs of hecklers

*Available records don't indicate if the offer was consummated. Former *Logos* contributor Brian Murphree told the author in 2016 that his memory had faded through the mists of fifty years. Murphree's memory is unequivocal, however, regarding the hostility he and colleagues faced. On May 2, 1966, a mob surrounded the *Logos* staff as it handed out literature on Memphis State's campus. "I thought we were going to be lynched," he recalled. Several friends were roughed up. He recalls, too, a friend on the police force saying he'd been advised to disassociate from Murphree because he was under investigation for his politics. "It seemed like a monumental waste of police time," he said.

and aggressive policemen. Morrison planned more vigils that summer, Withers said.[7]

How much of Withers's intel made it to Morrison's bosses at Memphis State is hard to say. But Lawrence routinely shared such information with the school. When professor John Dolphin Bass called MPD in 1966 for a parade permit to hold the city's first big demonstration against the war, for example, an officer called Lawrence, who, in turn, alerted military intelligence and Edward Donald McDaniel, Dean of Men at Memphis State. By the end of the spring 1967 term, Bass and Morrison were gone.[8]

"Just suddenly—boom!—he was fired," recalled Morrison's widow, Joella. The official letter of dismissal cited smoking in class, failure to attend commencement, tardiness, and other petty offenses. But "it was just an excuse," she said. "A lot of it had to deal with Vietnam. I'm sure it was an embarrassment to them." It happened so quickly, she said, graduate students working with Morrison saw thesis projects halted—they had to start over. "That was the most scurrilous thing they did," she said.[9]

Withers relayed reports on another, older war protestor, Thomas Van Dyke Potts, forty-nine. A decorated World War II bomber pilot and son of an affluent Memphis cotton linter, Potts had briefly joined the Communist Party in California, where he was a labor organizer, before returning to Memphis and teaming with Reverend Lawson in 1967 in a much-publicized "fast for peace. " He came under intense scrutiny as he helped lead the vigils downtown. Tapping his stable of sources, Lawrence maintained files on Potts; his wife, Haleen; his church, the Unitarian Universalist Fellowship of Memphis; and his causes, Clergy and Laymen Concerned About Vietnam and the National Students Strike for Peace—classifying all as potential security threats.[10]

Withers made significant contributions. The news photographer told Lawrence that Potts had "argued vehemently" with a group of Marines at one vigil; that he'd complained bitterly of a pro-war editorial run on WDIA, the popular African American radio station. Potts expressed anger that Bert Ferguson, the station's white owner—and one of Lawrence's many media contacts—had "bitterly denounced" Dr. King's stance against the war.[11]

Inviting Withers to a coffee discussion, Potts told him he would take his antiwar message directly to the black community: the next peace vigil would

be held in Handy Park on Beale Street, in the heart of the black business district—details the photographer passed to Lawrence. On another occasion, Withers called the agent at home after learning Potts was to appear in a WDIA debate on the war. The agent's reports typically were sterile, yet this one conveyed a controlled sense of outrage: How could popular radio personality Nat D. Williams put ex-Communist Potts on the air? In response, Withers vowed to find out. By the summer, Potts, too, had left town.[12]

"Memphis was a very scary place. To me, you could feel violence in the air," said Joella Morrison, also a target of FBI inquiry along with her professor husband.* The Morrisons and their five children moved so quickly they left their dog with another famous Memphis photographer, William Eggleston, a family friend. "It was so superficially clean. The garbage strike was to me like a metaphor for all of that. You weren't allowed to put your garbage out in front of your house in Memphis. The poor garbage guys had to go get tubs in your backyard, sometimes 200 feet, put the garbage in the tubs and carry it back out to the truck to make it look like Memphis was so clean and perfect. And underneath all of that it was seething."[13]

Withers had a clear role in expelling another activist from Memphis, William Jennings, a Kentucky native with flowing red hair and a fuzzy beard who deserted his Indiana-based Army Reserve unit in early 1969 as his opinion of the war soured.† Then twenty-six, he moved to the Bluff City with his parents and became active in the Draft Resistance Union of Memphis, which schooled young men on ways to avoid military conscription. Jennings was arrested on a sticky August day after attending a DRUM rally at the First National Bank plaza at Madison and Third. He unwittingly walked into a police gauntlet. That was his first mistake. Surrounding the thirty-five or so protestors were an array of plainclothes agents of the FBI and MPD, as well as several informers, including Withers. Jennings's second mistake involved chatting with the

*Lawrence kept a joint file on Joella Morrison and her husband, Jean. The agent's attention on the couple ran deep. He wrote in a June 16, 1967, report, for example, that an informant had reported that Joella "surreptitiously" used the mimeograph machine at Memphis State's Modern Language Department to produce leaflets for a peace rally.
†Jennings told the author in a 2016 interview he'd served five-and-a-half years of a six-year commitment when he realized a "moral imperative" to quit. After his arrest in Memphis he spent several weeks at Fort Campbell, Kentucky, part of that time served in the stockade, before his conscientious objector application was approved and he was discharged.

personable photographer. According to Lawrence's report, he fingered Jennings as a deserter "based on a composite information furnished by" Withers and two others.[14]

PEACE ACTIVISTS AND civil rights workers had more reason to be paranoid. Memphis was wired for dissenters in the late 1960s. The city had a long history of spying on political dissidents, particularly African Americans, but a series of factors converged in 1967 to make Memphis especially inhospitable.* Following massive urban rioting in Los Angeles, Newark, and Detroit, President Johnson's National Advisory Commission on Civil Disorders, better known as the Kerner Commission, recommended that police departments develop intelligence units "to gather, evaluate, analyze, and disseminate information on potential as well as actual civil disorders." When the federal Law Enforcement Assistance Administration extended funding, a nationwide conglomerate of local "red squads," including MPD's newly founded Domestic Intelligence Unit, blossomed. Abuse soon followed.[15]

In Memphis, the effort involved as many as fifteen officers and undercover agents. Benefiting from technical assistance from the FBI's Lawrence, MPD's Domestic Intelligence Unit assembled dossiers on hundreds of individuals and groups ranging from black nationalists like the Black Panthers and the homegrown Invaders to mainstream organizations including the NAACP, the Southern Christian Leadership Conference, the Memphis Labor Council, the American Civil Liberties Union, the Memphis and Shelby County Human Relations Commission, the National Council of Churches, the Mayor's Council on Youth Opportunity, and the Memphis Ecumenical Children's Association. Before the unit finally disbanded in the mid-1970s, it operated on a near-million-dollar annual budget (equivalent to roughly $4.2 million in 2018) and shelled out $10,000 a year to informers.[16]

*Political boss E. H. Crump often planted informants inside rallies held by African American political activist Rev. G. A. Long. A Crump informant reported in 1940 that orations by Long and another black pastor "might cause trouble" as they "preached race equality without any reservations." District Attorney General Will Gerber, Crump's hand-picked prosecutor, employed a black woman, who operated under the code name "R," to infiltrate rallies at Long's Beale Street Church. By 1963, MPD had an intelligence branch, a forerunner of the Domestic Intelligence Unit, investigating a variety of organizations, including the Congress of Racial Equality and the Nation of Islam.

Top brass denied it, yet evidence indicated MPD made warrantless searches of U.S. mail, gathered personal details such as political affiliations and even sexual preferences, and routinely accessed bank, telephone, student, and credit agency records.[17]

The full story would never be known. As lawyers for the American Civil Liberties Union rushed to federal court in 1976 to obtain subpoenas after learning of the operation, Mayor Wyeth Chandler ordered all files burned. Nonetheless, U.S. District Court judge Robert McRae signed a landmark consent decree two years later ordering MPD to no longer "engage in political intelligence." The decree forbade any electronic or covert surveillance, the keeping of files, or "any law enforcement activities which interfere with any person's rights protected by the First Amendment."[18]

It was tough and it was stinging, but the order completely overlooked MPD's silent partner in this great, clandestine undertaking—the FBI.

THE MEMPHIS PUBLIC first learned of MPD's political spying with news of that great file burning, but details of Withers's role have remained hidden—until now. Those details emerge when examining the operation's inner workings: MPD and the FBI worked in close collaboration, routinely sharing information each picked up from their intelligence networks.

"We were swapping information," said Lt. Eli Arkin, the dashing commanding officer of MPD's intelligence unit, who often socialized with the Bureau agents.* For years after Lawrence retired in 1970, Arkin maintained close ties to the federal agency, lunching with the agent's successors and becoming a Saturday-night regular on the FBI's recreational bowling squad, "The Alley Cats."[19]

Those relationships buttressed the FBI-MPD information exchange, a large share of which focused on groups protesting the Vietnam War.

On its end, MPD deployed a young police recruit named Byron "Gene" Townsend, an army veteran who served in Vietnam before joining the force in 1969. He spent the next five years undercover, working from the inside of

*A May 22, 1968, memo underscores the FBI's "excellent relationship" with MPD. The memo notes the disruptive financial burden the FBI had placed on black militants by informing MPD about such picayune matters as activists' failure to keep vehicle inspection stickers current or to properly register cars.

the peace movement, posing as a campus radical. With flowing, light-brown hair and a thick "hippie" mustache, Townsend—secretly coded in MPD files as "Agent 503"—infiltrated the local chapter of Vietnam Veterans Against the War, the Young Workers Liberation League, and other groups at Memphis State. Meeting in deserted parking lots under cover of night with MPD supervisors who paid him in cash, Townsend passed a steady flow of details to the police and, consequently, to the FBI.[20]

"It broke my heart that he lied to me all that time," Vietnam Vets leader Eric "Rick" Carter told a reporter in 1976 when Townsend*—his ex-roommate and best friend—finally blew his cover.[21]

LAWRENCE KEPT VIGILANT watch on the New Left, but he wasn't big on COINTELPRO dirty tricks or disruption—not officially, anyway. The files of the Memphis Division's New Left counterintelligence program reveal just thirteen serials. Most constituted quarterly reports listing no activity. In fact, Memphis sought headquarters approval of just one serious disruption proposal.† Compare this to the overall output—nationwide, FBI field offices submitted 381 separate proposals to disrupt the New Left between October 28, 1968, and April 27, 1971—and COINTELPRO seemed all but nonexistent in Memphis.[22]

In reality, however, disruption tactics were much more common in Memphis.

Although COINTELPRO was a clearly defined program requiring headquarters' approval before field agents could take action, Memphis operated an alternative program that, with little oversight, likely produced many of the same effects. Under the so-called "interview program," Lawrence and a second agent—typically, his longtime partner, Hugh Kearney—pounded the pavement, knocking on doors and cornering targets. The dragnet was

*Townsend served thirty-three years in the MPD, rising to the rank of captain before his retirement and death in 2003.

†Part of the inactivity involves the fact that Memphis was the "office of origin" for just one clear-cut New Left organization, the Southern Student Organizing Committee based in Nashville, within the Memphis Division's jurisdiction. On March 6, 1969, Memphis proposed that the FBI exploit a developing rift between the SSOC and the Northern-based Students for a Democratic Society by anonymously mailing copies of an article in an SDS publication critical of the SSOC. Although headquarters applauded the effort "to confuse and disrupt" the New Left, it rejected the proposal as unnecessary after members of an SDS convention in Austin, Texas, voted to break ties with the SSOC.

aimed squarely at Memphis's growing Black Power movement. But it took aim, too, at members of the New Left and its associates—anyone with the potential of giving "aid and comfort" to America's internal enemies.

White businessman John T. Fisher received such a visit at his car dealership on Union Avenue. His wife, Jean, had marched in support of the sanitation workers. Fisher became close to Jim Lawson, and he was befriending some of the younger activists in the movement's militant wings.

"The FBI, in my opinion, was being paranoid," he said years later, describing how two agents in dark suits showed up to warn him off his militant associations. "Somehow my name came up in that process and they came to see me, which I thought was ridiculous."[23]

Intimidation was a key component of the program. Lawrence learned this in the '50s when busting up Memphis's Communist Party and running William "Red" Davis and others out of town: there was power in face-to-face contact with a target and his associates. Few things irked an employer, a friend, or a colleague in conservative, Cold War–era Memphis like two dour agents in dark suits at the door asking questions about loyalty and un-Americanism. A stated purpose of the program was to "cast suspicion," mirroring the advice of James O'Connor, the FBI's New Left specialist in Philadelphia who urged agents to increase contacts with activists to raise "the paranoia endemic in these circles and to further serve to get the point across that there is an FBI agent behind every mailbox." It also served to discourage potential recruits from joining Memphis's radical Left and, in turn, aided the FBI in its own recruitment of informants. The Memphis field office reported in May 1968 that it had developed three informants in less than a year through the approach.[24]

One such would-be informant was Laura Ingram, a nineteen-year-old sophomore active in the local chapter of Students for a Democratic Society at Memphis State in 1968 when two agents paid her a visit at the communal "hippie house" where she lived near the medical district. She'd been on their radar for some time. Withers had shot identification photos of the blond activist in March 1968 as she protested in support of the city's striking sanitation workers and again that August as she attended a rally at City Hall. Her interest in civil rights raised more suspicion. Ingram had been identified as part of a white-black student alliance working increasingly with

the Invaders in social protest. Leading the two agents through Ingram's door was Marrell McCollough, the undercover cop who had infiltrated the Invaders and would appear in a picture in *Life* magazine on the balcony of the Lorraine Motel with Dr. King's body after he was shot.[25]

"They wanted to talk to me because they felt like I wasn't, you know, a serious, dangerous radical, that I was being misled," Ingram recalled years later. The entourage seemed intent to make her an informer or "at the very least get me to stop" participating politically.[26]

Ingram's case provides evidence, too, that Lawrence didn't need a formal COINTELPRO program to disrupt Memphis's left-wing activists. After efforts failed to win Ingram's confidence, Lawrence evidently moved to disrupt her employment. Without ever submitting a formal COINTEL-PRO proposal, the agent seems to have hatched a plan to get Ingram fired in November 1968 from a part-time education job she held through a federal War on Poverty program, Operation Head Start. Lawrence spoke that month with an informant who said "he would not have any hesitation" talking about Ingram with a conservative South Memphis pastor whose church housed the Head Start program. It's unclear if Lawrence went through with the plan, though records indicate the informant he spoke with almost certainly was Withers.*

The Memphis Division spelled out its indifference toward a formal COINTELPRO program in June 1968, informing headquarters that, when it came to the New Left, "it is felt that this group is vulnerable (already) through the rigid enforcement of local, State and Federal laws" such as "parking, traffic, narcotics, and with increasing frequency the Selective Service laws." In other words, left-wing activists had to keep on their toes: the authorities in Memphis had them in a virtual trap.[27]

And they were working particularly hard laying traps for the city's leading resident Communist, Kathy Hunninen.

*A January 2, 1969, memo by Lawrence released outside the settlement lists Withers's informant file number, indicating his involvement. The memo says the unnamed informant offered to speak with Rev. J. C. Atkins, whose church housed the Head Start program. The informant told Lawrence that Lt. Wendell Robinson—Withers's old friend at the Memphis Police Department—was a member of the church. As for Ingram, she had no memory nearly fifty years later of how her employment ended at Head Start.

THE COMMUNIST RESURGENCE: DIRTY TRICKS, FEAR, AND HARASSMENT

IT WAS A PERFECT DAY for a wedding. Sunlight danced in dappled dashes along the oaks and poplars hugging the Mississippi's east bank, a great green bluff of groomed lawn and virgin forest that sloped gently downward before falling hard into the coffee-brown water below. Kathy Roop Hunninen recalls it well: May 21, 1971. The young bride, in a blue and gold sari, and carrying a simple bouquet of daisies, beamed. Her groom, goateed guitar picker John Hunninen, smiled widely. Together, they stood near the bluff's crest, waiting for their friend Ernest Withers to snap their picture.

Kathy first met the photographer in 1968. An outspoken college student, she got to know him as she marched for a myriad of causes: in support of the sanitation workers, against school segregation, and, increasingly, in the effort to end the war in Vietnam. It was strictly professional at first. But over time, despite divisions of race and class, they got to know and like each

other. The older Withers socialized with Kathy and her friends, an array of peace activists and students affiliated with Memphis's emerging New Left. He shot pictures to accompany articles they arranged in left-wing publications, went to get-togethers in their homes, and even attended the wedding here at the First Unitarian Church along the Mississippi River south of downtown, where Kathy Roop became Kathy Hunninen, proudly hiring the gregarious newsman to shoot her wedding album.

Unbeknownst to her, Withers also shot as many as fifty-two photos of her at rallies and meetings, covertly passing them to the FBI between 1968 and 1973 along with a variety of reports on her political activities as agents investigated her as a suspected Communist and a security threat.[1]

The investigation would come back to haunt her years later—and cost her a career.

Hunninen never suspected Withers, certainly not on that sunny afternoon when he aimed his camera at her wedding party. In his viewfinder, the photographer eyed Kathy and her friends—conscientious objector Allan Fuson, squinting behind dark sunglasses; Michael Welch, a Southern Student Organizing Committee leader, looking glum and out of place in a red tie; Michael Honey, now a professor at the University of Washington Tacoma who has authored some of Memphis's quintessential histories, including *Going Down Jericho Road: The Memphis Strike, Martin Luther King's Last Campaign*. Back in 1971, Honey worked as the regional director of the National Committee Against Repressive Legislation, a civil liberties advocacy group formed in 1960 to abolish the House Un-American Activities Committee.

Withers stamped each picture, shot in color, with his famous Beale Street imprint, "Ernest C. Withers Photographer."

These accomplished activists and circle of friends had a hand in raising some of Memphis's venerable institutions, organizing an early predecessor of the Mid-South Peace & Justice Center and providing early support to WEVL, the city's long-running nonprofit community radio station. The story of the FBI's interest in them is the story of overreach that colored so many of the agency's investigations into the peace and civil rights movements.

That interest peaked as members of the group spoke out against the war and, more critically, as they developed ties to the Communist Party. In

1970, they formed a chapter of the Communist Party's youth organization, the Young Workers Liberation League. The squeaky-clean group focused on human rights, poverty, and labor issues. But the return to Memphis of the Communist Party, which Bill Lawrence had worked so hard to eviscerate in the 1950s, drew special attention from the FBI—and from Withers. As they organized, Withers tossed the FBI nuggets of intelligence:

The group was bringing an out-of-town activist to Memphis to drum up support for the jailed radical Angela Davis, he said; they were meeting with suspected communist sympathizer Anne Braden. The photographer said Hunninen had secured financial donations for her leftist causes from an executive at Stax Records; that she was trying to organize workers at a local factory; that she and Fuson were attending a memorial for King; that Fuson was hosting activists who'd traveled to communist East Germany.[2]

Among his more invasive tips, Withers passed on a phone number that allowed the FBI to conduct what appears to be a warrantless search of Fuson's and Welch's long-distance phone charges. It happened on December 4, 1969: Withers gave Lawrence an unlisted telephone number used by roommates Welch and Fuson.* Lawrence then reached his contact at Southern Bell Telephone Company. She advised that Welch had opened the account the previous July. She also provided details on Welch's employment. The phone company source "was requested to search any long-distance toll charges made from or to # 278-2356, and she advised she would do so and contact this office as soon as this information is available," Lawrence wrote. His report made no reference to any warrants or court orders allowing legal collection of personal information.[3]

The action described in Lawrence's report was a common Cold War investigative technique. Though wiretapping had been illegal since 1934, Hoover's FBI tapped phones of suspected foreign spies during World War II and later expanded the practice to an ever-growing range of "subversives," mainly American citizens. Collection of phone records was used to identify a target's associates and strategies. "That was their concern: What were their plans?" said political surveillance historian Athan Theoharis. The data

*The settlement records show Withers passed phone numbers to the FBI frequently between 1961 and 1973. Incidents involving the Invaders are discussed in chapters 22–24, including one in which Withers gave Lawrence the organization's official notebook with pages of phone numbers.

wasn't used directly in criminal prosecution, but could always be "laundered," Theoharis said—used as a lead to obtain incriminating information through other, legal means.[4]

"Ernest Withers was my friend," Fuson said years later when confronted with the long-concealed FBI records. "He came over sometimes. We thought he was part of the movement. And I had no idea he wasn't."[5]

WITHERS ALSO PLAYED a shadowy role in an evident FBI bid to get one of the young activists, Mark Allen, fired from his job as a truck driver. It happened in 1972, months after Allen moved to Memphis from Michigan. Many people around Memphis's Cooper-Young neighborhood know Allen today as a gifted guitarist whose mesmerizing performances feature flamenco and Latin music. Back in the early '70s, he helped run a nonprofit bookstore in Midtown and served as president of the fledgling WEVL, the commercial-free radio station that still operates in Memphis. But it was his affiliation with another organization, the Young Workers Liberation League, that attracted the attention of the FBI—and Withers.

Withers "advised that *as instructed* he contacted the Chandler Wrecking Company, 1223 North Watkins, and obtained the information that Mark Allen is employed by the Chandler Wrecking Company as a driver of a truck," an agent wrote in a July 3, 1972, report. The item, part of a larger roundup on subversive activity reported by Withers, concluded that "the only information contained" in the employer's file on Allen was his address—a Midtown duplex—and his Social Security number, which the photographer copied and relayed to the FBI.[6]

Later, two FBI agents showed up—Allen heard about it from a crane operator who was taking a break in Chandler's offices at the time.

"He said the FBI had come there to the office to tell them about me," Allen said years later. But company co-owner Jimmy Chandler shrugged them off. "They came and told us you were a Communist," Allen recalls his boss telling him with a laugh. "He said, 'I knew you were a Yankee. Yankee, Communist. What's the difference?' So that trick didn't work." But "one trick did work," Allen said. The FBI often paid home visits to young men and women who expressed interest in the Young Workers Liberation League:

Deputy Ben Selby frisks Ernest Withers as he enters the Tallahatchie County Courthouse in September 1955 for the trial of Roy Bryant and J. W. Milam, accused of murdering fourteen-year-old Emmett Till. Though both later confessed in a paid magazine article, the two half-brothers were acquitted by an all-white jury. Credit: The Commercial Appea*l*.

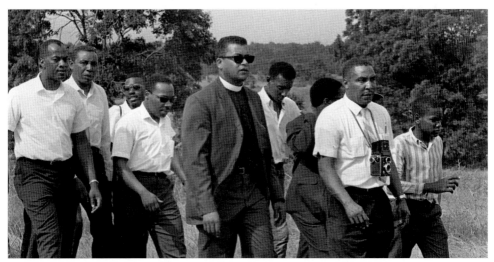

Withers (front with camera) walks with Dr. Martin Luther King, Jr., in Mississippi on June 7, 1966, in the March Against Fear following the sniper wounding there of James Meredith. Among those in the photo are Floyd McKissick (in back, second from left), head of the Congress of Racial Equality; King (left center); Rev. James Lawson (sunglasses and clerical collar); and Stokely Carmichael (head bowed). Credit: *Fred Griffith,* The Commercial Appeal.

Ernest Withers (far right) and musician Ben Branch chat with a shotgun-wielding lawman at the Lorraine Motel on April 4, 1968, shortly after Dr. Martin Luther King, Jr., was shot by a sniper there. Branch was speaking with King from the parking lot below the balcony seconds before King was shot. Credit: *Preservation and Special Collections Department, University Libraries, University of Memphis*—Press Scimitar collection. *By William Leaptrott.*

THAT ▯ COULD BE RELEASED AFTER HE HAD "ACQUIRED THE PROPER

BACKGROUND." WITHERS WOULD NOT TELL ▯ EXACTLY HOW MUCH

IT WOULD COST TO GET ▯ OUT OF PRISON BUT INDICATED IT WOULD

BE AT LEAST $12,000 TO $16,000.

▯ WORKING WITH MEMPHIS OFFICE IN ATTEMPTING TO

ARRANGE A MEETING WITH WITHERS TO COMPLETE THE NEGOTIATIONS

FOR WITHERS' TRIP TO NASHVILLE.

 ERNEST COLUMBUS WITHERS WAS FORMERLY DESIGNATED AS

ME 338-R, ▯

CAPTIONED "ERNEST COLUMBUS WITHERS; CI." THESE CASES WERE

This passage from a 1977 FBI report opened the door to revealing Withers's secret life as an informant. The document, released in 2009 through the Freedom of Information Act, was written when Withers was under investigation in a corruption probe. The report references Withers' previous life in the 1960s as racial informant ME 338-R. Credit: *FBI files.*

William H. Lawrence, left, poses with fellow FBI agent E. Hugo Winterrowd in 1965. Lawrence ran the FBI's domestic intelligence operations in Memphis over two decades and controlled informant Ernest Withers. Credit: *Preservation and Special Collections Department, University Libraries, University of Memphis—Press Scimitar collection. By William Leaptrott.*

Withers, right, is pushed back by police in riot gear on March 28, 1968, as violence disrupts a demonstration led by Dr. Martin Luther King, Jr., in downtown Memphis. Credit: *Preservation and Special Collections Department, University Libraries, University of Memphis*—Press Scimitar *collection.*

Special agent William H. Lawrence relaxes at home with his basset hound, Bertha. Credit: *Courtesy of Betty Lawrence.*

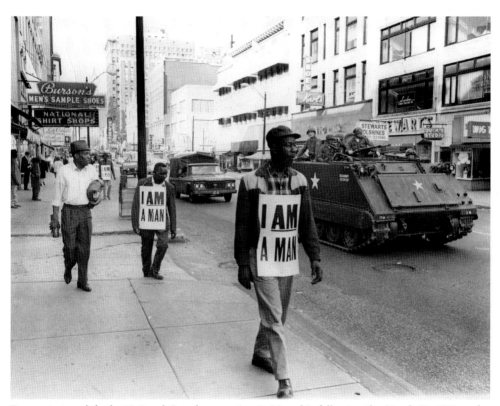

File No. _105-160 1A47_

Date Received _2-4-64_

From _Ernest C Withers_
(NAME OF CONTRIBUTOR)

CS(RAC) Memphis Tenn
(ADDRESS OF CONTRIBUTOR)

(CITY AND STATE)

By _William H Lawrence_
(NAME OF SPECIAL AGENT)

**Negroes Can Have Freedom
And Justice Over Night**

Good Homes — Money
Friendship In All Walks of Life

THE TRUTH MUST BE TOLD

HEAR — THINK
AND THEN JUDGE FOR YOURSELF

VISIT

Muhammad's Mosque

MEETING

Friday 8:00 P.M. — Sunday 2:00 P.M.

307 SOUTH THIRD STREET

Starting in 1961, Withers helped monitor the Nation of Islam, a religious sect the FBI viewed as exotic, and which posed a national security threat. He gave an agent this handbill (right) in 1964, advertising a rally at a Memphis mosque. An evidence slip (left) shows the photographer was operating then as a Confidential Source in Racial Matters, an FBI program which kept suspicious watch over black America. Credit: *FBI files.*

Demonstrators defy the National Guard occupation in Memphis following the March 28, 1968, melee that erupted during King's march. Credit: *Preservation and Special Collections Department, University Libraries, University of Memphis—Press Scimitar collection. By Ken Ross.*

Rev. James Lawson marches in downtown Memphis surrounded by militant activists. To his right is Invaders leader John B. Smith. Over Lawson's left shoulder, Memphis Police Department Detective Ed Redditt follows. Credit: *Preservation and Special Collections Department, University Libraries, University of Memphis*—Press Scimitar *collection. By William Leaptrott.*

In January 1969 Withers gave the FBI a spiral-bound notebook maintained by the Invaders that detailed the militant organization's financial information as well as names and phone numbers of its sympathizers and associates. Domestic intelligence agents often funneled phone numbers to telephone company sources to search toll charges in hopes of ascertaining a subject's associates. Credit: *FBI files.*

William H. Lawrence's handwritten notes from November 1978. The then-retired agent had spoken with Withers—referenced here as 338 R—as he was heading to testify in closed session to a congressional committee re-examining Dr. Martin Luther King, Jr.'s, assassination in Memphis. Lawrence writes that he warned the photographer not to mislead the committee about his informing. Lawrence's handwritten notes reveal his subtle witness coaching. He suggested that Withers tell the committee that his cooperation with the FBI was "based on … the peaceful and effective preservation of the civil rights movement." Credit: *Courtesy of Betty Lawrence.*

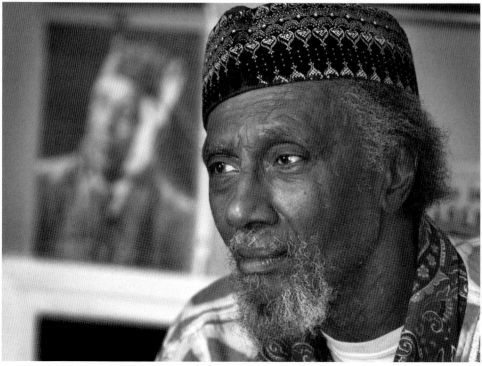

Former Black Power militant Lance "Sweet Willie Wine" Watson, now known as Suhkara Yahweh, in his home in 2010. On the wall behind him is a portrait of Withers, whom Yahweh affectionately called, "My daddy." Credit: *Karen Focht,* The Commercial Appeal.

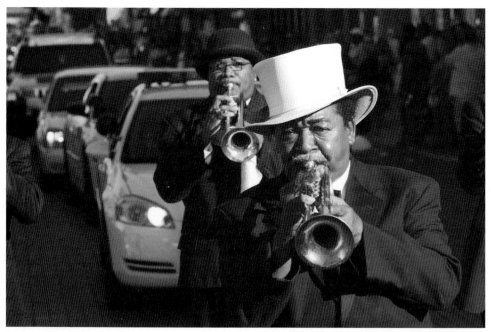

Rudy Williams plays "Precious Lord" on his trumpet as he leads Withers's funeral procession down Beale Street following the photographer's death in October 2007. Credit: *Jeff McAdory,* The Commercial Appeal.

"They would stop coming. The FBI would tell them, 'We've got enough to arrest. But we're watching them to see who they get together with.' They made it seem an arrest was imminent because we're doing illegal things."[7]

The group knew they were being harassed by police and the FBI. But none of them knew Withers had a hand in it.

"He was a jolly old guy," said Hunninen, who often called the photographer when big stuff happened: the night her car was bombed by a suspected right-wing extremist; when she first tried her hand at labor organizing; when she heard the joyous news she'd been offered a scholarship to enter the University of Cincinnati's doctoral program in environmental health.

"I mean, he was friendly with everybody."

THE FBI'S ATTENTION on the group started well before the formation of the YWLL in 1970. It started with the war. As early as 1967, Withers informed Lawrence that YWLL organizer Michael Lane Welch, then under suspicion for his involvement in the radical Southern Student Organizing Committee (SSOC), had helped organize a series of peace vigils in downtown Memphis.[8]

It was through SSOC that Welch and Fuson met in Nashville.

Raised a Quaker, Fuson grew up in the shadow of Nashville's Fisk University, where his father, Nelson Fuson, a pacifist, chaired the Physics Department. The Nashville movement's heroes often visited their home—future congressman John Lewis, James Bevel, and Bernard LaFayette. Diane Nash, who famously confronted Mayor Ben West on the courthouse steps making an impassioned plea to end segregation and who later coordinated the Freedom Rides, babysat Allan and his younger brother, Dan.[9]

Drawn to the ideal of a classless society, young Allan immersed himself in the writings of Karl Marx, Friedrich Engels, and Vladimir Lenin. "I buzzed through these books, and a lot of what they were saying made sense. And it was like, 'Jeez, why is that so bad?'" he later recalled.[10]

When he moved to Memphis in 1969 to begin his alternative service as a conscientious objector, Fuson landed in the FBI-MPD gauntlet.

On one end, there was Gene Townsend, the undercover MPD officer posing as a radical activist, who often attended YWLL meetings. Police

learned Fuson roomed for a time with a young African American active in radical politics; that he solicited donations for his causes from Stax Records; that he read the Communist Party newspaper *The Daily Worker* and owned books by Party officials Gus Hall and Claude Lightfoot; that he supported the unsuccessful bid for a fourth term by liberal Tennessee senator Albert Gore, Sr., in 1970; that he and his white colleagues often worked on anti-poverty and civil rights concerns with a range of black activists, including the ultra-militant Black Panthers.[11]

On the other end was Withers. The photographer helped keep the FBI abreast of Fuson's political doings—he spotted the activist with Kathy Hunninen in 1970 at an MLK memorial rally heavily attended by black radicals; he reported in 1972 that the pair planned to attend the Democratic National Convention in Miami. He reported on his personal life as well.[12]

Withers told the FBI in 1973 that Mike Honey had invited him over to Fuson's Midtown apartment "to attend an international night party sponsored by the Memphis Chapter of the Communist Party," according to a report by agent Howell S. Lowe, who'd assumed the shared duty of running the FBI's domestic intelligence operations in Memphis following Lawrence's 1970 retirement. Withers reported that an interracial group of twenty-one people attended the event to hear two Memphis women discuss their recent trip to East Germany for the World Festival of Youth and Students in Berlin. They reportedly delivered a propaganda-laced lecture: crime is low in East Germany, food and housing are good, and trains run on time, they said. Withers said the meeting wrapped up near midnight, when Honey announced a meeting the following week "to study police brutality and political prisoners."[13]

Despite constant pressure, Fuson and his friends inside the small YWLL chapter gave the FBI-MPD alliance little to work with—they were simply a bunch of wonks and idealists. Lieutenant Arkin and his counterparts at the FBI failed to pick up any incriminating information—no drug use, no acts of subversion, no evidence of sabotage, no contacts with foreign powers or any plot to overthrow of the government. Nonetheless, they kept the pressure up—most of it focused on Kathy Roop Hunninen and her sharp critique of American imperialism and economic policy.

WITHERS FIRST INFORMED on her in late November 1968 during her junior year at Southwestern, the elite Memphis liberal arts school now called Rhodes College. The photographer shot twenty pictures of the pig-tailed activist at a welfare-rights rally and turned them over to Lawrence along with Hunninen's license plate number.* The agent's interest was high. Tapping informants, he had logged Hunninen's attendance over the previous month at as many as four meetings of Students for a Democratic Society, the radical Northern-based group whose local chapter increasingly was teaming with black militants in anti-poverty and civil rights efforts.[14]

The FBI's interest in SDS in Memphis had peaked four days earlier.

On November 25, 1968, a group of white SDS members teamed with leaders of the Black Power group, the Invaders, in a takeover of the administration building at LeMoyne-Owen College, the private, historically African American school where students were seeking lower tuition and cafeteria prices, better books, and black history courses. The activists allowed Withers into the building during the occupation, and he later told Lawrence that some of the Invaders were armed. He reported seeing a shotgun, a rifle with telescopic sights, a bayonet, a Derringer, and a second pistol inside the building. The agent recorded that Withers told him the Invaders "had hoped to have a confrontation with the police," yet the occupation ended peaceably. No charges were filed.[15]

FBI reports on the incident make no mention of involvement by Hunninen either in the planning or actual occupation of the building.

"I never was in SDS," Hunninen said nearly fifty years later, characterizing her association with the group as a shared interest in ending the war. "The war was awful. All my friends were being drafted."

Nonetheless, she was swept up in the times—and the FBI's intel dragnet.

Withers shot photos of her for Lawrence as she marched with an anti-poverty group, the Memphis Welfare Rights Organization, and confirmed her connection to a similar group, Citizens Opposed to Starvation Taxes.[16]

*Lawrence wrote in longhand on a form FD-340, or evidence slip, that Withers shot the photos on November 29, 1968. Though the slip references twenty photos, the government released a single picture to the author that Withers shot that day, a grainy photo of Hunninen's left profile.

FBI interest intensified when Hunninen began associating with suspected Communists in 1970.

Available records show the FBI first recorded such a connection on January 12, 1970, when the activist reportedly attended "a Marxist-Leninist study session" at a two-story stone house in Midtown. The meeting was covered by as many as three informants. That June, an informant reported Hunninen was "a member of the Memphis unit of the" Young Workers Liberation League, the communist youth group brought to Memphis by Allan Fuson and Michael Welch. Agents meticulously recorded the addresses of a series of apartments where the student lived, the names of restaurants where she held waitressing jobs, her educational history, and other personal details. They logged her appearance at more than sixty meetings, rallies, and political events between 1968 and 1970.[17]

The FBI redoubled its interest as Hunninen became involved in the campaign to free Angela Davis, the jailed Communist Party member and Black Panther supporter. Withers shot pictures in January 1971 of Hunninen conferring with civil rights icon Anne Braden, who had come to rally support for Davis, and he told agents weeks later of Michael Honey's plans to bring in a West Coast leader in the Committee to Free Angela Davis.[18]

Combustible as it was, the Angela Davis campaign triggered incendiary consequences—literally—for the group. Someone tossed a hand grenade in the parking lot outside Hunninen's Midtown apartment one evening in April 1971. The blast punched holes in her Volkswagen station wagon featuring a "Free Angela" sticker on the tailgate. No one was arrested. The incident sent chills through Hunninen and her friends, who long suspected a right-wing extremist or a police informer.[19]

"We hear this huge explosion. My car's on fire," Hunninen said. "It definitely was because of my activities."

One of the first people she called was Withers.

Aiming his camera into the darkness, the photographer shot more than a dozen pictures, stamping prints with his distinctive "Pictures Tell The Story" imprint on the back. One shows Hunninen in a colorful muumuu peering into her charred VW. It ran along with an article in the *Southern Patriot*, the news organ for Carl and Anne Braden's Southern Conference Educational Fund.[20]

EIGHT DAYS BEFORE he photographed the car bombing, Withers reported to the FBI that Hunninen had been soliciting money for her communist youth group from Stax Records. A Stax executive "gave Kathy Roop and the YWLL $250 and also has made donations to Free Angela Davis," agent Howell Lowe wrote in April 1971. * The report was one of many from a range of informants deployed that spring to help monitor the prolific activist.[21]

The FBI logged Hunninen's attendance at thirty meetings, rallies, and other events between that January and April. Like Hunninen's fund-raising at Stax, every bit of that activity involved constitutionally protected political activity. Several reports involved meetings in private homes and churches to discuss the war, Angela Davis, and the legal defense of activists jailed for trying to move poor squatters into public housing without authorization. Representatives of the FBI and MPD listened as Hunninen spoke at a downtown rally, as she characterized the country's selective service laws as racist and condemned the U.S. bombing of Laos and Cambodia. Hunninen told the crowd "the bombs dropped on Laos were greater than the bombs dropped on any country in the history of warfare," an agent reported.[22]

The FBI kept the heat on through 1972, taking interest in her first big job after college: working as a labor organizer for the Distributive Workers of America, Local 19—the same union (but with a slightly altered name) that Sen. James Eastland had denounced in public hearings in 1951 as a communist front. Hunninen hired Withers that summer to chronicle her efforts to organize some four hundred workers at the Donruss Bubblegum Co.'s Memphis plant. The *Southern Patriot* published an uninspired photo he shot of ten workers, black and white, posing outside the plant. It accompanied an article discussing the interracial union's long struggles in Memphis.[23]

Again, Withers kicked the information to law enforcement behind

*The April 19, 1971, report helps illustrate the breadth of Withers's informing. Starting with an FBI form FD-306, or "Cover Sheet for Informant Report or Material," the report gives updates on a range of leftist and militant groups Withers followed, including the National Welfare Rights Organization, the Young Workers Liberation League, and the Black Panther Party. Though the FBI fought efforts by the author in his lawsuit to release serial numbers from Withers's informant file, this report lists the corresponding serial in Withers's file: 170-70-808. That means this report appears as the 808th in his file. An FD-306 filed in November 1975 shows that the number of reports in Withers's file reached 893. The actual number of reports likely is higher. The FBI started its 170 "extremist informant" classification in 1964. The number of reports involving Withers before that, between 1958 and 1963, is unknown.

Hunninen's back. He reported Hunninen's organizing efforts to the FBI on July 5, 1972, along with details about her working relationship with her supervisor, Earl Fisher, the same African American labor leader whom Senator Eastland had grilled and berated in his 1951 hearings on communism.

"Kathy has indicated that her boss, Mr. Earl Fisher, and leader of the Distributors Local, is watching her very closely to see if she will be successful in her first organizing attempt," an agent wrote after debriefing Withers. The photographer reported, too, that Hunninen and her colleague Allan Fuson planned to attend the Democratic National Convention in Miami.[24]

Adhering to the mandate from headquarters to maintain a virtual "day-to-day appraisal" of subversive activity, agents inventoried her appearance at as many as sixty-two meetings and political events between May 1971 and January 1972, when it cranked up its attention yet another notch after learning she'd assumed the chairmanship of the Harriet Tubman Club, a suspected communist front. But the Memphis office's file on Hunninen neared its terminus on August 12, 1974, when, in its 659th report on the activist, the agency learned she was leaving town.[25]

Withers said Hunninen had just told him over the phone she was moving to Ohio, where she'd received a scholarship for graduate study.[26]

BY 1984, HUNNINEN had left Memphis far behind her. She'd earned a master's degree and was completing a doctorate at the University of Cincinnati Medical School in the arcane field of gas chromatography—the analysis of toxic chemicals—when the National Institute for Occupational Safety and Health offered her a position as an industrial hygienist. The ex-activist, then thirty-six, would test workplaces for hazardous chemicals and materials like asbestos. But there was a snag.

Conducting a "name check," a cursory review routinely performed on new federal employees, the FBI told the Office of Personnel Management that its indices showed Hunninen had been the focus of a national security investigation between 1971 and 1975. In turn, OPM asked for a full field investigation—interviews of employers, educators, and associates as well as extensive records searches—aimed at determining Hunninen's loyalty. When she refused to sign a privacy waiver, the pro-

bationary employee was fired. She was reinstated after filing a suit in federal court.[27]

Still, OPM pushed for a full field investigation. The controversy hinged on a polarizing Cold War–era policy that screened the politics and behavior of federal employees. OPM sought the investigation in accordance with Executive Order 10450 signed by President Eisenhower in 1953. The measure had revoked Truman's Loyalty Order, reforming its more overt political elements. It remained oppressive, however, in the estimation of many. Critics have written much in recent years of its "immoral or notoriously disgraceful" clause that banned gays from federal employment for decades.[28]

The impasse dragged on for more than a year when Hunninen's lawyer, David Gersch, moved to end her probationary limbo. In a sharply worded letter, he asserted the government's 1970s security investigation of his client had pivoted on "illegal surveillance" by MPD's Domestic Intelligence Unit. The lawyer advised FBI officials of the 1978 federal court order that had disbanded the Memphis police unit for its many First Amendment violations. He reminded them that Hunninen's duties, testing for asbestos and clean indoor air, were hardly matters of national security. "Moreover," he wrote in October 1985, "the records which the FBI does have regarding Ms. Hunninen are probably over ten years old and concern her domestic political activities, not contacts with foreign powers."[29]

But Hunninen was worn down. Three months later—in January 1986—she resigned.

IN A POSTMORTEM of her employment, the Justice Department weighed in. Then–Counsel for Intelligence Policy Mary C. Lawton wrote an internal memo advising that, despite Hunninen's nonsensitive position, a full field investigation would have been warranted had she stayed on. A key consideration involved her "knowing membership in a domestic organization that seeks to overthrow the Government of the United States," Lawton wrote. Among concerns, records of the FBI's investigation showed Hunninen had remained active in the Communist Party in Cincinnati until at least 1975. Like the probe in Memphis, however, those records showed nothing explicitly traitorous: she spoke in favor of women's rights

at one meeting; she marched for equality; she attended a convention in Chicago.[30]

"It had nothing to do with supporting Russia, with supporting Red totalitarianism," Hunninen said, reflecting on not just her membership in the Communist Party, which she said lasted a year and a half or less, but the larger experience of communist activists in Memphis. "The only reason I joined the Communist Party was they were the only ones standing up against racism."

She remains deeply embittered toward the FBI—and Withers.

"This man has ruined my life. He has ruined my life," Hunninen said after reviewing records detailing Withers's repeated reporting to the FBI.

"Betrayal? Betrayal isn't even the word. I have been scarred for life."[31]

TO THE BRINK: THE FBI'S WAR ON DR. KING AND BLACK POWER

THE RISE OF THE INVADERS: COINTELPRO, THE MEDIA, AND THE FBI

WINTER 2010

A N OLD MAN IN A wheelchair wobbled down the linoleum hallway as the explosive reports of a dry cough resonated from a distant room around the corner. This is the Americare nursing home, once the notorious Oakville Sanatorium. Now it was home to one of Memphis's most feared denizens of the late 1960s, Black Power militant Charles Cabbage.

"I really thought we were going to succeed, overthrow the United States government," he told me as he sat in bed wearing just a hospital gown. "At that time in history it needed it."

He was sixty-five now and in failing health. His right leg had been amputated below the knee as a result of diabetes. His tired face sagged from years of hard living—he was but a wisp now. In five months he'd be dead. But back in 1968 teams of undercover police treated him as a legitimate threat.

As cofounder of the Invaders, a homegrown Black Power group styled after the militant H. Rap Brown's SNCC and influenced by Oakland's Black

Panthers, he spread the gospel of black separatism. He urged young African American men to tear up draft cards and boycott the "white man's war" in Vietnam. He had a much-publicized summit meeting with Martin Luther King, Jr., at the height of the sanitation strike, when the leader of the non-violent movement tried to rein him in. He was incorrigible. He studied books on Marx and Mao, talked revolution, even handed out leaflets with instructions for making the street fighters' weapon of choice, the Molotov cocktail.

He was mostly talk.

If Charles Laverne "Cab" Cabbage ever shot or killed a man, there's no record of it. Murder wasn't in him. But many misdeeds short of it were.

His life on the wrong side of the law started as a matter of principle. Prosecuted by the federal government for evading the draft, Cab turned to street crime. A gifted athlete who'd played basketball at Memphis's Carver High School before attending Morehouse College in Atlanta where he was radicalized, he was a natural leader: smart, articulate, blessed with a hearty sense of laughter. During our visit he joked of running for the nursing home's resident council. "They do *not* want me on their board," he giggled. But there was a dark side, too. He smiled coyly as he recalled his efforts to "organize" the hustlers, thieves, and gamblers on Beale Street, to enlist them as soldiers in the movement. What he managed to do was to build his own lengthy rap sheet for burglary, carrying a pistol, and unseemly conduct.

"I basically was a pimp," he confessed. "I fell in with the Beale Street crowd. Image went to shit."[1]

I had come here to see Cab with Coby Smith, who cofounded the Invaders with Cab in 1967. Smith had been giving me a tour of his old haunts, and Cab, his old friend, was a must-see. The two couldn't have been more different: Cab lean and tall; Smith short and stocky. They differed philosophically, too. Like Cabbage, Smith's activism grew from his opposition to the war. But as elements of the Black Power movement trended away from the struggle for equality, toward separatism and violence, Smith pulled back. He focused on personal advancement. He was among the first black students to attend Memphis's elite Southwestern College, and he later moved north to pursue a doctorate in education.

His studies just might have saved him from Cab's fate—and the fate of many others in the Invaders.

"You thought you were paranoid. Everybody's after you," Smith recalled of the forces that drove him from the Black Power movement. He feared the Invaders' more militant wing, which emulated radicals like Huey Newton and Bobby Seale. He feared the police more. At one point he thought he was marked for assassination. "A friend told me, 'All the police got a picture of Coby and Cab.' He said, 'Man, the police are taking pictures of you and Cab out of trees.'"

The Invaders have been lionized in recent years, celebrated as young, angry freedom fighters battling oppression. Indeed, the group made significant contributions by raising awareness of police brutality, poverty, and black pride. Yet its alter ego, the much-feared street gang, is largely overlooked. Not everyone who was an Invader was a crook, but many were. Elements within the informal group, which included scores of youths, set buildings on fire, extorted tribute from businessmen, intimidated newsmen, and physically beat rivals senseless. One of Cab's closest friends in the Invaders went to prison for robbery. Three others were convicted for the sniper wounding of a Memphis police officer. Many more did jail time for drug possession, thievery, and a range of minor offenses.[2]

THOUGH THE INVADERS were deeply flawed in their own right, the truth is the FBI targeted them for destruction. In close cooperation with the Memphis Police Department, Bill Lawrence and his colleagues at the Bureau infiltrated the Invaders with as many as five informants and undercover MPD officers. It's believed, though unproved, that at least a share of the Invaders' criminal acts were provoked or encouraged by one or more of these operatives. This much is certain: the FBI fed a flow of detail on the Invaders' transgressions to the news media as a counterintelligence tactic intended to undercut the group's support in the black community. The agency placed Cab and Coby on its Security and Agitator indices, targeting them for special attention as enemies of the state. It unsuccessfully lobbied the Justice Department to prosecute the Invaders' leaders for sedition. More troubling, the FBI aimed its campaign of dirty tricks at law-abiding moderates who so much as sympathized with the Invaders.

Much of what the FBI learned about the group came from its prized informant in the black press, Ernest Withers.

Cab and Coby never knew it, but Withers—a virtual father figure to the young militants—informed on them, too. Between 1966 and 1969, as he worked to gain the trust of key players in the blossoming Black Power movement, Withers passed as many as seventy-three photos of the two activists to the FBI along with oral intelligence documenting their activities—details contained in eighty-seven separate reports. Much of the information he shared was aimed at Cabbage's dereliction and Smith's outspokenness.

"He was a dear friend," Cab said when asked about an old Withers photo he'd saved. A grainy black-and-white, it was propped up in his hospital room's windowsill, one of Cab's few remaining possessions. Taken in 1968, it depicted a young Cabbage on his feet at a church rally, angrily confronting one of the mainstream leaders of the Memphis sanitation strike. As Cab recalled it, he was accusing union leader Jessie Epps of stealing donations intended for the striking garbagemen. Withers captured the moment.

Withers was always there: through wit and charm, he found a front-row seat at the Invaders' clandestine meetings at their office on Vance Avenue, where the photographer served as an adviser to the group. He developed personal relationships with several of the young men, listening to their complaints, helping them work through troubles, even providing small cash loans and gifts to some.

But all those pictures made some suspicious. Though he got over it, there was a time when Cab, too, wondered about the loyalties of his older photographer friend.

"Ernest always had the pictures," Cabbage said with a slight scowl as Smith nodded. "Where was he getting the finances to supply himself with so much film?"

THE FBI OPENED its thick file on Coby Vernon Smith on November 29, 1966, as agent Lawrence explored perceived communist influences on local campuses. Smith was twenty then, a student at Southwestern, where he'd penned a "bitter" article in the school newspaper on racial bias. In a memo styled "COMINFIL of Southern Student Organizing Committee," Law-

rence said Smith had "divorced" himself from the moderate NAACP and had become active in the militant SSOC. The agent began seeking regular updates on Smith the following spring as the activist became involved in Memphis's blossoming peace movement. Again, Withers played a key role. The photographer learned Smith had temporarily dropped out of school and moved to New Orleans—he turned over Smith's Louisiana contact information, including his address and phone number, details that would allow the FBI to monitor his comings and goings and to conduct warrant-less searches of his phone calls if it so desired.* When Smith returned, With-ers shot a series of identification photos, a close-up of Smith's smiling face that fills the frame along with wider-angle shots depicting the activist in smoke-black shades at a peace rally—pictures that Lawrence shipped to the FBI's New Orleans, Atlanta, and Washington offices to help monitor his activities.[3]

Withers assured the agent he would continue to assist that effort.

"He stated that he would attempt to run into Smith or find some logi-cal pretext under which to contact him and ascertain if possible his future plans, in view of this Bureau's investigative interest in Smith," Lawrence wrote.[4]

That investigative interest grew as Smith began making provocative statements about Black Power. As Withers and other informers listened, Smith told an assemblage of peace activists at a downtown Memphis park that April that he'd like to form a Black Power group, perhaps a Mem-phis chapter of SNCC, that could work "hand in hand" with peace activ-ists in opposing the war. By July, as tensions seethed in riot-torn Detroit and Newark, Smith reportedly announced he'd like "a good race riot" and vowed to "turn Memphis upside down," Lawrence wrote.[5]

Smith's rhetoric mirrored that of Stokely Carmichael, the newly installed chairman of the Student Nonviolent Coordinating Committee who oversaw a metamorphosis at SNCC. He moved to expel whites from the organiza-tion, and worked to shift the goals of the freedom struggle from equality and integration to self-sufficiency, pride, and political might—Black Power. His rhetoric inspired countless young African Americans like Smith who

*As early as November 20, 1967, records show, Lawrence began tapping his sources at Southern Bell to check phone records connected to members of the Invaders.

had tired of white supremacy and its many afflictions—police brutality, oppression, and poverty.

Two developments collided in July 1967 that caused the FBI to zero in on the blossoming Black Power movement in Memphis: the destructive race riots that month (now often called the Detroit and Newark rebellions) and the return to Memphis of Charles Cabbage. Graduating from Morehouse College in Atlanta, SNCC's home base, Cabbage had met the group's leaders there and been baptized in the Black Power calling. When he came back to Memphis, he and Smith became fast friends. As rumors spread that the pair planned to form a SNCC chapter in Memphis, the FBI's antennas went up. Withers scoped out a two-story brick home in South Memphis where Smith was said to have opened a "Freedom House," but reported to Lawrence it was vacant. When the FBI discovered it had no identification photos of Cabbage, the photographer searched his files for pictures of the activist from his days playing basketball.[6]

Withers provided the FBI with plenty of photos over the next month. That August he handed Lawrence as many as thirty-one new pictures of Cabbage and Smith, several of them posed portraits he shot in his Beale Street studio.

"When we first walked down Beale Street, Ernest called us over to his studio and took a picture of us then," said Smith, who'd known Withers all his life as the photographer who'd shot his family portraits and graduation picture—whom he trusted implicitly. Withers evidently misrepresented his purpose. "Withers took these photos," Lawrence wrote, "under the pretext that he was going to send them to *Jet* Magazine, a Negro publication, which was potentially interested in the story concerning Smith and Cabbage."[7]

WITHERS SNAPPED SEVERAL of these behind-the-scenes shots as public controversy enveloped Cabbage and Smith for the first time. On August 4, 1967, the *Memphis Press-Scimitar*'s celebrated investigative journalist Kay Pittman Black reported the two men had been hired by a federally funded War on Poverty program called MAP-South. Cabbage and Smith were believed to be "members or sympathizers" of SNCC, Black wrote. Rumor had it they advocated rioting. It didn't help that they'd been hired by MAP-

South chairman Rev. James Lawson, viewed dimly by the moderate NAACP and by that time under investigation by the FBI for five years. The story intensified as segregationist Sen. James Eastland and Republican congressman Dan Kuykendall pushed for official investigations. Cabbage and Smith were fired but rehired in a hearing weeks later when civil liberties attorney Lucius Burch, who represented the men free of charge, argued that their political affiliations were irrelevant. "If they are members of SNCC or the Ku Klux Klan either, this has nothing to do with their employment," Burch said.[8]

Available records don't say how Kay Black broke the MAP-South story. But quite possibly the FBI had fed it to her. Black became a critical contact as the Bureau moved to break the Black Power movement in Memphis. As part of a COINTELPRO operation directed at "black nationalist hate groups," the one-time beauty queen wrote stories at the FBI's direction aimed at fracturing support for militant activists in the black community. She wrote a watershed piece in February 1969 under the headline, "Invaders vs. the Law—Box Score to Date," detailing the criminal records of thirty-five members of the Invaders, including its executive secretary, Oree McKenzie, found guilty of assault with the intent to commit murder in the sniper-ambush wounding of MPD patrolman Robert James Waddell. The piece also featured Charles Ballard,* charged with murdering another militant, and Invaders "Prime Minister" Lance "Sweet Willie Wine" Watson, who had served three years for burglary in the mid-'60s. The action lacked the treachery of some of COINTELPRO's dirty tricks—the FBI simply pointed Black to arrest records and public source material she could have found on her own—but it was a classic counterintelligence motif intended to publicly humiliate targets of an investigation. And it was just one of many such actions.[9]

Black "advised that she will continue to write articles in an effort to discredit this Invader group at Memphis, Tennessee," Lawrence's new partner in internal subversion investigations, Howell S. Lowe, wrote to headquarters.[10]

*The charge against Ballard was later dismissed.

BLACK WAS JUST one of several contacts Lawrence maintained among Memphis's white media. He spoke often with Clark Porteous, the pipe-smoking journalist who wrote for the *Memphis Press-Scimitar* over parts of five decades, and with Burt Ferguson, the white owner of WDIA, the vener-able AM-band radio station that broadcast the blues and news to a massive black audience throughout the South, taking editorial positions occasion-ally at odds with the movement's leaders.*

My own newspaper, *The Commercial Appeal*, apparently cooperated, too.[11]

Following the March 28, 1968, violence that broke out in the back of a march Dr. King led through downtown Memphis, the Bureau disseminated a blind memo to "cooperative news media." Intended to paint King as a hypocrite, it likened him to Judas, contending he'd led "lambs to slaugh-ter," then disappeared "when the violence broke out." Though it's never been definitively established, many believe the FBI influenced *The Commercial Appeal*'s editorial the next day, which condemned King, saying "his pose as a leader of a nonviolent movement has been shattered." A front-page story reported King had met with representatives of the Invaders, noting he stayed in an expensive "$29-a-day room at the Holiday Inn-Rivermont," then one of the city's premier hotels—a theme trumpeted in the FBI memo. The story failed to mention that police escorted King to the Rivermont because routes to other hotels were blocked by the unfolding melee.[12]

The following winter, the FBI's Memphis office sought headquar-ters approval to approach a reporter at *The Commercial Appeal* "who has always been cooperative," seeking to "leak information of a derogatory nature regarding the Invaders and other black nationalist militants."[13]

These were dubious undertakings. Journalistically, the ethics of becom-ing a mouthpiece for government propaganda is contorted at best. Still, few journalists are going to turn away an FBI agent offering information. Seth Rosenfeld writes in *Subversives*, his classic study of FBI surveillance

*Porteous had a long relationship with Lawrence possibly stretching to 1951, when the reporter ap-peared before Sen. James Eastland's communism hearings in Memphis. Porteous testified that he was told that as many as seven hundred copies of the *Daily Worker* were coming into Memphis a day. In 1967, Porteous arranged for Lawrence to receive *Press-Scimitar* photos of war protestor Thomas Van Dyke Potts, and told the agent of a televised debate in which James Lawson expressed sympathies for communism. The reporter also passed on leads during the 1968 sanitation strike.

of campus activists at UC-Berkeley, that agents there often received information "from their special contacts in the media," including an employee at the *San Francisco Examiner* who delivered unpublished photos from a rally. Reporters need sources to survive. Pleasing a source now can lead to more stories later. It's doubtful, too, that reporters like Kay Black viewed these stories in the same way the FBI did. Bureau memos state an intent to "discredit" and disrupt. Yet the motives of Black and her cohorts, biased as they often were by a mindset favoring law and order over protest and equal rights, included a sense of fairness. They universally reached out to news subjects, incorporating their comments when available to balance their stories. Yet, in choosing to cooperate, in many ways they were not unlike their counterpart in the black press, Ernest Withers. [14]

Still, there are critical differences. First and foremost, Withers was *paid*. There is no record to date that shows any other Memphis journalist received money from the FBI. In fact, among scores of confidential sources the FBI maintained in the media, in academia, among student activist groups, civil rights organizations, political parties, private business, local government, and labor organizations, only five informants in this period were paid to report on the city's racial turmoil. And one was Withers. [15]

The tensions of 1967 brought Withers deeper into the FBI fold. Following the photographer's 1961–1963 trial as a Potential Confidential Informant, Lawrence had kept Withers parked in the status of a Confidential Source. But the riots in Newark and Detroit the summer of 1967 changed that. Under pressure from Lyndon Johnson's White House to ramp up intelligence in urban areas, the Bureau created the Ghetto Informant Program. It comprised as many as 7,400 informers, including so-called listening posts— many of them white shopkeepers doing business in black communities— who kept alert for unrest and possible rioting. The program offered Withers more assignments, more opportunity for pay, and a moniker, ME 338-R.* He remained in this status as a racial informant until 1971. By then, the photographer's assignments had shifted to reporting nearly exclusively on fringe groups, including a small chapter of the Black Panthers, and a resurgent

*Withers first appears as ME 338-R in a report dated December 16, 1967.

Communist Party whose youth organization, the Young Workers Liberation League, became active in Memphis. Accommodating his redesignation as an extremist informant, the FBI revised the suffix of his code number, repackaging him as ME 338-E—"E" for extremist.[16]

THERE'S NO EVIDENCE, either, that any other Memphis newsperson shared such a volume of information with the FBI or acted as a directed informant as did Withers, whose work veered far outside mere journalism. To the contrary, there is evidence other black journalists were courted as potential informants by the FBI—and they resisted.

Earl Caldwell, the pioneering black *New York Times* reporter, is one writer who refused to bend. Caldwell was at the Lorraine when King was shot there in 1968. He was assigned the following year to cover the Black Panthers in Oakland. Being black opened special access that enabled him to write critical articles about the Panthers' tactics and plans—plans that intrigued not only the public but the FBI, which unsuccessfully pressured him to become an informant. When Caldwell resisted a subpoena to testify before a federal grand jury, a group of seventy black journalists took out a full-page ad in the New York *Amsterdam News* titled "Message to the Black Community."

"We will not be used as spies, informants or undercover agents by anybody. We will protect our confidential sources, using every means at our disposal. We strongly object to attempts by law enforcement agencies to exploit our blackness," read the ad signed by some of the big names in the business, including broadcasters Ed Bradley and St. Clair Bourne, *Ebony*'s Phyllis Gardner, and novelist Louise Meriwether.[17]

"There was tremendous pressure on all kinds of people to be a participant in that," Caldwell said years later. "How is it that Ernest got trapped up in something that we all said we will not do this? This is a line we will not cross. How did Ernest get on the other side of that?"[18]

22.

"IS ANYONE LOOKING FOR US?": THE RISKS OF WORKING UNDERCOVER

CHARLES CABBAGE SEETHED WITH URGENCY.

The young militant appeared unusually hostile as he approached Withers on this frosty winter day in 1968. At Cab's side was Clifford Louis Taylor, twenty-one, his "lieutenant," a rough, street-savvy associate from Memphis's Riverside neighborhood. Both had been subjects in a series of confidential reports the photographer funneled to Lawrence as the special agent investigated the fledgling Invaders.

"Has anyone been here looking for us?" Cabbage demanded.

"I mean," he prompted, "someone such as *the FBI*?"

Withers was shaken. But he kept his composure. No, he lied. No special agents had been to see him. No one was asking him questions.

As he ad-libbed, Withers, dubbed ME 338-R just weeks earlier, sensed the depth of his predicament. His secret was about to unravel. He quickly contacted Lawrence, who recorded the incident in a January 5, 1968, report.

"Informant was warned that they may be on to him," the agent wrote. To counteract their suspicions, he devised a plan: he would arrange a "fake" FBI interview with Withers. Lawrence believed Cabbage and Taylor were agitated by a recent round of interviews he and agent O. V. Johnson had conducted in a campaign to intimidate the militants, possibly even recruit some as informants. To get the heat off Withers, Lawrence determined the photographer must appear as just another target. At the agent's instruction, Withers told Cabbage and Taylor the FBI learned he'd taken recent photos of Black Power advocates and wanted copies, but he'd told the agents he had none—he'd sent the negatives to *Jet* and similar publications and hadn't kept any.

"Cabbage and Taylor seemed to 'fall' for this story," Lawrence wrote. "In other words, he [Withers] became one of the 'fraternity' of FBI interviewees, and it is felt as a result a closer fraternal relationship will develop." It did. Cabbage opened up. He talked manically of the tall "cracker"—Lawrence—who'd been asking about him. "Cabbage was particularly worried," the agent wrote after debriefing Withers, "feeling that the FBI is about to take some legal action against him and his followers, and apparently fears that he may be arrested on some unknown charge in the near future."[1]

WITHERS WAS SHAKEN. But it wouldn't be the only time. Repeatedly, his secret came perilously close to disclosure. In time, he would be called to testify behind closed doors to a congressional committee, narrowly escaping detection. But danger came much earlier. Withers narrowly avoided detection on the night of King's April 4, 1968, assassination. A visitor overheard him talking on the phone at his Beale Street studio. Was it the FBI? Or the police? He couldn't tell. Fifteen months later—another close call. A militant accused him of leaking a photo to the FBI. The picture identified a fugitive Invader wanted for a double shooting. Withers stood his ground. He dismissed the accusation as a "fishing" expedition.[2]

Withers was nearly found out again in 1970 when two news photographers confronted him. They "accused the informant of furnishing photographs of black leaders, organizations, demonstrations, and meetings of Negro citizens to the FBI," agent Howell S. Lowe wrote that April. The photographers, Sam Melhorn of *The Commercial Appeal* and Jack Cantrell

of the *Memphis Press-Scimitar*, confronted Withers following a hearing on police brutality at the Shelby County Courthouse. In a move evidently motivated by professional jealousy, Melhorn told Withers that he and other photographers at the two daily newspapers "had been ordered not to give out any photographs to any [police] agency."[3]

Asked about the incident forty-six years later, Cantrell said he didn't recall it but remembers unspecific rumors among press photographers that Withers "was working for the FBI on the side." Though Lowe's memo suggests that other news photographers might have been doing the same, Cantrell said, "I didn't do it and I don't know anyone else who did."[4]

THE REVELATION THAT some suspected Withers is intriguing. Following publication of my initial stories in 2010, a Withers associate argued his relationship with the FBI "was not a secret," citing a passage in the photographer's 2000 book of civil rights–era photos, *Pictures Tell The Story*, that mentions agent Lawrence. I'd done an immense amount of research prior to publication, but I flat missed this. The development stung. It grieved me— until I checked deeper.

Withers's account appears as a single, six-sentence paragraph in the 192-page book. Specifically, it appears in the book's forty-two-page essay on Withers's life and civil rights photography written by F. Jack Hurley, former chairman of the history department at the University of Memphis. The context is the volatile 1968 sanitation strike.[5]

Hurley quotes Withers as saying:

> I never tried to monitor what they were doing (too closely). I was
> always interested in their outside work but I tried not to know too
> much about the inside because I always had FBI agents looking
> over my shoulder and wanting to question me. I never tried to
> learn any high powered secrets. It would have just been trouble . . .
> I was solicited to assist the FBI by Bill Lawrence who was the
> FBI agent here. He was a nice guy but what he was doing was
> pampering me to catch whatever leaks I dropped, so I stayed out
> of meetings where real decisions were being made.

That's it. Nothing more. The reference to "pampering" seems to suggest Withers was paid. But it's never confirmed here. The essay never explores the many questions raised in the quote: Was Withers saying he was an informant? Just what did he do? How long did he do it?

Clearly, Withers's confidential relationship with the FBI had suffered leaks over the years. But the contention it "wasn't a secret" is simply counter-intuitive. Perhaps it wasn't the best-kept secret. Jim probably told more people than me. Over time, as the events of the '60s fell into a safe distance, Withers may have talked to others, too. Maybe, he got comfortable. Many a crime, many an extramarital affair, has come to light, not because it wasn't secret, but because the perpetrator eventually told someone.

But when a person becomes an informant, the FBI offers a pledge of confidentiality. The purpose is secrecy. Lawrence said as much in his congressional testimony. He talked of protecting Withers, who wasn't named, saying they took care to meet "under what we hoped were safe conditions." Simply put, if Withers's relationship with the FBI had been widely known, he couldn't have been effective. And as 1967 morphed into 1968, and the volatile sanitation strike broke out, Lawrence needed Withers—he needed confidential informant ME 338-R—to be effective.[6]

PERHAPS WITHERS DID hold back at times—perhaps he avoided some "high-powered secrets," as he said. Though Lawrence trusted Withers, reports indicate that trust might not have been absolute. In July 1968, for example, the agent fed Withers a red herring. At the request of MPD commanders who hoped to "divert" suspicions from undercover officer Marrell Mc-Collough, Lawrence told Withers someone else had infiltrated the Invaders.

"It was indicated to ME 338-R that Oree McKenzie was thought to be a PD informant," Lawrence wrote. His report doesn't say whether Withers was clued in to the disinformation or not. But clearly, the agent knew the gossipy photographer would broadcast it vigorously.[7]

Nearly fifty years later, the scheme to put the snitch jacket on McKenzie, a militant activist who later became a Gospel-preaching pastor, seemed to

still be working. "I think he was undercover," Coby Smith said in 2010 over breakfast.[8]

Though it's unclear what Withers really knew about McKenzie, this much is certain: informing on the Invaders could be especially risky. Police reports tell how Invader "enforcers" stripped and beat a suspected informant in 1969 after he was seen speaking and laughing with three MPD patrolmen who addressed him by name. Operating out of a small office two blocks south of present-day FedExForum, the Invaders "reinstated" the misidentified snitch when an interrogation by the militants failed to produce sufficient evidence.[9]

BY EARLY 1968, Cabbage and Smith had formed the Black Organizing Project, or BOP. Modeled after the Black Panther Party's "Ten-Point Program" demanding jobs, housing, and exemption from military service, BOP developed a platform seeking a black-run school board, black police to patrol African American neighborhoods, and economic independence. Though the group became popularly known as the Invaders, a name adopted from a popular sci-fi television show about extraterrestrials living here disguised as Earthlings as they prepared to launch an invasion, BOP served as an umbrella group with smaller Black Power–oriented "cells" located at Memphis State, downtown, and in individual neighborhoods and high schools. As Shirletta J. Kinchen notes in her study *Black Power in the Bluff City*, much of the Invaders phenomenon involved a fad. The city's youth mimicked the hip style of men like Invaders lieutenant John B. Smith—smoke-black shades, an Afro hairstyle, and a military jacket with the name "Invaders" stitched across the back—while not necessarily committing to the discipline of the cause.[10]

As Withers told the FBI at the height of the sanitation strike, although "many teenagers in Memphis have put the word 'Invaders' on backs of their jackets" they are not necessarily members but "do this more or less as a symbol of their self-professed affinity with Black Power." Lawrence wrote, "On 5/22/68 ME 338-R (Ghetto) advised SA Lawrence that one can no longer distinguish legitimate Black Power advocates, such as the Black

Organizing Project group in Memphis, by the dress of the average Negro male or female."[11]

In a similar manner, the photographer helped Lawrence and his cohorts understand that they were wrong about some individuals suspected of radicalism. As the agent would later tell Congress, he wanted "objective" information that could help separate true radicals from "dupes" and those "innocently involved." Withers reported in March 1970, for example, that a young family man working in education "is not known to be active in any militant activities at the present time" and that one-time Invader Charles Harrington "is also no longer connected with any known militant organizations." Instead, he drove a food truck.[12]

But the thrust of his reports involved intel on the group's doings and plans. He had the perfect access. Cabbage, Coby Smith, and John B. Smith often hung out on Beale Street, often in the Withers Photo Studio.[13]

Withers knew, for instance, if the FBI needed to find LeMoyne student leaders James Elmore Phillips and Clinton Roy Jamerson, both Black Power ideologues, one haunt to check was the Pink Pussy Cat in Hyde Park. And if they needed Cab or John B., try the Log Cabin, a nightclub on South Parkway.[14]

Though the men kept abreast of current events, as young adults they concerned themselves, too, with one of youth's great distractions, partying. They often congregated at "The Crib," John Smith's South Memphis apartment. An Air Force veteran with "a John Wayne idea of American patriotism," Smith's view morphed, he says, when a white gas station attendant tried to cheat him out of money, and called him a racial slur. Then, the police came. "Nobody wants to listen to me. I'm a black man accusing a white man of taking my gas cap." Smith was arrested and charged with disorderly conduct.[15]

His outlook darkened when, like Cabbage and Coby Smith (no relation), he became a target of Kay Black's poison pen. She wrote in September 1967 that he drew two federal paychecks in apparent conflict with civil service rules, simultaneously working part-time as an anti-poverty worker who canvassed neighborhoods for MAP-South and full-time at the Memphis Defense Depot. Though in reality MAP-South was a private,

nonprofit company that merely received federal money, the accusation stung. "It is a complete hatchet job," Smith said.[16]

Hundreds of Memphis youths eventually came to identify as Invaders, yet, as Smith would later recall, the group couldn't muster more than ten to fifteen members until the 1968 sanitation strike raised their profile. Still, Lawrence kept a laser focus on them.[17]

"Cabbage and his associates intimidated white professors and talked of getting guns," Lawrence wrote that November after debriefing Withers. The subject: a BOP meeting at the LeMoyne campus. Another source told of a meeting at Owen College (LeMoyne and Owen merged the following year), where Cabbage reportedly told a gathering, "The black man must overthrow capitalism by any means necessary"—a quote loosely borrowed from one of his heroes, Malcolm X. Cab bragged of bringing feared radical Stokely Carmichael to town, Withers said.[18]

As the FBI monitored Cabbage's travels, Withers reported a trip the militant planned for Little Rock "to make some talks on black power." In preparation, Lawrence shipped a photo of the activist to the FBI's Little Rock office, along with a physical description—six-foot-two-and-a-half and one hundred sixty-five pounds—plus a description of his vehicle. Withers shot a flurry of photos, including one depicting the would-be revolutionary's lighter side, hamming for the camera as he peered comically over the tops of his sunglasses.[19]

Over the months, Withers opened a spigot of details—Cabbage distributed leaflets with instructions on making Molotov cocktails, he told Lawrence; he's "romantically attached" to the secretary of a prominent lawyer; he drives a blue Mustang. Withers gave Lawrence the tag number—details shared with MPD's Lieutenant Arkin. Cabbage later was pulled over and arrested on a trumped-up charge of suspicion of auto theft and improper registration. The photographer also relayed a series of phone numbers used by Cabbage; Lawrence ran them through his phone company sources.[20]

WITHERS ALSO CONTRIBUTED to Cabbage's prosecution for draft evasion. Of all the counterintelligence operations aimed at the Black Power movement in Memphis, and there were many, this remains among the most troubling.

Nine months before Cabbage was indicted, the then-twenty-three-year-old confided to the older Withers: he feared the draft. Withers, in turn, told Lawrence—Cabbage didn't plan to return to school, and he faced losing his student deferment. The army wanted him. "He will refuse to go," Lawrence wrote after debriefing the photographer. The agent jumped on it. He contacted the local Draft Board, sharing concerns with the board's secretary, Eunice Holloway: Charles Cabbage is preaching Black Power on local college campuses. "This registrant has been under F.B.I. investigation for quite a while," Holloway wrote in a report placed in Cabbage's Selective Service file. "His actions are being closely watched by the F.B.I."[21]

Available records are unclear as to whether Lawrence contacted Holloway before an October 17, 1967, hearing when the board first rejected Cabbage's bid for certification as a conscientious objector, voting instead to reclassify him as 1-A. But the record is crystal clear on this: the FBI's interference poisoned the board's final decision, inviting a federal appeals court's eventual condemnation.

Cabbage's fate was sealed at a November 14 appeal hearing when the board again rejected his request for conscientious objector status. Lawrence had this meeting covered. He and two senior MPD intelligence officers staked out the passageways in the federal building that morning. They watched as Cabbage, wearing his trademark dark sunglasses, stepped off the elevator and ambled down the seventh-floor hallway to restate his case to Selective Service Board No. 83. A source described the drama inside the hearing: Cabbage argued most vehemently—the draft was discriminatory. "He said when laws are unjust it is the obligation of the people to oppose them by any necessary means and that the government has systematically opposed his people, the black people," Lawrence later wrote, emphasizing that Cabbage "used the word 'black'"—the newly adopted term in the freedom struggle—"not Negro." Cabbage argued he should remain a civilian—an "organizer" for African Americans to reform draft laws.[22]

At that moment in 1967 the view of the Vietnam War as unjust—particularly for African-Americans soldiers—was hardly a fringe opinion. King had fully come out against the war seven months earlier. Even before that, leaders like Stokely Carmichael railed against "American imperialism," asking a troubling question: Why should blacks fight and die in a

"white man's war" when they were denied basic rights at home? The draft itself seemed patently unfair: an estimated two-thirds of eligible blacks were drafted, yet just a third of whites. In Memphis, Lawrence had observed the militant movement's strenuous opposition to the war up close for more than seven months now. Withers had first told him about Coby Smith's involvement in the peace vigils the previous spring. Just weeks before the appeal hearing, the photographer reported that Cabbage and two colleagues planned to drive 875 miles in a cramped Volkswagen to participate in the massive "Confront the Warmakers" march on the Pentagon.[23]

Even absent Lawrence's interference, Cabbage's appeal may have failed. He'd refused for months to fill out the conscientious objector forms the board supplied, contending they were unconstitutional—they required affirmation of religious beliefs. But he was unpersuasive. Lacking legal representation and with just one witness—a fellow activist from his neighborhood—his presentation appeared loud and disorganized and, at least to the board of three whites and one black man, who worked as the head waiter at the elite Memphis Country Club, insubstantial. They again denied his request for C.O. status.[24]

CABBAGE FAILED TO report for military induction the following May. He was indicted in July, then convicted in April 1969 following a three-day federal trial. Judge Bailey Brown sentenced him to four and a half years. But the case was later overturned. Citing Lawrence's "clearly prejudicial" report—which Cabbage never knew about and had no opportunity to rebut—the U.S. Court of Appeals for the Sixth Circuit in Cincinnati ruled in 1970 that the militant had been denied a fair hearing. In the meantime, the FBI kept up the pressure. It shadowed Cabbage, by then struggling with anxiety and depression, chronicling his slide into crime.[25]

Cabbage is hiding, Withers said in July 1968 after the activist failed to report for military service. Over time, the photographer learned more: Cabbage is staying in a motel; now he might be in Atlanta; he's getting advice from pacifist pastor James Lawson; he's broke; he's desperately raising money for his legal defense; he bums money; he's become a "con artist"; a "gigolo"; a "pimp and a hustler." His friends are army deserters. That fall,

Withers said that Cabbage might have been involved in the burglary of Christian Methodist Episcopal Church headquarters.[26]

Withers's informing also had a direct impact on Cabbage's placement on the Security Index. Under a heading labeled "Basis for recommendation on Security Index," Lawrence's first sentence in a March 1968 report reads, "Continuously from 7/5/67 to 3/15/68, ME 338-R (Ghetto) has advised that Cabbage has been the leader of a SNCC-oriented group in Memphis, Tennessee, and has by his admission made trips to consult with SNCC and black power leaders in Atlanta."[27]

For all his double dealing, Withers loaned Cabbage, his "dear friend," ten dollars—the cash-strapped activist was headed to Washington to participate in the "Resurrection City" demonstrations there that summer. Withers went, too. He caught up with the young militant there, snapping a picture on the street showing Cabbage dressed in a stylish Nehru jacket, glancing downward, toward the sidewalk. He gave a copy to the FBI.[28]

AS CABBAGE FADED from the Invaders, another Black Power figurehead appeared. The rise of Lance "Sweet Willie Wine" Watson came in near-mystical fashion. An ex-convict and a street hustler, the gaunt, goateed Watson became the public face of the Invaders. Folk hero to some, villain to others, he stirred fear and awe in his Black Panther–inspired beret, dark turtleneck, and military jacket and his self-anointed title as prime minister of a group that, rhetorically at least, looked favorably toward the overthrow of the U.S. government. What he really believed is hard to say. By the mid-1970s, he'd changed his name to Suhkara Yahweh. He could be seen across the years dressed in flowing robes and open-toed sandals, and other outfits, making epic public statements, like the time he marched for two and a half hours across Memphis with a large cross strapped to his back or the time he ran for governor of Arkansas or when he sued Richard Nixon for "crimes against humanity," or chained himself to railroad tracks or tossed his blood on the door of a Memphis abortion clinic.[29]

Watson was an enigma. When he emerged from obscurity in the summer of 1968 as the leader of the Invaders, Withers tried to make sense of him.

The two grew close. Over the next six years, Withers relayed dozens of tips about "Sweet Willie," never stirring a hint of suspicion, it seemed.

"That's my daddy," Yahweh would say decades later as he nodded toward a portrait of Withers hanging on his living room wall alongside other mementos. One, a glass case, contained a military-styled jacket with "Invaders" emblazoned on the back. Nearby, a bumper sticker hung. Designed by Yahweh in 1968, it read "Damn the Army, Join the Invaders."[30]

Withers first told Lawrence about the bumper sticker on November 12, 1968. At the time, the agent was investigating the placement of one of the stickers on a door at the federal building. Authorities noticed it following a visit by Yahweh. Then very much in his "Sweet Willie Wine" persona, Watson/Yahweh had showed up with three or four Black Power colleagues at the army recruiting station on the first floor. According to a sergeant there, the men harassed a young recruit as he was filling out army paperwork. They demanded an office of their own to recruit "their army." Shown a lineup of photos, the sergeant could identify only Lance Watson. Then Lawrence consulted Withers. Listed in the report as ME 338-R, an informant providing "coverage with regard to Invaders and BOP," Withers said "Wine" and his men had printed a series of "Damn the Army" stickers and were selling them for fifty cents each. He gave the names of two printers who might be producing them. But Lawrence subsequently dropped the investigation when he found no federal laws had been broken.[31]

Over time, Withers fed the FBI's fixation on Watson, reporting an incredible range of political and personal developments: Watson was forming a Stokely Carmichael–inspired Black United Front in Memphis; he was attending a Black Power conference in Philadelphia; he was supporting striking workers at St. Joseph's Hospital; he'd "called for violence" against workers who crossed picket lines; he was having a baby with a girlfriend; he was stabbed by a woman in a brawl; he was seeking a small business loan; he'd met backstage with soul singer James Brown following a concert at the Mid-South Coliseum. Withers gave the FBI political leaflets Watson had authored, one titled "Goddam You White Man, Goddam You," and another, "Swing Don't Sing," a winding, typewritten ten-page treatise that

endorses the use of force against oppression and begins with a brief auto-biography describing Watson as a former "pimp, theif [*sic*], gangster and Preacher."[32]

According to Lawrence's reports, Withers knew plenty about his young friend's criminal life. "Informant stated that 'Willie Wine' strictly lives by his wits, has a sharp mind, although he has little formal education," Lawrence wrote in November 1968 after debriefing Withers. "He stated that he is an excellent pickpocket and is probably the sharpest individual in Memphis with a pen knife and can slit the back pocket of a man's pants and lift his wallet quicker than anyone he has ever seen." The photographer reported later that month that Watson had "indicated" he could "get $100 a week in extortion money" from a South Memphis liquor store, though available reports are silent on any detail.

A year later, Lawrence reported this from Withers: Watson was "a con man," who "is not seriously interested in any particular movements" and who "definitely" won't "engage in any violence." The photographer said Watson was running a "racket" called Operation Breakfast, which solicited money to feed needy children, patterned after a program run by the Black Panthers in Oakland. Withers handed over a leaflet promoting the program. He characterized it, Lawrence wrote, as a "publicity stunt" to "help buffer the financial status of Wine." The program was short-lived, but its demise is generally attributed to a lack of community support, not any graft by Watson.[33]

Withers chronicled Watson's slide from a feared radical to irrelevancy. By 1970, the activist had formed "We the People," a grassroots organization that Withers agreed to join as a board member. The photographer reported only a "handful" of followers—significantly, Withers himself and Don Pigford, an undercover MPD officer who had infiltrated the Black Power movement. The day of the Invaders was fading fast.[34]

"On 7/15/70 ME 338-R advised that Lance Watson continues to fast and is spending his nights and most of his daylight hours lying in a coffin at the Community Church on Texas Street," begins a three-page FBI roundup of movement militancy in July 1970. The eccentric militant had turned activism into performance art.[35]

As the years slipped away, Watson-turned-Yahweh remained loyal to his older friend, living in the seeming bliss of ignorance.

"If he was [an informant] I don't know anything about it," he said. "He would call me his son. Right now, I'm still part of the family. I talked to Rome [son Andrew Jerome Withers] just the other day. I talked to [Ernest] on his death bed."[36]

"HOW ROTTEN, HOW FILTHY": UNDERCUTTING SYMPATHIZERS AND SUPPORTERS

B OBBY DOCTOR UNDERSTOOD THE PRESSURE the FBI could bring. In 1968, he was a twenty-eight-year-old field-worker for the U.S. Civil Rights Commission. His sympathies for Black Power landed him squarely in Lawrence's crosshairs. In those days, before the commission's south region office moved to Atlanta, it was headquartered in Memphis. And Doctor, who would go on to become the agency's southeastern regional director, nearly lost his job when Lawrence conducted a loyalty investigation based on intelligence he received from Withers and other informants.

"I'll admit I was very close to the militant movement in Memphis. But I was also close to the traditional leadership," Doctor would say years later in retirement. "I tried to bridge the gap."[1]

Lawrence opened a file on Doctor in November 1967 after police detectives relayed information from an MPD informant. The snitch said Charles Cabbage had attended "interracial parties" hosted by Doctor at his South

Memphis apartment.* Days later, an NAACP informer told the special agent that Doctor is "one of the adult advisers" of Cabbage's "incipient SNCC-oriented black power clique." Uninvited, the "clique" had attended an NAACP leadership workshop. "Doctor brought the group and left with them," Lawrence wrote.[2]

THE AGENT USED Withers to sharpen his focus on Doctor during the explosive sanitation strike and in the volatile months that followed.

The photographer reported Doctor's attendance at a series of Black Power–oriented meetings, including a September 1968 rally at cavernous Clayborn Temple where soul singer Isaac Hayes addressed the all-black crowd. Eleven months before he released his classic *Hot Buttered Soul* to diverse acclaim, Hayes—in his role within the Black Knights, a radical North Memphis cell of the Black Organizing Project—preached Black Power and spite for "Whitey." Hayes "was extremely militant, warned all present not to take notes, and allowed no pictures taken," Lawrence wrote after debriefing Withers. "[Hayes] said the whites did nothing for blacks until a few brave blacks used Molotov cocktails and broke a few windows. He said this is the only way to fight 'Whitey.' He said, 'We have to hurt Whitey where it hurts, in his pocketbook—have to get control of the dollar.'"[3]

Withers reported Doctor's presence at the Invaders' headquarters in March 1969 and saw him there a second time that month as about forty militants, including members of the East St. Louis–based Black Egyptians street gang, listened to tapes of Malcolm X and discussed issues ranging from fund-raising to mistreatment by police.[4]

"I taught classes on black awareness at the Invaders headquarters," Doctor later said. He didn't see his involvement in opposition to his job. As a field-worker for the Civil Rights Commission, established in 1957 to investigate discrimination and voting rights violations, Doctor maintained relations in all corners of the black community. A former activist who participated in the 1960 sit-ins in Orangeburg, South Carolina, he spent a good

*Lawrence originally recommended opening a "140" file, the FBI's classification for federal employees suspected of posing risks to national security. Doctor's file was altered to 157, a classification designating investigations related to civil disorder.

deal of his time in 1968 and 1969 smoothing over tensions between the Invaders and members of King's staff as they pursued an uneasy, months-long collaboration to advance civil rights. "The line between my official and private life was always blurred," he said.

But where Doctor saw gray, Lawrence saw black and white. And in the agent's view, Doctor had stepped over the line. Lawrence's antipathy is best seen in two inflammatory reports he wrote after debriefing Withers.

"ME 338 added that during the 10/5/68 sympathy march for striking city hospital employees that Robert C. Doctor, aka Bobby Doctor, male Negro employee of U.S. Civil Rights Commission, was with Audrey Dandridge, female Negro who used to do volunteer office work for SCLC. Dandridge is married as is Doctor, yet they were holding hands," Lawrence wrote in November 1968. "Photos of Doctor holding hands with Dandridge were furnished by ME 338."[5]

Then this seven months later:

"Informant added that one thing that concerns him is that Bobby Doctor, employee of the U.S. Civil Rights Commission, Third Floor, FOB (Federal Office Building), Memphis, an admitted agnostic non-believer in Christ, as recently as 5/2/69 was telling many BSA (Black Student Association) students along with some Invaders that the theory of SCLC of non-violence and Christian ethics is baloney and that the only way young blacks could get their way was through militancy, even of a violent nature if necessary."[6]

NEARLY FIFTY YEARS later the accusations emblazoned on official FBI stationery still sting.

"I didn't want to tear the country apart. I wanted the country to do right by all of its citizens," Doctor said on a lazy autumn day from an easy chair in his home in Fayetteville, Georgia.

He said he never knew Withers was an informant. But now it made sense. "Ernie made an effort to befriend the militants in Memphis, Tennessee," he said. He recalls the photographer's common interest in topics like police brutality. Often, he shared photos he'd shot of victims cruelly beaten by officers.[7]

"I'm not mad at Ernie," Doctor said, focusing his anger at the FBI.

"Now, don't misunderstand me. I was doing a lot of things in Memphis. But none of what I was doing was illegal. And I'll go to my grave saying that. Now, a lot of what the FBI did was illegal."

Doctor denied Lawrence's insinuation in the November 1968 report that he was involved in improper extramarital conduct.* He questioned the purpose of such an assertion—a "dirty, rotten" smear, he called it—in a government report. If the FBI ever used the information in an official COINTELPRO action there is no known record of it. But the agency did make an unofficial effort to neutralize the activist-turned-field-worker. As Doctor tells it, two FBI agents delivered a "thick report" on his activities to his boss, Bill Taylor. "They clearly were trying to get Bill to fire me. That didn't work," he said.

All over the country, the FBI took similar measures. According to the Church Committee, the FBI directed numbers of disruption actions against "black nationalist hate groups" and their supporters as part of COINTEL-PRO. Many targets were hardly extremists—King's SCLC, for one. Benign campus student associations fell victim, too.

Here, the perniciousness of the 1960s surveillance state comes into focus. When the news of Withers's secret FBI relationship first broke, some people didn't understand: What harm could an informant do in an open, transparent movement? "I don't think Dr. King would have minded him making a little money on the side," Andrew Young said.

But the Church Committee identified several concerns. For one, the FBI's intelligence informants had few restrictions. The broad, vacuum-cleaner approach they employed, collecting "any and everything," was excessively intrusive, the committee found. Then there was the attendant fear. Many groups knew they were being watched. But by whom? The fear of unknown informants chilled the exercise of constitutional guarantees to free speech and political association. Some citizens simply avoided polit-ical participation for fear of being associated with an unfavorable group. Others had specific worries, like being dropped from consideration for a

*In separate interviews, both Doctor and Dandridge denied Lawrence's insinuations. Dandridge, too, didn't blame Withers. "He just did what he had to do," she said. Both signed privacy waivers allowing release of their FBI files to the author. To date neither has been received, nor has the "holding hands" photo been released.

government job requiring a security clearance.[8] Then, there were the direct, disruptive actions, like those waged against Doctor, which weren't even formally part of COINTELPRO.

Doctor's coworker, Rosetta Miller, fell in jeopardy, too. Withers gave Lawrence identification photos of her—one depicting the petite field-worker as she smiled sweetly at an unknown social gathering, her hair permed and a corsage pinned to her lapel—along with some intel. "He said she is the type who is a rumormonger and one who will give aid and comfort to the black power groups," Lawrence reported Withers as saying. A few months later, the photographer reported that Miller—described by Lawrence as "the controversial Negro"—was involved in a marriage that "lasted only one week," and that she'd "since left town."[9]

Decades later, she harbored a bit more bitterness toward Withers than Doctor did.

"My *friend* Ernest Withers," she said sarcastically as the news of Withers's informing sunk in. "Mr. Withers was at everything. He'd be there taking pictures. You just wouldn't think of it."

In the intervening years, Miller achieved great success. She became Nashville area director of the U.S. Equal Employment Opportunity Commission and later opened the *Tennessee Tribune*, a Nashville-based newspaper serving a largely African American readership. Going now by Miller-Perry (after her husband of twenty-five years, the late Dr. Ludwald Orren Pettipher Perry, believed to be Tennessee's first black gastroenterologist), she said the Civil Rights Commission headquarters was alerted after the FBI contacted her Memphis bosses. She and Doctor were called in for hearings.

"It's scary even when I think about it now. They could have really destroyed me. I would not be where I am today if I had lost my government job."[10]

Though it's common today for some older civil rights veterans to speak critically or even derisively of the Invaders and similar radical groups, in truth sentiment about the militant Black Power movement is much more complex. In Memphis in 1968, the city's black elite openly condemned the Invaders, yet many in the larger African American community embraced them.

"Too many Memphians, black and white, are too quick to dismiss these youths as thugs, criminals, drop-outs, and lunatic fringe fools," legendary

Memphis disc jockey Nat D. Williams wrote in the *Tri-State Defender*. "But let's face it. They do have some very legitimate gripes . . . They are black youths who have felt the sting of white racism, the frustration of inadequate employment, the injury of social rejection, the despair of hopelessness, the desperation of a loss of faith in anything except their own strength." The newspaper embraced the militants in its treatment of the March 28, 1968, melee that broke out during King's march through downtown Memphis. The front-page coverage included an editorial denouncing police assaults on innocent bystanders alongside a political cartoon titled "Black United Front"—the name of a collaborative organization lead by militant activist Stokely Carmichael. The cartoon depicted a circle of African Americans holding hands, including militants, radicals, Muslims, "non-violents," conservatives, and "Uncle Toms."[11]

Lawrence understood the sentiment well. He wrote that Withers told him "as much as he hated to admit it, the majority of the black community in Memphis basically supports the Invaders," saying that they got "a vicarious thrill as they hold the impression that the Invaders are causing the white power structure to squirm."[12]

AS THE INVADERS gained traction, Jerry Fanion's sympathies for them put him under intense scrutiny. They may have even contributed to the one-year prison sentence he ultimately served for misapplying bank funds.

Again, Withers played a critical role.

Back in 1968, Gerald A. "Jerry" Fanion was a leader in the black community. The personable ex–postal worker, then thirty-seven, served as Shelby County's director of community relations until he won appointment that year as the deputy director of the Tennessee Council on Human Relations, or TCHR, a nonprofit group that investigated discrimination, police brutality, and issues affecting minority communities. When the sanitation strike broke out, he was a familiar figure at the many rallies and marches.

And as Lawrence and his colleagues at MPD clandestinely learned, Fanion, like many in the black community, secretly cheered on the young militants on the movement's fringe, the Invaders.

Withers first mentioned Fanion that February. The sanitation strike

had just gotten under way. The photographer reported a keen observation to Lawrence: the labor struggle that was tearing Memphis apart had its own, internal, struggle, a "power fight" to direct the strike. On one side was the old guard, conservative NAACP leaders like Jesse Turner. And on the other, mavericks like Rev. James Lawson, fiery Presbyterian pastor Ezekiel Bell, and Fanion's boss, Baxton Bryant, a white liberal who headed the TCHR. Where Fanion fell in the schism wasn't clear. But Withers relayed an intriguing tidbit that provided an early indication of where he stood: Fanion told him that Invaders Charles Cabbage and John B. Smith wanted to insert fire-breathing Stokely Carmichael into the fray, though they lacked the resources to arrange his participation.[13]

Withers mentioned Fanion again that summer. In one of those sweeping intelligence reports that helped the FBI keep its suspicious eye on Memphis's black community, the photographer provided updates on as many as twenty-five people over the course of five pages, many of them Black Power militants, but also mainstream community fixtures like Alma Morris, longtime president of the Kennedy Democratic Club (she was close friends with the mother of one of the Invaders, Withers said); North Memphis barber and civic leader Warren Lewis (he was active in the Black Organizing Project's North Memphis cell, the Black Knights); and the SCLC's Rev. R. B. Cottonreader (in town recruiting young men as marshals for the Poor People's March on Washington and running out of money). The shutterbug had this to say of Fanion: he "got a job" for Invader "troublemaker" John Henry Ferguson, arranging for him to work in public relations for insurance executive Harold Whalum. "Fanion wants Ferguson to get experience, and then Fanion promised to put Ferguson to work for the West Tennessee chapter of the Tennessee Council on Human Relations," Lawrence summarized from Withers's tips.[14]

FANION'S OUTREACH TO the young militants couldn't have come at a more inopportune time. In its quest to eviscerate the Invaders, the FBI

weighed sedition charges* and also contemplated an ambitious COINTEL-PRO campaign against the organization's supporters. Lawrence wanted not just oral intelligence but written confirmation of the collaboration—financial documents, telephone records, leaflets the group handed out. Repeatedly, Withers came through. He produced a financial report that showed Community on the Move for Equality, the minister-led organization that oversaw the sanitation strike, had given $2,600 to the Invaders' umbrella group, the Black Organizing Project, as a donation and for attorney fees. He handed over a leaflet Cabbage had passed out at a strike rally that quoted militant H. Rap Brown—"For every Max Stanford and Huey Newton (both incarcerated revolutionaries) there must be 10 dead racist cops"—and contained a crude drawing and instructions for making a Molotov cocktail. (Withers told Lawrence none of the pastors "made any effort whatsoever" to restrain Cabbage from handing it out.) The photographer got his hands on the Invaders' official notebook containing pages of telephone numbers of its members, relatives, and associates. The FBI made two photocopies—one for its files and the other for MPD.[15]

The spiral notebook also listed sympathizers like progressive auto dealer John T. Fisher, who had hired a couple of the Invaders as mechanic's helpers. Over the course of ten months, Withers relayed a series of tips to the FBI involving Fisher's links to members of the Invaders. The popular Plymouth-Chrysler dealer had referred one young militant to a professor at Memphis State who might help him arrange night classes, Withers said; the photographer reported efforts by a movement activist to convince Fisher to hire more of the Invaders. Eventually, two agents came to see him. "They asked me some questions about what my motive was," Fisher recalled years later. The agents were particularly interested in his relationship to another Invaders sympathizer, militant pastor James Lawson. "People were terrified of Jim Lawson," he said.[16]

Withers also helped the FBI monitor relationships between the Invaders and sympathetic Paulist priests at St. Patrick's Catholic Church. The

*Special agent Burl F. Johnson of the Memphis office sought an opinion from Washington on December 30, 1969, for bringing sedition charges. Assistant Atty. Gen. J. Walter Yeagley later cited insufficient evidence for such a case, noting that the depleted Invaders by then had only seven active members.

imposing stone cathedral provided office space for the Invaders' "minister of defense," Melvin Smith, the photographer told Lawrence. He said Smith was close to the church's progressive leader, Fr. William Greenspun, reporting that the young activist may be abusing the relationship in a scheme to wring grant money from the church. Withers also handed the agent fourteen pictures of Greenspun's colleague Fr. Charles Mahoney, described in reports as Smith's "close friend," who "allows Melvin" and other militants to use church facilities. Lawrence kept files on Greenspun and Catholic Sister Adrian Marie Hofstetter, both of whom, Withers reported, had become active in a new chapter of the Southern Christian Leadership Conference. The FBI's Memphis office also kept a file on Fr. James Lyke, later the Archbishop of Atlanta. Withers told Lawrence in 1969 he'd seen Lyke at a draft resistance rally downtown.[17]

"The FBI was really on the wrong track," one of the Paulist priests, Fr. Charles Martin, recalled years later. "We were all kind of with the civil rights thing. We rubbed shoulders with a lot of different groups." That included radicals, he said. But, the mission was Christian outreach— tolerance and understanding. "We were for the workers, the sanitation workers. And a lot of people in the town didn't like us for that."[18]

In fall 1968, a key ally, the African Methodist Episcopal Church, wavered in its support. Fanion announced that H. Ralph Jackson, the AME official who'd approved the $2,600 grant for the Invaders, would no longer allow the militants to keep office space or meet at Clayborn Temple. But Lawrence continued to receive reports of a partnership. He dug in. "All sources have been alerted to attempt to pinpoint any actual proof that employees of the AME Church are giving financial support to the Invaders and if such proof is forthcoming separate communication will be written to the Bureau concerning any possible counterintelligence action which might be instituted with certain AME high church officials in this regard," he wrote.[19]

IT WAS IN this tense and tangled environment that Fanion tried to juke the resolute internal security agent. As assistant director of the TCHR, Fanion threw his support behind construction of a new public housing development in Memphis's Frayser area. The Invaders, too, lobbied for the project,

arguing it would reverse substandard housing conditions for poor African American families. But Frayser's white majority opposed it. Fanion personally called Lawrence and said he planned to support the project at a City Hall hearing but "hoped the Invaders, et al, would not come." Then Lawrence talked to Withers.[20]

"It was apparent that Fanion was being untruthful, for on 8/21/68 ME 338-R (Ghetto) advised the writer that Invader John Henry Ferguson told informant that Fanion solicited Ferguson to get all of the Invaders and BOP to City Hall the afternoon of 8/20/68 to support the Turnkey Housing Project and that Fanion brought the signs for potential pickets and supervised the black protest," Lawrence wrote. For good measure, Withers gave Lawrence a copy of Fanion's press release—complete with Invader-like language that referred to the project's opponents as living in "lily white neighborhoods"—as well as photos of "many of the characters" involved in the protest. The agent cut up the photos and placed them in individual files. "This includes nearly all of the key leaders of the Invaders, the leading Black Power troublesome organization in Memphis," the agent wrote.[21]

Though Fanion reportedly began "drawing away" from BOP that September, Lawrence learned he'd been taking cigarettes to jailed Invaders. And there was this: "Gerald Fanion has purchased a liquor store on South Lauderdale near Parkway," Lawrence wrote after debriefing Withers.* "Fanion is still West Tennessee Director of Tennessee Council on Human Relations. He purchased the liquor store through money provided by a silent partner, Tommy Willis, Comptroller of the Universal Life Insurance Company, and brother of prominent Memphis Negro attorney and state Legislator Archie W. Willis, Jr."[22]

The report seems to imply something improper about Fanion simultaneously running a civil rights organization and owning a liquor store. There is no known record that the FBI took a COINTELPRO action against Fanion. Yet the incident poses troubling questions, considering the federal government later prosecuted Fanion and Tommy Willis for running a check-kiting operation out of the liquor store.

"What concern was it to Bill Lawrence or anybody else that Jerry owned

*Though Withers is indicated as the likely source, this is one of those reports written imprecisely enough that it's possible Lawrence could have learned about the liquor store through other sources.

a liquor store?" asked Bruce Kramer, the Memphis attorney who represented Fanion in the criminal case alleging misapplication of $380,000 in bank funds. Fanion pled *nolo contendere*—no contest—to the charges and was sentenced to a year in 1977. It's difficult to draw a direct link to Fanion's prosecution and his earlier activism. As many as six years separated the intelligence operation and the start of the investigation of the bank scheme—charges Fanion didn't deny. Yet Lawrence's report put Fanion's liquor store on law enforcement's radar. As early as 1969, the activist-turned-businessman filed a complaint alleging MPD officers were harassing him and his customers. Kramer, an ACLU attorney who sued MPD over its Red Squad abuses, said the intrusion of the 1968 report into Fanion's personal affairs remains disturbing.[23]

"You could ask that same question for almost all of the activities that Bill Lawrence and MPD's Domestic Intelligence Unit did," he said. "It was Keystone Cops."

Fanion died in 2010. His son, Gerald Fanion, Jr., said he had no details on the case. Efforts by the author to obtain the FBI's files on the liquor store investigation through FOIA have been unsuccessful.

DEATH OF A MOVEMENT: THE FBI AND THE COLLAPSE OF THE SCLC

ONE OF THE GREAT OVERLOOKED stories of the movement involves the collapse of the SCLC in Memphis, and how Ernest Withers gave the FBI a front-row seat to the wrath and passion of that tumultuous crash. To understand it, one needs to return briefly to April 4, 1968—the assassination.

Withers holds legitimate claim to the unofficial title, "The Movement's Greatest Photographer." But he missed the big one. The most iconic image. He was blocks away, sitting in his Beale Street studio, his feet on the desk, when King fell—when the movement died. Someone else got it. Nearly everyone above a certain age knows the image: King lying on his back on the balcony of the Lorraine Motel as Andrew Young and others point desperately toward a forsaken rooming house where the shot erupted.

The photographer who took it, a young South African named Joseph Louw, was staying at the Lorraine, a couple doors down from King. Seconds after the shot rang out, Louw, then a skinny twenty-eight-year-old, stepped

onto the balcony with a 35mm camera. He shot some of the biggest news photos of the twentieth century: King lying in a pool of blood. The police hustling into the motel courtyard, reaching for their guns. King's friends straining with paramedics as they carry the fallen leader down the narrow steps and into an ambulance.[1]

Withers missed the shot, but he recovered admirably. As with so many other pivotal moments he'd witnessed, Withers played an all-but-invisible though critical role that night. Louw was visiting Memphis to assist in the making of a documentary film. But, as Withers later recalled, the South African was less than proficient when developing film. So Withers did it for him. He took Louw to his studio where the young man jammed the film in his camera. He couldn't rewind it. Withers took over.

"I knew exactly what to do. But Joe Louw wouldn't have known," Withers said. "He was just wanting to develop it . . . but the noise that he was making in the darkroom, I just told him to put film in a, in the paper box, and went in and then loaded the two rolls, developed . . . the two rolls of film. Perfect development."[2]

NOT ONLY DID Withers save Louw's photos for history that night, he reported one of the first tips linking King's murder to a possible plot by elements of the Ku Klux Klan. It happened like this:

Louw lived in New York. FBI agents visited him there after a dozen or so of his assassination photos ran in *Life* magazine later that month. He told the agents that when he was in Withers's studio he overheard the photographer talking on the "telephone to either police or FBI." It had been an intoxicating moment.

Louw didn't know it, but Withers was on the phone with Lawrence. Roughly four hours after King was shot, the photographer called the agent to report his suspicion of a man with ties to a West Tennessee Klan group. The suspect was Withers's old friend Renfro Hays, a private detective well known in Memphis, who would later work for James Earl Ray's defense. Withers had first told Lawrence about Hays in 1966 after the private eye said he had joined a klavern of the United Klans of America in Brownsville, Tennessee, supposedly at the behest of a client seeking intel on the group.

Lawrence, in turn, interviewed Hays. He found him cooperative, but too unstable "to develop him as an informant."[3]

But Withers's suspicions of Hays piqued the day before King's murder. A bearish man with a nervous tic that pulsed through his right cheek, the private eye had come by, insisting "on being informed" about where King was staying in Memphis. Though accounts linger to this day about possible Klan involvement in King's murder, the tip didn't yield any direct connections. Presumably, Lawrence did a thorough check. He and domestic intelligence partner Hugh Kearney had battled the Klan in Mississippi and West Tennessee for years, and the pair had a reputation as a formidable duo. "J. H. Kearney and Wm H. Lawrence are the two agents who are, as it seems, determined that no klan will again ride in West Tennessee," a Klansman complained in 1960 in a letter intercepted by an informant. "I will be forced to hold up my work here until Kearney who is a Roman Catholic, and the rest of Hoovers [sic] stooges are put back in their place."[4]

No matter who killed him, King wasn't coming back. The SCLC—the movement—would have to go on without him.

IN HIS VIEWFINDER, Withers saw Coretta Scott King. She wore a long, dark veil. Leading a mass march through downtown Memphis, the march her now-dead husband was to lead, she stared solemnly ahead, friends and family beside her. James Bevel and Harry Belafonte paced in the flank to her right alongside three of her small children, Martin, Dexter, and Yolanda; to her left were Ralph Abernathy and Andrew Young. They stepped past the State Theatre, where Elvis Presley's latest movie, *Stay Away Joe*, was playing, a sea of mourners lurching behind. It was the first of many return visits the SCLC team would make to Memphis over the next eighteen months. Withers helped the FBI monitor each of them.

Already, he'd been pitching in for three weeks, since before King was shot. He was among the sources who helped corroborate the meeting between King and the militant Charles Cabbage on March 29, 1968, the morning after the infamous "riot" that crippled King's march through downtown Memphis. From the start, it was hardly a secret. A news reporter paced the hall outside King's room at the towering Rivermont Hotel over-

looking the Mississippi River when Cabbage and two Black Power colleagues arrived. So, when Withers told Lawrence what little he knew about what had transpired inside the blue-carpeted room, it was no coup, but it added detail. As King continued to reach out to the young militants, hoping to build an alliance that would enable him to return to Memphis and lead a peaceful march, Withers proved a valuable resource.[5]

When King returned on April 3, the day before he was shot, the photographer was all over it. He told Lawrence that day of the strategy meeting that wound deep into the night; how union leaders planned to bring in out-of-towners for the march; how King's staff had agreed with Memphis community leaders to give the young militants a role in it; how Jesse Jackson was appointed as a liaison to the Invaders; how Hosea Williams urged a "united front" with the militants. Withers reported details of King's arrival at the Lorraine and his later attendance at a strategy meeting; how he and top aides Andrew Young and Dorothy Cotton finally sat down at the motel's diner for a dinner with Charles Cabbage and other militants—firsthand, real-time details that helped the FBI assess the direction the volatile sanitation strike was heading.[6]

Withers was clear: he believed the Invaders were trying to blackmail King, trying to obtain money "by giving the impression that they could control potential violence," Lawrence wrote. King wanted to pacify them. But across the racial divide, the city's white leadership saw only trouble in the alliance. Testifying that morning in federal court, Memphis Police and Fire director Frank Holloman cited King's meeting with the Invaders as a reason he believed another march would stir chaos. "There is great likelihood that there will be rioting and looting and lawless acts," he said. Lawrence, too, saw no good in it. "King chose to team up with SNCC and Stokely Carmichael on civil disobedience & irresponsibility in its attack on our govt.," he wrote in retirement, contending King maintained "relationships with violent groups" like the Invaders as a strategy to push his agenda.[7]

After King was shot, Withers covered his funeral in Atlanta. As advisers grieved, bracing for an expected collapse of financial contributions to the SCLC with the loss of the charismatic King, an informer picked up this tidbit: aides Bernard Lee and James Orange planned to return to Memphis "to resume SCLC support of the Sanitation Strike." To the FBI, the message

was clear: Memphis, quiet now after another round of rioting, should brace for trouble. The Memphis office sent an "urgent" Teletype to headquarters.[8]

A WEEK LATER, on April 15, Abernathy led a raucous rally in South Memphis as the sanitation strike lingered. The following morning, Withers gave Lawrence a report: Bevel delivered another frenetic Black Power speech. But Abernathy stole the show. He talked of blocking garbage trucks—"putting our bodies in front of them." He called for night marches; marches through white neighborhoods; marches through Chickasaw Gardens, one of the most affluent neighborhoods in all of Tennessee. He talked of "massive work stoppages" to "completely disrupt Memphis."[9]

"Now that King is dead," Lawrence wrote after debriefing Withers, "Abernathy is more militant in his remarks."[10]

Abernathy would never launch this campaign. The next day, the city signed a memorandum of understanding with the newly recognized union, the American Federation of State, County and Municipal Employees, ending the sixty-five-day sanitation strike.

Eight days later, SCLC was back. Bevel and other staff members held a strategy meeting with Memphis community leaders at the Lorraine, Withers reported. Preparing to launch King's long-awaited Poor People's March on Washington, the group set a goal: they hoped to send a thousand Memphians to the nation's capital on fifty buses. Withers handed over a recruitment leaflet—"Youths & Adults Wanted!"—and reported from a rally the next day that Bevel had urged children to skip school to travel to Washington. Five days later, he planted himself inside the mass rally at Mason Temple, where King had delivered his last speech. Coretta sang a solo as eight thousand people listened.[11]

As if running its own internal news agency, the FBI chronicled the events in its files with Withers's photos: Coretta King speaking to reporters. Andrew Young in a denim jacket as he rallied the campaign's pilgrims in nearby Marks, Mississippi. The scoop: the Poor People's Campaign was shaping into a colossal failure. Organizers expected 1,000 people, but only 369 boarded the ten Greyhound buses that departed for Washington, Withers said. Deep into May and then June, SCLC insiders

"admitted" to the informant that the ambitious venture wasn't gaining traction.[12]

Among other troubles, Withers reported that organizers had to remove an Invader and two of his young friends from a bus for making "radical and violent statements." In addition to the rains and the thickening mud that dampened "Resurrection City," the interracial, plywood-and-canvas shanty-town built on the National Mall with help from the Invaders, a major story that spring in D.C. involved youths from Memphis and other cities who were becoming violent. "They went around and beat up on our white people," Andrew Young complained after expelling about two hundred residents. "We had to get them out." Invaders leader Lance Watson, put on the camp's security detail, was gaining press attention. Withers arrived at the camp in mid-June and spotted the young militant there. He shot a group picture of several Invaders before the Lincoln Memorial. He gave a copy to the FBI.[13]

SIX SHORT WEEKS after the first shanties went up, Resurrection City came crashing down on June 24. A thousand or more police officers armed with clubs and gas masks cleared the camp with little resistance. Ralph Abernathy led a long column of marchers to safety before the police arrived. Routed, the Poor People's Campaign ended with a few defiant shouts of "Black Power!" blocks away, outside SCLC's Washington office. The organization King had founded eleven years earlier in the afterglow of the Montgomery Bus Boycott had hit bottom. Historian Gerald McKnight writes in his book, *The Last Crusade*, that the campaign likely would have failed on its own—largely because of the leadership vacuum caused by the assassination—but argues the FBI played a role, too, through its intense surveillance and smear campaign that had diminished King's image among many Americans.[14]

The SCLC would regroup seven weeks later in Memphis for its annual convention, facing more animosity—and another confrontation.

ABOUT FIFTY INVADERS stormed Mason Temple waving a "Liberation" flag featuring a dagger encircled by a wreath—the young militants were

back. With a shout, they shattered the decorum of SCLC's 12th annual convention. As Withers later informed Lawrence, the mayor of Gary, Indiana, Richard Hatcher, was speaking when the Invaders stormed in, led by Lance Watson and John B. Smith. "The Invaders were claiming the SCLC through its deceased former President, Martin Luther King, Jr., had promised The Invaders a considerable amount of financial support when he was in Memphis in early April, 1968, just prior to his murder," the agent wrote after debriefing his photographer-informant. The militants contended King promised them $300,000 and four automobiles. Withers felt certain King had offered something as he tried to placate the young men. But he called their representation a "gross exaggeration," Lawrence wrote.[15]

The showdown started earlier that night. As an MPD informant watched, a few of the militants confronted Andrew Young. It got tense. "I carried a pistol. Threatened to shoot him," one of the militants involved, John Smith, recalled years later. It was just a bluff. But Smith was angry. "They were still saying we were responsible for the riot, and maybe even the assassination," he said. The confrontation ended when Invader Lance Watson stepped between them. "Andrew Young of S.C.L.C. didn't feel that S.C.L.C. owed them anything," MPD's Lieutenant Arkin wrote of the incident. His informant watched as the young men later composed a two-page handwritten statement, rifled off numbers of copies on a mimeograph machine, and then raced down to Mason Temple.[16]

Withers described the melee to Lawrence like this: The Invaders storm in. Rev. James Lawson tries to quiet them. No luck. The militants pass out copies of their leaflet. It is full of stinging allegations. "While poor Black Brothers and Sisters were sleeping in the rain and mud" eating cheese and bologna sandwiches at Resurrection City, it reads, "S.C.L.C. staff was sleeping in the Pitts Motel with white girls" and "eating steak." Young talks. He calls the Invaders "children." It looks like it might get physical. The Black Knights are there. The North Memphis militant group is providing security for the convention. Abernathy gets up. He talks. Finally, a man called "Barracuda"—described as six-foot-two and 270 pounds with connections to Chicago's Blackstone Rangers gang—subdues the Invaders and restores order.[17]

For all the trouble, the Invaders received a $500 check, signed by SCLC treasurer Cirilo A. McSween and drawn on Citizens Trust Bank in Atlanta. Withers took a picture of it and gave it to the FBI. The Bureau's Atlanta office agreed to trace the payment and "be alert" for any future SCLC payments to any Memphis groups or individuals. A week later, headquarters directed Memphis to consider counterintelligence actions "to neutralize" the Invaders.[18]

At that point, August of 1968, the SCLC remained in a tailspin. In Memphis, a power struggle brewed. The movement there had long been directed by the NAACP. Though prominent Memphis pastors Samuel Billy Kyles and Ben Hooks had both sat on King's national board of directors, the SCLC didn't have a chapter in the city. But now a group of upstarts wanted to form one. Young Turks, Lawrence called them. And from what Withers was telling him, it was causing considerable friction with "old line" leaders Kyles and Hooks. "Source has learned that there is a lot of dissension within SCLC ranks," Lawrence wrote.[19]

The Turks were younger men and women—several of them professionals, others a "grass roots" variety who sported denim. Some had been active in Resurrection City. They moved at a frenetic pace, raising funds and organizing. According to what Withers was telling Lawrence, some of their aggressive tactics amounted to "semi-extortion." Some Turks "were putting the heat on white businessmen for donations for SCLC," Lawrence wrote after debriefing Withers. One businessman hit hard by the solicitors was William Loeb, Mayor Henry Loeb's brother. "Informant has reliably learned that William Loeb . . . has contributed large amounts of money to SCLC and other black pressure groups" including the Invaders, Lawrence wrote.[20]

Withers connected the dots for Lawrence: The SCLC is opening operations at the office of real estate agent O. W. Pickett; Pickett is a political crony of activist Cornelia Crenshaw; Crenshaw is close to O. Z. Evers; Evers, the man who integrated the Memphis bus system and who'd been a focus of tips Withers passed to the FBI for five years, was close to Tarlease Mathews. Mathews had first gained attention in Memphis in 1958 for a lawsuit that hastened the end of segregated attendance at the Memphis Zoo. She and her colleagues weren't elites. They were everyday people—Evers a pest control man; Mathews a hairdresser; Crenshaw, a housing manager—whose activ-

ism had effected true change. They made the status quo nervous. Their militancy had a direct link to King. The last time King had come to Memphis, it wasn't Kyles or Hooks who picked him up at the airport. It was Tarlease Mathews.[21]

THE SCLC FINALLY formed an affiliate in Memphis in late 1969—with Ernest C. Withers on its founding board of directors. Lawrence immediately had an insider's view. The board has thirty-two members, Withers told him; Invaders leader Lance Watson has an invitation to join. The board included several whites, he said. One, an agitating schoolteacher, "bears watching," Lawrence wrote; the first meetings are being held at Jim Lawson's church.

Seven years after he first began reporting on Lawson, describing him in those early days as a "thorn in the side" of Memphis's conservative NAACP-led movement, Withers listened as the militant pastor directed the upstart SCLC group, telling them in his clipped, Yankee accent that the NAACP had "lost its influence." That meant Lawrence lost, too. He had worked hard to sway and receive cooperation from the NAACP in Memphis. And now this. Many of the details his informant was relaying struck the agent as risible, his reports indicate. The SCLC affiliate aspires to be a militant group, to "make an issue of *so-called* police brutality in Memphis," the agent wrote.[22]

The new movement captured the imagination of *Jet* magazine, which sent writer Valerie Jo Bradley to town, Withers told Lawrence. "He said the feeling is that there is too much conservatism in the black leadership in Memphis, and she wants to emphasize the point," the agent wrote.[23]

A major rift in the city's black leadership had sparked the rise of the SCLC's Memphis affiliate. In the autumn of 1969, as part of the United Black Coalition, a loose association of twenty-five community organizations, the NAACP led a series of marches and boycotts—a rare campaign of direct action for the more conservative organization. The ambitious undertaking was fought on two fronts: improving educational opportunities for black youth and supporting the striking workers at St. Joseph's Hospital. The school battle was pivotal. Pushing to desegregate the city's schools and install blacks on the city's all-white school board, leaders

orchestrated a series of "Black Monday" boycotts—as many as 67,000 black children skipped school on the first day of the school week in protest. Many teachers stayed out, too. But as the venture veered toward crisis, the NAACP wanted out.

Lawrence used Withers and his stable of sources to monitor the "Black Monday" movement, watching as it grew, flourished, then collapsed. He kept a particularly close eye on the developing rift between the NAACP and the rest of the coalition. Police sources told Lawrence that Vasco and Maxine Smith, his longtime NAACP informers, may have been "bought off" by the city's white elite who wanted to end the boycott. "Inspector (Don) Smith pointed out that it is significant that in the past week neither of the Smiths has made any flamboyant or highly emotional remarks," Lawrence wrote on November 7 as the rift deepened. Available records don't clarify what Lawrence might have told the NAACP power couple. But the agent seemed to cover his bases. Pressed by news reporters, Maxine had publicly denied that the NAACP had initiated the Black Monday boycotts. But the agent knew otherwise. Withers handed him a nine-page packet of NAACP papers written "in connection with its call for boycott of Memphis public school system."[24]

Withers reported that some in the fraying United Black Coalition were taking desperate measures to keep it going—using the Invaders "as a sort of 'Black Mafia' to round up young thugs to participate in marches and to attempt to mentally and possibly physically intimidate students from going to school in an effort to build up the pressure of the black movement," Lawrence wrote. It wasn't working. "The coalition is rapidly losing strength," the agent wrote after consulting Withers.[25]

The coalition finally spun apart when the NAACP's divided leadership voted to temporarily halt the Black Monday boycotts. Disheartened, the organization's president—militant pastor Ezekiel Bell—quit in protest. Cornelia Crenshaw was so dismayed she "nearly got into a physical fight" with Maxine Smith, a source told the FBI.[26]

EVEN RALPH ABERNATHY couldn't reunite the coalition. Flying in from Atlanta, Abernathy participated in at least three large demonstra-

tions that fall. Each time, Withers reported his actions. The photographer was part of an FBI-MPD gauntlet that closely observed a November 10 mass march. The city had informed movement leaders a day earlier that it would forbid late-afternoon or night marches, citing traffic snarls and safety concerns. Organizers ignored the dictum. Withers reported to Lawrence at 5:05 p.m. from Clayborn Temple that some two thousand activists were preparing to defy the city and begin marching. As news reporters, FBI agents, and police watched, the crowd lurched forward. Onlookers threw bottles from rooftops as more than sixty marchers were arrested, including Abernathy and Memphis movement leader H. Ralph Jackson. Later that night, Withers reported that organizers were planning another march in the morning.[27]

Withers reported the next day that Abernathy, fresh out of jail, told the Clayborn gathering that pressure would intensify until demands were met; he urged students to stay out of school. When Abernathy prepared a return trip in December, Withers gave Lawrence a two-day advance warning, providing the civil rights leader's travel information—Eastern Airlines Flight 395 from Atlanta.[28]

By late December, leaders of the month-old Memphis SCLC affiliate were complaining about Abernathy—and a spiraling debt. The upstart organization launched that November "already is $5,000 or more" in the red, Lawrence wrote after speaking with Withers. H. Ralph Jackson blamed phone, mail, and travel expenses. But mostly he blamed Abernathy, Withers said. "Another expense were hotel rooms and food bills run up for Ralph David Abernathy and his staff," Lawrence wrote. The informant said Jackson had called them "freeloaders" who "didn't work and merely ate a lot of food and run up big bills." Lawrence wrote that Withers confirmed another story supplied by a police informant: when Abernathy was caught in a rainstorm at the end of the November 11 march, he went to Julius Lewis department store and bought a $200 suit (roughly equivalent to $1,300 in 2018) and a $100 pair of alligator shoes—items evidently paid for by others. Withers said members of a local church later gave Abernathy a $2,300 "love offering" before he flew back to Atlanta.[29]

The Memphis authorities finally found a creative way to stop the

Black Monday movement. On December 9, a state grand jury indicted Abernathy, Vasco and Maxine Smith, James Lawson, Ezekiel Bell, and fourteen others on charges of interfering with the operations of public schools and contributing to the delinquency of minors. It took the steam right out of the operation. As 1969 faded into 1970, the civil rights direct action movement in Memphis effectively was over.[30]

THE BLACK PANTHERS, HOOVER, AND THE END OF AN ERA

FIVE WEEKS AFTER THE BLACK Monday protests were finally crushed, Bill Lawrence retired. He turned in his FBI handbook, his badge—No. 276—his agent's briefcase, and a Colt revolver (though, with permission, he'd carried his own .38-caliber Smith and Wesson on duty). "Dear Mr. Hoover," the agent wrote, "This is to advise you of my request to retire at the close of business, Jan. 23, 1970 . . . I shall always cherish my long and satisfying association with the FBI. I shall do everything possible to assist the Bureau and to uphold its wonderful heritage. I have never had an autographed photograph of you, and would greatly appreciate your autographing one for me if this is possible."[1]

Withers was handed off to other agents, principally Howell S. Lowe, a junior agent who had worked with Lawrence since 1968. The photographer continued to report on "mainstream militants." From his position on the SCLC board, he relayed months of details: Cornelia Crenshaw and Ezekiel

Bell are pushing again for more "militant activity," he said; they are planning a King memorial service; his old friend Joe Crittenden was renting a flatbed truck as a speaker's platform for the event; the chapter again was broke—just $212 remained in its treasury.[2]

The scope of his monthly or periodic reports remained broad and sweeping: a report in June 1970 updated the files of sixteen people (some reports involved dozens of individuals), including Clarence Cecil Adams, a black veteran who fought in the Korean War and was held for three years as a POW before defecting to China and ultimately returning to Memphis in 1966 to face charges by the House Un-American Activities Committee. Despite efforts to blacklist him, Adams had successfully taken a test "to enable him to sell stocks, bonds, and insurance," Withers reported.

That September, the photographer reported he'd traveled to nearby Earle, Arkansas, with several Memphis pastors rallying support for Rev. Ezra Greer, wounded days earlier when armed whites attacked marching activists in what became known as "The Earle Race Riot of 1970." He reported that Memphis pastors Ezekiel Bell, Dick Moon, and Roosevelt Joyner all spoke or attended, as did Joe Crittenden, and that he "took photographs of everyone." He later reported that upstart politician Minerva Johnican was working with the League of Women Voters to establish another "Black United Front" to focus on voter registration and racial violence issues.[3]

BUT INCREASINGLY HIS focus turned to fringe groups like the small Black Panther Party contingent that formed in Memphis in late 1970. The revolutionary black nationalist organization founded in Oakland, California, in 1966 began as a line of self-defense against widespread police brutality in that city. The Panthers created a variety of "survival" programs to feed and clothe poor children and promote cultural awareness. But their violent rhetoric damaged their reputation, as did a series of shootouts with police in 1969 in Los Angeles and Chicago. In a story almost certainly coordinated with the FBI, *Press-Scimitar* reporter Kay Pittman Black broke the news to Memphians in December 1970 that the Panther movement had arrived. But months before that, Withers had scouted leads for the Bureau:[4]

Two Black Panther Party members are visiting Memphis, he told agents

that February; former Invader Maurice Lewis wants to build a Panther organization in the city, Withers said in May. That June, he turned over the personal phone numbers of two members of the newly formed group; he reported interstate contacts with Panthers from Mississippi. By year's end, he identified individuals handing out Black Panther Party newspapers on Beale Street.[5]

Then he went deep. Just as he'd done with the SCLC—as he'd done with the Invaders, the peace movement, and the Communist Party's youth organization in Memphis—Withers penetrated the Panthers. He became an insider. The first clear indication involves an incident in January 1971. Influenced by confrontations in other cities, the fledgling Memphis Panthers had an armed standoff with police. A group of them broke into vacant units at the Memphis Housing Authority's Texas Court Apartments. They squatted there with poor families who'd been denied decent housing. The Panthers—eight men and three women—surrendered without incident. While preparing for trial, the Panthers produced a brochure publicizing the situation. Titled "Is Providing Housing for the Homeless a Crime," the brochure featured photos shot by Withers—an image of the young activists being led away in handcuffs; another depicting a poor family outside their rundown home.[6]

Eventually, Withers penetrated the Panthers' very inner circle. He's listed in a June 1973 report as one of seven "active members" in the Panthers' Memphis chapter. Perhaps he used that old charm and wit, perhaps he pretended to be more militant than he really was. But this phase of his informing is extremely difficult for even the photographer's most ardent supporters to argue away. Clearly, Withers, a World War II veteran then in his fifties, didn't suddenly become a black revolutionary. Records show he was part of an FBI-MPD team that had worked hard to infiltrate the group. One of the other members, Tyrant Moore, was an undercover police officer. Details that Withers was kicking back to the FBI indicate that the Bureau was prepared to meet the Panthers with deadly force if necessary.[7]

IT WAS A gray January day in 1973 as Withers aimed his camera across the street, through a thicket of leaf-bare trees, toward a rambling, two-story

frame house in South Memphis—the local Black Panther Party headquarters. In all, Withers delivered three pictures to the FBI of the home at 1498 Marjorie Street, each shot from a different angle: across the street; up close, near the steps leading to the broad, front porch; and from the backyard, depicting a narrow, rear entrance. Over the coming months, Withers, who'd been converted from racial informant ME 338-R to extremist informant ME 338-E,* would describe what he saw inside, too: two .38-caliber pistols, one kept in a room where party leaders Janice Payne and John Charles Smith stayed, the other "in the living room in the coffee table drawer," Withers told special agent Howell Lowe. "They also have in their possession a 12-gauge shotgun, which is kept in the living room of the house."[8]

By pinpointing the home's points of ingress and egress, and by describing in detail the locations of weapons, he painted a picture—a virtual layout of the home—needed in case police decided to storm the house. In a way, it wasn't unlike the 1969 incident in Chicago, where police stormed an apartment sketched out by a Bureau informant, firing eighty to a hundred rounds into the home as its denizens slept, killing Black Panther leader Fred Hampton and another man. But there was a critical difference: this home was never stormed.[9]

"The government looked to crush Black Power and used the rhetoric of its advocates to justify ruthless tactics," Yohuru Williams writes in the stirring study *The Black Power Movement: Rethinking the Civil Rights–Black Power Era*. He notes that Hoover identified the Panthers as "the single greatest threat to the nation's internal security."[10]

The truth was, despite rhetoric, the Black Panthers in Memphis never posed any large public threat. Withers might have had cause to fear one Panther, John Charles Smith, the former Invader who stood six-foot-two, weighed well over two hundred pounds, and had been convicted for wounding a man and a woman in a shooting. But by the early '70s, Smith had settled into a decorous life. He drove a school bus. He and chapter leader Janice Payne worked in Vasco Smith's successful 1973 campaign for Quar-

*Withers first appears as ME 338-E in an Aug. 11, 1971 report. The development roughly coincides with another blunder. Just as agent Lawrence once made the mistake of placing an informant contact sheet (form FD-209) in a case file, Withers's new handlers repeatedly placed informant reports (cover sheet for Informant Report or Material form FD-306) in case files. This made them subject to the settlement. The reports reveal more details about what Withers did for the FBI.

terly Court; Payne was employed by the Sickle Cell Anemia Board. She had political aspirations. "Janice Payne continues to hope that she will be able to run for some type of political office," agent Lowe wrote after debriefing Withers. Party members were regular attendees at meetings of Maxine Smith's Shelby County Democratic Club, the informant said.[11]

The Black Panther Party in Memphis "is for all intents and purposes dead," Withers declared in August 1974.[12]

THAT AUGUST WOULD forever change Ernest Columbus Withers. He ran for public office again—and won. On August 6, in a nine-man race, he was elected constable of Shelby County's Second Civil District. The position involved serving legal papers and was largely ceremonial in terms of battling crime. But as a sworn and bonded peace officer with arrest powers, Withers was a cop again.

Then, twelve days later, heartbreak. Wendell Withers, the fourth of Ernest and wife Dorothy's eight children—named after his old police partner at MPD, Wendell Robinson—died. Just twenty-three, he'd been in a coma for two years following a car accident. Many friends came to see him over those two years, including Stokely Carmichael, who'd marched with Wendell, and whose photo Ernest had taken and sold to the FBI. In a front-page obituary in the *Tri-State Defender*, Ernest's son Perry wrote of the family's grief, of "one disconcerting crisis after the other." Ernest would lose three more of his children before his own death in 2007.[13]

The last known report he filed with the FBI came on December 3, 1975.* By then, Withers was working for Gov. Ray Blanton, getting in over his head in the political corruption that engulfed Tennessee. His monthly report included updates on members of the Communist Party's Young Workers Liberation League—a group of out-of-town Communists had been in Memphis to pick up local members for a convention in Pittsburgh, he said. Janice Payne of the all but nonexistent Black Panthers has a new job. Former Invader Maurice Lewis was meeting for unknown reasons with inmates out on work release. "His wife, Belva, is pregnant," Withers reported.[14]

*According to the FBI's statement stipulated in the Withers settlement, the photographer continued to work for the FBI until 1976, though no records from that year were released.

The report included new details on Isaac Taylor, who'd opened an African culture and clothing store in 1968 called the Black Arcade. The FBI kept a file on the store and monitored it for years. In 1975, the agency remained suspicious. Withers said Taylor, who by then had changed his name to Nkosi Ajanaku, dreamed of opening a medical school to train black doctors in Memphis. Two members of the Ajanaku family, a circle of individuals who wore African clothing and promoted African culture, were engaged in a spat and hadn't spoken for months, Withers said.

"Because of this," an agent wrote on the last line of the last page of that last report, "the Ajanaku women have become hard to get along with."

AFTERWORD

T HE WITHERS COLLECTION MUSEUM AND Gallery sits in Beale Street's quiet east end, away from the bustle of the neon-lit night spots, B.B. King's, Rum Boogie, Blues Hall, Alfred's, and the others. Still, the museum holds its own. Opened in 2011, it features many of Ernest Withers's poignant, black-and-white photographs—images of the tumultuous sanitation strike, the Memphis blues scene, Negro Leagues baseball, and the tragic aftermath of Dr. Martin Luther King, Jr.'s murder. The museum's grim assassination gallery includes pictures of the civil rights leader's blood pooled on the Lorraine Motel's balcony and of King in his casket. This is sacred ground. Yet the shadowy details of Withers's collaboration with the FBI remain, as of this writing, out of the spotlight. It's a history Memphis must face—that it must dissect, analyze, study, and embrace—to fully understand this pivotal period.

In our current moment of fear and political suspicion, the nation is still trying to do the same.

The Church Committee began the search for meaning forty years ago. It opened its report on the FBI's broad, corrosive use of domestic intelligence informants by quoting Thomas Erskine May. "Men may be without restraints upon their liberty; they may pass to and fro at pleasure," May wrote in his nineteenth-century work *Constitutional History of England.* "But if their steps are tracked by spies and informers, their words noted down for crimination, their associates watched as conspirators—who shall say that they are free?"

The question provides an apt framework for understanding Withers— for understanding the vast 1960s surveillance state.

At its peak, the FBI employed more than seven thousand intelligence informants. The agency set few limits on the scope of information they gathered. Former informants testified they reported "any and everything" on targeted groups, handing over membership lists, financial information, and a "broad spectrum" of personal and political detail. The ill effects on democracy were obvious: The system chilled the exercise of constitutionally guaranteed free speech and political association. Many citizens were deterred from political participation for fear their attendance at a meeting or rally "would mark them as a member in an informant's eyes," the committee found. They may have feared, too, that an informant's report would prevent them from gaining a job, particularly one requiring a government security clearance.

The committee's impact was immediate. The then–attorney general Edward Levi adopted sweeping reforms in 1976, testifying that "government monitoring of individuals or groups because they hold unpopular or controversial political views is intolerable in our society." For the first time, the nation's domestic intelligence apparatus focused squarely on investigating actual crimes, and terrorism. No longer would it be used, as the Inspector General's Office later said, "as avenues for intelligence collection."

Levi's guidelines laid out a clear protocol. For cause, agents could open preliminary and limited investigations followed by a full investigation only when specific evidence arose of "activities which involve the use of force or violence." Use of informants was reined in, too. That included greater Justice

Department oversight. The reforms triggered a precipitous drop in domestic surveillance. The number of open subversive cases, which had reached a high of fifty thousand in 1961 and hovered around forty-five thousand in 1972 when J. Edgar Hoover died, soon fell to fewer than twenty thousand. As Director William Webster later testified, domestic security investigations had fallen to fewer than five thousand in 1976, and by 1978 the FBI was "practically out of the domestic security field."

The FBI's in-house historian, John F. Fox, Jr., recognizes the forces that drove the agency to the lengths it took—the turbulence, the riots, the soul-consuming paranoia. Yet even he isn't about to defend the Bureau's actions.

"The unrest really was disturbing to people. And the federal government saw its role as trying to identify the sources of the unrest, to some extent to deal with them," Fox told me in 2017. "And we didn't do a terribly good job in many respects. In hindsight, of course, probably we tasked far too widely in looking at subversive ideology versus actual criminal and violent activity."

YET FOR ALL the reform, for all the disclosure by the Church Committee and others, we still know little, fifty years later, of the detail: Who were the informers? What motivated them? How did the government induce them to spy on their fellow citizens? A major hurdle in uncovering Withers's role—and one that still shields the identities of countless others—is the Freedom of Information Act's "exclusions" provision. Passed by the Reagan administration, it treats informant records as if they don't exist. It gives the government the right to legally lie—to contend it has no records when a requestor asks about an informer. Literally, it allows a law enforcement agency to "treat the records as not subject to the requirements" of FOIA. The law aimed to protect individuals engaged in the dangerous work of informing on drug cartels. Yet it's also used to conceal the identities of those very 1960s domestic intelligence informers the FBI now concedes had trampled the rights of wide swaths of law-abiding citizens. Short of some type of legislative relief or an executive action to selectively open some of these files, unraveling the identities of the 1960s-era surveillance state informers and their deeds remains a daunting task.

Typically, unmasked informants have lost their cover in one of two ways: through congressional hearings or an inadvertent disclosure by the government. Congressional hearings in the '70s led to the unmasking of bookkeeper James A. Harrison as an informant inside Dr. King's Southern Christian Leadership Conference and to the revelation of Klan informer Gary Rowe. More recently, just as government censors failed to redact Withers's code number, the FBI botched a 2012 FOIA release that revealed Berkeley-based Black Panthers icon Richard Aoki as an informant. These mistakes keep coming.

An FBI memo released in July 2017 names eight informers, including Withers, who were passing information to special agent William H. Lawrence in 1963. Most of those named appear to have been Klan informers.* Inadvertent disclosures like these present opportunities for discovery. But it will require work—intensive digging, research, and, likely, litigation. That costly and time-consuming responsibility will fall mostly on academia. Given its declining state and its core mission—to report current events— journalism can't be counted on to any large extent.

IN HIS RETIREMENT, Lawrence became a vocal defender of Hoover's surveillance state. In an opinion piece published in 1977 by *The Charlotte Observer* under the headline "FBI Agent Acted in Good Faith To Protect the Nation," he lashed out at the broad, post-Watergate assault on his former employer. "What has changed?" Lawrence wrote. "Does much of the criticism of the FBI spring from a belief that it exceeded its authority on rare occasions, or from a growing 'fashionable' attitude that any covert operation taken in the name of national security is somehow illegitimate?"

In Lawrence's view, the FBI's war on militancy was wholly justified. He wrote in his personal notes that Withers collaborated "to detect and deter

*The December 4, 1963, memo, released through the JFK Assassination Records Collection Act, shows Lawrence contacted thirteen informants and confidential sources as he fished for leads relating to President Kennedy's murder in Dallas twelve days earlier. Lawrence appears to have reached out mainly to sources familiar with white extremism in the Memphis area. Two of the eight named were segregationist Willis Ayres and Rolland J. Johnston, a Memphis electrician. Both are listed as prospective PCIs or Potential Confidential Informants. Johnston appeared again in an October 29, 1965, report Lawrence wrote on the doings in West Tennessee of the United Klans of America. According to the report, an informant said Johnston was mentioned at a Covington, Tennessee, Klan meeting as one who might be interested in joining. Johnston died in 1976 at age seventy-seven and Ayres died in 2004 at eighty-five.

violence," motivated by "patriotism and concerns of civic morality" to protect "his family, race and community from destructive violence, and not for mere monetary gain." Preventing violence definitely was a factor. But as the Church Committee and the Withers files demonstrate, the government's view was often skewed. There was no evidence of any real danger to national security or civil order posed by Kathy Hunninen, Mark Allen, Bobby Doctor, Rosetta Miller, Audrey Dandridge, Allan Fuson, Jerry Fanion, O. Z. Evers, James Lawson, or any of a number of other activists or government employees whom Withers helped the FBI target. The Withers records suggest many other citizens were harmed. It may take years of digging to determine exactly how.

Consider the case of Fr. William Greenspun, the Paulist priest at St. Patrick's Catholic Church, investigated for his association with the Invaders through an outreach ministry. The FBI collected a range of his personal data. That included a January 1970 tip from Withers, who said the priest was "extremely close" to another Invaders sympathizer, Rev. Malcolm Blackburn, the white pastor at otherwise all-black Clayborn Temple. The tip hints at impropriety. Although details are redacted in the Withers settlement, a more lightly censored version of the same report released forty years earlier reveals some of what Withers reported: that Greenspun and Blackburn had taken "recent trips" together. They'd traveled to the priest's home state of Connecticut, for example, to see his elderly father get married, Withers said. A common sentence of roughly ten words is redacted in both versions of the report. Though it is left to the imagination to fill in the blank, one could rationally speculate Withers had suggested the men were gay.

"It doesn't surprise me. They'd do anything to smear somebody's character," Gloria Greenspun told me in 2017. Mrs. Greenspun knew the now-deceased cleric wasn't gay—she'd married him in the 1970s after he left the priesthood. But she also understood that her late husband had faced great pushback for his stance on civil rights—supporting the sanitation strike, embracing Black Power militants, and giving office space to the Invaders. "I knew Bill had an FBI file. He told me that," she said. Yes, she said. Her husband was close to Blackburn, also now deceased. But there was "no basis in reality" of the gay relationship the FBI seemed to imply. "It could have been very damaging," she offered. Similar damaging personal details col-

ored other FBI reports. An agent wrote in 1972 that Withers said one activist then under suspicion "is a homosexual and is known as such by members of the Negro race." A source at the local Selective Service office once told Lawrence that a student peace activist under investigation "has furnished a doctor's certificate certifying he is a homosexual."

Volatile details like these gave the FBI leverage. Fleshing them out, fifty years later, is challenging. It's hard to know how often agents acted on such information to disrupt the movement. But the Selective Service office appears to have been a much-used tool. Acting on a tip from Withers, Lawrence contacted the Draft Board trying to secure the induction of militant activist Charles Cabbage. The agent also contacted a source on the board to measure the possible induction of Cabbage's friend, activist Coby Smith. Others likely received similar treatment. As the Memphis field office reported in 1968, it remained "continually alert" for any Selective Service violations and other legal infractions by activists.

I MISSED AN opportunity to cast more light on the surveillance in Memphis by never interviewing Withers about his FBI collaboration. It was a mistake and I regret it. But, as I've said, I never thought I'd write this story after Jim initially disclosed it. For me it died with James Earl Ray. When Jim wouldn't provide the cooperation I needed, my view dimmed. I saw this story through the eyes of a reporter, through the short shelf life of news. Indeed, the flurry of reporting by local and national media on events surrounding King's assassination quickly faded after Ray succumbed to liver disease on April 23, 1998.

I still believe I would have gotten little or nothing from Withers had I confronted him. He was asked to go public in 1978 when he testified in closed session before Congress—he declined. The following year, when he was charged in the Tennessee Clemency for Cash scandal, he never even told his defense attorney, Reed Malkin, that he'd been an informant. He could have used that detail to leverage a better deal with prosecutors. In fact, through dozens of interviews Withers gave across the decades there is just one I know of in which he discusses his relationship to the FBI. That's

the interview he gave for F. Jack Hurley's essay in *Pictures Tell The Story*. His discussion of the FBI there is oblique, terse (six sentences in a 192-page book), and wholly unsatisfactory. It omits every critical detail of his service: his pay, his long tenure, the specifics of what he did.

The possibility of exposure was something Withers lived with for years. He likely turned it over many times in his mind: What exactly would he say if his secret was forced into public view? He told the congressional committee he was never directed—the FBI didn't give him assignments or control his actions, he said. Records tell a far different story. Unlike activists like Julian Bond, Andrew Young, and H. Rap Brown or journalists like Moses Newson—all of whom had innocent contacts with the FBI—Withers was paid.

Not only was he paid, as ME 338-R, he was among a select group of informers assigned a code number, known in the business as a symbol number.

"Informant symbol numbers are not assigned to all informants of the FBI," Dennis J. Argall, the assistant chief of the FBI's records dissemination section, said in an affidavit in our lawsuit. "They are only assigned to informants who have been developed, instructed, closely monitored and, in many cases, paid for their services."

Critically, Withers named names. He gave agents inside details underscoring Rev. James Lawson's alleged subversion; he told them about the sympathies of government workers Bobby Doctor and Rosetta Miller, both of whom nearly lost their jobs; he reported nuggets of intel that landed Charles Cabbage and Coby Smith on the Security Index. He provided personal and political details on scores of others.

Does this erode Withers's legacy? The answer remains subjective, and I've tried over the years to steer away from offering an opinion. My pursuit has been to expose this hidden history, to tell an untold story. The records released through my newspaper's lawsuit are now part of the public domain, available for anyone to scour and form his or her own conclusions.

But I will offer this: between 1946 and his death in 2007, Withers shot some of the most powerful images of his time, boldly and faithfully recording stories that many wanted to suppress, often at great personal risk.

Among the million or so photos he shot in his life, if he'd only snapped three—King on the bus; Moses Wright pointing his accusing finger; and those abused garbagemen unburdening their timeless message, "I AM A MAN"—he would secure a place of honor in history. Perhaps with these three images, the Holy Trinity of that righteous movement, Ernest Columbus Withers finds his absolution.

ACKNOWLEDGMENTS

There are many people to thank, but I'll start where this book took root, at *The Commercial Appeal.* The venerable Memphis newspaper continues to struggle financially, yet its soul lives on in the power to inform—to investigate, to educate, to discover. So many talented people have passed through its well-worn halls. I was fortunate to work many years with one, my longtime editor Louis Graham, among the most gifted journalists I've known. For all his knowledge, Louis admittedly knew little of civil rights history. But he knew a good story when he saw it. He gave me the freedom and the resources to do what needed to be done. He patiently endured mounds of paper that piled up and encouraged even the most incremental progress. He let me fly to North Carolina on little more than a wing and a prayer; by grace it paid off. Chris Peck encouraged me, too. Chris has taken a lot of heat through the years, some earned, some not. But he was the ultimate force that made this happen. The former editor-in-chief pushed the tight-fisted executives at

parent-company E. W. Scripps in Cincinnati to finance our FOIA lawsuit. It cost so much it hurt. But it changed history—it deepened our understanding of government surveillance in Memphis. To that end, I'm indebted, too, to Scripps CEO Rich Boehne, who kept the money coming.

Credit for our most unlikely victory over the FBI belongs to Chuck Tobin, our Washington counsel. Simply put, Chuck outsmarted the government. He beat them at their own game. He got plenty of capable assistance from talented junior counselors Christine Walz and Drew Shenkman, and from Dave Giles, Scripps's affable in-house counsel. Others made valuable contributions. We got early assistance from veteran FOIA litigator Scott Hodes. James Lesar offered encouragement, too. Judge Amy Berman Jackson deserves kudos for her wisdom in navigating the government's artifice and its repeated obstructions. That said, I always will admire the Justice Department's Betsy Shapiro for coming to the table in mediation and negotiating a settlement both parties could live with—one that primarily benefits history.

Special thanks to Athan Theoharis and David Garrow, brilliant historians who have graciously provided advice and insight over the long course of this effort, starting in 2009, when I first matched ME 338-R to Ernest Withers, right up to the present, reading drafts of my book, reviewing FBI reports, and offering expert commentary. My initial news stories would have been impossible without them; this book, too. I am especially indebted to David. We first met as I covered James Earl Ray's unsuccessful legal bid to spring from prison. He has always been helpful and kind, always available despite his many accomplishments and busy schedule—a great teacher. Thanks, too, to the various retired officers of the U.S. Army, FBI, and Memphis Police Department who helped me. That help stretches back twenty years, to the first, foundational interviews I did that shaped my understanding of domestic intelligence operations in Memphis in the 1960s. In recent years, three former FBI agents stand out—Hank Hillin, who headed the Clemency for Cash investigation; Corbett Hart, whose many adventures bridged Tennessee's civil rights and corruption periods; and Bob Campbell, who patiently helped with understanding the Bureau's intricate policies and procedures. I can't forget W. Hickman Ewing, the former federal prosecutor, who allowed me to tap his sharp memory and incredible mind for detail.

Numerous others made valuable contributions in gathering records

from public and private collections. Harold Weisberg first got it all going back in 1997 when he let me into his file cabinet–filled basement. Many people know Weisberg as a conspiracy writer. But he was also a Freedom of Information hero. It was through him I learned of the FBI's files on the Invaders and the sanitation strike. After he passed, and I discovered Withers's FBI code number, his friend, scholar Gerald McKnight, graciously shipped me boxes of Weisberg's old records to search for more clues. Former Lt. Eli Arkin loaned me records he salvaged from MPD's Domestic Intelligence Unit; attorney Bruce Kramer supplied assorted records from the ACLU's lawsuit that halted MPD's unlawful political surveillance. The staff at the University of Memphis's Special Collections tirelessly helped in my research of the sanitation strike and West Tennessee's Tent City struggle. After settlement of our lawsuit, Martha Murphy and her staff at the National Archives and Records Administration were most professional in processing the large records release and in fielding my many questions.

Many thanks go to the daughters of special agent William H. Lawrence. Nancy Mosley and sister Betty Lawrence are two of the kindest, most earnest people I've ever had the pleasure to meet. I am especially grateful to Betty, who first opened her home to me on a chilly autumn day in 2010 and gave me access to her late father's handwritten notes, photos, and mementoes. In the years since, she has kindly provided tips, advice, and encouragement. Never has she tried to whitewash her father's story. She doesn't agree with me a hundred percent. But her interests involve accuracy, fairness, and decency. She is a gem of a person and I am deeply indebted. Similarly, Barbara Sullivan, daughter of the late FBI agent Hugh Kearney, opened her home, sharing precious keepsakes and memories of her father. Targets of the FBI's intelligence investigations cooperated, too. Kathy Roop Hunninen generously shared the photos Withers shot of her wedding along with personal papers and the painful memories of her years of victimization. Allan Fuson, Bobby Doctor, Mark Allen, Danny Beagle, Rosetta Miller-Perry, Jerry Jenkins, Heath Rush, and others graciously shared accounts of the abusive treatment they received from their government for doing little more than standing up for equal fights, for fighting against the war—for holding unpopular political views.

I cannot forget Coby Smith, the ex-Invader, who's devoted many hours through the years showing me his old haunts and introducing me to forgot-

ten civil rights soldiers. G. Wayne Dowdy at the Memphis Public Library and Information Center provided valuable insight and advice. Craig Gill at the University Press of Mississippi encouraged me to keep pushing forward. I'd also like to thank the dozens of people who signed privacy waivers allowing me to get their FBI files, though many of those FOIA requests remain unfilled.

A very special thanks goes to my friend and colleague Daniel Connolly, who in his young age has already navigated the perilous world of book publishing and who provided invaluable tips, advice, and words of encouragement when I was ready to give up. This book would not have been possible without him. Similarly, the Fund for Investigative Journalism came through in a big way with a grant in my darkest hours.

But more than anyone, my wife and best friend, Tina, deserves credit. She put up with years of distractions, of me working after hours, on weekends, and on vacation to finish "the book." She endured piles of paperwork and the loss of our walk-in closet, which became my office. Through it all, she offered endless hugs, home-cooked meals, wise counsel, and love for me and our three kids. She's the bond that holds us all together. For that, I'm eternally grateful.

ENDNOTES

Unless otherwise noted, all citations of FBI reports relate to records released through *The Commercial Appeal*'s 2013 settlement agreement with the FBI, known as the Withers settlement. FBI records obtained independent of the settlement are referred to as Non-Withers records or NW.

Chapter One

[1] Memphis Police Department report of officer Willie B. Richmond (Richmond report), "Surveillance of Martin Luther King & vicinity of Lorraine Motel, April 4, 1968," (April 4, 1968) See also statement of Willie B. Richmond, from the B. Venson Hughes private collection of King assassination–related files (April 9, 1968).

[2] **stiff and guarded:** "Man of the Year," *Time* magazine, Jan. 3, 1964, 13. The magazine reported King dressed with "funeral conservatism" and that "he has very little sense of humor."

[3] "Pictures Don't Lie," CNN, *Black in America* special report, February 2011.

[4] FBI report, Memphis Sanitation Strike file, 157-1092-273&274 (April 5, 1968).

[5] A quick online overview of the history of the Lorraine, "The Famous Lorraine Motel," can be found at the National Civil Rights Museum's website http://www.civilrightsmuseum .org/news/posts/the-famous-lorraine-motel.

[6] **"crazy genius":** Author interview with Andrew Young, January 30, 2013. There are multiple accounts of Bevel's erratic behavior. More details appear later in this chapter.

[7] For a characterization of the Mason Temple speech, see Joan Turner Beifuss, *At the River I Stand*, 256–59. Also, Taylor Branch, *At Canaan's Edge: America in the King Years, 1965–68*, 718–20.

[8] Beifuss, *At the River*, 291–317.

[9] See David J. Garrow, *Bearing the Cross: Martin Luther King, Jr., and the Southern Christian Leadership Conference*, 611–20. Also, Branch, *At Canaan's Edge*, 732–44, 752–54.

[10] **catfish lunch:** Beifuss, *At the River*, 378–80. **phoned their mother:** Branch, *At Canaan's Edge*, 761. **pillow fight:** Andrew Young, *An Easy Burden: The Civil Rights Movement and the Transformation of America*, 464. The author interviewed several SCLC associates including executive staff members Young, Dorothy Cotton, and Jesse Jackson as well as King's friend, Kentucky state senator Georgia Davis Powers, resulting in a digital narrative on the civil rights leader's final hours called "6:01," the time King was shot. See http://601.commercialappeal.com/.

[11] **one unidentified female:** FBI report, Memphis file on MLK, "Martin Luther King Jr., Security Matter—C," 100-4105-60&61 (March 20, 1968). The reference to a female is not explained in the eight-page report that covers a range of topics. The reference, however, is believed to be at least potentially significant, given J. Edgar Hoover's obsession with King and women. There is no evidence in the Memphis field office files that agents gathered any salacious material on King in the final days of his life. However, they were under explicit orders to do so. A series of memos that winter and spring alerted agents to King's "sexual aberrations." A memo on March 29, 1968, instructed Memphis agents to be watchful for any "improper conduct on the part of King," and to "stay on him until he leaves Memphis." It's possible Withers or another informant might have caught wind of such conduct and withheld it. It's possible, too, the FBI had developed such information and simply dropped it when King suddenly died. If Ralph Abernathy can be believed, King was engaging in the very sort of personal conduct in Memphis that the FBI so desperately wanted on the married Baptist preacher. In his memoir, *And the Walls Came Tumbling Down*, Abernathy linked King to three different women in those final hours. One, Georgia Davis, a state senator from Kentucky, later wrote her own book, revealing her year-long affair and last night with King at the Lorraine.

[12] **"extramarital relationship":** FBI memos, 100-4105-1 (January 4, 1965), and 100-4105-4 (January 7, 1965). **degenerate:** David J. Garrow, *The FBI and Martin Luther King, Jr.: From "Solo" to Memphis*, 121–22.

[13] 100-4105-4.

[14] The brief biographical sketch of agent William H. Lawrence is from personal and FBI records as well as family accounts laid out in greater detail later in this book.

[15] **cut them off:** Testimony of Det. Ed Redditt, U.S. House Select Committee on Assassinations (HSCA), Investigation of the Assassination of Martin Luther King, Jr., Vol. IV, 204. **mesmerizing speech:** Branch, *At Canaan's Edge*, 758. See also Ralph David Abernathy, *And the Walls Came Tumbling Down*, 432–33.

[16] **disappeared again:** Beifuss, *At the River*, 377. Abernathy gave a hotly disputed account of where King was that night in *And the Walls Came Tumbling Down*, 433–36.

[17] This characterization largely comes from David Halberstam, *The Children*, 396–99, 437. **hear voices:** Branch, *At Canaan's Edge*, 12.

[18] FBI memos. **sex "hang-ups":** "American Federation of State, County and Municipal Employees file," 157-1516-494 (January 27, 1970). According to the report, Withers heard from Memphis NAACP leader Ben Hooks that Bevel "has weird sexual 'hang-ups.'" It

doesn't elaborate. His personal life was the focus of wide rumor. Months before he died in 2008, Bevel was convicted of incest and sentenced to fifteen years in prison. **separated:** 100-4105-60&61. **obscenities:** "American Federation of State, County and Municipal Employees file," 157-1516-494 (January 27, 1970). According to the report, Bevel had shocked a Los Angeles church congregation by "using extreme vulgarities and obscenities in his speech."

[19] FBI memo, 100-4105-62&63 (March 21, 1968).

[20] Another witness to Bevel's lecture that day, Rev. Harold Middlebrook, says he was not disturbed by it. "I don't remember him proposing with young people anything that was violent," Middlebrook told the author in an April 18, 2017, interview. "Now if Withers was selling that to the FBI I did not know it, OK?" Middlebrook, a one-time SCLC staff member with close ties to the King family, said he often heard Bevel go off on tangents but never knew him to veer from nonviolent tactics.

[21] FBI memos. **backgrounds:** "NAACP" file, 100-662-1137&38 (February 26, 1968). This report is one of many examples of background Withers provided on multiple individuals. In the report, Withers, as Source One, discusses Lawson's previous involvement in the peace movement and his involvement in the formation of the Student Nonviolent Coordinating Committee. **power struggle:** ME-157-1092-16 (February 23, 1968) (NW). Withers and a second source said the sanitation strike was suffering from a "power struggle" between the conservative NAACP and the more militant Unity League, each trying to "outdo the other" to become the spokesman for the black workers. **move swiftly:** One example of the FBI's quick response to a tip from Withers is found in Lawrence's report 100-662-1154&55 (March 12, 1968). Lawrence wrote that Withers told him on March 12 that Rev. Ezekiel Bell had preached at a rally at Clayborn Temple the night before, telling marchers to prepare for another sit-in at City Hall. Scores of demonstrators had been arrested during a sit-in there a week earlier ("117 Strike Backers Take Stroll to Jail Escorted By Police," *CA*, March 6, 1968, 1). Withers, listed in the report as Source One, "stated that it appeared that Bell was attempting to tell them to provoke disorderly conduct arrests" again. MPD and military intelligence were quickly notified "of the above proposed plans," Lawrence wrote. That afternoon, FBI agents and police watched as the marchers converged on City Hall, taking seats in the council chamber. But, evidently, they changed plans. When the City Council rejected another request for a dues checkoff for the striking garbage workers, the protestors engaged in a walkout and left.

[22] **"how rotten":** Author interview with Bobby Doctor, March 18, 2013.

[23] Author interview with Kenneth O'Reilly, March 18, 2013.

Chapter Two

[1] **"Violence is necessary":** Branch, *At Canaan's Edge*, 633–34. Also, Bryan Burrough, *Days of Rage: America's Radical Underground, the FBI and the Forgotten Age of Revolutionary Violence*, 41.

[2] **"Minister of Transportation":** HSCA, Vol. VI, 430.

[3] Richmond report. The officer noted "MAX drove up into the parking lot" with Orange and Bevel. His report lists no specific time for McCollough's appearance but places it between 5:50 and 6:00 p.m.

[4] As part of McCollough's cover, he enrolled at Memphis State. He appears in a variety of intelligence reports that veer from pure black militancy. For example, McCollough was assigned to help monitor an August 1969 draft resistance rally. FBI memo, Draft Resistance Union of Memphis file, 100-4630-62&63 (August 25, 1969).

[5] **"Mr. Smith":** Transcript of the MPD statement of Walter Bailey (April 6, 1968). Questioned by Insp. Graydon Tines, Bailey agreed he'd asked officers to use the alias when phoning him through the motel switchboard. Tines contends in the report he wanted names of guests "as security measures for Dr. Martin Luther King." **intelligence officers:** Author interview with Eli Arkin, Sept. 9, 1997.

[6] **in federal court:** Ernest Withers (The HistoryMakers A2003.147), interview by Larry Crowe, 06/28/2003, The HistoryMakers Digital Archive. Session 1, tape 3, story 8, Ernest Withers remembers the days preceding Dr. Martin Luther King, Jr.,'s assassination. **tight restrictions:** Branch, *At Canaan's Edge*, 764.

[7] FBI memos. **economic boycott:** 100-4105-89&90 (April 5, 1968). Withers, listed as Source One in the report, told Lawrence on April 3, 1968, about a strategy meeting he attended the night of April 2 that spilled into the early morning of April 3. The meeting comprised members of King's SCLC executive staff; Community on the Move for Equality (COME), the ministerial alliance overseeing the sanitation strike; and the Black Organizing Project (BOP), the Black Power group also known as the Invaders. According to the twenty-page report, Withers gave Lawrence a detailed account of the meeting, including a presentation by Jesse Jackson, who spoke of his Operation Breadbasket program. Jackson spoke of plans to contact "all storekeepers or grocers" in Memphis's black neighborhoods and insist "very emphatically" they cease selling Hart's Bread, Wonder Bread, and Coca Cola or face a "massive Negro boycott," the report said. Jackson also spoke of a "massive nationwide boycott" of Plough because of its hiring practices. Jackson said that Plough chairman Abe Plough was a close friend of Mayor Henry Loeb, who was fighting dues check-off for the sanitation workers. Jackson said unions, including the Teamsters, would likely cooperate, stopping nationwide shipping of Plough products. **cozy:** 100-4105-93&94 (April 6, 1968). According to the report, Withers, as Source One, said Hosea Williams, spoke "on the late evening of April 3, 1968," with Invaders leaders Charles Cabbage and John B. Smith. Williams told them that he and SCLC staffer James Orange "would be willing to continue to talk with them," as "he and Orange were probably better able emotionally to deal" with them. See also, 100-4105-89&90. Lawrence wrote that Withers told him Williams considered the Invaders "belligerent" but rationalized that "nevertheless they are Negroes" and they would have to "form a united front" and "maintain liaison with them." **"get your guns":** 157-1092-30&31 (February 27, 1968). Smith spoke at a night rally at Clayborn Temple, and has been alternatively quoted as saying, "You better get some guns" or "Get your guns," maintaining, "You can't pray your way out." An unidentified source told Lawrence about Smith's speech that night. The following morning, Withers confirmed it. Listed in the report as Source Two, the photographer said Smith said, "We have to get some guns." "Source two stated that Smith did not call for actual fighting of the police but still emphasized on several occasions that the black people, or Negroes, should obtain guns," Lawrence wrote.

[8] FBI memo, 157-1092-273&274 (April 5, 1968). Withers said King and aides Andrew Young and Dorothy Cotton ate dinner with Charles Cabbage, Edwina Harrell, and Don Neely of the Invaders.

[9] FBI memo. **"drop a pigeon":** 100-4105-93&94. **"won't be blackmailed":** Ibid.

[10] **three in four Americans:** "Half of 160 Negroes In a Survey Oppose Dr. King on Vietnam," *The New York Times*, May 23, 1967, 3. **Marian Logan:** Garrow, *Bearing the Cross*, 600–01.

[11] **holocaust:** Dr. Martin Luther King, Jr., "Showdown For Non-violence," *Look* magazine,

April 16, 1968, 23–25. In his book, *Martin Luther King, Jr.: Apostle of Militant Nonviolence*, James A. Colaiaco featured this quote from King in a longer form in demonstrating the militant tone of King's Poor People's Campaign. King believed such a campaign was needed to not only reverse rampant poverty but to stem inner-city rioting. "Our nation is at a crossroads of history," King had said in unveiling the campaign. "It is impossible to underestimate the crisis we face in America." **"Commie"** . . . **"traitor":** Garrow, *Bearing the Cross*, 601–02.

[12] The observations attributed to Lawrence here come from his personal notes handwritten in retirement. His family allowed the author to copy them.

[13] **Children's Crusade:** Halberstam, *The Children*, 438–42. **against the Vietnam War:** Branch, *At Canaan's Edge*, 576–77. Branch describes how Bevel interrupted King's January 1967 vacation in Jamaica to lobby him about the war. Andrew Young recalled the incident like this in a January 30, 2013, interview with the author, "He said, 'Jesus came down and sat down on the dryer while I was washing clothes. And he sat on the dryer and told me I had to get Martin Luther King to go to Vietnam and stop this war. Take a boatload of prominent citizens and put themselves on the Mekong Delta.' I said, 'Bevel, you know, that's not very realistic.' He said, 'But I have to talk to Dr. King.'" **burned their draft cards:** Garrow, *Bearing the Cross*, 556–57; and Branch, *At Canaan's Edge*, 599–600. **sent copies:** 100-4105-62&63.

[14] FBI memo, 157-1092-256&57 (April 4, 1968). Withers, listed as Source Three in the report, drew Lawrence's attention to a young man from Detroit who "has threatened some newsmen" and was associating with members of the Invaders.

[15] See testimony of retired FBI agent William H. Lawrence, HSCA Vol. VI (November 21, 1978), 552. Lawrence testified that he spoke virtually daily with his secret informant, often by phone, or "in person under what we hoped were safe conditions."

[16] FBI Teletype, headquarters file on sanitation strike, 157-9146-X8 (February 26, 1968) (NW).

[17] **"Uncle Tom"** . . . **"white ministers":** Beifuss, *At the River,* 116–17.

[18] FBI memos. **"police snitchers":** 100-662-1154&55 (March 13, 1968). **particularly bitter:** 100-662-1158&59 (March 15, 1968).

[19] **put his feet up:** Ernest Withers (*The HistoryMakers* A2003.147), interview by Larry Crowe, 06/28/2003, The HistoryMakers Digital Archive. Session 1, tape 3, story 8, Ernest Withers remembers the days preceding Dr. Martin Luther King, Jr.'s assassination.

Chapter Three

[1] HSCA, Final Report, Dr. Martin Luther King Findings. See pages 325–74 for discussion of the FBI's investigation of the King murder; 441–59 for discussion of the FBI's conspiracy investigation. The committee's official finding states, "The Department of Justice and the Federal Bureau of Investigation performed a thorough investigation into the responsibility of James Earl Ray for the assassination of Dr. King, and conducted a thorough fugitive investigation, but failed to investigate adequately the possibility of conspiracy in the assassination."

[2] "Court Order Too Late; Police Burn Intelligence Files," *Memphis Press-Scimitar,* September 11, 1976, 1. The newspaper reported that MPD burned "100 garbage bags full of domestic intelligence files" at the direction of Mayor Wyeth Chandler. The incineration at the city's Scott Street sanitation substation came as the mayor's office learned the ACLU was seeking a temporary restraining order in federal court. During a series of interviews with the author in 1997, Arkin said he supervised the destruction of the files.

[3] *Chan Kendrick et al. v. Wyeth Chandler et al.*, U.S. District Court for the Western District of Tennessee, Order, Judgment and Decree entered September 14, 1978, by Judge Robert McRae. The order reads in part, "The provisions of this Decree prohibit the defendants and the City of Memphis from engaging in law enforcement activities which interfere with any person's rights protected by the First Amendment to the United States Constitution, including but not limited to, the rights to communicate an idea or belief, to speak and dissent freely, to write and to publish, and to associate privately and publicly for any lawful purpose."

[4] Athan Theoharis, *Spying on Americans: Political Surveillance from Hoover to the Huston Plan*, 136–42. Theoharis writes that COINTELPRO "was initiated without the knowledge or authorization of either the attorney general or the president." The FBI no longer wished to simply prosecute communist leaders, determining that "more aggressive and extralegal techniques were essential and feasible."

[5] Garrow, *The FBI and Martin Luther King, Jr.*, 124–34. Garrow writes that King was greatly distraught by the FBI's tactics. "They are out to break me," he told a friend. To another, King remarked, "They are out to get me, harass me, break my spirit."

[6] Garrow, *The FBI and Martin Luther King, Jr.*, 182–83. See also, Kenneth O'Reilly, *Racial Matters: The FBI's Secret File on Black America, 1960–1972*, 280–84.

[7] HSCA MLK report, Vol. VI, 407–43. Includes a narration by chief counsel G. Robert Blakey and testimony from Marrell McCollough.

Chapter Four

[1] Kevin McKenzie, "SCLC Women Honor Photographer Withers for Civil Rights Role," *The Commercial Appeal*, April 6, 2003, B2. Withers, then eighty, was presented the Lifetime Achievement Award in Atlanta by Evelyn G. Lowery, founder of the SCLC Women's Organizational Movement for Equality Now, Inc., and wife of Rev. Joseph E. Lowery, longtime SCLC president. "We kind of call him the original photographer of the civil rights movement," Mrs. Lowery said.

[2] Marshand Boone, Oral History Interview of Ernest Withers for The Civil Rights and The Press Symposium at Syracuse University's Newhouse School of Public Communications, 2004.

[3] This quote comes from HistoryMakers interview. Session 1, tape 4, story 1, Ernest Withers recalls Memphis funeral home viewing after Dr. King's assassination. See also, Boone, Oral History. In an October 31, 2010, interview with the author, Dr. Jerry Francisco, the surgeon who performed Dr. King's autopsy, said Withers's account of handling King's "skull cap" appears accurate. "You have to remove the skull cap in order to get the brain," Dr. Francisco said. That involves cutting out a circular or oval section of the skull that is roughly 5 by 8 inches in radius. "In order to make a complete examination you have to examine the brain . . . we would put the skull cap (back) in and tacked the scalp together," Francisco said. Tacking the scalp involves a couple stitches sewn on either side of the head to ensure "it stays in place." Embalmers generally prefer to do their own suturing of the scalp later, Francisco said. Similarly, the wounds in King's jaw and neck were left for the embalmer to suture, the doctor said.

[4] This quote comes from HistoryMakers interview, Session 1, tape 4, story 1, Ernest Withers recalls Memphis funeral home viewing after Dr. King's assassination.

[5] For more detail on Withers's childhood in North Memphis and early adult life, see chapter 10. A discussion of the same can be found in the Chrysler Museum of Art book by Ernest C.

Withers, F. Jack Hurley, Brooks Johnson, and Daniel J. Wolff, *Pictures Tell The Story: Ernest C. Withers, Reflections in History*, 31–55. For an analysis of the manipulation of African American voters and others in Memphis during the years of political boss E. H. Crump, see G. Wayne Dowdy, *Mayor Crump Don't Like It: Machine Politics in Memphis*, 22–28.

[6] This passage and quote come from a 2006 interview on *Real People with Bill Waters*, WKNO-TV Channel 10, the Public Broadcasting Service affiliate in Memphis. See also, *Ernest Withers: His Brother's Keeper*, a video biography produced in 1995 by WKNO-TV.

[7] Ibid.

[8] Withers et al., *Pictures Tell The Story*, 38–55. WKNO-TV, *Brother's Keeper*. Property records maintained by the Shelby County Register's Office.

[9] **"paid very sparingly"**: WKNO-TV, *Brother's Keeper*. **"gave me $10"**: WKNO-TV, *Real People with Bill Waters*. **produced a booklet:** Withers et al., *Pictures Tell The Story*, 61. See also, Maurice Berger and Thulani Davis, *For All the World to See: Visual Culture and the Struggle for Civil Rights*.

[10] WKNO-TV, *Real People with Bill Waters*.

[11] This quote comes from HistoryMakers interview, Session 1, tape 3, story 5, Ernest Withers describes dangerous moments photographing the civil rights movement.

[12] Charles Cabbage interview with author, January 2010.

Chapter Five

[1] This account comes from several sources, principally Hank Hillin, *FBI Codename TennPar: Tennessee's Ray Blanton Years*, 248–49, 255. See also; "Memphis Club Owner Gets Five-Year Term," *CA*, December 20, 1975; Michael Lollar, "Jury Calling Officers; Club Favors Suspected," *CA*, December 15, 1976, 1; Jerome Wright, "Baldwin Returned As Possible Witness," *CA*, January 17, 1977; Don Groff, "Baldwin Guilty in Cocaine Trial As Jurors Return Split Decision," *CA*, August 23, 1977; Lawrence Buser, "FBI Informant Known for His Unlawful Acts," *CA*, December 20, 1978, 3; Otis L. Sanford, "Baldwin Lists Campaign Gifts Aimed At Buying Influence," *CA*, September 20, 1979.

[2] "Our Hillbilly Nixon," *CA*, Memphis, September 18, 1977, G4; Bill Rose, "The Hillbilly Nixon," Knight-Ridder newspapers, January 23, 1979.

[3] "Governor Promises To Pardon Slayer," *CA*, September 16, 1977; Lawrence Buser, "Humphreys' Father Bares Strain," *CA*, September 22, 1977. LeRoy Williams, Jr., "Father Hits Blanton Pardon Plan," *CA*, September 19, 1977. Hillin, *TennPar*, 1–5 and 204–205.

[4] Hillin, *TennPar*. **Cole:** 108–09 and 178–82. See also, William Bennett, "Parole Cost $10,000, Ex-Convict Testifies," *CA*, July 25, 1979. **Prater:** 124–33. See also, Peter Maas, *Marie: A True Story*, 128–35, 139–44, 300–303, 346–53. At trial, Prater gave conflicting accounts. He testified he saw Thompson pass Sisk an envelope of payoff money, but under cross-examination said he couldn't swear what was in the envelope (see William Bennett, "2 Witnesses Link Thompson To Clemency-For-Cash Cases," *CA*, July 28, 1979, 3).

[5] Hillin, *TennPar*, 135.

[6] Ibid. **"in abeyance"**: 189. **"case is dead"**: 230–31. In a May 2, 2012, interview Hillin told the author that politics "almost killed the case completely . . . The case was over. Closed. Kaput. That was it . . . They wanted us to shut it down."

[7] Ibid. **"it's final"**: 240. **"no longer under . . . investigation"**: 242. Also, Larry Daughtery and Nancy Varley, "Sisk Claims Persecution Tactics Used," *The Tennessean*, May 28, 1977, 1. The article discusses Eddie Sisk's accusation that Hillin was on "a vendetta" and a "wild goose chase" aimed at Sisk's "persecution."

⁸ Ibid. **Griffin Bell:** 215–16 and 219–20. **"We were foolish":** 230–31.

⁹ In the author's interview with retired agent Hillin, he acknowledged the Withers–Baldwin development was critical. "All that came together at the right time," he said. "It was an answer to prayers I'd been making. It was huge." Hillin also cites the cooperation of Sheryl Leverett, who paid $9,500 with money supplied by the FBI for the release of her husband, John, who was sentenced to six to twenty years for armed robbery.

¹⁰ These passages from Baldwin's closed-session testimony are found in *USA v. Thomas E. Sisk et al.*, 79-30054 Middle District of Tennessee, Jencks Materials, Re: Art Baldwin. This file, hereafter referred to as Baldwin file, contains sworn testimony given in closed session by Baldwin to W. Hickman Ewing and U.S. attorney Mike Cody, including sessions on September 6, Sept. 8 (Vol. I) and October 10, 1977 (Vol. II). **Kenneth Turner:** Vol. I, 47. **Minerva Johnican:** Vol. I, 50. **John Ford:** Vol. I, 62. Additional details come from author's interview with Ewing, December 13, 2011.

¹¹ Ibid., Vol. I, 194.

¹² Ibid. **secure his release:** Vol. I, 189–92. **gave the pair cash:** Vol. II, 101–03; Vol. II, 32, 101.

¹³ Ibid., Vol. II, 92–3. At another point, Baldwin says, "You can't contact Mr. Murrell. Mr. Withers is Murrell's go-between. You have to go through Mr. Withers to get in contact with Mr. Murrell."

¹⁴ Hillin, *TennPar*, 255. Details on Withers's solicitation of liquor from Baldwin are found in FBI reports in the author's possession, the serial numbers redacted. The reports are a Teletype and a letterhead memo from Memphis to headquarters, both dated May 18, 1978, located in headquarters file 194-161. Withers's solicitation also was described by Ewing in author's interview.

¹⁵ Ibid., 271–72. Hillin describes how he and Corbett Hart traced Taylor from the highway patrol to his special duty as driver for the governor's brother. Withers later testified in court about his tie to Taylor (see Jim Balentine, "Tapes in Court Allege Shelby Political 'Deals,'" *MPS*, April 8, 1981.

¹⁶ Ibid., 272–73. See also, FBI reports, HQ-194-161-24. The key report is a five-page Teletype from Memphis to headquarters. Also, ME-194-39-102 and 105. These are two memos dated October 18 and 19, 1978. Hillin's book names Taylor, but the patrolman's name is redacted in the FBI reports. See also, Maas, *Marie: A True Story*, 402–03.

¹⁷ FBI Teletype, 194-161-26 (September 20, 1978).

¹⁸ Hillin, *TennPar*, 292–96.

¹⁹ In testimony at trial, FBI agent Corbett Hart discussed numbers of secret tapes recorded in the final push to take down the Clemency for Cash conspirators. See *USA v. Thomas E. Sisk et al.*, U.S. District Court for the Middle District of Tennessee, 79-30054, Benson trial transcript (April 9, 1981), 1412–1634, and "Excerpt of Proceedings" (April 9, 1981), 1–15.

²⁰ For a detailed account of the final takedown, see Hillin, *TennPar*, 335–61. Benson's arrest is found on page 356; Sisk's on 357–58. See also Maas, *Marie: A True Story*, 404–05.

²¹ *USA v. Ernest Columbus Withers and John Paul "J.P." Murrell*, CR-79-20009-1, Western District of Tennessee. See "Order to Surrender" (Nov. 27, 1979). Though Withers's attorney asked he be placed in a halfway house in Memphis, the order required Withers to report to the federal prison camp at Maxwell Air Force Base in Montgomery at noon on December 13, 1979.

²² **year in prison . . . six months suspended:** *USA v. Withers*, Judgment order (November 13, 1979). Though Withers's involvement ran deep in the Clemency for Cash case, pros-

ecutors considered his role in the extortion case to be minor. "He more or less did what Mr. Murrell told him to do. He was more or less a bagman," prosecutor Dan Clancy told the court. "I suggest to the court that Mr. Withers has suffered a lot." Nonetheless, Judge Harry W. Wellford insisted Withers serve at least six months of his sentence behind bars given he'd been a law enforcement officer. **testify in two trials:** Otis L. Sanford, "Guilt Is Admitted in Extortion Case," *CA*, August 7, 1979.

[23] Even Withers's defense attorney, Reed Malkin, didn't know about the photographer's previous work as an informant. "The first I heard about that was when it came out (in 2010) in the paper," Malkin told the author on September 20, 2017. "When it came out it was a big surprise." Had he known, he believes he could have used it as leverage. "I think I could have got them to drop the case," he said. Why his client never told him is unclear. "I think he was concerned about his legacy and his reputation. I could see that he didn't want anybody to know about that stuff with the FBI, probably more than anything to protect his family. I could see where he would have felt that would be detrimental to his family and his legacy." Withers also may have been shaken by his closed-session appearance months earlier before the House Select Committee on Assassinations.

[24] *USA v. Ernest Columbus Withers and John Paul "J. P." Murrell*, CR-79-20009-1, Western District of Tennessee. See sentencing information and Withers testimony (August 7, 1979). Lee Hyden was convicted in connection with his previous role as a Shelby County commissioner.

[25] Ibid., **released:** See "Conditions of Probation" form filed June 4, 1980, stating Withers was "released from prison on May 23, 1980," and that his one year of probation now begins. **fine:** Ibid. Withers's sentence also included four hours of community service a week. **revoke his probation:** Probation officer's report of April 6, 1981, contending Withers "has not paid $2,500 fine." Also, order of Judge Harry W. Wellford, May 1, 1981, admonishing Withers for "failure to pay the entire amount." Withers told the court he "was taking steps to liquidate assets" to pay the fine.

[26] *Jet* magazine, August 4, 1977, 6–7.

Chapter Six

[1] **Rickey Peete:** Buser, "51 Months For Peete; Former City Council Member Learned Nothing In Prison, Judge Says," *CA*, November 15, 2007, A1. **Joe Cooper:** Buser, "Informer Going to Jail For 6 Months; Cooper Helped FBI In Official Corruption Case," *CA*, June 19, 2008, A1; and Perrusquia, "Tanner Said to Have Paid For Judge's Florida Vacation; Cooper Says He Did Peete a Favor With Boss' Credit Card," *CA*, November 17, 2005, B3.

[2] The author interviewed Withers about his involvement in the Clemency for Cash scandal in December 2006, for a series of stories on the legacy and impact of public corruption in Memphis. "People lust for gold, lust for money," he said. Politicians are in it for the money, he said. Bagmen—the little guys like Withers—simply follow orders. "I was just doing what I was supposed to do," he said.

[3] Perrusquia, "Edwards Maintains Innocence," *CA*, June 20, 1989, A1; Perrusquia, "Miss. Killer Edwards Dies In Gas Chamber," *CA*, June 21, 1989, A1.

[4] *USA v. John Ford*, Western District of Tennessee, exhibit 62a. During the twenty-five-minute undercover audiotape, played April 12, 2007, at the trial, Ford also said in a rambling discourse over drinks in a hotel barroom that he'd like to shoot a businessman. "I don't mind shooting that *motherfucker*," Ford told undercover agent L. C. McNeil. Unknown to Ford, the businessman he wanted to shoot was really a retired FBI agent

posing as the corrupt owner of fictitious E-Cyle Inc. Ford also insinuated that he'd like to shoot his attorney, David Caywood, who represented him in the child support case that led to the ethics charges against him. "That *motherfucker* got me in all this *goddam* trouble," Ford said.

[5] **shoved the citation:** Perrusquia, "John Ford in Fracas at Airport Over Ticket: 'I Am a Senator, You Can't Lock Me Up,' He's Quoted," *CA*, August 10, 1999. **"legislative immunity":** Richard Locker, "Inquiry Says Trooper Ticketing Ford Needs Courtesy Counseling," *CA*, March 3, 1994.

[6] Perrusquia, "Cherokee Won't Let State Review Spending; Auditor: "Ford Says It's 'None of Our Business,'" *CA*, May 14, 2000, A1.

[7] Perrusquia, "Sen. Ford Tells Court He Juggles 2 Families—Cites Law He Wrote In Child-Support Scrap," *CA*, January 23, 2005, A1.

[8] See HSCA, Final Report, 411–12. Page 670 of the report says, "It should be noted that at the informant's request, the committee has agreed not to disclose his identity in this report."

[9] See Perrusquia, "King Scrutiny a Myth, Say Agents Here in '68; Army Intelligence Was Worried About Riots, They Recall," *CA*, November 30, 1997, A1. The story relied on declassified reports and interviews with retired agents of the Atlanta-based 111th Military Intelligence Group, who said their mission had less to do with King and more with watching for outbreaks of violence during the volatile sanitation strike. The article benefited from interviews with Christopher Pyle and Ralph Stein, former army intelligence officers who'd blown the whistle on domestic spying in congressional hearings in the early '70s, and with retired Col. Edward McBride, who oversaw the 111th Military Intelligence Group's operations from Fort McPherson in Atlanta as well as Jimmie Locke, who oversaw the 111th's operations in Memphis and Merrill T. Kelly, special assistant to the Department of the Army's Assistant Chief of Staff for Intelligence. See also, Perrusquia, "Ray Expected Pay For Killing King, Investigators Conclude," *CA*, March 22, 1998, A1, and Perrusquia, "King Conspiracy Theories Snowballed As FBI Sat Back," *CA*, March 23, 1998, A1.

Chapter Seven

[1] Author interview with John Elkington, March 18, 2011.

[2] Speech on January 19, 2004, before the Museum of Fine Arts in Boston, WGBH Educational Foundation's Forum Network, Civil Rights Movement Series, http://forum-network.org/series/civil-rights-movement-series/.

[3] Michael Lollar, "Nearly a Thousand Mourn Withers; Accompany Photographer on Final Trip Down Beale," *CA*, October 21, 2007, B1.

[4] FBI file, ME-194-16-3. These statements attributed to Withers come from a fifteen-page transcript of a phone tap dated September 13, 1977.

[5] FBI report, ME-194-75-Sub B-223. In a copy of the two-page memo dated February 2, 1979, the name of the man giving the statement is redacted. In a second FBI report dated January 10, 1979, Withers admits to receiving $5,000 from the man, identified as a contractor, but denies personally pocketing money, which was passed to other conspirators. The contractor said he paid Withers in installments starting in early 1976 to secure the release of his son from a thirteen-year sentence for robbery. "He agreed to let me pay in two installments. A couple of days later I met him at his office and paid him $2,500 in $100 bills," the man would later tell the FBI in a written statement. "I asked if I could

get a receipt and he told me I could not." A few months later Withers called and said he needed the rest of the money, which the man paid—again in hundred-dollar bills. His son was paroled that December, the report said. The account closely reflects that of Elroy Grantham, a brick mason who testified at one Clemency for Cash trial that he paid Withers $5,000 (see Jim Balentine, "Withers Testifies About Role in Clemency-For-Cash Deal," *MPS*, April 7, 1981).

[6] FBI report, ME-194-75-Sub H-82. The report is a seven-page Teletype from the FBI's Los Angeles office to Memphis dated March 16, 1979. The name of the man, identified as a narcotics dealer who was unwilling to testify, is redacted. He told agents he delivered briefcases stuffed with twenty- and hundred-dollar bills to Memphis. Once, he met Withers and some confederates at a Travel Lodge motel. On another occasion, he said, he gave Withers $20,000 in an automobile. As the payments stretched out, with his wife still in prison, he began complaining. "Just give me a figure," he snapped at Withers. "I'm tired of coming back and paying and not getting shit." He later told investigators that Withers dismissed his protests. "Don't worry about it," Withers told him. Because of the FBI investigations, the parole board was under tremendous pressure, and it would take time to secure his wife's release, Withers allegedly said.

Chapter Eight

[1] Kelley served as special agent in charge of the Memphis office from November 1960 to October 1961. He rated Lawrence as "excellent" in a March 1961 evaluation, citing his initiative, aggressiveness, and outstanding performance working with informants. In retirement, Lawrence wrote a series of letters in the 1970s in support of his former boss, then the embattled FBI director. (Personnel file of William H. Lawrence obtained by the author through the Freedom of Information Act, FOIPA Request No.: 1271512-000. [NW]) In 1963, Felt, then overseeing the FBI Academy, interviewed Lawrence following two weeks of special training, commending him as a "very capable agent."

[2] Interview of Rosalind Withers by Kontji Anthony, WMC-TV, Channel 5, Memphis, on September 13, 2010. The revelation brought condemnation on Withers from several quarters. Comedian-activist Dick Gregory called the photographer "Judas." Longtime Memphis judge and activist D'Army Bailey called Withers's actions a "bitter betrayal."

[3] Author's phone interviews with Betty Lawrence, September–October, 2010.

[4] Betty Lawrence bought the house in 1986. Property records say it was built in 1880, but its longtime resident, the journalist and war adventurer Paul Ayres Rockwell, said in a 1976 interview the original house was built in 1832 and expanded over the years. Rockwell lived in the home from about 1910 until his death. See "Colonel Paul Rockwell, interviewed by Dr. Louis D. Silveri, July 22, 1976, Southern Highlands Research Center, University of North Carolina at Asheville."

[5] Just as FBI censors failed to redact Withers's information, they blundered on covering the names of NAACP leaders Vasco and Maxine Smith in documents released years earlier. The Smiths were first revealed as FBI informants in David J. Garrow's 1981 book, *The FBI and Martin Luther King, Jr.* Though the Smiths both had "170" files identifying them as "extremist informants," unlike Withers, there is no evidence they were paid. The author's source, identified as "Jim," said the FBI considered the Smiths more as liaison sources than full informants.

[6] Ex-agent Lawrence evidently had spent quite a bit of time at the library researching this paper. Though some of his citations don't appear precise, pieces of his research can be

found in these articles, among others: "4 Women Who Visited Hanoi Will Lose U.S. Passports," *The New York Times*, January 18, 1967, 9; "Woman Reports on Trip," *The New York Times*, January 21, 1967, 3; David Halberstam, "The Second Coming of Martin Luther King," *Harper's*, August 1967, 39–51; Leroy F. Aarons, "King Urges Cease-Fire And End of Bombing, Denounces U.S. Role," *The Washington Post*, April 5, 1967, 1.

Chapter Nine

[1] Testimony of retired FBI agent William H. Lawrence, HSCA, Vol. VI, 555 (November 21, 1978).

[2] See FBI, "Martin Luther King Jr., Security Matter—C," Memphis file 100-4105. The Memphis field office opened a security file on King in 1965. Through the month of his death there in April 1968, the file involved up to a hundred serials, or reports, totaling about 190 pages, though some pages are entirely redacted.

[3] 100-4105-1, 4. These involve rumors King once "openly consorted" with the first wife of singer Harry Belafonte, the late Marguerite Belafonte, discussed in greater detail in chapter 1.

[4] Lawrence testimony, HSCA, Vol. VI, 541. See also "Report of the Department of Justice Task Force to Review the FBI Martin Luther King, Jr., Security and Assassination Investigations" (also known as the Shaheen Report), 24. The reports says the FBI had "five paid confidential informants providing intelligence regarding the racial situation to the Memphis Field Office on a continuing basis."

[5] In exploring the sabotage issue, the committee took testimony from multiple people, including three members of the Invaders (see HSCA, Vol. VI). The committee "found no basis for a conclusion that the FBI, directly or through its informants, provoked the violence." At the same time, the committee found that the Memphis field office was aware of the "potential for disturbances" and that "violence was likely to occur" that day, yet took no action to prevent it (see HSCA Final Report, 412–13). That knowledge included information that march participants would carry placards on pine sticks. The FBI also was aware that numbers of student marchers had thrown rocks that morning at Memphis police officers.

[6] The committee "found evidence that some members of the Invaders, resorting to inflammatory rhetoric and acts of violence, encouraged the disturbances that marred the sanitation workers march" (see HSCA Final Report, 411). According to an FBI report, a few members of the group were seen prior to the march saying they would "tear this S.O.B. town up today." The men were later seen during the march running into an alley to obtain "some sticks and bricks." Lawrence wrote in the report that Withers said the Invaders "did not organize any violence as such," but that he'd seen some members "indiscriminately giving out the 4-foot pine poles to various teenage youngsters," and telling them "not to be afraid to use these sticks" (see 157-1092-184&185).

[7] **approached the FBI . . . He agreed:** HSCA Vol. VI, 550. See also HSCA, Final Report, 411–12. **Asked to go public, He declined:** HSCA, Final Report, 670. The report says, "It should be noted that at the informant's request, the committee has agreed not to disclose his identity in this report." See also Lawrence testimony, HSCA Vol. VI, 550–55.

[8] Another point of corroboration that Withers is the informant whom Lawrence testified about involves records the FBI released on May 15, 2012, pursuant to a judicial order in *The Commercial Appeal*'s lawsuit. Judge Amy Berman Jackson had ordered the FBI to release any "non-exempt, reasonably segregated" records from Withers's informant

file. Among records released were six cover sheets from the House Select Committee on Assassinations stating the "following material has been reproduced for excising and review."

[9] It's uncertain if Withers met with the full committee or perhaps only with staff and a representative. The committee's reports say only that the informant in question was interviewed by staff and his name was revealed to ranking members. See HSCA, Vol. VI, 550, and Final Report, King findings, 411-12.

Chapter Ten

[1] Ernest Withers told the legend of his great-grandfather Silas many times. The principal sources here involve his 2004 Boone interview and HistoryMakers interview, Session 1, tape 1, story 3, Ernest Withers discusses a slave ancestor's murder during the Civil War. See also, the *Tri-State Defender*, "Arthur Earl Withers Is Buried; Leader In North Memphis Area," January 3, 1970, 1. Details on slave owner Albert Q. Withers come from U.S. Census information reviewed at Ancestry.com and from "Marshall County, Mississippi: Largest Slaveholders From 1860 Slave Census Schedules and Surname Matches For African Americans on 1870 Census," transcribed by Tom Blake, February 2002, http://freepages.genealogy.rootsweb.ancestry.com/~ajac/msmarshall.htm.

[2] U.S. Census records of 1880 and 1900 in Marshall County, Mississippi, and Shelby County, Tennessee, help enumerate the size of the growing family. Withers's reference to the "Faulkner herd" is from WKNO-TV, *Brother's Keeper*. See also, *TSD*, "Arthur Earl Withers Is Buried."

[3] *TSD*, "Arthur Earl Withers Is Buried." Also, draft registration card of Arthur Earl Withers, June 5, 1917; Shelby County marriage records, October 29, 1917.

[4] The 1935 Polk directory of Memphis shows that Withers's neighbors included physician Lewis T. Burley and Universal Life Insurance assistant district manager Elijah L. Simon, among others. Characterizations of Ernest Withers's boyhood principally comes from HistoryMakers interview, Session 1, tape 1, story 6, Ernest Withers remembers major employers in his childhood community.

[5] This account of Withers's visits to his grandmother and her fear of certain neighborhoods comes from Ernest C. Withers et al., *Pictures Tell The Story*, 31–32.

[6] Roger Biles, *Memphis in the Great Depression*, 22–33.

[7] Ibid., 88–89.

[8] Ibid., 24–25, 89.

[9] **ward heeler:** HistoryMakers interview, Session 1, tape 1, story 10, Ernest Withers describes his parents' political affiliations. **front porch:** Withers et al., *Pictures Tell The Story*, 103. **Lincoln League:** Elizabeth Gritter, *River of Hope: Black Politics and the Memphis Freedom Movement*, 1865–1954, 42. For a discussion of some of the election fraud and manipulation of black voters under E. H. Crump, see G. Wayne Dowdy, *Mayor Crump Don't Like It: Machine Politics in Memphis*, 9, 21–22, and 25–28. Also, William D. Miller, *Mr. Crump of Memphis*, 102–03, 121, and 152.

[10] The Withers family home purchase is found in Shelby County property records; the account of baptisms at Gospel Temple Baptist Church is from a page on the church's website which as of 2017 was no longer functioning.

[11] Withers's comments on his mother's death are from the HistoryMakers interview, Session 1, tape 1, story 5, Ernest Withers remembers his mother and her death when he was seven years old. The author also consulted Pearl Withers's death certificate.

[12] WKNO-TV, *Brother's Keeper*. Minnie Withers's perfectionism is also discussed in Withers et al., *Pictures Tell The Story*, 32.

[13] WKNO-TV, *Brother's Keeper*.

[14] Ibid. This account of Withers's army experiences comes from a variety of other sources, too, including: Ernest Withers's army enlistment papers; WKNO-TV, *Real People with Bill Waters*; HistoryMakers interview, Session 1, tape 2, story 4, Ernest Withers discusses his days as a photographer in the U.S. Army; Boone interview; and Withers et al., *Pictures Tell The Story*, 36–38.

[15] **train to Chicago:** Boone interview. **Studio . . . on Beale:** WKNO-TV, *Waters* interview. Property records show Ernest and Jacob Withers bought a house for their first studio for $300 cash plus a $2,950 note.

[16] Details on the Eli Blaine matter come from several sources, principally "The Tragic Case of Eli Blaine," *The Memphis World*, July 1948; E. H. Crump Collection, Memphis Public Library and Information Center, box 255, Folder: "Negro File, 1948"; Bob Marks, "Two Police Officers Accused of Beating, Blinding Negro," *CA*, May 18, 1948, 1.

[17] For a discussion of the Blaine controversy and other incidents leading to the integration of the Memphis Police Department, including the police slaying of sanitation worker James Mosby, see Laurie B. Green, *Battling the Plantation Mentality: Memphis and the Black Freedom Struggle*, 81–111.

[18] Details on Ernest Withers's police hiring, training, and career come from his police personnel file, in the author's possession. See also HistoryMakers interview, Session 1, tape 4, story 4, Ernest Withers remembers his time as a Memphis, Tennessee police officer.

[19] David Acey's quote is from WKNO-TV, *Brother's Keeper*.

[20] Lawrence and Withers may have met briefly in May 1948 when the agent helped conduct a loyalty investigation of the photographer's friend Howard Cash, who was applying for a job as a postal carrier. Cash and Withers had served together in the army and later joined a veteran's group included on the Attorney General's List of Subversive Organizations. The probe uncovered no subversive activity by Cash, who passed his check and served a long career with the Post Office. Though Withers was unwittingly interviewed by a Bureau informant, it's uncertain if he and Lawrence actually met then. See FBI report, "Loyalty of Government Employees," 121-3958-6, (May 19, 1948), from the Memphis field office. See also, FBI, 100-344537-40, "United Negro and Allied Veterans of America," an October 4, 1946, report by the Houston field office.

[21] Author's interview with retired Capt. Jerry D. Williams, October 7, 2014. See also, Withers et al., *Pictures Tell The Story*, 52–53.

[22] Ernest Withers MPD personnel file. For a characterization of Quianthy's police career, see "Lee Quianthy Rites Monday—Led Fearless Crime Fight," *CA*, March 1, 1968.

[23] See WKNO-TV, *Brother's Keeper*. Also, HistoryMakers interview, Session 1, tape 4, story 4, Ernest Withers remembers his time as a Memphis, Tennessee police officer; Withers et al., *Pictures Tell The Story*, 53–54.

[24] Withers personnel file. The file includes four transcribed hearing interviews—one each with Withers, Johnson, his mother Mary Johnson, and liquor store owner Joe Raffanti—along with other reports.

[25] Jim Willis, "Photographer Recalls His Varied Vocations," *MPS*, May 2, 1975.

[26] Author's interview with Williams. The retired captain's account of long-running corruption has many points of corroboration. For a discussion of payoffs received by Memphis lawmen during Prohibition, see Dowdy, *Mayor Crump Don't Like It*, 45–48.

Chapter Eleven

[1] Precisely what happened that day between fourteen-year-old Emmett Till and Carolyn Bryant, twenty-one, has been the subject of much conjecture and controversy through the years. Among the most recent accounts is Timothy B. Tyson's painstakingly researched *The Blood of Emmett Till*, based, in part, on an interview with an elderly Bryant, who backpedals on much of her original story. She had testified at trial that Till grabbed her by the waist and spoke obscenities. "That part isn't true," Bryant confessed to Tyson. She confirmed what witnesses have consistently said, that Till whistled at her as he was leaving. But Bryant was adamant: "Nothing that boy did could ever justify what happened to him."

[2] This account is taken from a variety of sources, primarily: The transcript of the Emmett Till murder trial at Sumner, Mississippi, September 21, 1955 (the transcript is included in the Federal Bureau of Investigation's 2006 reexamination of the Till murder); Stephen J. Whitfield, *A Death in the Delta: The Story of Emmett Till*, 17–20; John N. Popham, "Brothers Admitted Till Abduction, Sheriff Says," New York Times News Service as published in *The Atlanta Constitution*, September 22, 1955, 1; Chicago Tribune Press Service, "Kidnap Admissions Told At 'Whistle' Trial," as published in *The Washington Post*, 59.

[3] References to photos Withers shot before the Till trial come from "Items Top Baptist Confab Slate," *TSD*, September 3, 1955, 1. Also, "Slate of Top Events On Convention Program," *TSD*, September 10, 1955, 1.

[4] WKNO-TV, *Brother's Keeper*.

[5] The story quickly caught on in the black press and later in the larger media. See, "Is Mississippi Hushing Up A Lynching: Mississippi Gunmen Take Life," *Jet* magazine, May 26, 1955, 8–11. Also, David T. Beito and Linda Royster Beito, "The Grim and Overlooked Anniversary of the Murder of the Rev. George W. Lee, Civil Rights Activist," The History News Network, George Mason University, May 9, 2005. And, Simeon Booker and Carol McCabe Booker, *Shocking the Conscience: A Reporter's Account of the Civil Rights Movement*, 20–21.

[6] See "'KKK' Strikes; Minister Slain Gangland Style," *TSD*, May 14, 1955, 1.

[7] For more on the federal investigation of Lee's murder see Booker, *Shocking the Conscience*, 24–25.

[8] Withers et al., *Pictures Tell The Story*, 68–70.

[9] **pictures attributed to staff writer Moses J. Newson:** *TSD*, September 17, 1955, 5. **photo of Till's mutilated face:** *TSD*, September 10, 1955, 1. **appears shaky at best:** Among the most credible sources making the claim is bestselling author Timothy B. Tyson, who writes in *The Blood of Emmett Till* on page 75 that both *Jet* photographer David Jackson and Withers "snapped pictures of Emmett's body at the (Chicago) funeral home, Withers a close up and Jackson a full-body shot." Tyson continues: "Withers's close-up of Emmett's face, published in *Jet* on September 15, four days before Roy Bryant and J. W. Milam went on trial for the killing, was passed around at barbershops, beauty parlors, college campuses, and black churches, reaching millions of people. Perhaps no photograph in history can lay claim to a comparable impact in black America." However, *Jet* reporter Simeon Booker, who accompanied Jackson to the A. A. Rayner & Sons Funeral Home on September 2 when Till's body arrived from Mississippi, gives credit to only Jackson (see Simeon Booker, "Best Civil Rights Cameraman In Business Dies," *Jet*, April 21, 1966, and Booker, *Shocking the Conscience: A Reporter's Account of the Civil Rights Movement*, 62). Additionally, a 2016 *Time* magazine production, "100 Photos: The Most Influential

Images of All Time," credits only David Jackson with the Till death photos. "I was told by the Johnson Archive that all the photos they sent me were taken by Jackson," *Time* producer Paul Moakley said in an e-mail to the author. Withers didn't take credit for any of the death photos in *Pictures Tell The Story* or in key interviews with WKNO-TV and The HistoryMakers digital archive. One possibility for the confusion involves the 1955 pamphlet Withers produced, the "Complete Photo Story of Till Murder Case." It includes one of the death pictures. However, in the foreword to *Pictures Tell The Story*, Brooks Johnson notes the photos in the pamphlet were shot "mostly by Withers." If Withers did shoot any of the death photos, he probably did it independently of the Booker-Jackson visit. He would have had to travel to Chicago, where the teen's body arrived on Friday, September 2, 1955, taken pictures sometime over the weekend while the body was on display, then quickly returned to Memphis. On the morning of Till's September 6, 1955, Chicago funeral, Withers was in Memphis, shooting pictures for the National Baptist Convention there (see Withers photos, *TSD*, September 10, 1955, 1 [bottom of page].

[10] "8-Man Team Covers Till Case Trial," *TSD*, September 24, 1955, 1.

[11] Characterizations of the open racism at the trial are found at: L. Alex Wilson, "Jim Crow Press At Trial; Frisk Newsmen: Picking of Jury Delays Opening," *TSD*, September 24, 1955, 1; Booker, *Shocking the Conscience*, 65–66. See also, HistoryMakers interview, Session 1, tape 2, story 8, Ernest Withers discusses his experience covering the Emmett Till murder trial.

[12] This account of Withers in the courtroom comes from Booker, *Shocking the Conscience*, 74.

[13] See Corbis Images online photo gallery, http://www.corbisimages.com/stock-photo /rights-managed/U1292863INP/mose-wright-testifying?popup=1.

[14] For Withers's accounts of selling the Mose Wright photo see: WKNO-TV, *Waters* interview; Withers et al., *Pictures Tell The Story*, 60.

[15] Ernest Withers and Daniel Wolff, *The Memphis Blues Again: Six Decades of Memphis Music Photographs*, 9.

[16] This account comes from a 1951 statement by Withers in his MPD personnel file, in author's possession.

[17] WKNO-TV, *Brother's Keeper*. See also Withers et al., *Pictures Tell The Story*, 43.

[18] See Ernest C. Withers and Daniel Wolff, *Negro League Baseball*. The book explores the detail of Withers's storied history chronicling baseball in Memphis.

[19] Shelby County property records.

[20] **Edmund Orgill:** "Tells Plan of Action," *TSD*, October 29, 1955, 1. **murdered in a lounge:** "Reward for Slayer of M. Young," and "Where Brutal Murder Occurred," *TSD*, December 24, 1955, 1.

[21] "Baffling Mystery Cloaks Violent Death of 11-Year-Old Boy On Mississippi Farm; Victim of Another Puzzling Death in Mississippi," *TSD*, November 5, 1955, 1.

[22] "Gus Courts, Miss. NAACP Head Tells How He Was Shot Down; Mississippi's Fourth Victim of Violence Escapes Death," *TSD*, December 3, 1955.

[23] Gene Roberts and Hank Klibanoff, *The Race Beat: The Press, the Civil Rights Struggle, and the Awakening of a Nation*, 120. See also Garrow, *Bearing the Cross*, 23–24.

[24] Wilson, "Gives On-Spot Report Of How Montgomery Ended Racial Segregation on Its Buses," *TSD*, December 29, 1956, 1.

[25] WKNO-TV, *Waters* interview.

[26] See "In Montgomery: An Exciting Day For Thousands," *TSD*, December 29, 1956, 1.

Chapter Twelve

[1] Author's interview with Moses Newson, Nov. 4, 2014.

[2] For a characterization of the Little Rock school crisis see Taylor Branch, *Parting the Waters: America in the King Years 1954–63*, 222–24. Regarding the beating of L. Alex Wilson and Eisenhower's use of federal troops see Benjamin Fine, "President Threatens To Use U.S. Troops, Orders Rioters In Little Rock To Desist; Mob Compels 9 Negroes to Leave School; Eisenhower Irate; Says Federal Orders 'Cannot Be Flouted With Impunity,'"*The New York Times*, September 24, 1957, 1; Roberts and Klibanoff, *The Race Beat*, 176–80.

[3] Withers's photo is reproduced in Withers et al., *Pictures Tell The Story*, 66.

[4] FBI report, "James Rufus Foreman aka James Forman," September 6, 1961, "Racial Situation in Fayette County" file (hereafter called FBI Little Rock report), ME-100-3595-Sub A-100A. Pages 6 and 7 of this report discuss Withers's September 28, 1958, visit to the FBI office in Little Rock.

[5] Ibid.

[6] Ibid., 8–9.

[7] Wil Haygood, "The Man From Jet," *The Washington Post*, July 15, 2007. Booker used his rapport with the FBI to get stories like "The Negro in the FBI" (*Ebony*, September 1962), in which Hoover discussed the agency's handful of black agents. Despite his cooperation, Booker didn't always get the protection he desired. He was with two busloads of Freedom Riders when they were viciously attacked in Alabama in May 1961. Kenneth O'Reilly writes in *Racial Matters: The FBI's Secret File on Black America, 1960–1972* that Booker called the FBI's Cartha DeLoach before the activists reached Anniston, Alabama, where one of the buses was firebombed (see 83–84). Agents watched as vigilantes entered the second bus and beat two riders. The FBI "demonstrated a remarkable tolerance for police brutality" as it maintained a "cozy relationship" with segregationist Southern law enforcement (110–14), O'Reilly wrote.

[8] **considered the photographer as a PCI:** FBI identification report, January 6, 1958, released May 15, 2012, pursuant to *The Commercial Appeal*'s litigation and identified as FBI-Withers-886. The report involves a background check performed at headquarters on Withers on behalf of the Memphis office's consideration of him as a PCI.

[9] Newson interview.

[10] In *Racial Matters*, O'Reilly (see 107–08) makes a distinction between movement people who had innocent contacts with the FBI and those who "named names" or who took injurious actions. On one end was Julia Brown, a Cleveland informant who worked covertly with the FBI for nine years and whose testimony in 1962 caused eighteen people to be called before the House Un-American Activities Committee to answer charges that they were Communists. On the other end were pillars of the movement like James Farmer, A. Phillip Randolph, and Andrew Young, who occasionally alerted the FBI to their travel itineraries. "Similarly, John Lewis said the FBI often called Julian Bond at the SNCC offices 'to find out what was going on or should they be notified, that sort of thing,'" O'Reilly reports. Many times, such individuals believed they were merely "informing on themselves"—most often because of the need for protection. Even the radical H. Rap Brown contacted the FBI at times. "When you were down South and something happened you'd call the FBI," he once wrote.

[11] **no records responsive:** See *Memphis Publishing Co. and Marc Perrusquia v. Federal Bureau of Investigation*, case 1:10-cv-01878-ABJ, U.S. District Court for the District of

Columbia. Specifically, see "Defendant's Opposition To Plaintiff's Motion For Summary Judgment and Memorandum In Support of Its Cross-Motion For Summary Judgment," hereafter referred to as "Defendant's Opposition," filed June 15, 2011, Exhibit D: A letter dated July 31, 2008, to Perrusquia from David M. Hardy, section chief of the FBI's record information dissemination section. **"therefore denied . . . The FBI denies":** Plaintiff's "Complaint For Declaratory and Injunctive Relief," filed November 3, 2010, and defendant's Answer, filed December 6, 2010.

[12] Rome and Billy Withers interview aired by WMC-TV Channel 5 on July 15, 2012. During an uncut version of the interview, the brothers indicated the FBI provided some protection to their father who was often out on dangerous news assignments. If agents asked him questions, "it's like an obligation to discuss it," Billy Withers said.

[13] Christine N. Walz and Charles D. Tobin, "The FOIA 'Exclusions' Statute: The Government's License to Lie," *Communications Lawyer*, March 2014. See also, Attorney General's Memorandum on the 1986 Amendments to the Freedom of Information Act, Edwin Meese III, December 1987, http://www.justice.gov/oip/86agmemo.htm. Regarding the (c) (2) exclusion aimed at the "threatened identification of confidential informants," Meese says the provision "contemplates the situation in which a sophisticated requester could try to ferret out an informant in his organization." The exclusions, used for "especially sensitive law enforcement matters," provide complete opaqueness, he said: "In other words, an agency applying an exclusion in response to a FOIA request will respond to the request as if the excluded records did not exist."

[14] See *Memphis Publishing Co. et al. v. FBI*, "Defendant's Opposition," 40. See also, Exhibit 2 of same, "Declaration of Dennis J. Argall," 16.

[15] Ibid., "Defendant's Opposition": Argall deposition, 19; and Exhibit X, Part 1, 12.

[16] Ibid., Memorandum Opinion by Judge Amy Berman Jackson, January 31, 2012, 17.

[17] Ibid., Notice of Filing of Vaughn index, July 2, 2012, 4–7.

[18] Ibid., Notice of filing of Vaughn index, July 2, 2012.

[19] Ibid., Motion to Vacate Order on Motion to Compel, August 2, 2012; Sealed document, In Camera, Ex Parte Declaration of Dr. John F. Fox, Jr., August 2, 2012; Motion for Reconsideration, August 17, 2012; Notice of Appeal to DC Circuit Court, September 28, 2012.

[20] Ibid., status conference, August 28, 2012, 6.

[21] Settlement agreement, February 22, 2013.

Chapter Thirteen

[1] FBI report, "Racial Situation in Tennessee, Fayette and Haywood Counties, Racial Matters," ME-157-184-22 (January 24, 1962), hereafter called FBI Rush report.

[2] Senate Select Committee to Study Governmental Operations with Respect to Intelligence Activities (Church Committee), book II, 175; book III, 449–51, 479–81.

[3] The Justice Department stymied prosecution of suspected subversives in 1956 in the wake of the Junius Scales case. DOJ advised that prosecution under the Smith Act required "an actual plan for a violent revolution." According to the Church Committee, "the FBI kept on investigating 'subversive' organizations 'from an intelligence viewpoint' to appraise their 'strength' and 'dangerousness.'" (Church Committee, book III, 449.)

[4] Withers's eighteen-year tenure as a domestic intelligence informer is a long one in comparison to examples listed by the Church Committee: a woman reported on the Vietnam Veterans Against the War for seventeen months; Ku Klux Klan informant Gary Rowe operated for six years.

[5] FBI report, "West Tennessee Voters Project" file, ME-157-646-180 (September 3, 1965) and 157-646-1A-3 (August 5, 1965). Lawrence told Sullivan a third person in the picture was Henry Brim Balser, a Cornell student who, he said, had participated in an antiwar demonstration at the school's spring 1965 ROTC ceremony.

[6] Author interview with Daniel S. Beagle, May 14, 2015.

[7] By some accounts, no black person had voted in Haywood County since Reconstruction. See William Bennett, "Negroes Claim Vote Prevented," *CA*, July 29, 1959. The account of the government's litigation in Fayette and Haywood counties comes from multiple sources but is perhaps best summarized in two documents by Justice Department lawyer J. Harold Flannery. The papers are both found in the University of Memphis Special Collections' Tent City Collection. The first, a March 14, 1960, memo to Henry Putzel, Jr., chief of DOJ's voting and elections section, is found in box 10 folder 16; the other, a February 26, 1963, letter to James R. Prickett, is in box 10 folder 26. See also, "Evictions Case Is Legal First," *CA*, December 16, 1960; and *United States of America v. Herbert Atkeison et al.*, civil action 4131, filed December 14, 1960, in the Western District of Tennessee.

[8] Simeon Booker, "Negroes Who Live In Tents Because They Voted," *Jet*, December 29, 1960, 12–16.

[9] "Cold War in Fayette County," *Ebony*, September 1960, 27–34. Also: "Tent City Negroes Hail Injunctions, Say They'll Not Return to Fields," *Washington Post*, December 31, 1960; and "Negroes Cheered By Eviction Curb," *The New York Times*, December 31, 1960.

[10] O'Reilly, *Racial Matters*, 51–53.

[11] In the wake of the 1954 *Brown v. Board of Education* decision, Lawrence's duties began shifting. He received a week of civil rights law training in 1956 in Washington. (Lawrence personnel file, January 31, 1956, memo.) As the civil rights period deepened, the agent took on dual roles, investigating civil rights activists and the people who antagonized them.

[12] Details of Lawrence's participation in Fayette County civil rights investigations are found in FBI reports in UM's Tent City Collection, box 10 folder 1. For the "hog" investigation, see box 10 folder 6.

[13] FBI memo (NW), "Re: Robert Kerr Archbell et al.; Currie Porter Boyd et al.—Victims; Civil rights, election laws," (December 23, 1960) located in box 10 folder 16, Tent City Collection. Also, Trezzvant W. Anderson, "Whites Tell of Depopulating Plan: U.S. Lays 'Squeeze Plot' Open Before Whole World," *Pittsburgh Courier*, December 31, 1960, 3.

[14] FBI report, James Cogshell file, ME-100-3774-4 (January 31, 1961).

[15] FBI reports, 100-3774-4 (January 31, 1961) and ME-100-3774-6 (February 9, 1961).

[16] Ibid.

[17] The account of Lawrence's background check on Withers comes from FBI memo, "Ernest Columbus Withers, PCI" (February 7, 1961), released May 15, 2012, pursuant to *The Commercial Appeal*'s litigation and identified as FBI-Withers-893 and 894.

[18] Withers's evolving informant status is seen over a wide range of records released by the FBI. Some of the early files (see, for example, "Racial Situation in Tennessee, Fayette and Haywood Counties, Racial Matters," ME 157-184) list him alternately as a Potential Confidential Informant or a Confidential Informant. The PCI label disappeared from reports in March 1963. Between 1963 and 1967 he largely was listed as a CS— Confidential Source. Thereafter, he is listed as Confidential Informant ME 338-R. Retired FBI agent Bob Campbell told the author two years was a long time to be kept in PCI status; generally, that involves a matter of months. The move likely guaranteed Lawrence

some freedom. Confidential informants are overseen in Washington, but PCIs are not, Campbell said.

[19] The former first lady wrote about Freedom Village in her news column carried by many papers on January 4, 1961, deploring the violence and intimidation faced by evicted sharecroppers.

[20] WMC-TV Channel 5 interview with Joshua "Billy" Withers, July 15, 2012, uncut version.

[21] Another indicator of Withers's possible initial role as a criminal informant between 1958 and 1961 involves the notation, "Re Serial 60," at the top of Lawrence's February 7, 1961, background report on Withers. In releasing records to *The Commercial Appeal*, the FBI redacted serial numbers that would indicate the volume of reports in Withers's informant file. It appears censors missed this redaction. If in fact "Serial 60" refers to a report in Withers's "137" file, it indicates he played a role as a criminal informant in sixty different reports between January 1958 and February 1961.

Chapter Fourteen

[1] James Forman, *The Making of Black Revolutionaries*, 196–98; also Raymond Arsenault, *Freedom Riders: 1961 and the Struggle for Racial Justice*, 409–10.

[2] FBI Little Rock report, 1–10.

[3] FBI Little Rock report, 2–3.

[4] The account of Withers's March 16, 1961, meeting with Lawrence comes from FBI Little Rock report, 2–3. Various accounts of McFerren's dispute with rival leaders include: "Fayette Vote Founder 'Ordered' To Resign," *The Tennessean*, January 28, 1961; and "Negro Factions Hurl Charges," *CA*, January 31, 1961.

[5] See "37 Groups Are Scheduled To See Filmstrip on Reds," *CA*, January 8, 1961, III, 7. Also, "Four-Hour Anti-Red Show To Attract 6,000 Today," *CA*, December 4, 1960, 1; and "Mock A-Bomb Hits Memphis," *CA*, April 29, 1961, 17.

[6] This item appeared in the weekly column, "Left Side Down Front, *TSD*, August 19, 1961, 3.

[7] Forman, *Black Revolutionaries*, 116–30.

[8] Branch, *At Canaan's Edge*, 121–22.

[9] FBI report, "Negro Sit-down Strikes" file, ME-157-38-350 (December 8, 1961). Also, Forman file (January 8, 1962). Withers's early relationship with the FBI was built on the foundation of photographs he provided. Early reports make reference to Withers selling the agency photos of activists like Freedom Rider Daniel Horne and CORE's Eric Weinberger.

[10] Forman, *Black Revolutionaries*, 143–50. The summation of the Freedom Rider movement is taken generally from Arsenault, *Freedom Riders*, 140–327.

[11] Forman, *Black Revolutionaries*, 158–63. Re: the Kissing Case see Timothy B. Tyson, "Robert F. Williams, 'Black Power,' and the Roots of the African American Struggle," *Journal of American History*, September 1998, 551–56.

[12] Forman, *Black Revolutionaries*, 163, 174.

Chapter Fifteen

[1] "Tables Turned," *TSD*, July 8, 1961. See also, FBI memo, "Congress on Racial Equality" file, ME-100-3572-57 (July 6, 1961).

[2] HistoryMakers interview, Session 1, tape 3, story 5, Ernest Withers describes dangerous moments photographing the civil rights movement.

[3] FBI Memphis office's Freedom Riders' file, "Freebus-Racial Matters," 157-140-389&405.

Though most Freedom Riders traveled to Jackson, Mississippi, this bus traveled to Little Rock, Arkansas, to test integration at public accommodations along a westerly route.

[4] Ibid. Because there were no incidents in Memphis it is difficult to know if police and FBI agents who followed the Freedom Riders in their taxicab from the bus station to Owen College intended to protect them. Nonetheless, for years, activists passing through the Memphis area contended that police and the FBI were quick to investigate them but seldom offered protection. These reports show FBI agents spoke with the Freedom Rider activists about their intentions but there is no reference to offers of protection.

[5] FBI report, 157-140-444 (July 28, 1961). This form FD-209 reports Withers was paid $15 for the Freedom Riders intel and was also contacted regarding the Nation of Islam and an unknown elections law case. The report, handwritten in Lawrence's distinctive scrawl, notes Withers's coverage involved "general Negro criminal and racial matters."

[6] FBI evidence receipts, ME 105-160-1A24 to 1A28 (August 16, 1961).

[7] Ibid. The "S" in ME 170-S designates a security informant.

[8] There is a five-month gap in the Withers settlement records between February and July 1961, in which Lawrence evidently filed no reports referencing Withers, though that is dubious; in a later report, the author located a reference to a March 16, 1961, meeting between the agent and informant. In July, a flurry of reports come. In the first two, Withers is listed as a "former PCI." After that he appears as just PCI. From then into the mid-1960s, the agent and the photographer met or spoke regularly, generally at least once and often several times a month, records indicate. There are some additional gaps in the records, a couple as long as three months.

[9] Lawrence testimony, HSCA, Vol. VI, 541.

[10] FBI Little Rock report, 1.

[11] **press credentials:** Forman's attempt to get a press card is noted in the FBI Little Rock report, 1, and *TSD*, August 19, 1961, 3. **crisscross directory:** Details of the phone number and subsequent interview of the Orange Mound man come from FBI Little Rock report, 2, and Forman file, 100-443566-X2.

[12] FBI Little Rock report and Forman file, 100-443566-X5.

[13] FBI memos. **lodging . . . loafing:** 100-3572-61 (August 16, 1961). **Opportunist:** CORE file, 100-3572-70&71 (August 1, 1961).

[14] Details of Withers's August 14, 1961, conversation with Lawrence are found in FBI Little Rock report, 1–2, 5.

[15] Arsenault, *Freedom Riders*, 409.

[16] The account in these paragraphs of the 1961 Monroe race riot comes from a variety of sources, including "Racial Violence Stirs Up Mob In Carolina City," *CA*, August 28, 1961, 16. Also, Forman, *Black Revolutionaries*, 190–202; and Arsenault, *Freedom Riders*, 409–12.

[17] Forman, *Black Revolutionaries*, 353.

[18] Arsenault, *Freedom Riders*, 414.

[19] Tyson, "Robert F. Williams," 565, 569–70. The image of Rosa Parks as a quiet, passive seamstress has been turned on its ear in recent years. Danielle L. McGuire writes about Parks's militant battle against interracial rape in *At the Dark End of the Street: Black Women, Rape, and Resistance—a New History of the Civil Rights Movement from Rosa Parks to the Rise of Black Power*. Parks's biographer Jeanne Theoharis also writes about Parks's affinity for Malcolm X—her "personal hero"—and her belief in the moral right to self-defense.

Chapter Sixteen

[1] **Bromberg shooting and Rush beating:** Arsenault, *Freedom Riders*, 408–10. Also, "Integrationist's Letter Says He Felt Like Escaped Slave," *The High Point Enterprise*, August 31, 1961, 11C. **Rush and Bromberg in Haywood County:** FBI memo, Memphis file 157-184-46&47 (February 12, 1962).

[2] Author interview with Heath Rush, May 18, 2015. Their arrest in the train station marked the start of a forty-day ordeal behind bars. Most of it was spent at Parchman, Mississippi's infamous maximum-security prison. Sleeping without mattresses and engaged in a hunger strike, they made the best of it by singing. They regaled guards with a flow of movement standards, "Gospel Plow," "Keep Your Eyes on the Prize," "Oh Freedom," and "We Shall Not Be Moved."

[3] **"crack-pot":** FBI memo, "Racial Situation in Haywood County," file, 100-3595-Sub B-35&36 (November 15, 1963), 5. **Withers would follow:** Records show Withers relayed information about the activist nine times between 1962 and 1969.

[4] FBI Rush report.

[5] FBI Airtel, Memphis to HQ, ME 157-184-32 (January 26, 1962).

[6] Rush interview.

[7] **retirement:** "Honored," *TSD*, February 25, 1961. **drill team:** "Memphis Man Was Part Of Award-Winning Drills," *TSD*, February 22, 1964.

[8] **helped hide:** HistoryMakers interview, Session 1, tape 3, story 4, Ernest Withers remembers James Meredith's controversial attendance at the University of Mississippi. See also, Withers et al., *Pictures Tell The Story*, 74–75. **took pictures:** Larry Still, "Negro Tells His Experiences at 'Ole Miss': Ex-GI Hopes His Actions Changed Course of Miss. History," *Jet*, October 4, 1962, 14–21. **followed a . . . caravan:** *Jet* and HistoryMakers interview. **military helicopter:** Withers et al., *Pictures Tell The Story*, 76. For a good description of the riots, see Charles W. Eagles, *The Price of Defiance: James Meredith and the Integration of Ole Miss*, 303–53. Meredith was denied entrance three times that fall. Withers's account of following a caravan down from Memphis is consistent with Meredith's first rejection on September 20, 1962.

[9] HistoryMakers interview.

[10] FBI memos. **mosque:** 105-160-1A-60 (April 3, 1964). **Handpicked:** 100-3774-19 (December 20, 1963). **car tag:** ME 100-3774-24 (June 10, 1964). **restaurant:** 100-3774-26 (October 12, 1964). **Muhammad Speaks:** 100-3774-43 (July 8, 1965) and 100-3774-17 (December 10, 1962). **Doodad's:** 105-160-1A-57 and 100-3774-24 (April 23, 1964). **McFerren:** 100-3774-27 (October 15, 1964).

[11] 100-3774-24.

[12] FBI memos. **back in Memphis . . . particularly quiet:** 100-3572-84 (November 7, 1961). **provided the names . . . where it was printed:** 100-3572-159 (September 11, 1963). **back-bite:** the FBI's "Desegregation of Employment and Public Service Facilities" file, 157-284-168 (November 18, 1964).

[13] 100-3774-24.

[14] FBI memo 100-3572-211 (November 2, 1964).

[15] Author interview with Mark Stansbury, August 13, 2017.

[16] "Withers Is Beaten, Jailed In Jackson; Snatched By Cops in Mississippi," *The Memphis World*, June 22, 1963.

[17] See FBI memo, ME-157-184-46&47 (February 12, 1962) for some details Lawrence

swapped with Brownsville police, the Haywood County Sheriff's Office, the Tennessee Highway Patrol, and the army's 111th Military Intelligence Group.

[18] Former Memphis NAACP executive secretary Maxine Smith told the author in 2009 that she collaborated with the FBI because she saw it as a safe alternative to the brutal Memphis Police Department.

[19] Records show Weinberger was first arrested March 5, 1962, for investigation of burglarizing a fruit stand and released the same day. Three days later he was arrested for speeding. He spent the next two weeks in jail for refusing to pay his fine on grounds his arrest constituted "official harassment due to his work in this racially tense area." Local civil rights leaders contended Weinberger was beaten in jail. A year later he was arrested for disorderly conduct and assault and battery for allegedly kicking sheriff's deputy George Sullivan as police routed demonstrators from Brownsville's business district. The charges appear to be wholly unsubstantiated. A final entry in the 1963 Haywood County Circuit Court docket made as Weinberger was set to stand trial says the case "is hereby retired from the dockets . . . upon motion of the Attorney General and upon payment of the costs by the defendant with leave to reinstate at any time." Records indicate he never returned to Haywood County.

[20] FBI memo, ME 157-184-65 and 66 (March 9, 1962).

[21] Ibid.

[22] See FBI Memphis file 157-184, serials 65, 66, 79, 82, 83, and 1A7. Also, 100-3595-Sub B-35&36, 4. Weinberger's arrest history is found in Haywood County General Sessions and Circuit Court dockets 1962 and 1963. **shot photos:** *TSD*, April 7, 1962, 3 and 10.

[23] FBI report, 100-3595-Sub B-35&36 (November 15, 1963).

[24] Ibid.

[25] 227 F. Supp. 556 (1964) *James A. Dombrowski et al. v. James H. Pfister, Individually, Etc., et al.* Civ. A. No. 14019, United States District Court, Eastern District of Louisiana, New Orleans Division (February 20, 1964).

[26] Federal appeals court Judge John Minor Wisdom opened the door for the dismissal in state court when he opined that "under the pretext of protecting itself from subversion" the state of Louisiana had "harassed and humiliated" the men "solely because their activities in promoting civil rights for Negroes conflict with the state's steel-hard policy of segregation." Despite the dismissal, Dombrowski and his colleagues later came into jeopardy again when a federal court declined to invalidate the Louisiana statute. Dombrowski appealed to the Supreme Court, which in 1965 found the Louisiana law overly broad. It halted prosecution and ordered the return of personal papers seized in the raids.

[27] 100-3595-Sub B-35&36.

[28] Memos in Lawrence's personnel file echo his daughter's recollections. An annual efficiency report dated April 14, 1948, cites the agent's "great personal and official interest in Communist activities," noting his "considerable research both during and after office hours." On April 5, 1952, a supervisor noted that Lawrence "does much investigating after hours. He is definitely not the clock-watching type."

[29] See FBI memo, "DETCOM—Searches," HQ file100-356062-28-6&7 (NW). These serials include two memos from Memphis to Washington dated August 23 and September 21, 1950, and a September 21 reply with instructions to include Davis's home in a Master Search Warrant. Though the names of FBI agents are redacted in official reports documenting the long-running surveillance of Davis, censors failed to remove Lawrence's initials, WHL, on two critical documents. One pinpoints Lawrence as the author of

an August 23, 1950, memo that discusses details of the surveillance and recommends searches of Davis's midtown Memphis apartment and a labor hall downtown where agents believed the boatman was reproducing communist propaganda with a mimeograph machine.

[30] FBI memo, "William Edward Davis . . . Loyalty of Government Employees," HQ file 121-12712 (NW). Though not a government employee, Davis was investigated as a deckhand for the Inland Waterways Corporation, administered by the Department of Commerce.

[31] *Communism in the Mid-South: Hearings Before the Subcommittee to Investigate the Administration of the Internal Security Act and Other Internal Security Laws of the Committee on the Judiciary,* United States Senate (October 28 and 29, 1957), 62–65.

[32] FBI memo, "William E. Davis, Security Matter—C," HQ file 100-347485 (NW), serials 20 and 31. Reference to the Civil Rights Congress is found in serial 8, p. 5 of an April 21, 1948, report from Memphis to Washington. See also, Davis Loyalty Probe, serials 16 and 22.

[33] Author interview with H. T. Lockard, Janauary 20, 2010. See also, Michael K. Honey, *Southern Labor and Black Civil Rights: Organizing Memphis Workers,* 272.

[34] See COINTELPRO-CPUSA, , ME 100-3-104-28-1 (September 10, 1964). Lawrence wrote in the memo that Scales's arrest led "CP leadership in New York to suspicion a 'leak' within the CP in Memphis," causing the Communist Party's Southern leadership to sever ties with its Memphis unit.

[35] Lawrence contemplated moving Withers to a Confidential Source-Racial status as early as November 1961, noting that "the bulk of the information" the photographer furnished "is racial in nature." See FBI memo 100-3572-84 (November 7, 1961). Withers began appearing in reports as a confidential source in March 1963. See FBI memo 157-184-92 (March 25, 1963). A good definition is found in the comptroller general's February 24, 1976, report to the House Judiciary Committee, "FBI Domestic Intelligence Operations—Their Purpose and Scope: Issues That Need to be Resolved," 105. A confidential source is defined as an anonymous source providing information in a given situation or on a continuing basis, including "bankers, telephone company employees, landlords, and police officers." These sources don't "seek out information but merely obtain and furnish information readily available to them."

[36] **Yacub:** Claude Andrew Clegg III, *An Original Man: The Life and Times of Elijah Muhammad,* 50–2. **FBI report:** Albany to HQ, "Development of Racial Informants in the Nation of Islam," copied to the "Memphis NOI" file, 105-160-6523 (October 2, 1969). **"Deeply racist":** Southern Poverty Law Center website, https://www.splcenter.org/fighting-hate/extremist-files/group/nation-islam.

[37] Clegg writes that values promoted by the Nation included group study of the Bible and the Koran, gymnastics and fitness, and black self-help. See Clegg, *The Life and Times of Elijah Muhammad,* 101.

[38] Interview with author, March 27, 2014.

[39] Ibid.

Chapter Seventeen

[1] The characterization of Vicki Gabriner's early involvement in the civil rights movement is largely taken from Wisconsin Historical Society, Freedom Summer Collection, Interview of Vicki Gabriner, Madison, Wisconsin, May 22, 1966; Audio 840.

[2] References for violence against the activists include: "Second Visit By Rights Workers

Likely Saturday," *The Fayette Falcon*, May 6, 1965, 1; Tim Hall interview with author, June 25, 2015; Memphis FBI file, Debbie Rib, 100-4141-1 (May 12, 1965).

³ Withers's connection to the activists is evidenced in several reports, including "Sally Batista, SM-C," ME-157-646-294 (July 13, 1966). The report describes how the photographer-informant provided assistance after a car driven by activist Tim Hall had broken down. Withers allowed Hall and a companion to spend the night in his photography studio. Additionally, a female, Sally Batista of San Francisco, spent the night with Withers and his wife, Dorothy, and their children, the report says. Batista told Withers she worked in the SNCC office in San Francisco. Agent Lawrence contacted the FBI's San Francisco office to search its indices and contact security sources to determine any possibly subversive connections.

⁴ For the account of Vicki Gabriner's letter to Withers, who in turn gave it to the FBI, see FBI report, "Vicki Gabriner, SM-C," ME-157-646-253 (February 7, 1966).

⁵ For Lawrence's ninety-five-page memo, see Memphis FBI file, "West Tennessee Voters Project," 157-646, serial 185 (September 10, 1965).

⁶ Ibid. Additional details about Lawrence's interest in sexual activity within the group is found in a memo, "West Tennessee Voters' Project," ME 157-646-240 (November 19, 1965).

⁷ Details of Lawrence's meeting with Withers are found in Memphis FBI file, "W.E.B. DuBois Clubs of America", ME 100-3991-56 (May 21, 1965).

⁸ **"changing times":** Withers and Wolff, *The Memphis Blues Again*, 15.

⁹ FBI reports. **donations to . . . Black Panthers:** Informant report, "Black Arcade" file, 157-2112-96 (November 7, 1972). According to the report, Al Bell donated $1,000; Isaac Hayes, $1,000; and Al Green, $500. The money went to a Black Panther survival program to give groceries to the needy, Withers said. **Communist Party:** Informant report, Kathy Roop file, 100-4708-333 (April 19, 1971). Withers said a Stax executive gave $250 to the Young Workers Liberation League, an arm of the Communist Party. **John Gary Williams:** Memo, "Invaders" file, 157-1067-614 (November 22, 1968). Withers said Bell has been a strong supporter of Williams, a member of the militant Invaders and a member of the "Mad Lads" singing group. **Black Arcade:** Informant report, 157-2112-90 (September 6, 1972). **"Hoover . . . a homosexual":** Memo, "MURKIN" file, 44-1987-sub-M-494 (April 7, 1969).

¹⁰ FBI version of photo: ME 157-646-1A-4. Public version: "Smith Leads Marchers in Tipton," *TSD*, July 31, 1965, 1.

¹¹ **Jenkins:** FBI reports, ME-157-646-185&86, 7 (September 10, 1965), and ME-157-646-240 (November 19, 1965). **boycott:** see George Sutton, "Fayette Schools May Be Closed," *CA*, (August 3, 1965).

¹² Author interview with Jerry Jenkins, June 29, 2015.

¹³ **Bob Gabriner:** FBI evidence slip, ME 157-646-1A-3 (August 5, 1965). Returning from a news assignment, Withers delivered twenty-seven photographic prints to Lawrence. **Vicki, beaming:** Ibid. **ties to the Bradens:** 157-646-185&86, pp. 42–43. **Henry Balser:** FBI evidence slip ME 157-646-1A-3. **Deborah Rib:** FBI evidence slips, 157-646-1A-2 (August 5, 1965) and 100-4141-1A-3 (August 23, 1965).

¹⁴ FBI memos. **repulsive personality:** 100-4141-1 (May 12, 1965). **Malcolm X . . . Black Muslims:** 157-646-185&86, 15. **"well aware" of . . . "open inter-racial sex":** Ibid.

¹⁵ **Sullivan's attention:** 157-646-180. **couldn't prosecute:** Author interview with Athan Theoharis, October 23, 2016.

¹⁶ Author interview with Danny Beagle, December 29, 2015.

¹⁷ Theoharis interview.

[18] July 27, 1965, letter from Dowd to Stokes, Tent City Collection, box 14 folder 33.

[19] FBI report, 100-4141-1 (May 12, 1965).

[20] Ibid.

[21] **first . . . since Reconstruction:** "New Court Takes Seats Monday in October Session," *The Fayette Falcon* (October 20, 1966). **dutifully reported:** FBI memo, 157-646-331 (August 24, 1966).

Chapter Eighteen

[1] FBI report, "Mid-South Citizens Dissatisfied with United States Policies in Vietnam" file, ME 100-4285-42 (May 26, 1966).

[2] Author interview with James Lawson, August 26, 2015.

[3] **outed the trio:** Garrow, *The FBI and Martin Luther King, Jr.*, 190, 295–96. It's believed the Smiths and Turner were recruited through Hoover's "Liaison With Groups Sponsoring Integration" program.

[4] Author interview with Maxine Smith, June 18, 2009.

[5] **Thurgood Marshall cooperated:** See Neil A. Lewis, "Files Say Justice Marshall Aided F.B.I. in 50's," *The New York Times*, December 4, 1996. Also, David T. Beito and Linda Royster Beito, *Black Maverick: T.R.M. Howard's Fight for Civil Rights and Economic Power*, 132–34, 160–63. The Beitos suggest Marshall's motives included animus toward rights leader T.R.M. Howard, a rival. **Roy Wilkins cooperated:** David J. Garrow, "FBI Political Harassment and FBI Historiography: Analyzing Informants and Measuring the Effects," *The Public Historian*, fall 1988, 12–13. O'Reilly writes in *Racial Matters* that the NAACP's cooperation in the 1950s stemmed largely from McCarthyism. The organization created loyalty oaths and purged itself to keep the McCarthyites at bay (see 104), he writes.

[6] **do-gooders and dupes:** Garrow, "FBI Political Harassment," 11. **Memphis libraries:** G. Wayne Dowdy, *Crusades For Freedom: Memphis and the Political Transformation of the American South*, 61–63. **Memphis State:** Despite holding a master's degree from prestigious Middlebury College, Maxine Smith was denied entrance to a graduate program at Memphis State. Her attempt paved the way for the school's first black students, the "Memphis State Eight," in 1959.

[7] Vasco Smith's value to the FBI is seen in a February 23, 1968, memo to HQ, ME-157-1092-16 (NW). The report cites two sources, Withers and Vasco Smith, who essentially say the same thing: the sanitation strike was suffering from a "power struggle" between the conservative NAACP and the more militant Unity League, each trying to "outdo the other" to become the spokesman for the black workers.

[8] FBI memo, "NAACP" file, ME-100-662-809 (July 12, 1963). See also Lawrence's memo, 100-4105-7 (January 18, 1965). An informer told Lawrence "the most difficult phase of the local Negro desegregation movement to control in Memphis is the youth," who are "primarily led and counselled" by Lawson, "a close associate of the more militant section of Negro movement and is a consultant for Rev. Martin Luther King's SCLC and of the Student Non-Violent Coordinating Committee."

[9] FBI memos. **"advocate of non-violence":** "Racial Situation in Tennessee" file, 100-3595-978 (July 17, 1962). **back and forth:** "Communist Influence in the National Baptist Convention USA" file, 100-3824-8&9 (May 15, 1963). Lawrence quotes Withers as saying that "many thinking Negroes" believed King had ulterior motives; that he and his followers were leveraging the tension in that city to raise the preacher's clout within the National Baptist Convention, USA. **sympathy marches:** 100-662-809.

[10] Author interview.

[11] **satyagraha:** James Lawson oral history, University of Memphis Special Collections (UMSC), Sanitation Strike Collection (SSC), box 22 folder 131, Series IV, 2–3.

[12] Author interview with Lawson, January 17, 2013.

[13] Ibid.

[14] **workshops:** UMSC, SSC, box 22 folder 128, tape V, 9–14. **traveling to:** UMSC, SSC, box 22 folder 134, tape II, series VI, 3.

[15] See Branch, *Parting the Waters*, 272–75, and Arsenault, *Freedom Riders*, 84–87. Also, Lawson interview with International Center on Nonviolent Conflict, "Lunch Counter Sit-Ins in Nashville," June 23, 2009.

[16] Ibid.

[17] **"Nonviolent army":** Garrow, *Bearing the Cross*, 168–69. **Wilkins fired off:** Branch, *Parting the Waters*, 297–99.

[18] For details on Lawson's arrest see Branch, *Parting the Waters*, 482–85. Also, Lawson interview and UMSC, SSC, box 22 folder 134; and "Jailed Freedom Rider is BW Grad," *Cleveland Press*, May 25, 1961.

[19] FBI memo, in Memphis file "Racial Situation in Tennessee," 100-3595-978 (July 17, 1962).

[20] FBI memos. **been in Birmingham:** 100-3824-8&9. **secured a letter:** ME 100-3595-Sub B-35. **New York couple:** "NAACP" file, 100-662-840 (April 8, 1964). Withers said he received a letter from New York journalist Jimmy Hicks informing him that wealthy real estate investor Louis Smadbeck and his wife, Justine, a writer for the *Amsterdam News*, would be visiting. Withers introduced the couple to Lawson and NAACP leader Jesse Turner. Lawson told the couple, he'd been "conducting classes in nonviolent demonstration tactics each week end at his church," Lawrence wrote after speaking with Withers. **meetings at Lawson's church:** "Communist Influence in Racial Matters" file, 100-4070-8 (December 7, 1964). A secret source—a member of Lawson's church—told Lawrence he didn't believe Braden had come to the meeting. Withers, too, said he wasn't at the meeting but learned Braden apparently wasn't with Vivian.

[21] FBI memo, 157-646-277 (June 9, 1966).

[22] Lawrence testimony, HSCA, Vol. VI, 541.

[23] FBI memo, "Desegregation of Employment and Public Service Facilities" file, ME-157-284-329 (October 22, 1965).

[24] Author interview, August 26, 2015.

[25] For an explanation of confidential sources, see Report to the House Committee on the Judiciary By the Comptroller General of the United States: FBI Domestic Intelligence Operations—Their Purpose and Scope: Issues That Need to be Resolved (February 24, 1976), 105.

[26] Withers et al., *Pictures Tell The Story*, 82.

[27] FBI memos. **"inferiority complex":** 100-662-809 (July 12, 1963). **"firmly entrenched":** 157-284-168 (November 18, 1964).

[28] **sit-ins:** Memphis Public Library Special Collections, Maxine Smith Collection, NAACP executive board minutes, box 3 folder 3: April 5, 1960, meeting. According to the minutes, board member W. C. Patton "suggested that someone talk with the students who have taken part in the Sit-ins, and advise them that one time at the Library was sufficient for a suit, and another visit is not necessary." The NAACP was more firmly behind sit-in demonstrations in 1961 at downtown restaurants and lunch counters. (See Dowdy, *Crusades For Freedom*, 80.) **school segregation:** Dowdy, *Crusades*, 81–82.

[29] FBI memo, ME-100-662-815 (August 20, 1963).
[30] Ibid., ME-157-646-261 (April 13, 1966).
[31] Ibid., 100-662-1029&1030 (July 1, 1966), 4.
[32] For details of the Vietnam trip see Branch, *At Canaan's Edge*, 263–64 and 841. Also, Mary Hershberger, *Traveling to Vietnam: American Peace Activists and the War*, 16–21.
[33] ME-157-284-329.
[34] FBI memo, ME-157-646-261 (April 13, 1966).

Chapter Nineteen

[1] FBI memo, "National Coordinating Committee to End the War in Vietnam" file, 100-4135-38 (November 17, 1965).
[2] **"God's hands":** "Joking and Laughing Stops When Troop Plane Arrives in Vietnam," *TSD*, March 30, 1968, 1. **rejoiced:** "Welcome Home," *TSD*, March 8, 1969, 1.
[3] **constable:** "Ernest Withers Offers For Constable Post," *TSD*, June 25, 1966, 1. **Running ads:** *TSD*, July 15, 1966, 11. **Tri-State Defender:** "Three Good Men Better Than One," *TSD*, August 6, 1966. **Press-Scimitar endorsement:** "Ernest C. Withers," *MPS*, July 29, 1966, 6. **Lincoln League and . . . Unity League:** "Withers and Backers," *TSD*, June 30, 1966.
[4] "Ernest C. Withers," *MPS*, July 29, 1966, 6.
[5] K. W. Cook, "Pryor, Halle, Orgill Lead Court Vote," *CA*, August 5, 1966, 1. Three seats were up for grabs in the 2nd District. The article noted Turner was among the top three vote-getters.
[6] FBI memo, *Logos* file, 100-4284-117 (June 2, 1966).
[7] FBI memo, Memphis to HQ, "Demonstrations protesting U.S. Policy in Vietnam" file, 100-4491-14&15 (June 22, 1967). More details on Withers's reporting on Morrison are found in 100-4285-77&83.
[8] Details on Bass's parade permit and the FBI funneling the information to Memphis State are found in FBI memo, 100-4285-1 (March 8, 1966).
[9] **"boom!—he was fired":** Author interview with Joella Morrison, April 12, 2016. **letter of dismissal:** June 10, 1967, dismissal letter from William B. Brewer, acting chairman of Department of Modern Languages, in Morrison's Memphis State personnel file. The school's conservative administration, already perturbed by Morrison's quirky habits and alleged womanizing, perceived him and Bass as radicals too close to elements like *Logos*, which had caused Memphis State so much negative publicity the year before. In short, they were troublemakers. The professors' contracts weren't renewed for the 1967–1968 school year, and both left—Bass for Tulane and Morrison for the University of North Carolina at Greensboro.
[10] **bomber pilot:** Sarah Lawrance, "Lt. Potts, Back From Italy, Tells How Sea Saved Him," *MPS*, March 9, 1944. **"fast":** "Fast For Peace Begins In City," *MPS*, February 8, 1967. An example of the various files Lawrence kept related to Potts is found in an FBI memo, Memphis file on "Clergy and Laymen Concerned About Vietnam," 100-4452-1 (March 13, 1967). The copy list at the bottom shows the report was copied to files on Potts (file No. 100-2750), his wife, Haleen (100-2753), the Unitarian Universalist Fellowship of Memphis (100-4361), and the Spring Mobilization Committee (105-1053), among others. In the FBI's file system, 100 is the classification for domestic security or subversive matters; 105 involved a range of foreign intelligence, alien communist, and internal security matters.
[11] FBI report, 100-4285-77 (April 19, 1967), 6. Also serial 84, 4.
[12] **coffee:** FBI memo, 100-4285-83, p. 2. **Handy Park:** FBI memo, May 5, 1967, 100-4285-

84&85. **WDIA debate:** 100-4452-1, p. 12. Potts's son, Clifton, told the author in a July 26, 2017, interview he didn't know why his parents left Memphis but said the couple had been harassed by the FBI in Tennessee and California.

[13] Author interview with Joella Morrison, April 12, 2016.

[14] See serials 42 and 43 dated August 15, 1969, in the Memphis office file, "Draft Resistance Union of Memphis," 100-4630.

[15] Paul G. Chevigny, "Politics and Law in the Control of Local Surveillance," *Cornell Law Review*, April 1984, 736–37.

[16] Summary released September 14, 1978, by the American Civil Liberties Union on the settlement of its lawsuit to disband MPD's Domestic Intelligence Unit.

[17] Ibid.

[18] See *Chan Kendrick, Mike Honey and the American Civil Liberties Union of West Tennessee v. Mayor Wyeth Chandler and Police Chief W.O. Crumby, Capt. P. T. Ryan and Deputy Chief George N. Hutchison*, U.S. District Court for Western Tennessee (September 20, 1976). Among allegations, ACLU attorneys Bruce S. Kramer, Jack D. Novik, and Melvin L. Wulf contended MPD had trampled on the First Amendment, which guarantees the right to free speech and to peaceably assemble, and the Fourth Amendment, protecting against unwarranted search and seizure. Critically, the lawyers argued that MPD's actions had a "chilling effect" on the exercise of these cherished American rights: in essence, the city's spy apparatus, which had targeted supposed un-American activity, was itself un-American. "By instilling fear" through the collection of personal information that served no lawful purpose or legitimate criminal investigation, MPD had "cast a pall upon constitutionally protected political activity," deterring individuals' "rights to express their political beliefs, to dissent from government policies, to advocate unpopular or controversial ideas, to exercise their freedom of association and the freedom of the press," the lawyers argued.

[19] Details on Arkin's link to Lawrence and his sharing information with the FBI are from Arkin's August 11, 1977, deposition in *Kendrick et al. v. Chandler et al.*, 365, 489–98. Reference to the bowling squad is from author interviews with Arkin, September 12, 1997, and longtime FBI secretary Betty Norworth, September 2010.

[20] MPD personnel file of Byron Gene Townsend. Arkin deposition, 418–20. Undated 2010 author interview with Townsend's brother, Danny Townsend.

[21] Weiler, "Police Order Burning of File on Vietnam War Protestor," *CA*, Sept. 8, 1976.

[22] "Counterintelligence Program-New Left," Memphis file, 100-449698, serials 1–13. See also James Kirkpatrick Davis, *Assault on the Left: The FBI and the Sixties Antiwar Movement*, 8.

[23] Author interview with John T. Fisher, August 2010. According to the Church Committee, COINTELPRO had three purposes: protecting national security, preventing violence, and maintaining existing social and political order (see Church Committee, book III, 5–7).

[24] **"interview program":** "Counterintelligence Program-Black Nationalist-Hate Groups," 100-448006, memos (April 22 and May 22, 1968). **"every mailbox":** Davis, *Assault on the Left*, 8.

[25] Withers's photos are found in FBI file, "Laura Calvert Ingram," 100-4593, serials 1A-2 and 1A-5. Some details on Ingram's interactions with Black Power activists are found in Louis Clifford Taylor file, memo, 100-4575-17 (January 16., 1968).

[26] Author interview with Laura Ingram, February 27, 2016.

[27] See 100-449698-2.

Chapter Twenty

[1] FBI file on Kathy Roop Hunninen, ME-100-4708. Per the Withers settlement, the government released ten photos the photographer shot of Hunninen. Reports reference another forty-two photos.

[2] FBI memos. **support for . . . Angela Davis:** 100-4481-216 (March 1, 1971). **meeting with . . . Anne Braden:** 100-4708-1A3. A photo Withers shot shows Roop sitting with Braden. **executive at Stax:** 100-4708-333 (April 19, 1971). **organize workers:** 100-4708-559 (July 12, 1972). **attending a memorial:** FBI memo, Students For a Democratic Society file, 100-4000-1540 (January 27, 1970). **hosting activists:** 100-4708-623 (October 5, 1973).

[3] FBI memo, Rev. Richard M. Moon file, 100-4481-173 (December 12, 1969). Withers and a second informant both told the agent that SSOC executive secretary Michael Welch had given them the number as his home phone.

[4] Author interview with Athan Theoharis, August 27, 2016. Though the issue at hand is not a wiretapping issue per se, the FBI's history of phone tapping is instructive. Before the 1978 passage of the Foreign Intelligence Surveillance Act, which created secret courts to oversee "national security" wiretaps and electronic surveillance, the FBI operated in a murky and at times illegal arena when it came to surveilling suspected subversives. Theoharis writes in *Spying on Americans* (98–113) that despite a 1934 law outlawing wiring tapping, President Roosevelt in 1940 authorized selective tapping of aliens in national security cases. Attorney General Tom Clark extended that order in 1946 to American citizens, a decision that extended wiretapping to an ever-broadening range of people suspected of subversive activity. Lawrence contended in retirement that "warrantless searches and entries for audial and visual checks were legal in national security cases" between 1940 and 1972, though he conceded "the law is confusing and ambiguous." (Lawrence personnel file, May 23, 1977, letter to Ed Williams, editorial page editor, *The Charlotte Observer*, 2.) Lawrence wrote the opinion piece in defense of retired FBI agent John Kearney, who was indicted for warrantless mail openings while investigating the radical Weather Underground. Charges against Kearney were later dismissed.

[5] Author interview with Allan Fuson, March 21, 2016.

[6] This information is from a report attached to an FBI form FD-306, "Cover sheet for Informant Report or Material," dated July 5, 1972, contained in the FBI's file on the Black Arcade, 157-2112-86. Withers is identified in the report as ME 338-E—the "E" signifying an extremist informant. The FBI tweaked Withers's code number in August 1971, converting him from a racial to an extremist informant. It's unclear if Withers contacted Chandler Wrecking Co. posing as a potential employer or creditor or precisely how he obtained Allen's personal information.

[7] Author interview with Mark Allen, July 22, 2017.

[8] FBI memo, Memphis file "Mid-South Citizens Dissatisfied With United States Policy in Vietnam," 100-4285 (April 19, 1967), serials 77 and 78.

[9] **chaired the Physics Department:** "Death Notice—Nelson Fuson," *Physics Today*, January 2010. **movement's heroes . . . visited:** Allan Fuson interview.

[10] Fuson interview.

[11] These details on Fuson come from MPD Intelligence Bureau reports forwarded to the FBI. Redactions and other concerns don't allow Townsend be pinpointed as the source. Yet references to the undercover policeman in the reports suggest him as the source for

some if not all the information. Some of these reports are found in the FBI's "Invaders" file, 157-1067, serials 1911 and 1991.

[12] **at . . . memorial rally:** 100-4000-1540. **attend . . . Convention:** FBI report, Kathy Roop file, 100-4708-559 (July 12, 1972).

[13] 100-4708-623.

[14] FBI memos. **shot twenty pictures:** 100-4708-1A2. **license plate:** FBI report, Tennessee Council on Human Relations file, 100-3481-51 (December 31, 1968). **four meetings:** by FBI special agent Burl F. Johnson to the Secret Service (February 10, 1971), released to author January 30, 2014, hereafter referred to as Johnson Report (NW).

[15] FBI report, HQ file on Black Organizing Project, 157-8460-17&18 (November 27, 1968), pp. 1, 11, 14.

[16] See 100-4708. **shot photos:** serial 24. **confirmed her connection:** serial 65.

[17] Johnson report.

[18] **conferring with . . . Braden:** 100-4708-1A3 (the FBI released a photo cutout depicting the right profiles of Braden and Hunninen engaging in an evident small-group discussion). **Free Angela Davis:** 100-4481-216.

[19] Lloyd Holbeck, "Grenade Blast Spurs Inquiry," *CA*, April 21, 1971, 21. "Hand Grenade Damages Two Crusader' Autos," *MPS*, April 20, 1971, 1.

[20] Photos supplied to author by Kathy Hunninen. See also *Southern Patriot*, May 1971.

[21] 100-4708-333.

[22] Report by agent Johnson, April 30, 1971.

[23] *Southern Patriot*, October 1972.

[24] 100-4708-559.

[25] **"day-to-day appraisal":** see Church Committee, book III, 448. **as many as sixty-two meetings . . . communist front:** FBI report, by agent Johnson (February 11, 1972).

[26] FBI report, 100-4708-659 (August 12, 1974).

[27] Details of Hunninen's name check, termination and reinstatement come from FBI releases to author on January 30 (release #250070) and October 1, 2014 (289369) (NW). Critical details were gleaned from several documents, including an April 8, 1985, letter to the FBI from the Arnold & Porter law firm in the October 1 release and an undated internal FBI memo in the January 30 release.

[28] See Charles Francis, "Perved: Eisenhower Anti-Gay Executive Order Turns 60," *The Huffington Post*, May 2, 2013.

[29] Letter, October 29, 1985, from Gersch to Gary L. Stoops, FBI chief of operations section in records management.

[30] Memo, Mary C. Lawton to Floyd I. Clarke, assistant director, FBI's Criminal Investigation Division (February 14, 1986), released to author by the National Security Division on February 11, 2014 (NW).

[31] Author interview with Kathy Hunninen, February 3, 2016.

Chapter Twenty-One

[1] Author interview with Charles Cabbage, January 5, 2010.

[2] The scope of criminal activity attributed to the Invaders was broad. In February 1969, three former Invaders were convicted of luring Memphis patrolman James Robert Waddell into an ambush and wounding him in the leg. (Charles Edmondson, "Invaders May Serve About Two years," *CA*, February 19, 1969, 19.) Withers helped detect some crime. The day after the body of Anthony "Red" Warren was found in a field in January 1969,

Lawrence called Withers for help. Police suspected members of the Invaders were involved but had made no arrests. They had a lead on a name, "Al Frierson." Withers told the agent that "is probably Albert Frison," a pastor's son. Frison and two others were arrested the next day. Frison later pleaded guilty to involuntary manslaughter. (See FBI memo, February 5, 1969, 157-1067-930.) The report says Withers also provided information in the case of a man shot in the foot by an Invader.

[3] FBI report, Coby Vernon Smith file, ME-100-4394-1 (November 29, 1966). Also, report 100-4394-23 (April 12, 1967) and serials 1A-1 to 1A-3, all dated May 5, 1967. Also, report NAACP file, 100-662-1069&70 (April 27, 1967).

[4] 100-4394-23.

[5] 100-662-1069&70. Also, report, 100-4394-60A (July 21, 1967).

[6] **fast friends:** Author interview with Coby Smith, January 5, 2010. **Withers scoped out . . . searched his files:** 100-4394-60A.

[7] **"Ernest called us over":** Smith interview. **"Under the pretext":** FBI report, 100-4394-83 (August 18, 1967).

[8] Kay Pittman Black, "Two Names Cause Stir," *MPS*, August 4, 1967, 1. Also, Charles A. Brown, "Two 'Angry Young Men' Kicked Out," *MPS*, August 8, 1967, 1; Kay Pittman Black and Bill Evans, "Senate Prober Checks In Memphis," *MPS*, August 10, 1967, 1; Charles A. Brown, "Decision Expected Tonight in Case of Two Dismissed Poverty Workers," *MPS*, August 24, 1967, 12.

[9] Kay Pittman Black, "Invaders vs. the Law—Box Score to Date," *MPS*, February 20, 1969, 19.

[10] FBI report, COINTELPRO-Black Nationalist Hate Groups, 100-448006 (April 3, 1969). The serial is illegible, but appears to be 811.

[11] The Church Committee reported that FBI headquarters maintained lists of "friendly" media. Field offices also kept unpaid "confidential sources" in the media, journalists who could be counted on to protect the Bureau's interests. These contacts often were used to place unfavorable articles about targeted groups and to leak "derogatory information intended to discredit individuals." See Church Committee, book III, 35–36.

[12] FBI report, 100-448006 (March 29,1968). Lawrence wrote in an April 19, 1967, memo that "an established contact" at *The Commercial Appeal* turned over details he'd gleaned from reporter Barney DuBois, who'd just covered a peace march. See 100-4285-78.

[13] FBI report 100-448006-717 (February 23, 1969).

[14] Seth Rosenfeld, *Subversives: The FBI's War on Student Radicals and Reagan's Rise to Power,* 273.

[15] Lawrence testimony, HSCA, Vol. VI, 541. See also "Report of the Department of Justice Task Force to Review the FBI Martin Luther King, Jr., Security and Assassination Investigations" (also known as the Shaheen Report), 24. The reports says the FBI had "five paid confidential informants providing intelligence regarding the racial situation to the Memphis Field Office on a continuing basis."

[16] Re: Ghetto Informant Program see Church Committee book III, 252-55. Re: Withers as extremist informant, see FBI report, AFSCME file, 157-1516-558 (August 11, 1971).

[17] *Amsterdam News*, February 21, 1970, 22.

[18] CNN, *Black in America* special, February 2011.

Chapter Twenty-Two

[1] FBI memos, 100-4575-14&21 (January 5 and 25, 1968).

[2] **overheard:** FBI report, Memphis "MURKIN" file, 44-1987-Sub E-318. This Teletype from the FBI's New York to Memphis offices dated April 14, 1968, references New York's

interview with Joseph Louw. **A militant accused:** FBI memo, 157-2112-6 (July 10, 1969).

[3] FBI memo, Charles Cabbage file, 100-4528-485 (April 27, 1970). The report misidentifies Melhorn as "Sam Melborne."

[4] Author interview with Jack Cantrell, December 15, 2016.

[5] Withers et al., *Pictures Tell The Story*, 82.

[6] Lawrence testimony, HSCA, Vol. VI, 552 (November 21, 1978).

[7] FBI memo 157-1067-189 (July 5, 1968).

[8] Author interview with Coby Smith, January 5, 2010.

[9] FBI memo 157-1067-909 (February 5, 1969).

[10] Shirletta J. Kinchen, *Black Power in the Bluff City: African American Youth and Student Activism in Memphis, 1965–1975*, 57–8. Details on BOP's structure can be found in the congressional testimonies of Calvin Taylor, Charles Cabbage, and John B. Smith, HSCA, Vol. VI, 445–538.

[11] **"do this . . . as a symbol":** FBI memo, 100-4528-182&183. **"can no longer distinguish":** FBI memo, 157-1067-142 (June 6, 1968).

[12] **wanted "objective" information:** Lawrence testimony, HSCA Vol. VI, 541. **Withers reported:** FBI memo, 100-662-1506 (March 12, 1970).

[13] Some details on Withers's studio as a gathering spot for the Invaders are found in these FBI reports: Calvin Taylor file, 100-4579-1 (November 7, 1967) (a police informer says the studio at 327 Beale "was used as a meeting place" for Coby Smith and Cabbage, but Withers had them leave when he learned "it was a Black Power type meeting"); Clifford Louis Taylor file, 100-4575-9 (December 4, 1967) (an informer says Cabbage, Coby, and John B. Smith used to hang at Withers's studio but that Black Power associate Calvin Taylor "has since discouraged them from doing so"); and 100-4575-12 (December 27, 1967) (Withers told Lawrence that John Smith visited him but was just "horsing around").

[14] 100-4575-12.

[15] Author interview with John B. Smith, November 1, 2012.

[16] Ibid. See also, Kay Pittman Black, "MAP-South Men Defend Controversial Anti-Poverty Work," *MPS*, September 11, 1967.

[17] Smith interview. See also FBI memo, October 20, 1967, National Mobilization Committee to End the War in Vietnam file, 62-111181-1732, which mentions an insufficient number of followers.

[18] **"intimidated white professors" . . . "any means necessary":** FBI memo, 100-4528-176 (March 25, 1968). **Stokely Carmichael:** 100-4575-12.

[19] **Little Rock:** FBI report, 100-4528-100 (January 11, 1968). **hamming:** FBI evidence slip, 100-4528-1A5 (October 1, 1967).

[20] **Molotov cocktails:** FBI memo, 100-4528-182&83 (March 30, 1968), p. 10. **"romantically attached":** FBI memo, 157-1092-146 (March 25, 1968). **gave . . . the tag number:** Memo, 100-4528-188 (April 2, 1968). **arrested:** 100-4528-230 and Cabbage's MPD Bureau of Identification file, in author's possession. Cabbage's arrest is described in a May 1, 1968, report by Lt. W. E. Lloyd. **relayed . . . phone numbers:** FBI report, 100-4528-177 (March 25, 1968), 2.

[21] **told Lawrence . . . "He will refuse to go":** 100-4528-177, p. 4. Withers told Lawrence that Cabbage lacked a sufficient grade-point average to transfer to Memphis State without taking an entrance exam, which he refused. **Holloway wrote:** *USA v. Charles Laverne Cabbage*, 430 F.2d 1037 (6th Cir. 1970).

[22] 100-4528-177, pp. 5–6.

[23] **two-thirds of eligible blacks:** Joseph A. Fry, *The American South and the Vietnam War:*

Belligerence, Protest and Agony in Dixie, 208. **march on the Pentagon:** 62-11181-1732.

[24] *USA v. Cabbage.*

[25] Ibid. Also, Cabbage interview.

[26] FBI memos. **hiding:** 100-4528-304 (August 6, 1968). **motel:** 100-4528-254 (July 3, 1968). **Atlanta:** 157-1067-586 (November 20, 1968). **getting advice:** 100-4528-304. **broke:** 100-4575-39 (September 13, 1968). **raising money:** 100-4528-303 (August 6, 1968). **bums money:** 100-4575-39. **"con artist":** 100-4575-34. **"gigolo":** 100-4528-452 (May 6, 1969). **"pimp and a hustler":** 100-4528-382 (December 12, 1968). **army deserters:** 157-166-757 (June 12, 1969). **burglary:** 100-4575-39.

[27] 100-4528-176.

[28] **ten dollars:** FBI memo, 100-4528-237 (May 24, 1968). **copy . . . to FBI:** Evidence slip, 100-4528-1A9 (July 25, 1968).

[29] The description of Yahweh's public life comes from several sources, principally an eighteen-page handout from Yahweh and author interview with Yahweh. Yahweh's MPD Bureau of Identification file shows he was arrested or charged twelve times before 1968, mostly for minor offenses. Criminal Court records show he was sentenced in 1965 to three years in prison for burglary.

[30] Suhkara Yahweh interview with author, January 14, 2010.

[31] FBI memo, 157-1067-578&79 (November 15, 1968).

[32] FBI reports. **Black United Front:** 100-4579-26. **Philadelphia:** "Liaison With Groups Sponsoring Integration" file, 100-3481-29 (September 3, 1968). **striking workers:** 157-1067-1A55 (October 17, 1968). **"called for violence":** 100-4528-366 (October 22, 1968). **baby . . . stabbed:** 157-1067-1339 (July 3, 1969). **loan:** Ibid. **James Brown:** 157-1067-1577 (September 26, 1969). **"White Man":** 157-1067-1A63 (November 22, 1968). **"Swing Don't Sing":** 157-1067-1A62 (November 14, 1968). Re: James Brown, Yahweh has said in interviews the singer made his bail bond once to secure his release from jail.

[33] FBI memos. **"lift his wallet":** 157-1067-586. **"extortion money":** 157-1067-614 (November 22, 1968). **"con man" . . . "racket":** 157-1067-1594 (October 7, 1969). **lack of community support:** Kinchen, *Black Power in the Bluff City*, 114, 178. Kinchen writes that "the failure of Operation Breakfast to gain widespread support was emblematic of the strained relationship between the organization and the community."

[34] FBI memo 100-4481-216 (March 1, 1971).

[35] FBI memo, "Memphis Mobilizers" file, 157-2269-214 (July 20, 1970).

[36] Yahweh interview.

Chapter Twenty-Three

[1] Author interview with Bobby Doctor, December 4, 2012.

[2] FBI memos. **"interracial parties":** 100-4579-1. **"power clique":** 100-4528-177, p. 10.

[3] FBI memo, 100-4579-29 (October 2, 1968). Withers named many in attendance, including a school principal and a lawyer. Lawrence's report notes that guards would not let white activist Baxton Bryant enter.

[4] FBI memos: 100-4528-423 (April 2, 1969); 100-4579-41 (April 3, 1969).

[5] FBI memo, "SCLC" file, 157-166-552 (November 1, 1968). The report doesn't stipulate that Withers knew how Lawrence intended to use the photo. However, the wording of the report indicates Withers drew the agent's attention to an association between Doctor and Dandridge. Both Doctor and Dandridge told the author there was no extramarital relationship between them.

[6] FBI memo, 157-166-724 (May 14, 1969).

[7] Withers often documented victims of police brutality. As an example, see "Cops Wage War On Black Community," *TSD*, April 6, 1968, 1. The newspaper's page-one coverage of the March 28, 1968, police melee in downtown Memphis includes a photo Withers shot depicting the graphic head wounds of Morris Webb, a bystander who was beaten by baton-wielding police as he parked a car.

[8] Church Committee, book III, 227–31. The committee noted that abuses often are compounded in intelligence cases. Unlike criminal cases, intelligence matters are rarely prosecuted, hence, there is no court review. See also, Garrow, "FBI Political Harassment," 17. Fear of the unknown informant could have detrimental effects, he writes: "Widespread suspicion of informant penetration provided fertile ground for accusations of betrayal whenever movement tensions led to angry, personal recriminations."

[9] FBI reports. **identification photos . . . "rumormonger":** 157-1067-45&1A-2 (May 13, 1968). **"lasted only one week":** 157-1067-513 (October 22, 1968).

[10] Marc Perrusquia, "Withers Prolific Spy, FBI reports—Tips Not Limited to '60s Activists," *CA*, July 8, 2012, 1. Withers wasn't the only one reporting on Miller. MPD detective Ed Redditt claimed Miller had once threatened him and made inflammatory comments about Black Power. (April 1, 1968, report of Det. Ed Redditt and patrolman Willie Richmond.) But Miller told the author, "I was never part of that." She said, "I was trying to be a socialite. I wasn't trying to be part of that mess."

[11] **"dismiss these youths":** Nat D. Williams, "A Point of View," *TSD*, February 1, 1969, 6. **political cartoon:** "Black United Front," *TSD*, April 6, 1968.

[12] FBI memo, 100-662-1220 (January 10, 1969).

[13] FBI memo, 157-1092-67 (March 12, 1968).

[14] FBI memos. **sweeping intelligence reports . . . "got a job":** 157-1067-189 (July 5, 1968). **"troublemaker":** Ibid.

[15] FBI memos. **financial report:** 157-1092-357 (July 26, 1968). **leaflet:** 100-4528-182&183. **official notebook:** 100-4528-413 (February 13, 1969). Three months later, Lawrence said he'd made arrangements to review toll calls on the telephone at Invaders' headquarters. See FBI memo 157-1067-1159 (May 8, 1969).

[16] **arrange night classes:** FBI memo 157-1067-519 (October 21, 1968). **hire more of the Invaders:** FBI memo 100-4528-454 (May 6, 1969). **Fisher recalled:** Author interview, August 2010.

[17] FBI reports. **abusing the relationship:** 157-1067-1339. Lawrence's report says Withers told him Smith had bragged that he "conned" the church into "giving him a $6,000 grant" to open a day care center. The report provides no evidence to support the claim. **fourteen pictures:** 157-1067-1A81 (July 31, 1969). **"allows Melvin":** 157-1067-1468 (August 7, 1969). **become active:** 157-1516-444 (December 22, 1969). **draft resistance rally:** 100-4630-42&43 (August 15, 1969). Lyke's name is misspelled in the report as Light.

[18] Author interview with Fr. Charles Martin, January 6 and 29, 2010.

[19] FBI memos. **no longer allow:** 100-4528-359 (October 1, 1968). **counterintelligence action:** 157-1067-1159 (NW) (May 8, 1969).

[20] FBI memo, 100-3481-25 (August 26, 1968).

[21] FBI memos. **"untruthful" . . . "lily white neighborhoods":** 100-3481-25. **photos of . . . "characters":** 100-3481-29 (September 3, 1968).

[22] FBI memo 157-1067-614 (November 22, 1968).

[23] **"What concern":** Author interview with Bruce Kramer, December 22, 2016. **misappli-**

cation: "77-Count Indictment Accuses Pair of Check-Kiting Scheme At 2 Banks," *CA*, February 18, 1977. **harassing him:** "Judge Denies Part In Case Transfer," *CA*, October 30, 1969.

Chapter Twenty-Four

[1] Louw's photographs ran in a six-page spread in *Life* magazine, April 12, 1968, 74–9.

[2] HistoryMakers interview. Session 1, tape 3, story 9, Ernest Withers recalls the aftermath of Dr. Martin Luther King, Jr.'s assassination.

[3] **He told the agents:** FBI Teletype, 44-1987-Sub E-318 (NW) (April 14, 1968). **called the agent:** FBI memo, serialized as 157-1092-259A and 44-1987-sub-16 (April 4, 1968) (both NW). **first told:** Memo, 157-646-275 (June 2, 1966). **too unstable:** 44-1987-sub-16.

[4] **nervous tic:** Gerold Frank, *An American Death* (New York, 1972), 258. **"being informed":** 44-1987-Sub E-318. **accounts linger:** Among recent accounts, Stuart Wexler and Larry Hancock wrote in a 2012 book, *The Awful Grace of God,* that the White Knights had offered a $100,000 bounty on King's head. **Klansman complained:** Lawrence personnel file, November 7, 1960, memo from Memphis to headquarters. The name of the letter writer is redacted.

[5] **reporter paced:** Beifuss, *At the River I Stand*, 332. **what little he knew:** 100-4528-182&83. Withers, identified in the report as Source One, told Lawrence he was "not certain" who met with King, but understood it was Cabbage and two others. Withers provided critical background on the militants, saying they'd tried earlier that day to meet with sanitation strike leader H. Ralph Jackson, but he was "fed up" and refused.

[6] 157-1092-273&74. Withers is identified in the report as "source one."

[7] **blackmail King:** Ibid. **Testifying that morning:** Testimony of Frank C. Holloman, *City of Memphis v. Martin Luther King Jr. et al* (April 4, 1968), 52, 59. **wrote in retirement:** Lawrence's notebook, "Martin L King, Background, Subversion & Black Power."

[8] **expected collapse:** FBI memo, New York to Memphis, 100-4105-99 (April 23, 1968). Adviser Stanley Levison is cited in the report as saying he expected a 75 percent drop in contributors because of the leadership change and Abernathy's "ill-suited" personality. He believed SCLC would have to convert to a membership organization. **"resume SCLC support":** FBI Teletype, HQ file 157-9146-14-1 (April 10, 1968). Withers is identified at the bottom as ME 338—R though wording leaves the source in doubt.

[9] FBI memo, 157-1092-329&30 (April 17, 1968).

[10] FBI memo, 157-1067-54 (May 13, 1968).

[11] FBI memos. **strategy meeting . . . skip school:** "Poor People's Campaign" file, 157-8428-762 (April 29, 1968). **rally at Mason Temple:** 157-8428-840 (May 3, 1968).

[12] **Coretta King:** "SCLC" file, 157-166-1A24. **Andrew Young:** "SCLC" file, 157-166-1A22. **only 369:** 157-8428-1127 (May 10, 1968). **"admitted" . . . wasn't gaining traction:** 157-8428-1332 (May 15, 1968) and 157-8428-2313 (June 12, 1968).

[13] **remove an Invader:** 157-8428-1332. **Andrew Young complained:** Adam Fairclough, *To Redeem the Soul of America: The Southern Christian Leadership Conference & Martin Luther King, Jr.,* 386. **spotted the young militant:** 100-4575-34. **group picture:** FBI memo, 100-4528-305 (August 6, 1968).

[14] **cleared the camp:** Gerald D. McKnight, *The Last Crusade: Martin Luther King, Jr., the FBI, and the Poor People's Campaign,* 137–38. **FBI played a role:** McKnight, *The Last Crusade,* 141–44.

[15] FBI memo 100-4528-317A (August 20, 1968).

[16] **informant watched:** MPD internal memo of August 19, 1968, attached to FBI report,

100-4575-37 (August 30, 1968). **"Threatened to shoot":** Author interview with John B. Smith, January 28, 2013. In a separate interview, Young said he didn't recall Smith threatening to shoot him. "I can imagine arguing with him," he said. "I was not opposed to physical encounters." The MPD memo doesn't mention a gun but says the Invaders "were very mad."

[17] The characterization of the meeting comes from 100-4575-37 and 100-4528-317A. Withers gave Lawrence a copy of the leaflet (see evidence slip 157-1067-1A26 (August 21, 1968)).

[18] **took a picture:** Evidence slip 157-166-1A6 (September 11, 1968). **trace the payment:** 100-4528-317A. **"neutralize" the Invaders:** 157-1067-354 (NW).

[19] FBI memo 157-166-325 (July 25, 1968).

[20] **"grass roots" . . . "semi-extortion":** FBI memo 157-166-333 (July 29, 1968). **"putting the heat" . . . the Invaders:** FBI memo 157-166-376 (August 12, 1968).

[21] **connected the dots:** 157-166-376 and 100-3572-159. **picked him up:** Report of Det. Ed Redditt, April 3, 1968. Mathews later changed her name to Adjua Naantaanbuu and founded Memphis's annual Africa In April festival.

[22] Details here come from two reports: 100-662-1413 (December 1, 1969) and 157-1516-444 (December 22, 1969).

[23] Ibid. Despite the anticipated criticism, Bradley wrote a balanced story that anchored a seven-page spread (see *Jet*, "Memphis: Blacks Finish Job Dr. King Began; NAACP and Hospital Workers Put Pressure on Whites," December 11, 1969, 14–20).

[24] FBI memos. **"bought off":** 100-662-1372 (November 7, 1969). **Withers handed him:** 100-662-1306 (October 17, 1969).

[25] FBI memos. **"Black Mafia":** 100-662-1372. **"losing strength":** 157-43-571 (November 20, 1969).

[26] **"physical fight":** FBI memo, 100-662-1451&52 (December 18, 1969).

[27] FBI memo, 100-662-1380 (November 13, 1969).

[28] FBI memo. **told the Clayborn gathering:** 100-4000-1447 (November 14, 1969). **travel information:** 100-662-1452 (December 18, 1969).

[29] This characterization comes from these reports: 157-1516-490 (January 19, 1970); 100-4000-1447; 100-662-1405 (November 24, 1969).

[30] Charles Edmundson, "Disorders Result in 19 Indictments Of Black Leaders," *CA*, Dec. 10, 1969, 1.

Chapter Twenty-Five

[1] Lawrence personnel file. **turned in:** Memo (February 4, 1970). **agent wrote:** resignation letter (November 18, 1969).

[2] FBI memos. **more "militant activity":** 100-662-1501 (March 11, 1970). **renting a flatbed truck:** 157-2269-179 (April 8, 1970). **just $212:** 100-662-1544 (May 12, 1970).

[3] FBI memos. **Clarence Cecil Adams:** 100-662-1547 (June 9, 1970). **support for Rev. Ezra Greer:** 100-4481-195 (September 28, 1970). **Minerva Johnican:** 100-4481-216 (March 1, 1971).

[4] **broke the news:** Kay Pittman Black, "Black Panther Group Formed Here; Free Breakfast Project Under Way," *MPS*, December 11, 1970, 13.

[5] FBI memos. **visiting Memphis:** 157-2269-158 (February 16, 1970). Withers said the two unnamed men had in their possession organizational literature, posters, and buttons. He said he would attempt to secure photographs of them. **build a Panther organization:** 100-662-1544. **personal phone numbers:** 100-662-1547. Withers gave the FBI phone

numbers of John Charles Smith, Maurice Lewis, and a third man. **interstate contacts:** "Black Panther Party" file, 157-1205-372 (June 9, 1970). Withers said "a number of Negro males identifying themselves as members of the Black Panther Party from Mississippi" have contacted him wanting to get in contact with the Invaders, the report said. **Panther Party newspapers:** 100-662-1561 (January 19, 1971).

[6] **standoff:** Calvin Taylor, Jr., "Armed Blacks Keep Police At Bay At Move-In At MHA Apartments," *CA*, January 18, 1971, 1. Also, Kinchen, *Black Power in the Bluff City*, 179–81. **surrendered:** Michael Lollar, "Case Continued For Chanting Panthers," *CA*, January 19, 1971, 1. **brochure:** A copy of the brochure, produced in summer 1971, is in the author's possession. Withers also shot photos of Katherine Wyath, whose son, Larry, was connected to the Panthers. The photos depict Ms. Wyath pointing to cuts in her new furniture she said police had slashed when they came to her home looking for Larry. ("Memphian Claims Cops Cut Furniture," *TSD*, January 30, 1971, 1.)

[7] FBI informant report, FD-306, 157-1205-1622 (July 10, 1973). Contacted by the author, retired police officer Tyrant Moore declined to be interviewed.

[8] **delivered three pictures:** Evidence slip, 157-1205-1A13 (January 17, 1973). **what he saw:** Informant report, 157-1205-1661 (November 12, 1973). Withers also had described weapons in the home in February and August of that year.

[9] Hampton's December 4, 1969, killing stirred wide condemnation. Within weeks, a special commission co-chaired by conservative NAACP leader Roy Wilkins was empaneled to investigate. Ralph Abernathy announced the SCLC would build new alliances with groups like the Panthers (see Peniel E. Joseph, ed., *The Black Power Movement: Rethinking the Civil Rights-Black Power Era*, 167–83).

[10] Joseph, *The Black Power Movement*, 175, 179. These passages appear in an essay by Yohuru Williams, "'Red, Black and Green Liberation Jumpsuit': Roy Wilkins, the Black Panthers, and the Conundrum of Black Power."

[11] Informant reports. **wounding a man:** 157-1067-1249 (June 6, 1969). **drove a school bus:** 157-1205-1743 (Oct. 22, 1975). **successful 1973 campaign:** 157-1205-1622 (July 10, 1973). **Sickle Cell . . . Democratic Club:** 157-205-1622 (July 10, 1973). John Charles Smith's criminal record is found in his MPD Bureau of Identification file. See also, *State of Tennessee v. John Charles Smith*, B22819 and 20. He was sentenced to a year in 1970 for assault with intent to commit voluntary manslaughter.

[12] Informant report, 157-1205-1700 (September 6, 1974).

[13] **elected constable:** "Father Like Son," *Tennessee Star Daily*, August 10, 1974, 5. **Wendell Withers . . . "crisis":** Perry O'Neal Withers, "In Coma 2 Years . . . Wendell Withers Buried," *Tennessee Star Daily*, August 24, 1974, 1.

[14] Informant report, 157-1205-1749 (December 3, 1975).

SELECTED BIBLIOGRAPHY

Archival Collections, Records Obtained Through FOIA, and Government Reports

Church Committee reports, also known as the Senate Select Committee to Study Governmental Operations with Respect to Intelligence Activities.

Communism in the Mid-South: Hearings Before the Subcommittee to Investigate the Administration of the Internal Security Act and Other Internal Security Laws of the Committee on the Judiciary, United States Senate, October 28 and 29, 1957.

Comptroller General's February 24, 1976, report to the House Judiciary Committee, "FBI Domestic Intelligence Operations—Their Purpose and Scope: Issues That Need to be Resolved."

William E. Davis, FBI file, titled "William E. Davis, Security Matter—C," HQ file 100-347485 (courtesy of Michael Honey).

William E. Davis, FBI file, titled "William Edward Davis . . . Loyalty of Government Employees," HQ file 121-12712 (courtesy of Michael Honey).

Allan Fuson personal materials. Photographs reviewed courtesy of Allan Fuson.

U.S. House Select Committee on Assassinations (HSCA), Investigation of the Assassination of Martin Luther King, Jr.

B. Venson Hughes private collection of King assassination-related files. Reports of the Memphis Police Department reviewed courtesy of B. Venson Hughes.

Kathy Roop Hunninen, portions of FBI file, obtained by the author on January 30 (release #250070) and October 1, 2014 (289369), through Freedom of Information Act, FOIPA request No. 1210240.

Kathy Roop Hunninen, "Health and Human Services" file, obtained by the author through the Freedom of Information Act, FOIPA request No. OIG -14-0290-KS.

Kathy Roop Hunninen personal materials. Photographs and media articles reviewed courtesy of Kathy Roop Hunninen.

Joseph Hugh Kearney, FBI personnel file, obtained by the author through the Freedom of Information Act, FOIPA request No. 1271375-000.

Joseph Hugh Kearney personal materials. Photographs reviewed courtesy of Barbara Sullivan.

William H. Lawrence, FBI personnel file, obtained by the author through the Freedom of Information Act, FOIPA request No. 1271512-000.

William H. Lawrence personal papers. Handwritten notes, media articles, and family photographs reviewed courtesy of Betty Lawrence.

Memphis Police Department reports related to the sanitation strike and the surveillance of Martin Luther King.

Memphis Police Department personnel files.

Memphis Public Library and Information Center: Special Collections, E. H. Crump Collection.

Memphis Public Library and Information Center: Special Collections, Maxine Smith Collection.

National Archives and Records Administration, Atlanta: Art Baldwin closed session testimony. *USA v. Thomas E. Sisk et al.*, 79-30054 Middle District of Tennessee, Jencks Materials.

Shaheen Report, also known as the Report of the Department of Justice Task Force to Review the FBI Martin Luther King, Jr., Security and Assassination Investigations.

Shelby County Archives: "Criminal Court and Memphis Police Department Bureau of Identification" files.

Subversive Control of Distributive, Processing and Office Workers of America: Hearings Before the Subcommittee to Investigate the Administration of the Internal Security Act and Other Internal Security Laws of the Committee on the Judiciary, United States Senate, October 25–26, 1951.

Emmett Till murder trial transcript at Sumner, Mississippi, included in the Federal Bureau of Investigation's 2006 reexamination of the Till murder.

Byron "Gene" Townsend personal materials. Photographs reviewed courtesy of Danny Townsend.

University of Memphis Special Collections: Sanitation Strike Collection.

University of Memphis Special Collections: Tent City Collection.

University of North Carolina–Chapel Hill, Davis Library microfilm: COINTELPRO, the counterintelligence program of the FBI.

University of North Carolina–Chapel Hill, Wilson Special Collections Library: Junius Irving Scales Papers, 1940–1978.

Wisconsin Historical Society: Freedom Summer Collection.

Ernest Withers, FBI file related to the Tennessee Pardons and Paroles investigation, obtained by author through the Freedom of Information Act, FOIPA request No. 1119994-000.

Ernest Withers, collection of seventy FBI case files released to author pursuant to the mediated settlement of *Memphis Publishing Co. and Marc Perrusquia v. the Federal Bureau of Investigation*, 10cv01878, U.S. District Court for the District of Columbia.

Interviews by Author

Mark Allen	Dick Gregory	Nancy Mosley
Eli Arkin	Tim Hall	Brian Murphree
D'Army Bailey	Corbett Hart	Moses Newson
Danny Beagle	John Herbers	Betty Norworth
Ezekiel Bell	Hank Hillin	Kenneth O'Reilly
Carol McCabe Booker	Michael Honey	Clifton Potts
Charles Cabbage	Kathy Roop Hunninen	Georgia Davis Powers
Bob Campbell	Laura Ingram	Sadie Puckett
Jack Cantrell	Jesse Jackson	Christopher Pyle
Mike Cody	Jerry Jenkins	Heath Rush
Dorothy Cotton	William Jennings	Coby Smith
Joe Crittenden	Merrill T. Kelly	John B. Smith
Audrey Dandridge	Bruce Kramer	Maxine Smith
Bobby Doctor	Betty Lawrence	Mark Stansbury
John Elkington	James Lawson	Ralph Stein
W. Hickman Ewing	H. T. Lockard	Barbara Sullivan
Gerald Fanion, Jr.	Jimmie Locke	Athan Theoharis
John T. Fisher	Reed Malkin	Danny Townsend
John F. Fox, Jr.	Charles Martin	Cash Williams
Dr. Jerry Francisco	Edward McBride	Jerry Williams
Allan Fuson	Gerald McKnight	Robert Winfrey
Vicki Gabriner	Harold Middlebrook	Suhkara Yahweh
David Garrow	Rosetta Miller-Perry	Andrew Young
Gloria Greenspun	Joella Morrison	Muhammad Ziyad

Legal Cases

Chan Kendrick et al. v. Wyeth Chandler et al., C-76-449, U.S. District Court for the Western District of Tennessee.

James A. Dombrowski et al. v. James H. Pfister, Individually, Etc., et al. 227 F. Supp. 556 (1964) Civ. A. No. 14019, U.S. District Court, Eastern District of Louisiana, New Orleans Division, February 20, 1964.

City of Memphis v. Martin Luther King Jr. et al., C-68-80, U.S. District Court for the Western District of Tennessee.

Memphis Publishing Co. and Marc Perrusquia v. Federal Bureau of Investigation, 1:10-cv-01878-ABJ, U.S. District Court for the District of Columbia.

United States of America v. Herbert Atkeison et al., Civ. A. No. 4131, U.S. District Court for the Western District of Tennessee filed, December 14, 1960.

USA v. Charles Laverne Cabbage, 430 F.2d 1037, Sixth Circuit Court of Appeals, 1970.

USA v. John Ford, 05-20201-B, U.S. District Court for the Western District of Tennessee.

USA v. Thomas E. Sisk et al., 79-30054, U.S. District Court for the Middle District of Tennessee.

USA v. Ernest Columbus Withers and John Paul "J. P." Murrell, CR-79-20009-1, U.S. District Court for the Western District of Tennessee.

Periodicals

Amsterdam News
The Atlanta Constitution
The Charlotte Observer
Cleveland Press
The Commercial Appeal (CA)
Communications Lawyer
Cornell Law Review
Ebony
The Fayette Falcon
The High Point Enterprise
The Huffington Post
The Ithaca Journal
Jet
Look
Memphis Press-Scimitar (MPS)
The Memphis World
The New York Times (NYT)
Physics Today
Prologue
The Public Historian
Southern Patriot
The Tennessean
Time
Tri-State Defender (TSD)
The Washington Post

Documentaries, Video Interviews, and Digital Presentations

Boone, Marshand. "Oral History Interview of Ernest Withers" for The Civil Rights and The Press Symposium at Syracuse University's Newhouse School of Public Communications, 2004.

Interview of Ernest Withers by Larry Crowe, The HistoryMakers Digital Archive (June 28, 2003).

"Marshall County, Mississippi: Largest Slaveholders From 1860 Slave Census Schedules and Surname Matches For African Americans on 1870 Census." Transcribed by Tom Blake, February 2002. http://freepages.genealogy.rootsweb.ancestry.com/~ajac /msmarshall.htm.

"Pictures Don't Lie." CNN, *Black in America* special report on the Ernest Withers informant revelation. February 2011.

"Real People With Bill Waters." Interview with Ernest Withers. WKNO-TV, Channel 10, the Public Broadcasting Service affiliate in Memphis, 2006.

Southern Poverty Law Center website, https://www.splcenter.org/fighting-hate/extremist -files/group/nation-islam.

Wall, Wendy. "Anti-Communism in the 1950s." The Gilder Lehrman Institute of American History. http://www.gilderlehrman.org/history-by-era/fifties/essays/anti-communism-1950s.

Withers, Ernest. Speech before the Museum of Fine Arts in Boston. WGBH Educational

Foundation's Forum Network (January 19, 2004), Civil Rights Movement Series. http: //forum-network.org/lectures/civil-rights-movement-on-film/.

Interview of Rome and Billy Withers. Aired by WMC-TV, Channel 5, Memphis, July 15, 2012.

Interview of Rosalind Withers by Kontji Anthony. WMC-TV, Channel 5, Memphis, September 13, 2010.

Ernest Withers: His Brother's Keeper. Video biography produced by WKNO-TV, Channel 10, the Public Broadcasting Service affiliate in Memphis, 1995.

Books

Abernathy, Ralph. *And the Walls Came Tumbling Down.* First Harper Perennial edition. New York: Harper Perennial, 1990.

Arsenault, Raymond. *Freedom Riders: 1961 and the Struggle for Racial Justice.* Oxford-New York: Oxford University Press, 2006.

Beifuss, Joan Turner. *At the River I Stand.* Memphis: St. Lukes Press, 1990.

Berger, Maurice. *For All the World to See: Visual Culture and the Struggle for Civil Rights.* New Haven, Conn., and London: Yale University Press, 2010.

Beito, David T., and Linda Royster Beito. *Black Maverick: T.R.M. Howard's Fight for Civil Rights and Economic Power.* Urbana, Ill., and Chicago: University of Illinois Press, 2009.

Biles, Roger. *Memphis in the Great Depression.* Knoxville, Tenn.: University of Tennessee Press, 1986.

Booker, Simeon, with Carol McCabe Booker. *Shocking the Conscience: A Reporter's Account of the Civil Rights Movement.* Jackson, Miss.: University Press of Mississippi, 2013.

Branch, Taylor. *At Canaan's Edge: America in the King Years, 1965–68.* First Simon & Schuster paperback ed. New York: Simon & Schuster Paperbacks, 2007.

——— *Parting the Waters: America in the King Years, 1954–63.* New York: Simon & Schuster Paperbacks, 1988.

Burrough, Bryan. *Days of Rage: America's Radical Underground, the FBI and the Forgotten Age of Revolutionary Violence.* New York: Penguin Books, 2016.

Clegg III, Claude Andrew. *An Original Man: The Life and Times of Elijah Muhammad.* New York: St. Martin's Press, 1997.

Colaiaco, James A. *Martin Luther King, Jr.: Apostle of Militant Nonviolence.* New York: St. Martin's Press, 1993.

Davis, James Kirkpatrick. *Assault on the Left: The FBI and the Sixties Antiwar Movement.* Westport, Conn., and London: Praeger Publishers, 1997.

Dowd, Douglas, and Mary Nichols, eds. *Step by Step: Evolution and Operation of the Cornell Students' Civil-Rights Project, Summer, 1964.* New York: W.W. Norton & Company, 1965.

Dowdy, G. Wayne. *Crusades for Freedom: Memphis and the Political Transformation of the American South.* Jackson, Miss.: University Press of Mississippi, 2010.

——— *Mayor Crump Don't Like It: Machine Politics in Memphis.* Jackson, Miss.: University Press of Mississippi, 2006.

Eagles, Charles W. *The Price of Defiance: James Meredith and the Integration of Ole Miss.* Chapel Hill, N.C.: University of North Carolina Press, 2009.

Fairclough, Adam. *To Redeem the Soul of America: The Southern Christian Leadership Conference & Martin Luther King, Jr.* Athens, Ga., and London: University of Georgia Press, 1987.

Forman, James. *The Making of Black Revolutionaries*. Seattle and London: University of Washington Press, 2000.

Frank, Gerold. *An American Death: The True Story of the Assassination of Dr. Martin Luther King, Jr., and the Greatest Manhunt of Our Time*. New York: Doubleday & Company, 1972.

Friedman, Mickey. *A Red Family: Junius, Gladys & Barbara Scales*. Urbana, Ill., and Chicago: University of Illinois Press, 2009.

Fry, Joseph A. *The American South and the Vietnam War: Belligerence, Protest and Agony in Dixie*. Lexington, Ky.: University Press of Kentucky, 2015.

Garrow, David J. *Bearing the Cross: Martin Luther King, Jr., and the Southern Christian Leadership Conference*. First Perennial Classics ed. New York: Perennial Classics, 2004.

——— *The FBI and Martin Luther King, Jr.: From "Solo" to Memphis*. New York: W.W. Norton & Company, 1981.

Gilmore, Glenda Elizabeth. *Defying Dixie: The Radical Roots of Civil Rights, 1919–1950*. New York and London: W.W. Norton & Company, 2009.

Green, Laurie B. *Battling the Plantation Mentality: Memphis and the Black Freedom Struggle*. Chapel Hill, N.C.: University of North Carolina Press, 2007.

Gritter, Elizabeth. *River of Hope: Black Politics and the Memphis Freedom Movement, 1865–1954*. Lexington, Ky.: University Press of Kentucky, 2014.

Halberstam, David. *The Children*. New York: Random House, 1998.

Haynie, Aeron and Timothy S. Miller, eds. *A Memoir of the New Left: The Political Autobiography of Charles A. Haynie*. Knoxville, Tenn.: University of Tennessee Press, 2009.

Hershberger, Mary. *Traveling to Vietnam: American Peace Activists and the War*. Syracuse, N.Y.: Syracuse University Press, 1998.

Hillin, Hank. *FBI Codename TennPar: Tennesssee's Ray Blanton Years*. Nashville, Tenn.: Pine Hall Press, 1985.

Honey, Michael K. *Southern Labor and Black Civil Rights: Organizing Memphis Workers*. Urbana, Ill., and Chicago: University of Illinois Press, 1993.

Joseph, Peniel E., ed. *The Black Power Movement: Rethinking the Civil Rights-Black Power Era*. New York: Routledge-Taylor & Francis Group, 2006.

Kinchen, Shirletta J. *Black Power in the Bluff City: African American Youth and Student Activism in Memphis, 1965–1975*. Knoxville, Tenn.: University of Tennessee Press, 2016.

Klehr, Harvey, John Earl Haynes, and Fridrikh I. Firsov. *The Secret World of American Communism*. New Haven, Conn., and London: Yale University Press, 1995.

Maas, Peter. *Marie: A True Story*. New York: Random House, 1983.

McGuire, Danielle L. *At the Dark End of the Street: Black Women, Rape, and Resistance—a New History of the Civil Rights Movement from Rosa Parks to the Rise of Black Power*. New York: Alfred A. Knopf, 2010.

McKnight, Gerald D. *The Last Crusade: Martin Luther King, Jr., the FBI, and the Poor People's Campaign*. Boulder, Colo.: Westview Press, 1998.

Miller, William D. *Mr. Crump of Memphis*. Baton Rouge, La.: Louisiana State University Press, 1964.

O'Reilly, Kenneth. *Racial Matters: The FBI's Secret File on Black America, 1960–1972*. New York: The Free Press, 1991.

Roberts, Gene, and Hank Klibanoff. *The Race Beat: The Press, the Civil Rights Struggle, and the Awakening of a Nation*. New York: Vintage Books, 2007.

Rosenfeld, Seth. *Subversives: The FBI's War on Student Radicals and Reagan's Rise to Power.* New York: Picador, 2013.

Scales, Junius, and Richard Nickson. *Cause at Heart: A Former Communist Remembers.* Athens, Ga., and London: University of Georgia Press, 2005.

Schlesinger, Jr., Arthur M. *Robert Kennedy and His Times.* Boston: Houghton Mifflin Company, 1978.

Sigafoos, Robert A. *Cotton Row to Beale Street: A Business History of Memphis.* Memphis, Tenn.: Memphis State University Press, 1979.

Theoharis, Athan. *Spying on Americans: Political Surveillance from Hoover to the Huston Plan.* Philadelphia: Temple University Press, 1978.

Tyson, Timothy B. *The Blood of Emmett Till.* New York: Simon & Schuster, 2017.

Weiner, Tim. *Enemies: A History of the FBI.* New York: Random House, 2013.

Wexler, Stuart and Larry Hancock. *The Awful Grace of God: Religious Terrorism, White Supremacy and the Unsolved Murder of Martin Luther King.* Berkeley, Ca.: Counterpoint Press, 2012.

Whitfield, Stephen J. *A Death in the Delta: The Story of Emmett Till.* Baltimore: Johns Hopkins University Press, 1991.

Withers, Ernest C. (photos), with Ronald W. Bailey and Michele Furst (eds). *Let Us March On! Selected Civil Rights Photographs of Ernest C. Withers, 1955–1968.* Boston: Massachusetts College of Art and Northeastern University, 1992.

Withers, Ernest C., with F. Jack Hurley, Brooks Johnson, and Daniel J. Wolff. *Pictures Tell The Story: Ernest C. Withers, Reflections in History.* Norfolk, Va.: Chrysler Museum of Art, 2000.

Withers, Ernest C., and Daniel Wolff. *The Memphis Blues Again: Six Decades of Memphis Music Photographs.* New York: Viking Studio, 2001.

Withers, Ernest C. (photos), and Daniel Wolff (essay). *Negro League Baseball.* New York: Harry N. Abrams Inc., 2004.

Young, Andrew. *An Easy Burden: The Civil Rights Movement and the Transformation of America.* New York: HarperCollins Publishers, 1996.

INDEX

Lewis, Maurice, 281, 283
Lewis, Robert, 38, 41
Lewis, Warren, 262
Lightfoot, Claude, 224
Lincoln, Abraham, 95
Lockard, Hosea T., 20, 180, 197–98
Loeb, Henry, 16, 274, 300n7
Loeb, William, 274
Logan, Marian, 17
Long, G. A., 214n
Louis, Joe, 40, 104, 106
Louis, Marva, 39–40, 106
Louw, Joseph, 267–68
Lowe, Howell S., 224, 239, 244–45, 279, 282–83
Lowery, Rev. Joseph, 84–85
Lyke, Fr. James, 264
Lynch, Jim, 174

MacDonald, J. C., 110–11, 151–52, 165
Mahoney, Fr. Charles, 264
Malkin, Reed, 290, 305n23
Marshall, Thurgood, 198
Martin, Fr. Charles, 264
Martin, J. B., 103
Mathews, Tarlease, 274–75
May, Thomas Erskine, 286
Mays, Willie, xii, 121
McAdory, Jeff, 83
McCollough, Marrell, 13, 14–16, 17n, 21, 33, 217–18, 246, 299n4
McCrackin, Maurice, 171
McDaniel, Edward Donald, 212
McFerren, John, 156, 159, 173, 186–87, 190, 192
McFerren, Viola, 191, 192
McGee, Willie, 180
McGrory, Sammye Lynn, 75–76, 77
McGurty, Larry E., 179–80
McKenzie, Oree, 239, 246–47
McKnight, Gerald, 272
McNamee, David, 47
McRae, Judge Robert, 215
McSween, Cirilo A., 274
Meadows, Nathaniel, 173–74
Meese, Edwin, 135, 314n13
Melhorn, Sam, 244–45

Mencken, H. L., 60
Meredith, James, 43, 63, 172, 318n8
Meriwether, Louise, 242
Middlebrook, Harold, 43, 299n20
Milam, J. W., 113, 116–19, 311n9
Miller-Perry, Rosetta, 260, 289, 291, 331n10
Mitchell, Bobby Joe, 101n
Mitchell, Stuart J., 189
Moakley, Paul, 312n9
Moon, Dick, 280
Moore, Tyrant, 281
Morris, Alma, 262
Morrison, Jean Antoine, 211–12, 213n, 324n7
Morrison, Joella, 212, 213
Mosley, Nancy Lawrence, 82–85, 178–79
Muhammad, Elijah, 10, 150, 181
Muhammad, Wallace Fard, 181
Murphree, Brian, 211n
Murrell, John Paul "Speedy," 54–55, 58–59

Nash, Diane, 10, 90, 159, 202, 223
Newson, Moses J., 116, 126, 130, 291
Newton, Huey, 18, 235, 263
Nifong, Mike, 88–89
Nixon, Richard, 82, 252

O'Connor, James, 217
Orange, Rev. James, 15, 17n, 270–71, 300n7
O'Reilly, Kenneth, 12–13, 149, 313n176, 313n10
Orgill, Edmund, 121

Paige, Satchel, xii, 5, 121
Parker, Junior, 121
Parker, Mack Charles, 36
Parks, Rosa, 122, 168, 188, 317n19
Patton, W. C., 323n28
Payne, Janice, 282–83
Payne, Larry, 7
Peck, Chris, 99, 132–33
Peete, Rickey, 61
Pepper, William, 28
Perry, Ludwald Orren Pettipher, 260
Phillips, James Elmore, 248
Pickett, O. W., 274
Pigford, Don, 254
Plough, Abe, 300n7